𝕿𝖍𝖊 𝕹𝖊𝖜 𝖄𝖔𝖗𝖐 𝕿𝖎𝖒𝖊𝖘

Traveler's Guide To

Art Museum Exhibitions 2003

The New York Times
Traveler's Guide To

Art Museum Exhibitions 2003

Edited by Susan Mermelstein

The New York Times

New York, New York

Distributed by Harry N. Abrams Inc., Publishers

Please send all comments to:
artguide@nytimes.com

Published by:
The New York Times
229 W. 43d St.
New York, NY 10036

ISBN 0-8109-9085-7
Printed and bound in the United States of America
First Printing
10 9 8 7 6 5 4 3 2 1

For the New York Times: Mitchel Levitas, Editorial Director, Book Development; Thomas A. Carley, President, News Services Division; Nancy Lee, Director of Business Development

Editor: Susan Mermelstein

Associate Editor: Mark Yawdoszyn

Photo Editor: Robert Candela

Contributors: Pamela Kent (London); Ladka Bauerova (Paris, Prague); Manuela Mirkos (Rome); Benjamin Jones (Madrid); Dasha Klimenko (Moscow); Chieko Mori (Tokyo); Eduardo Castillo (Mexico City); Nina Galanternick (Rio de Janeiro); Victor Homola (Berlin); Sarah A. Kass (Scandinavia); Alice Fung (Hong Kong); P.J. Anthony (New Delhi); Susan Gotthelf (Buenos Aires)

Design and Production: Mary Ciuffitelli; G&H SOHO, Hoboken, N.J.: Jim Harris, Gerry Burstein, Mary Jo Rhodes, Kathie Kounouklos

Cover Design: Barbara Chilenskas, Bishop Books

Cover Art: Agnolo Bronzino, *Portrait of Eleonora of Toledo and Her Son Giovanni,* ca. 1545. Oil on panel. The Detroit Institute of Arts. Gift of Mrs. Ralph Harman Booth in memory of her husband, Ralph Harman Booth.

Distributed by Harry N. Abrams, Incorporated, New York

Harry N. Abrams, Inc.
100 Fifth Avenue
New York, N.Y. 10011
www.abramsbooks.com

Table of Contents

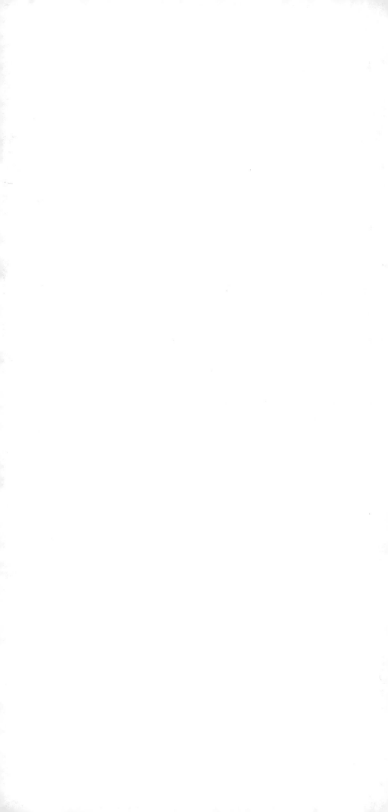

Editor's Note

In this fourth edition of The New York Times Travelers' Guide, we continue to add noteworthy museums and now have more than 400 listings. This edition also includes two essays by New York Times cultural writers that we trust you will find valuable: Roberta Smith muses on the pleasures of small museums like Boston's Isabella Stewart Gardner Museum and London's Wallace Collection. Alan Riding writes about the dependence of museums on tourism, and the recent phenomenon of building museums as tourist magnets, as in Bilbao, Spain.

While we aim to be as comprehensive and accurate in our exhibition listings as possible, we are constrained by the need to gather information from museums far in advance. We therefore urge you to contact the museum before you go to confirm exhibition dates.

As in the past we are using handy icons to indicate what services are offered by the museums. Here is the key to what they mean:

🎧 — Recorded tours only; guided and group tours are generally available.

👪 — Programs for children, including workshops, lectures and family activities.

☕ — Food and drink, ranging from vending machines to restaurants.

🛍 — Museum shop, including gifts, posters and artifacts.

♿ — Handicapped accessible.

We welcome your suggestions for further additions or improvements to this guide. Please write to: artguide@nytimes.com.

Susan Mermelstein

List of Illustrations

Large Pleasures From Small Museums

By Roberta Smith

Many art museums start small. Blessed are those that remain small.

Distinguished above all by their manageable size, the best can provide some of the most pleasurable, memorable and revelatory encounters with art objects that you are likely to have. Their fewer artworks are usually of exceptionally high quality. And their settings tend to be out of the ordinary, to say the least.

Small museums are total packages, little worlds unto themselves that come into being only when specific groupings of art objects are displayed permanently or semipermanently in an irreplaceable, history-laden environment — period houses, artists' former studios or exemplary buildings. Created most frequently by private collectors, but also by artists or their heirs, small museums can be found all over the world, in the middle of big cities like New York or Paris, on the edges of small ones like Basel, Switzerland, in the farmlands of central Iowa or the wilds of West Texas. Wherever they are located, a visit to them can be a pilgrimage, with all the implications of epiphany, renewed vision and rapture that the term implies.

I love big museums as much as anyone, especially the old ones with vast encyclopedic collections. What's not to like about the Metropolitan Museum of Art, the Louvre or British Museum? Even when visits to such places are marred by the spectacle of crowds and big-ticket shows, they are worth it.

But when you move beyond the great behemoths that were founded in the 18th or 19th centuries, or earlier, into the present, problems begin to loom. Today museums only get bigger. They expand with one horrible new wing after another, or they emerge whole from the renovation of an existing, already vast structure, like the Tate Britain.

Build it and they will come — to see the building — could be the mantra of many museum trustees. The block-buster exhibition has been replaced by blockbuster architecture. And some of the most famous of these blockbusters have

I

opened with almost no art to call their own. The best-known example is the bulging, undulating, relatively collection-free Guggenheim Bilbao in Spain; many of its visitors come only to see its extraordinary exterior, and never set foot inside.

Museums have always been star vehicles, or vanity productions, but the original stars were foremost the collections. Now museums are star vehicles for architects. It creates the phenomenon of architecture for architecture's sake: buildings that all but abandon their physical and social obligations for a higher calling, the architect's artistic expression. Museums conceived as relatively unobtrusive containers that complement rather than compete with the art are still being built, but they are steadily becoming an endangered species.

Of course small museums are not exactly ego-free. After all, what could be more egocentric than a collector who decides that his or her collection is too important to be absorbed into a larger museum, or for that matter sold at auction, and should exist in perpetuity in its original setting? Actually, the easy answer may be: only an artist with similar inclinations.

But while small museums often offer total immersion in their creators' taste or psyche, we encounter this egocentricity on a small scale and a one-to-one basis. Being finite, they remind us that most museums begin as a gleam in the eye of one person or a few people afflicted by an overriding passion for art. And yet they also offer unusually vivid cross-sections of the complex mixture of forces that surround art, of the economic and aesthetic power that constantly mingle in art institutions, and of the ever-present tensions between the material and the ideal.

The Italian palazzo that Isabella Stewart Gardner transported stone by stone to Boston around the turn of the last century for use as a private home is today a wonderfully atmospheric setting for her eclectic collection of European painting, sculpture and decorative arts. But it is also is a weirdly skewed time capsule, a fragment of Italian glory whose relocation to New England represents a moment of American economic might and cultural presumption.

This same moment finds a more straightforward, less Bohemian reflection in the mansion that the Pittsburgh steel baron Henry Clay Frick built on Fifth Avenue in New York City. There, with the help of powerful art dealers like Lord

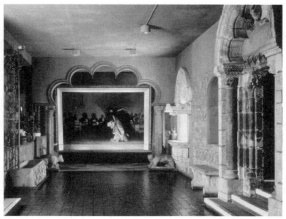

The Spanish Cloister at the The Isabella Stewart Gardner Museum.

Duveen, he built a stunning collection of European paintings
that includes Bellini's *St. Francis in the Desert*, Vermeer's *Mistress and Maid* and Holbein's portrait of Sir Thomas More,
works now displayed in rooms decorated largely as they were
in Frick's lifetime.

The mood can be even more personal at the Morgan Library
in New York, despite the fact that its galleries are often given
over to temporary exhibitions. Here, the visitor can wander
into J.P. Morgan's private study, with a vaulted ceiling and
imposing desk of Renaissance vintage, and a fabulous clutter
of small sculptures, paintings and objets d'art.

The London equivalent of the Frick is the Wallace Collection, which presents the wonderful selection of European
paintings (great Watteaus) assembled by Sir Richard and
Lady Wallace in their mansion, Hertford House. A far more
idiosyncratic vision of collecting can be experienced at the
nearby Soanes Museum, the joined townhouses redesigned
in the early 19th-century by John Soanes, architect of the
Bank of England, and filled to the brim with his collection
of Greek, Roman and early Christian antiquities and a collection of British paintings. The effect is of a triple-tiered
catacomb.

Among the relatively recent additions to the list of topnotch formerly private art collections is the venerated Menil
Collection in Houston, Tex. Now housed in an airy one-story

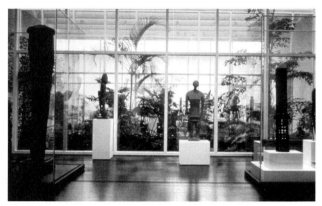

The Oceanic Gallery and Garden Atrium at The Menil Collection.

building designed by Renzo Piano that maintains a sense of domestic intimacy, the collection is the life's work of John and Dominique de Menil, formed mostly from the 1930's to the late 1970's. It is devoted to modernity wherever it is found and includes great works of 20th-century modernism, especially Surrealism, but also outstanding examples of African, Cycladic and pre-Columbian art.

A similar air of multicultural connoisseurship pervades the Beyeler Foundation in Basel, Switzerland, founded a few years ago by the art dealer Ernst Beyeler. Housed in another plain-spoken, light-filled Renzo Piano design, the collection is exceptionally strong in Picasso and Matisse in keeping with its founder's area of expertise.

The small museums created by artists or built post-humously around their achievements can be even more undiluted in their effect. In Paris, for example, a visit to the Musée Gustave Moreau will immerse the viewer in the hot-house sensibility of this French Symbolist painter and the eccentric, jewel-like images of Neo-Classical chimera it produced. The highlight is Moreau's theatrical main-floor studio, filled with paintings and accented by the sinuous tracery of a double-spiral wrought-iron staircase. Similar immersions are possible at the Musée Rodin, located in the historic Hotel Biron on the Rue de Varenne, and the Musée Picasso, ensconced in a small, exquisite 17th-century mansion in the Marais.

For the intrepid, I recommend a visit to Marfa, Tex., to see the Chinati Foundation, which was created by the Minimalist sculptor Donald Judd (1928-1994) in the last 20 years of his life. Located on the grounds of an old army fort, it consists of numerous barracks and command buildings and a riding arena, as well as a wool depot near the railroad tracks at the center of town. Judd carefully rehabilitated each of these structures, converting them, as he said, into architecture. These born-again structures are used for the permanent display of large works by other artists of his generation that he most admired, including Dan Flavin, John Chamberlain, Claes Oldenburg and Ilya Kabakov.

Most spectacular, however, is the installation, in two large, austere and ingeniously renovated artillery sheds, of Judd's largest serial work: 100 5-by-5-by-3-foot sculptures made of glowing milled aluminum, each a variation on his signature box form. To watch the West Texas light move across the planes of these bulky yet elegant objects can change the way you look at art.

Today, small museums are more important than ever. They offer great art in small but concentrated doses, providing wonderful experiences that also make viewers better prepared to enjoy the sprawling riches of a large museum. They also preserve an indispensable body of museological wisdom concerning visual perception, the ineffables of light, space and proportion and the reuse of existing architecture.

Finally, small museums almost always reflect their founders' vision and obsessions — whether acquisitive, artistic or both — with a clarity and realness that gets lost in big museums. They can inspire anyone who happens upon them, from the wealthy collector trying to decide how best to use his or her resources, to the young artist just starting out, to museumgoers with a vague interest in art. In bringing us thrillingly close to their guiding obsessions, the small museum demonstrates what an individual passion can foment, helping us to better understand the extent and direction of our own.

Roberta Smith is an art critic for The New York Times.

Major Traveling Exhibitions

After Whistler: The Artist and His Influence on American Painting
High Museum, Atlanta: November 15–February 8, 2004
The Detroit Institute of Arts, March 6, 2004–May 30, 2004

Andy Goldsworthy: Three Cairns
Neuberger Museum of Art, Purchase, N.Y.: January 26–April 13
Museum of Contemporary Art, San Diego: April 27–August 26

Anne Vallayer-Coster: Painter to the Court of Marie Antoinette
Dallas Museum of Art: Through January 5
Frick Collection, New York: Through March 23
Musée des Beaux Arts, Nancy, France: April 20–July 13

Ansel Adams at 100
Los Angeles County Museum of Art: February 2–April 27
MoMA QNS, New York: July 10–November 3

Art Deco, 1910–1939
Victoria and Albert Museum, London
March 27–July 20
Royal Ontario Museum, Toronto:
September 15–January 4, 2004
Museum of Fine Arts, San Francisco:
March 13, 2004–July 5, 2004
Museum of Fine Arts, Boston:
September 19, 2004–January 9, 2005

Courtesy of
Victoria and Albert Museum
Rene Lalique, Deux Paons
Lamp, 1925.

The Artist and the Changing Garden: Four Hundred Years of European and American Gardens
Iris & B. Gerald Cantor Center for Visual Arts at Stanford University, Stanford, Calif.: June 11–September 7, 2003
The Dixon Gallery and Gardens, Memphis, Tenn.: October 19–January 11, 2004

The Beginning of Seeing: Adolph Gottlieb and Tribal Art
Lowe Art Museum, Coral Gables, Fla.: June 12–July 27
Iris & B. Gerald Cantor Center for Visual Arts at Stanford University, Stanford, Calif.: September 10–January 4, 2004

Capturing Nureyev: James Wyeth Paints the Dancer
Farnsworth Art Museum, Rockland, Maine: Through January 5
Brandywine River Museum, Chadds Fords, Pa.: January 18–May 18

Casting a Spell: Winslow Homer, Artist and Angler
The Fine Arts Museums of San Francisco: Through February 9
Amon Carter Museum, Fort Worth, Tex.: April 19–June 29

The Color of Night
National Gallery of Art, Washington: April 13–July 13
Gilcrease Museum, Tulsa, Okla.: August 10–November 9

Conversion to Modernism: The Early Works of Man Ray
The Montclair Art Museum, Montclair, N.J.: February 16–August 3
Georgia Museum of Art: October 4–November 30

Debating American Modernism: Stieglitz, Duchamp and the New York Avant-Garde
Georgia O'Keeffe Museum, Santa Fe, N.M.: January 24–April 20
Des Moines Art Center: May 9–August 1
Terra Museum of American Art, Chicago: August 30–November 30

Degas and the Dance
Detroit Institute of Arts: Through January 12
Philadelphia Museum of Art: February 12–May 11

Degas in Bronze: The Complete Sculptures
Memorial Art Gallery of the University of Rochester, Rochester, N.Y.: Through January 5
San Diego Museum of Art: June 28–September 28

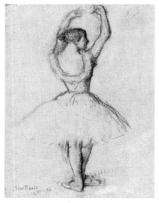

Courtesy of The National Museum, Belgrade.
Edgar Degas, *Dancer with Raised Arms, Seen from the Back*, 1894.

Distinctly American: The Photographs of Wright Morris
Iris & B. Gerald Cantor Center, Stanford, Calif.: Through January 12
Joslyn Art Museum, Omaha, Neb.: February 15–May 11

The Drawings of François Boucher
The Frick Collection, New York: October 24–January 4, 2004
Kimbell Art Museum, Fort Worth, Tex.: January 25, 2004–April 18, 2004

Edouard Vuillard (1868–1940)
National Gallery of Art and Sculpture Garden, Washington, D.C.: January 19–April 20
The Montreal Museum of Fine Arts: May 15–August 24

Edward Weston: Life Work
Milwaukee Art Museum: Through February 9
Portland Museum of Art, Portland, Me.: June 28–October 19

El Greco to Picasso From the Phillips Collection
Museum of Fine Arts, Houston: Through January 5
Phoenix Art Museum: January 26–May 4
Denver Art Museum: October 4–January 4, 2004

Ellsworth Kelly: Red Green Blue
Museum of Contemporary Art, San Diego: January 19–April 13
Museum of Fine Arts, Houston: April 27–July 20
Whitney Museum of Art: August through November

Eternal Egypt: Masterworks of Ancient Art From the British Museum
The Minneapolis Institute of Arts: Through March 16
The Field Museum, Chicago: April 26–August 10
Walters Art Museum, Baltimore: September 21–January 18, 2004
Royal Ontario Museum, Toronto, Canada: February 28, 2004–May 23, 2004

Fairfield Porter: A Life in Art
Frye Art Museum, Seattle, Wash.: Through January 19
Montgomery Museum of Fine Arts: February 1–March 20
Portland Museum of Art, Portland, Me.: June 19–September 7
Marion Koogler McNay Art Museum, San Antonio, Tex.: October 5–January 4, 2004

*Fred Wilson: Objects and Installations,
1985–2000*
Tang Teaching Museum and Art Gallery, Saratoga Springs,
N.Y.: Through January 7
University of California, Berkeley Art Museum and Film
Archive: January 22–March 30

Frederic Remington: The Color of Night
National Gallery of Art and Sculpture Garden, Washington,
D.C.: April 13–July 13
Gilcrease Museum, Tulsa, Okla.: August 10–November 9

George Washington: A National Treasure
Seattle Art Museum: March 21–July 20
Los Angeles County Museum of Art: Through March 9
The Minneapolis Institute of Arts: August 1– November 30
Oklahoma City Museum of Art, Oklahoma: December
12–April 11, 2004
Arkansas Arts Center: April 23, 2004–August 22, 2004

*Georgia O'Keeffe and the Calla Lily in American
Art, 1860–1940*
Georgia O'Keeffe Museum, Santa Fe, N.M.: Through January 14
Memphis Brooks Museum of Art, Memphis, Tenn.:
February 23–May 4

Gerhard Richter: Forty Years of Painting
San Francisco Museum of Modern Art: Through February 14
Hirschhorn Museum and Sculpture Garden, Washington,
D.C.: February 27–May 18

*The Gilded Age: Treasures from the Smithsonian
American Art Museum*
Dallas Museum of Art: Through January 12
Cleveland Museum of Art: February 23–May 18

Giorgio de Chirico and the Myth of Ariadne
The Philadelphia Museum of Art: Through January 5
Estorick Collection of Modern Art, London: January 22–April 13

*Illuminating the Renaissance: The Triumph
of Flemish Manuscript Painting in Europe,
1467–1561*
Getty Center, Los Angeles: June 17–September 7
Royal Academy of Arts, London: November 25–
February 22, 2004

James Rosenquist: A Retrospective
Museum of Fine Arts, Houston: May 18–August 17
The Menil Collection, Houston: May 16–August 17
Solomon R. Guggenheim Museum, New York: October
2–January 4, 2004

Kasimer Malevich
Deutsche Guggenheim Berlin, January 17–April 27
Solomon R. Guggenheim Museum, New York: May 22–
September 4
The Menil Collection, Houston: October 3–January 11, 2004

The Last Expression: Art and Auschwitz
Davis Museum and Cultural Center, Wellesley, Mass.:
January 9–February 16
Brooklyn Museum of Art: March 7–June 15

Leaving for the Country: George Bellows at Woodstock
Memorial Art Gallery of the University of Rochester,
Rochester, N.Y.: April 13–June 22
Terra Museum of American Art, Chicago: October 4–
January 11, 2004

Light Screens: The Leaded Glass of Frank Lloyd Wright
Orange County Museum of Art, Newport Beach, Calif.:
Through January 5
Renwick Gallery of the Smithsonian American Art Museum,
Washington: March 14–July 20

Magna Graecia: Greek Art from South Italy and Sicily
Cleveland Museum of Art: Through January 5
Tampa Museum of Art: February 2–April 20

Magnificenza! The Medici, Michelangelo and the Art of the Late Renaissance
Art Institute of Chicago: Through February 2
Detroit Institute of the Arts: March 16–June 8

Marsden Hartley
Wadsworth Atheneum, Hartford, Conn.: January 17– April 13
Phillips Collection, Washington, D.C.: June 7–September 7
Nelson-Atkins Museum of Art, Kansas City, Mo.: October
11–January 4, 2004

Matisse Picasso
Galeries Nationales due Grand Palais, Paris: Through January 6
MoMA QNS, New York: February 13–May 19

Max Beckmann
Centre National d'Art et de Culture George Pompidou, Paris:
Through January 6
Tate Modern, London: February 13–May 5
MoMA QNS, New York: June 26–September 29

Millet to Matisse: 19th- and 20th-Century French Painting From Kelvingrove Art Gallery, Glasgow
Speed Art Museum, Louisville, Ky.: Through February 2
Frick Art & Historical Center, Pittsburgh, Pa.: February 26–
May 25
Joslyn Art Museum, Omaha, Neb.: June 21–September 14
The Albuquerque Museum: October 8–January 4, 2004
Musée du Québec: January 29, 2004–May 2, 2004
Kalamazoo Institute of the Arts, Kalamazoo, Mich.: May 19,
2004–August 15, 2004

Modigliani and the Artists of Montparnasse
Albright-Knox Art Gallery, Buffalo, N.Y.: Through January 12
Kimbell Art Museum, Fort Worth: February 9–May 25
Los Angeles County Museum of Art: June 29–September 28

Old Masters, Impressionists, and Moderns: French Masterworks from the State Pushkin Museum, Moscow
Museum of Fine Arts, Houston: Through March 9
High Museum, Atlanta: April 5–June 29
The Los Angeles County Museum of Art: July 27–October 13

Over the Line: The Art and Life of Jacob Lawrence
Museum of Fine Arts, Houston: Through January 5
Seattle Art Museum: February 6–May 4

Painted Prints: The Revelation of Color in Northern Renaissance & Baroque Engravings, Etchings & Woodcuts
Baltimore Museum of Art: Through January 5
St. Louis Museum of Art: February 14–May 18

The Photography of Charles Sheeler: American Modernist

Museum of Fine Arts, Boston: Through February 2
Metropolitan Museum of Art, New York: May 2 –August 17
Städelsches Kunstinstitut und Städtische Galerie, Frankfurt: early 2004
Detroit Institute of Art: September 8, 2004–December 5, 2004

The Quest for Immortality: Treasures of Ancient Egypt

Kimbell Art Museum, Fort Worth: May 4–September 14
Museum of Science, Boston: Through March 30
New Orleans Museum of Art: October 19–February 25, 2004
The Denver Museum of Nature and Science: September 12, 2004–January 23, 2005
The Museum of Fine Arts, Houston: September 2, 2005–December 31, 2007

Red Grooms: Selections From the Graphic Work

Gibbes Museum of Art, Charleston, S.C.: September 19–December 14
Lowe Art Museum, Coral Gables, Fla.: November 20–January 18, 2004

Rembrandt's Journey: Painter/Draftsman/Etcher

Museum of Fine Arts, Boston: October 26–January 18, 2004
Art Institute of Chicago: early 2004

Sacred Treasures: Early Italian Paintings from Southern Collections

Georgia Museum of Art: Through January 5
Birmingham Museum of Art: January 26–April 13
The John and Mable Ringling Museum of Art, Sarasota, Fla.: May 30–August 10

Sargent and Italy

Los Angeles County Museum of Art: February 2–May 11
Denver Art Museum: June 28–September 21

The Sculpture of Henri Matisse

Dallas Museum of Art: October 12–January 11, 2004
Baltimore Museum of Art: February 22, 2004–May 16, 2004
San Francisco Museum of Modern Art: June 19, 2004–September 19, 2004
Fogg Art Museum at Harvard University Art Museums: October 17, 2004–January 16, 2005

The Sensuous and the Sacred: Chola Bronzes From South India
Arthur M. Sackler Gallery, Washington, D.C.: Through March 9
Dallas Museum of Art: April 6–June 15
Cleveland Museum of Art: July 6–September 14

The Shape of Color: Joan Miró's Painted Sculptures
Corcoran Gallery of Art, Washington, D.C.: Through January 6
Salvador Dalí Museum, St. Petersburg, Fla.: February 1–May 4

Thomas Gainsborough, 1727–1788
Museum of Fine Arts, Boston: June 15–September 14
Tate Britain, London: Through January 19, 2003
National Gallery, Washington, D.C.: February 9–May 11

Time Stands Still: Eadweard Muybridge and the Instantaneous Photography Movement
Cleveland Museum of Art: November 16–January 25, 2004
Iris & B. Gerald Cantor Center for Visual Arts at Stanford University: February 5–May 13
Hayward Gallery, London: June 5–August 24

Uncommon Legacies: Native American Art From the Peabody Essex Museum
Cincinnati Art Museum: Through January 5
Virginia Museum of Fine Arts, Richmond, Va.: April 17–July 20
Peabody Essex Museum, Salem, Mass.: September 19–November 16

Vital Forms: American Art and Design in the Atomic Age, 1940–1960
San Diego Museum of Art: Through January 26
Phoenix Art Museum, April 6–June 29

Works by Warhol From the Cochran Collection
Gilcrease Museum, Tulsa, Okla.: Through February 7
Gibbes Museum of Art, Charleston, S.C.: July 25–December 7

Artists on View

Below is a selective listing of artists who have exhibitions focusing on their work in 2003.

ANSEL ADAMS

Ansel Adams: Classic Images
Scottsdale Museum of Contemporary Art, Scottsdale, Ariz.:
January 18–April 27
Ansel Adams at 100
Los Angeles County Museum of Art: February 2–April 27
MoMA QNS, New York: July 10–November 3

DIANE ARBUS

Diane Arbus
San Francisco Museum of Modern Art: October 18–
February 15, 2004

RICHARD AVEDON

Richard Avedon: Portraits
The Metropolitan Museum of Art, New York: Through
January 5

MILTON AVERY

Milton Avery
Neuberger Museum of Art, Purchase, N.Y.: January
12–August 3

FRANCIS BACON

Francis Bacon and the Old Masters
Kunsthistorisches Museum, Vienna, Austria: September 15 –
January 31, 2004
Francis Bacon
Instituto Valenciano de Arte Moderno, Spain: December 11 –
March 1, 2004

MAX BECKMANN

Max Beckmann
Centre National d'art et de Culture George Pompidou, Paris:
Through January 6
Tate Modern, London: February 13–May 5
MoMA QNS, New York: June 26–September 29

PIERRE BONNARD

Bonnard
Denver Art Museum: March 1–May 25

Pierre Bonnard: Early and Late
The Phillips Collection, Washington, D.C.: Through
January 19

Pierre Bonnard: Observing Nature
National Gallery of Australia: March 7–June 9

MARGARET BOURKE-WHITE

Margaret Bourke-White: Photography of Design, 1927–1936
The Phillips Collection, Washington, D.C.: February 15–
May 11

MARY CASSATT

Mary Cassatt: An American in Paris
Marion Koogler McNay Art Museum, San Antonio, Tex.:
February 28–May 11

MARC CHAGALL

Marc Chagall
Galeries Nationales du Grand Palais, Paris: March 10–June 25

Chagall in Israel
Israel Museum, Jerusalem: Through January 11

GIORGIO DE CHIRICO

Giorgio de Chirico and the Myth of Ariadne
The Philadelphia Museum of Art: Through January 5
Estorick Collection of Modern Art, London: January 22–
April 13

SALVADOR DALÍ

Salvador Dalí
Egon Schiele Art Center, Czech Republic: Through April

LEONARDO DA VINCI

Leonardo da Vinci, Master Draftsman
The Metropolitan Museum of Art, New York: January 22 –
March 30

Leonard da Vinci and the Splendor of Poland
The Museum of Fine Arts, Houston, Tex.: Through
February 17

Leonard da Vinci: Drawings and Manuscripts
Louvre, Paris: May 9–July 14

EDGAR DEGAS

Degas and the Dance
Detroit Institute of Arts: Through January 12
Philadelphia Museum of Art: February 12-May 11

Degas in Bronze: The Complete Sculptures
Memorial Art Gallery of the University of Rochester,
Rochester, N.Y.: Through January 5
San Diego Museum of Art: June 28–September 28

Degas and the Italians
National Galleries of Scotland: December 12–
February 29, 2004

MARCEL DUCHAMP

Marcel Duchamp and the Handmade Readymade
The Tang Teaching Museum and Art Gallery, Saratoga Springs,
N.Y.: June 21–October 5

ALBRECHT DÜRER

Albrecht Dürer Prints From the Montgomery Museum of Art
Joslyn Art Museum, Omaha, Neb.: January 18–March 9
*Albrecht Dürer and His Legacy: The Graphic Work of a Renaissance
Artist*
British Museum: Through March 23

WALKER EVANS

Walker Evans
Minneapolis Institute of Arts: May 10–September 14

LUCIAN FREUD

Lucian Freud
The Museum of Contemporary Art, Los Angeles: February 9 –
May 25

THOMAS GAINSBOROUGH

Thomas Gainsborough, 1727-1788
Tate Britain, London: Through January 19
National Gallery, Washington, D.C.: February 9-May 11
Museum of Fine Arts, Boston: June 15-September 14

Gainsborough's Beautiful Mrs. Graham
National Galleries of Scotland: April 5–June 22

PAUL GAUGUIN

Gauguin in Tahiti
Galeries Nationales du Grand Palais, Paris: October 2–
January 19, 2004

ANDY GOLDSWORTHY

Andy Goldsworthy: Three Cairns
Neuberger Museum of Art, Purchase, N.Y.: January 26-
April 13
Museum of Contemporary Art, San Diego: April 27–
August 26

Andy Goldsworthy: Mountain and Comet, Autumn Into Winter
University of Michigan Museum of Art, Ann Arbor, Mich.:
February 1–April 13

EL GRECO

El Greco
The Metropolitan Museum of Art, New York: September 30–
January 11, 2004

MARSDEN HARTLEY

Marsden Hartley
Wadsworth Atheneum, Hartford, Conn.: January 17–April 13
Phillips Collection, Washington, D.C.: June 7–September 7
Nelson-Atkins Museum of Art, Kansas City, Mo.: October 11–
January 4, 2004

HANS HOFMANN

Hans Hofmann: Paintings From the 1960's, the UC Berkeley Art Museum Collection
Scottsdale Museum of Contemporary Art, Scottsdale, Ariz:
Through January 19

HANS HOLBEIN THE YOUNGER

Holbein: Portraits of Sir Henry and Lady Guildford
National Gallery, London: January 31–April 27

Hans Holbein the Younger
Mauritshuis, The Netherlands: Fall

WINSLOW HOMER

Casting a Spell: Winslow Homer, Artist and Angler
The Fine Arts Museums of San Francisco:
Through February 9
Amon Carter Museum, Fort Worth, Tex.:
April 19–June 29
Winslow Homer the Illustrator: His Wood Engravings, 1857–1888
Farnsworth Art Museum, Portland, Me.: November 9–
December 28

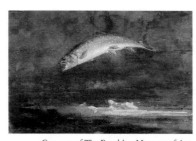

Courtesy of The Brooklyn Museum of Art.
Winslow Homer, *Jumping Trout,* 1889.

EDWARD HOPPER

Hopper: The Paris Years
Mint Museum of Art, Charlotte, N.C.: March 1–May 25

JASPER JOHNS

Past Things and Present: Jasper Johns Since 1985
Walker Art Center, Minneapolis: November 9–
February 8, 2004
Jasper Johns: Numbers
The Cleveland Museum of Art: October 26–January 11, 2004
Jasper Johns: Drawings
The Menil Collection, Houston, Tex.: January 31–May 4

WASSILY KANDINSKY

Wassily Kandinsky and Gabriele Munter, 1906–1914
Louisiana Museum of Art, Denmark: Spring
Musical Analogies: Kandinsky and His Contemporaries
Museo Thyssen-Bornemisza, Madrid: February 11–May 25

ERNST LUDWIG KIRCHNER

Ernst Ludwig Kirchner (1880–1938)
National Gallery of Art and Sculpture Garden, Washington,
D.C.: March 2–June 1
Van Gogh Museum, Amsterdam: November 7–February 8

PAUL KLEE

Paul Klee: 1933
Hamburger Kunsthalle, Germany: December 12–March 2004

Jeff Koons

Jeff Koons
The Astrup Fearnley Museum of Modern Art, Norway:
September 13–November 16

Roy Lichtenstein

Roy Lichtenstein
Louisiana Museum of Art, Denmark: Winter 2003-2004

Rene Magritte

Rene Magritte Retrospective
Galerie Nationale du Jeu de Paume, Paris: February 11–June 9

Kasimer Malevich

Kasimer Malevich
Deutsche Guggenheim Berlin, January 17-April 27
Solomon R. Guggenheim Museum, New York: May 22–
September 4
The Menil Collection, Houston, Tex.: October 3-
January 11, 2004
Kasimer Malevich: Suprematism
Deutsche Guggenheim Berlin: January 18–April 27

Edouard Manet

Edouard Manet and the Impressionists
Staatsgalerie Stuttgart, Germany: Through February 9

Henri Matisse

The Sculpture of Henri Matisse
Dallas Museum of Art: October 12-January 11, 2004
Baltimore Museum of Art: February 22, 2004-May 16, 2004
San Francisco Museum of Modern Art: June 19, 2004-
September 19, 2004
Fogg Art Museum at Harvard University Art Museums:
October 17, 2004-January 16, 2005
Matisse Picasso
Galeries Nationales due Grand Palais, Paris: Through
January 6
MoMA QNS, New York: February 13–May 19
Jazz by Henri Matisse
Dean Gallery, Scotland: Through February 13

Henri Matisse
Instituto Valenciano de Arte Moderno, Spain: October 23–
January 11, 2004

Michelangelo
Michelangelo: The Louvre's Drawings
Louvre, Paris: March 28–June 23

Joan Miró
Magical Miró: Prints and Books From the Bareiss Collection
Toledo Museum of Art, Toledo, Ohio: February 14–May 11
Joan Miró
The Shape of Color: Joan Miró's Painted Sculptures
Corcoran Gallery of Art, Washington, D.C.: Through
January 6
Salvador Dalí Museum, St. Petersburg, Fla.: February 1–May 4

Amedeo Modigliani
Modigliani and the Artists of Montparnasse
Albright-Knox Museum, Buffalo, N.Y.: Through January 12
Kimbell Art Museum, Fort Worth: February 9 - May 25
Los Angeles County Museum of Art: June 29–September 28

Claude Monet
Monet: The Seine and the Sea
National Galleries of Scotland: August 2–October 26

Henry Moore
Henry Moore
Instituto Valenciano
de Arte Moderno,
Spain: May 29–
September 7

Grandma Moses
*Grandma Moses in the
21st Century*
Portland Art
Museum, Portland,
Ore.: Through
January 5

Courtesy of Portland Art Museum.
Anna Mary Robertson "Grandma" Moses, *Joy
Ride*, 1953.

ISAMU NOGUCHI

Isamu Noguchi and Modern Japanese Ceramics
Arthur M. Sackler Gallery, Washington, D.C.: May 4–
September 7

Isamu Noguchi
Kunsthal Rotterdam, The Netherlands: May 31–September 6

GEORGIA O'KEEFFE

Georgia O'Keeffe and the Calla Lily in American Art, 1860–1940
Georgia O'Keeffe Museum, Santa Fe, N.M.: Through
January 14
Memphis Brooks Museum of Art, Memphis, Tenn.: February
23–
May 4

Georgia O'Keeffe in Southern Collections
The Weatherspoon Art Museum, Greensboro, N.C.: March 2–
May 11

Georgia O'Keeffe
Kunsthaus Zürich, Switzerland: October 23–February 1, 2004

PABLO PICASSO

Picasso Ceramics: Revisited
Museum of Art, Fort Lauderdale: Through July

Matisse Picasso
MoMA QNS, New York: February 13–May 19

Pablo Picasso
Museo Dolores Olmedo, Mexico City: April–June

CAMILLE PISSARRO

Pissarro in London
The National Gallery, London: May 14–August 3

JACKSON POLLOCK

Jackson Pollock's Blue Poles
National Gallery of Australia, Canberra; Through January 27

MAN RAY

Conversion to Modernism: The Early Works of Man Ray
The Montclair Art Museum, Montclair, N.J.: February 16–
August 3
Georgia Museum of Art: October 4–November 30

REMBRANDT
Rembrandt's Journey: Painter/Draftsman/Etcher
Museum of Fine Arts, Boston: October 26–January 18, 2004
Art Institute of Chicago: early 2004

FREDERIC REMINGTON
Frederic Remington: The Color of Night
National Gallery of Art and Sculpture Garden, Washington, D.C.: April 13–July 13
Gilcrease Museum, Tulsa, Okla.: August 10–November 9

PIERRE-AUGUSTE RENOIR
Renoir and Algeria
Sterling and Francine Clark Art Institute, Williamstown, Mass.: February 16–May 11
Idol of the Moderns: Pierre-Auguste Renoir and American Painting
El Paso Museum of Art: Through February 16

GERHARD RICHTER
Gerhard Richter: Forty Years of Painting
San Francisco Museum of Modern Art: Through February 14
Hirschhorn Museum and Sculpture Garden, Washington, D.C.: February 27–May 18
Jorge Pardo and Gerhard Richter
Dia Center for the Arts, New York: Through June 21
Gerhard Richter: Eight Gray
Deutsche Guggenheim Berlin: Through January 5

RODIN
Rodin: A Magnificent Obsession
The John and Mable Ringling Museum of Art, Sarasota, Fla.: Through January 5

JAMES ROSENQUIST
James Rosenquist: A Retrospective
Museum of Fine Arts, Houston: May 18–August 17
The Menil Collection, Houston: May 16-August 17
Solomon R. Guggenheim Museum, New York: October 2–January 4, 2004

JOHN SINGER SARGENT

Sargent and Italy
Los Angeles County Museum of Art: February 2–May 11
Denver Art Museum: June 28–September 21

EGON SCHIELE

Egon Schiele: Lugano, Switzerland
Museo dell'Arte Moderna, Switzerland: March 16–June 29

ALFRED SISLEY

Alfred Sisley: The Poet of Impressionism
Musée des Beaux Arts de Lyon, France: Through January 10

ALFRED STIEGLITZ

Alfred Stieglitz: Known and Unknown
The Museum of Fine Arts, Houston: Through January 5

TITIAN

Titian
The National Gallery, London: February 19–May 18

JMW TURNER

Turner and Venice
Tate Britain, London: October 15–January 9, 2004
JMW Turner: The Late Seascapes
Manchester Art Gallery, England: October 24–January 2004
The Vaughan Bequest of Turner Watercolors
National Gallery of Scotland: Through January 31

VINCENT VAN GOGH

Van Gogh: Fields
Toledo Museum of Art, Toledo, Ohio: February 23–May 18
Gogh Modern
Van Gogh Museum, Amsterdam: June 27–December 10
Vincent and Helene: The Significance of Van Gogh in the Kroller-Müller Collection
Kroller-Müller Museum, The Netherlands: February 14–October 12

EDOUARD VUILLARD

Edouard Vuillard (1868–1940)
National Gallery of Art and Sculpture Garden, Washington, D.C.: January 19–April 20
The Montreal Museum of Fine Arts: May 15–August 24
Vuillard
Galeries Nationales du Grand Palais, Paris: September 25–January 5, 2004

ANDY WARHOL

Works by Warhol From the Cochran Collection
Gilcrease Museum, Tulsa, Okla.: Through February 7
Gibbes Museum of Art, Charleston, S.C.: July 25–December 7
Andy Warhol
National Gallery of Australia, Canberra: July 21–September 14

WEEGEE

Weegee's Trick Photography
International Center of Photography, New York: Through February 16
Weegee's Story
Israel Museum, Jerusalem: Through April

EDWARD WESTON

Edward Weston: A Legacy
Huntington Library, Art Collections and Botanical Gardens, San Marino, Calif.: June 25–October 5
A Passionate Collaboration: Margrethe Mather and Edward Weston
Santa Barbara Museum of Art: March 8–June 15
Edward Weston: Life Work
Milwaukee Art Museum: Through February 9
Portland Museum of Art, Portland, Me.: June 28–October 19

JAMES MCNEILL WHISTLER

After Whistler: The Artist and His Influence on American Painting
High Museum, Atlanta: November 15-February 8, 2004
The Detroit Institute of Arts, March 6, 2004-May 30, 2004
Whistler and His Circle in Venice
Corcoran Gallery of Art, Washington, D.C.: February 1–April 29

Whistler in Venice: The Pastels
Freer Gallery of Art, Washington, D.C.: January 19–June 15

By Whistler's Design: Small Masterpieces
Freer Gallery of Art, Washington, D.C.: June 15–November 9

Whistler Rarities: Etchings From the Artist's 1888 Honeymoon
Freer Gallery of Art, Washington, D.C.: June 29–
February 1, 2004

James McNeill Whistler
Freer Gallery of Art, Washington, D.C.: Continuing

After Whistler: The Artist and His Influence on American Painting
High Museum of Art, Atlanta, Ga.: November 15–
February 8, 2004

*The Lithographs of James McNeill Whistler From the Collection of
Steven Block*
The Speed Art Museum, Louisville, Ky.: Fall
Whistler at the Hunterian
Beauty and the Butterfly: Whistler's Depictions of Women
Copper Into Gold: Whistler and 19th-Century Printmaking
Whistler and Scotland
Hunterian Art Gallery, Scotland: June 21–October 4

Whistler, Women and Fashion
The Frick Collection, New York: April 22–July 13

JAMES WYETH

Capturing Nureyev: James Wyeth Paints the Dancer
Brandywine River Museum, Chadds Fords, Pa.: January 18–
May 18

N.C. WYETH

N.C. Wyeth: Landscapes and Illustrations
Farnsworth Art Museum, Rockland, Me.: Through April 27
Summers in Maine: Paintings by N.C. Wyeth
Brandywine River Museum, Chadds Fords, Pa.: May 31–
September 1.

Exhibition Schedules for Museums in the United States

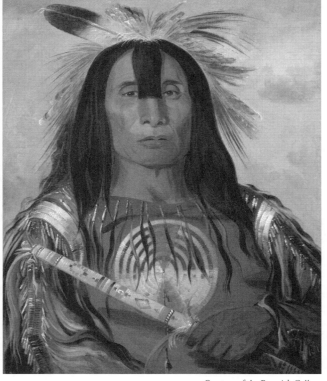

Courtesy of the Renwick Gallery.
George Catlin, *Stu-mick-o-súcks, Buffalo Bull's Back Fat, Head Chief, Blood Tribe*, 1832.

Alabama

Birmingham Museum of Art

2000 Eighth Avenue North, Birmingham, Ala. 35203
(205) 254-2566
www.artsBMA.org

2003 EXHIBITIONS

Through January 5
Matières de Reves: Stuff of Dreams From the Paris Musée des Arts Décoratifs
Furniture, jewelry, sculpture, ceramics and glass from the Middle Ages to the present. (Travels)

Through July 5
Stephen Hendee: Perspectives 7
Geometric sculptures by a New Jersey artist.

January 26–April 13
Sacred Treasures: Early Italian Paintings From Southern Collections
More than 50 Italian paintings from the 13th to 15th centuries, with a focus on religious themes.

March 9–May 25
Desire and Devotion: Art From India, Nepal and Tibet in the John and Berthe Ford Collection
Some 150 sculptures and paintings, primarily from the Hindu and Buddhist traditions of India, Tibet and Nepal. (Travels)

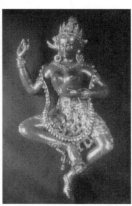

Courtesy of Birmingham Museum of Art.
"Vajravarahi," Nepal, ca. 1400.

June 27–August 31
The Paintings of Joan Mitchell
Some 60 groundbreaking paintings by the American Abstract Expressionist painter — the first comprehensive survey of her work since her death in 1992. (Travels)

PERMANENT COLLECTION

Largest municipal collection in the Southeast, with more than 21,000 works. Extensive Asian art collection; 18th-century decorative arts, including the Hitt collection of 18th-century paintings and decorative arts; the Beeson Collection of Wedgwood, the finest outside of England; Renaissance, Dutch, American and contemporary paintings. **Highlights:** Multilevel sculpture garden with monumental wall painting by Sol Le Witt; glass installation by Dale Chihuly. **Architecture:** International Style building, 1959; additions by Warren, Knight and Davis; expansion and renovation by Edward Larrabee Barnes, 1993.

Admission: Free.

Hours: Tuesday through Saturday, 10 a.m.–5 p.m.; Sunday, noon–5 p.m. Closed Monday, New Year's Day, Thanksgiving and Christmas Day.

Montgomery Museum of Fine Arts

One Museum Drive, Blount Cultural Park,
 Montgomery, Ala. 36117
(334) 244-5700
www.mmfa.org

2003 EXHIBITIONS

Through January 5
The Artful Teapot: 20th-Century Expressions From the Kamm Collection
About 250 teapots from all over the world in a range of styles.

February 1–March 20
Fairfield Porter: A Life in Art
Presents Porter's paintings in the context of his life as an artist, art critic, poet and political intellectual.

March 10–May 19
Whispers From the Walls: The Art of Whitfield Lovell
Installation piece that mixes found objects, photographs, wall

drawings and sound to depict African-American life in the South in the 1920's.

May 5–June
Watercolor Society of Alabama
Annual juried exhibition.

July–August
Ginnie Ruffner
Works by an artist at the forefront of the Studio Glass Movement.

September 6–December 7
Nostalgic Journey: American Illustrations From the Delaware Art Museum
Paintings, watercolors and drawings that were reproduced in books, periodicals, newspapers and advertisements, chronicling the history of American illustration. (Travels)

PERMANENT COLLECTION

More than 3,000 works, including 19th- and 20th-century American paintings and sculpture; Southern regional and folk art; European Old Master and contemporary works on paper; decorative art objects.

Admission: Free.
Hours: Tuesday through Saturday, 10 a.m.–5 p.m.; Thursday, until 9 p.m.; Sunday, noon–5 p.m. Closed Monday, New Year's Day, Independence Day, Thanksgiving and Christmas Day.

Alaska

Anchorage Museum of History and Art

121 West Seventh Avenue, Anchorage, Alaska 99501
(907) 343-4326; (907) 343-6173 (recording)
www.anchoragemuseum.org

2003 EXHIBITIONS

Through February 28
Looking Both Ways: Heritage and Identity of the Alutiiq People
Examines the art, archaeology, history and oral tradition of the
Alutiiq people of Alaska's south-central coast.

January–February
Earth, Fire and Fibre
Biennial statewide craft exhibition.

January–early March
Gary Kaulitz, Solo Exhibition
Paintings, drawings and mixed media depicting the experiences
and relationship of the artist's father and son, both deceased.

March–April
Susan Schapiro, Solo Exhibition
Works by an innovative Alaskan fabric artist.

Mid-March–mid-April
Alaska Positive
Statewide juried photography exhibition.

Mid-March–November
Points of View
Works from the collection chosen by a guest curator.

May–September
Eskimo Drawings
More than 200 rare illustrations depicting Eskimo life from the
Gold Rush period to the middle of the 20th century.

November–December
All Alaska Juried Art Exhibition

September–October
Carla Potter, Solo Exhibition
Works by an innovative Alaska ceramic artist.

October 5–December 18
A T-Rex Named Sue
Exact replica of Sue, the most complete T. Rex specimen ever
discovered. (Travels)

November–December
Woven Treasures: The Coverlets of Norway
Examples of what is considered the pinnacle of Norwegian
weavers' art, the coverlet.

November–December
Holiday Dolls and Toys
Antique dolls and toys, carved and painted animals from
Oaxaca, cloth dolls from Africa and a wooden Schoenhut Circus.

PERMANENT COLLECTION

More than 17,500 objects, 2,000 artifacts and 350,000 histor-
ical photographs about Alaskan history and culture, including
life-size dioramas of Alaskan homes and work environments
from the 1920's, traditional village dwellings of Aleuts,
Eskimos and Indians, and a piece of the Alaska Pipeline.

Admission: Adults, $6.50; seniors, $6; children 17 and
under, free.
Hours: May 15–September 15, daily, 9 a.m.–6 p.m.; Thursday,
until 9 p.m. September 16–May 14, Tuesday–Saturday, 10
a.m.-6 p.m.; Sunday, 1-5 p.m.; closed Monday. Closed New
Year's Day, Thanksgiving and Christmas Day.

Arizona

The Heard Museum —
Native Cultures and Art

2301 North Central Avenue, Phoenix, Ariz. 85004
(602) 252-8840; (602) 252-8848 (recording)
www.heard.org

Heard Museum North

34505 Scottsdale Road, North Scottsdale, Ariz. 85262
(602) 488-9817

PERMANENT COLLECTION

Founded in 1929 by Dwight B. and Maie Bartlett Heard to
house their collection of primarily Native American arti-

facts, the museum now has more than 32,000 objects of Native American art. More than 3,600 paintings, prints and sculpture that document the 20th-century development of the Native American Fine Art Movement. **Highlights:** The Barry Goldwater collection of 437 Hopi katsina dolls.

Admission: Adults, $7; seniors, $6; children 4–12, $3; children under 4 and Native Americans with proof of tribal enrollment, free.

Hours: Daily, 9:30 a.m.–5 p.m. Closed New Year's Day, Easter Sunday, Memorial Day, Independence Day, Labor Day, Thanksgiving and Christmas Day.

Phoenix Art Museum

1625 North Central Avenue, Phoenix, Ariz. 85004
(602) 257-1880; (602) 257-1222 (recording)
www.phxart.org

2003 EXHIBITIONS

January 26–May 4

Masterworks from El Greco to Picasso in the Phillips Collection
Fifty-three paintings and sculptures by more than 30 world-famous artists, including van Gogh, Monet, Renoir, Matisse, Degas, Cézanne, Delacroix, Picasso and El Greco.

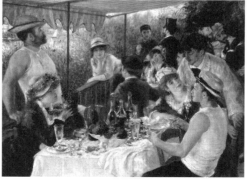

Courtesy of the Phoenix Art Museum.
Pierre Auguste Renoir, *Luncheon of the Boating Party*, 1880-81.

February 8–May 11
Keeper of the Flame: Art of Sri Lanka
Little-known paintings and sculpture from Sri Lanka,
highlighting the Buddhist and Hindu culture there through
1,700 years.

April 6–June 29
*Vital Forms: American Art and Design in the Atomic Age,
1940–1960*
More than 200 works looking at American culture in this
period through its architecture, furniture, design, painting,
sculpture, textiles and other arts.

October 18–November 16
38th Annual Cowboy Artists of America Exhibition
More than 100 new works by members of the Cowboy Artists
of America.

PERMANENT COLLECTION

More than 16,000 works of American, Asian, contemporary,
European, Latin American and Western American art, and
fashion design. The Thorne Miniature Rooms offer historic
interiors.

Admission: Adults, $7; seniors and students, $5; children
6–17, $2; children under 6, free. Free on Thursday.
Hours: Tuesday through Sunday, 10 a.m.–5 p.m.; Thursday,
until 9 p.m. Closed Monday and major holidays.

Scottsdale Museum of Contemporary Art

7374 East Second Street, Scottsdale, Ariz. 85251
(480) 994-2787
www.ScottsdaleArts.org

2003 EXHIBITIONS

Through January 5
Joel Meyerowitz: Before, After and Beyond the World Trade Center

Scottsdale

Through January 5
Skeet McAuley: The Garden of Golf

Through January 5
Mags Harries: Lucid Moment

Through January 19
Hans Hofmann: Paintings From the 1960's, the UC Berkeley Art Museum Collection

January 18–April 27
Howard Werner: Heroic Vessels

January 18–April 27
Ansel Adams: Classic Images

February 7–May 11
Lesley Dill: A Ten-Year Survey

May 10–August 17
Lee Bul: Live Forever

May 10–September 7
Selections From the Permanent Collection

May 30–September 7
Regional Architecture and Design

October 5–January 4, 2004
Hairstories

PERMANENT COLLECTION

More than 1,600 objects, including the largest collection of works by Arizona artists in the state; prints, including works by James Turrell, Faith Ringgold and William Wegman; photography; architectural blueprints and models.

Admission: Adults, $7; students, $5; members and children 15 and under, free. Free on Thursday.
Hours: Tuesday through Saturday, 10 a.m.–5 p.m.; Thursday, until 8 p.m.; Sunday, noon–5 p.m. Closed Monday and major holidays.

Tucson Museum of Art and Historic Block

140 North Main Avenue, Tucson, Ariz. 85701
(520) 624-2333
www.tucsonarts.com

2003 EXHIBITIONS

Through February 16
Talking Birds, Plumed Serpents and Painted Women: Ceramics of Casas Grandes
Focuses on the contributions of the ancient Casas Grandes culture of Northern Chihuahua, Mexico.

Through February 16
Directions: Mark Rubin-Toles
Installation created for the museum.

Through March 29
El Nacimiento
Traditional Mexican nativity scene.

Through May 18
Common Ground: Contemporary Native American Art From the Permanent Collection and Private Collections
Works in a range of styles since the 1970's.

Through October 13
On Paper: Graphic Works by Walt Kuhn
Boldly outlined, expressive drawings and prints of showgirls, circus performers and theater subjects.

February 21–March 23
Western Artists of America: Branding Iron Show
Works by Western artists.

March 1–May 18
Terence La Noue: Layers Concealed and Revealed
Abstract paintings created by layering canvas, fabric, acrylic paint and cast elements.

May 31–August 17
Arizona Biennial '03

Admission: Adults, $5; seniors, $4; students, $3; members and children 12 and under, free.

Tucson

Hours: Monday through Saturday, 10 a.m.–4 p.m.; Sunday, noon–4 p.m. Closed Monday from Memorial Day through Labor Day and major holidays.

The University of Arizona Museum of Art

Speedway Boulevard, Tucson, Ariz. 85721
(520) 621-7567
artmuseum.arizona.edu

2003 EXHIBITIONS

Through January 19
A Public Trust: Recent Acquisitions at the Museum of Art
Includes works by Pablo Picasso, Claude Lorrain, James Davis, Kiki Smith, Luis Jimenez and Ed Paschke.

Through January 26
At Risk: Depicting Danger, Hazards and Chance

Through February 9
Looking Back: Contemporary Portraits
Includes works in recent decades by Chuck Close, David Hockney, Luiz Cruz Azcaceta, Robert Morris and others.

Through February 23
Gloria and Miseria
Scenes of coronations, religious life and military exercises from the 16th and 17th centuries.

Through March 16
East of the Danube: Slovak Art of the 1990's

February 16–March 30
Human Islands: Figurative Works by Fritz Scholder

March 30–June 1
Mario Moreno Zaueta: SonoranScapes

PERMANENT COLLECTION

The more than 4,000 paintings, sculptures, drawings and prints in the museum include works by Hopper, Picasso,

O'Keeffe and Zuniga. On display are the 26 panels of the 15th-century Spanish altarpiece of Ciudad Rodrigo and 61 clay and plaster models by the 20th-century sculptor Jacques Lipchitz.

Admission: Free.
Hours: Monday through Friday, 9 a.m.–5 p.m.; Sunday, noon–4 p.m.; slightly shorter hours during the summer. Closed Saturday and university holidays.

Arkansas

The Arkansas Arts Center

Tenth and Commerce Streets, Little Rock, Ark. 72202
(501) 372-4000
www.arkarts.com

2003 EXHIBITIONS

Through February 2
Drawings of Choice From a New York Collection
Some 100 works by 40 artists from the 1960's to the present.

January 10–February 16
33rd Mid-Southern Watercolorists
Juried show organized by the mid-Southern Watercolorists.

January 18–March 3
A Strong Night Wind: The Art of Donald Roller Wilson
Surreal works by an Arkansas artist, such as chimpanzees dressed in court attire playing cards.

January 18–March 3
Benjamin Krain: From the Streets of Cuba
Street photography in Havana by a photojournalist at the Arkansas Democrat-Gazette.

February 20–April 20
The Other Side of the West: Recreating New Icons of the American West

Little Rock

New works by contemporary painters of the West.

April 11–June 8
Masterworks of American Drawings: 1900–1950
Works from the collection.

April 11–June 8
Nineteenth- and 20th-Century French Drawings From the Danish National Gallery
Eighty French drawings from nearly every major French art movement between the 1820's and the mid-20th century, including works by Degas, Manet, Picasso, Matisse, Gauguin and Cézanne.

PERMANENT COLLECTION

Paintings by Rembrandt, Picasso, Pollock, de Kooning, Mondrian, Wyeth, O'Keeffe, Bellows and others; drawings in all media; contemporary crafts. The museum also operates the Decorative Arts Museum in a historic home nearby.

Admission: Free.
Hours: Tuesday through Saturday, 10 a.m.–5 p.m.; Sunday, 11 a.m.–5 p.m. Closed Monday and Christmas Day.

Decorative Arts Museum

East Seventh and Rock Streets, Little Rock, Ark. 72202

2003 EXHIBITIONS

January 12–February 16
Pre-Columbian Art
Mayan, Aztec, Colima, Nayarit, Chavin, Mochica and Inca effigy pots from 2000 B.C. to A.D. 1400.

February 23–March 30
Challenge VI, Roots: Insights and Inspirations in Contemporary Turned Objects
Some 90 lathe-turned objects by 50 artists from eight countries.

PERMANENT COLLECTION

The center has 10 to 12 exhibitions a year by nationally recognized craftspeople.

Admission: Free.
Hours: Monday through Saturday, 10 a.m.–5 p.m.; Sunday, noon–5 p.m. Closed Christmas Day.

California

University of California, Berkeley Art Museum and Pacific Film Archive

2626 Bancroft Way, Berkeley, Calif. 94720
(510) 642-0808
www.bampfa.berkeley.edu

2003 EXHIBITIONS

Through 2003
Face of the Buddha: Sculpture From India, China, Japan and Southeast Asia
Graceful stone figures on loan from China as well as small Buddhist sculptures from the museum's collection.

Through January 19
MATRIX 200: Yehudit Sasportas
Works by an installation artist that fuse drawing, painting, sculpture and architecture.

Through February 9
Fast Forward II
A look at how the museum's collection has grown in the past five years, during which 2,000 works have been added.

Berkeley

Through February 9
The Subject Is Art: 1400–1800
Some 50 paintings, drawings, prints, photographs and sculpture from the museum's collection.

Through March
XXL II
Highlights monumental works from the museum's collection, including large-scale paintings and sculptures.

Through May
miniMATRIX
Small-scale innovative works by contemporary artists dealing with themes of temporality and transience.

January 22–March 30
Fred Wilson: Objects and Installations, 1985–2000
Mock museum installations in which the artist places provocative objects that reveal how museums, consciously or unconsciously, perpetuate racist beliefs.

February 2–March 23
MATRIX 202: Berni Searle
Performance and installation art focusing on the artist's body as a means to explore race, gender, sensuality and spirituality.

April 2–July 20
Everything Matters: Paul Kos, A Retrospective
About 17 works by a Bay Area pioneer in conceptual, video and installation art.

April 6–June 1
MATRIX 203: Jun Nguyen-Hatsushiba
Videos by a Vietnamese artist, including "Memorial Project, Nha Trang, Vietnam," an underwater dance of bicycle taxi drivers, and a new work on Vietnamese "boat people."

June 15–August 10
MATRIX 204: Anna Von Mertens
Hand-stitched conceptual quilts that describe personal events and environments.

August 27–December 21
Gene(sis): Contemporary Art Responds to Genomics
About 100 works in various media created in response to genetic engineering and the deciphering of the human genome.

PERMANENT COLLECTION

Western art from the Renaissance to the 20th century, with
particular strengths in contemporary and conceptual art; Asian
art, especially Japanese prints and paintings and Chinese
painting and ceramics; work by the Abstract Expressionist
Hans Hofmann.

Admission: Adults, $6; children, students and seniors, $4.
Free on Thursday.
Hours: Wednesday through Sunday, 11 a.m.–7 p.m. Closed
Monday and Tuesday.

Laguna Art Museum

307 Cliff Drive, Laguna Beach, Calif. 92651
(949) 494-8971
www.lagunaartmuseum.org

2003 EXHIBITIONS

Through January 12
In and Out of California: Travels of American Impressionists
Works by California artists who also had careers elsewhere and
East Coast artists who worked for periods in California.

Through January 12
Strange Fruit: New Paintings by Hung Liu
More than 20 works done within the last four years, which
saw the beginning of his veil paintings with a driplike appli-
cation of pigment.

Spring
Whiteness, A Wayward Construction
Works by 28 artists and collaborative teams working in vari-
ous media to explore representations of whiteness.

PERMANENT COLLECTION

A 1,200-piece collection including works by 19th-century
Californian Impressionists and contemporary Southern
California artists.

Laguna Beach/Los Angeles

Admission: Adults, $5; students and seniors, $4.
Hours: Tuesday through Sunday, 11 a.m.–5 p.m.; the first
Thursday of each month, until 9 p.m. Closed Monday, New
Year's Day, Thanksgiving and Christmas Day.

The Getty Center

The J. Paul Getty Museum, 1200 Getty Center Drive,
 Los Angeles, Calif. 90049
(310) 440-7300; (310) 440-7305 (for the deaf)
www.getty.edu

2003 EXHIBITIONS

Through January 12
Orazio Gentileschi's Paintings for Giovan Antonio Sauli
Three paintings by a follower of Caravaggio created between
1621 and 1623.

Through January 19
The Medieval Bookseller: Illuminated Books of Hours
Devotional books from France, Italy, Flanders and Holland
from the 12th to the 16th century.

Through February 2
Landscapes of Myth
Paintings, drawings, watercolors, prints, maps and
photographs from the 15th to the 19th century of sites from
Greek mythology.

Through February 9
*The Grapes of Wrath: Horace Bristol's California Photographs
(1908–1997)*
About 35 images by a documentary photographer for
magazines like Life and Time in the 1940s, including several
of Dust Bowl migrants.

Through March 9
Mise-en-Page: Placement on the Page
Explores the nature of draftsmanship in Western drawing as it
developed over five centuries.

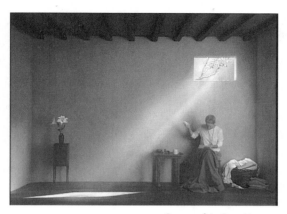

Courtesy of the Getty Museum.

Bill Viola, from *Catherine's Room*, 2001.

January 28–April 27
Bill Viola: The Passions and Five Angels
A video artist explores how facial expression and body
language express emotional states.

February 25–June 15
*Surrealist Muse: Lee Miller, Roland Penrose and Man Ray,
1925–1945*
Focuses on Lee Miller in her role as model for many other
artists, including Roland Penrose and Man Ray.

March 25–June 29
French Baroque Drawings
Includes landscapes by Jacques Callot and Claude Lorrain and
classically inspired work by Nicolas Poussin.

May 20–September 7
500 Years of Manuscript Illumination
Twenty-four illuminated manuscripts from Western Europe
and the Mediterranean in a variety of styles.

May 20–September 7
The Making of a Medieval Book
Explains how illuminated manuscripts were made in the
Middle Ages and Renaissance.

June 17–September 7
*Illuminating the Renaissance: The Triumph of Flemish Manuscript
Painting in Europe, 1467–1561*

Features illuminated manuscripts and leaves from manuscripts, panel paintings and drawings.

July 1–October 5
Points of Synthesis: Photographs by Edmund Teske
First major retrospective of the work of Teske (1911–1996) over a 60-year period.

PERMANENT COLLECTION

An international cultural and philanthropic institution devoted to the visual arts that includes an art museum as well as programs for education, scholarship and conservation. Features European paintings, drawings, illuminated manuscripts, sculpture, decorative arts and American and European photographs. **Highlights:** Van Gogh, *Irises;* the Boulle cabinet; Ensor, *Christ's Entry Into Brussels in 1889;* Rembrandt, *Abduction of Europa;* Robert Irwin, *Central Garden.* The Villa in Malibu is currently closed for renovation and will reopen as a center for comparative archaeology and cultures.
Architecture: Designed by Richard Meier, the museum, which opened in 1997, is a series of pavilions around an outdoor courtyard.

Admission: Free. Parking: $5.
Hours: Tuesday through Thursday and Sunday, 10 a.m.–6 p.m.; Friday and Saturday, 10 a.m.–9 p.m. Closed Monday and major holidays.

The Los Angeles County Museum of Art

5905 Wilshire Boulevard, Los Angeles, Calif. 90036
(323) 857-6000
www.lacma.org

2003 EXHIBITIONS

Through January 5
A Century of Fashion
More than 130 costumes from the museum's collection,

showing how changing styles of dress mirrored changes in society.

Through January 5
Donald Blumberg
Works by a photographer who explores how images function as social documents, formal remnants and conceptual statements.

Through February 2
Miracles and Mischief: Noh and Kyogen Theater in Japan
First major exhibition of art from the world of Noh and Kyogen, including carved wood masks, silk and gold costumes, painted fans and lacquered instruments.

Through February 17
Contemporary Projects 7: Keith Edmier and Farrah Fawcett
Collaborative project between a New York artist and the television star, in which each sculpts the other.

Through March 2
Munakata Shiko: Japanese Master of the Modern Print
Some 128 prints, calligraphies, paintings and ceramics by Shiko, regarded as one of the greatest Japanese artists of the 20th century.

Through March 9
George Washington: A National Treasure
Exhibition of the famous Lansdowne portrait of Washington by Gilbert Stuart, as well as other portraits of the president. (Travels)

February 2–April 27
Ansel Adams at 100
More than 200 photographs by Adams in commemoration of the 100th anniversary of his birth. (Travels)

February 2–May 11
Sargent and Italy
Works from throughout John Singer Sargent's career, reflecting the Italian-born 19th-century American artist's fascination with Italy. (Travels)

April 13–July 27
The Legacy of Genghis Khan: Courtly Art and Culture in Western Asia, 1256–1353
About 225 works, including illustrated manuscripts, tilework, ceramics, textiles, jewelry and metalwork, exploring the

artistic and cultural achievements in the Iranian world as a result of the Mongol invasions of western and eastern Asia.

June 29–September 28
Modigliani and the Artists of Montparnasse
The first major Modigliani exhibition in the United States in more than 40 years, featuring more than 50 paintings, sculptures and works on paper.

July 27–October 13
Old Masters, Impressionists and Moderns: French Masterworks From the Pushkin Museum
Some 76 paintings from the 17th to 20th centuries, including works by Poussin, Lorrain, David, Ingres, Corot, Courbet, Monet, Renoir, Cézanne and Matisse.

PERMANENT COLLECTION

More than 100,000 works from around the world, spanning the history of art from ancient times to the present.

Admission: Adults, $7; students over 18 and seniors, $5; ages 6–18, $1; children 5 and under, free. Free on second Tuesday of every month.
Hours: Monday, Tuesday and Thursday, noon–8 p.m.; Friday, noon–9 p.m.; Saturday and Sunday, 11 a.m.–8 p.m. Closed Wednesday.

The Museum of Contemporary Art (MOCA)

250 South Grand Avenue, Los Angeles, Calif. 90012
(213) 626-6222
www.moca.org

2003 EXHIBITIONS

Through January 5
Thomas Struth: A Retrospective
Approximately 80 photographs from the late 1970's to the present by one of the most renowned German artists to emerge in the last 25 years.

February 9–May 25
Lucian Freud
Major retrospective of paintings, drawings and prints by the artist considered to be Britain's greatest living realist painter, best known for his portraits and nudes of people in his life.

Opening May 4
Juan Muñoz
Sculptural and installation works by the Spanish artist.

MOCA at the Geffen Contemporary

152 North Central Avenue, Los Angeles, Calif. 90013

2003 EXHIBITIONS

Through February 9
Sam Durant
Using sculpture, drawing, photography, video and sound, this Los Angeles-based artist explores the disconnect between working-class culture and the rarified concerns of fine art.

Through March 9
The Car Design of J Mays
A look at Ford's innovative automotive designer.

March 15–June 15
A Minimal Future: Art as Object, 1958–1968
Historical examination of the emergence of "minimal art" in the United States, featuring works by about 40 artists.

MOCA at the Pacific Design Center

8687 Melrose Avenue, West Hollywood, Calif. 90069

PERMANENT COLLECTION

Devoted exclusively to art from 1940 to the present, the museum features exhibitions of painting, sculpture, drawings, prints, photographs, installations and environmental work.
Architecture: The museum is located in three art exhibition spaces: MOCA, designed by Arata Isozaki; MOCA at the Geffen Contemporary, designed by Frank Gehry; and MOCA at the Pacific Design Center.

49

CALIFORNIA

Los Angeles

Admission: Adults, $8; seniors and students, $5; children under 12, free. Free on Thursday, 5–8 p.m.
Hours: Tuesday through Sunday, 11 a.m.–5 p.m.; Thursday, until 8 p.m. Closed Monday, New Year's Day, Thanksgiving and Christmas Day.

UCLA Hammer Museum

10899 Wilshire Boulevard, Los Angeles, Calif. 90024
(310) 443-7020; (310) 443-7000 (recording)
www.hammer.ucla.edu

2003 EXHIBITIONS

Through January 5
Catherine Sullivan: Five Economies (big hunt/little hunt)
Works by a Los Angeles artist who combines installation art and traditional theater techniques.

Through January 5
Dave Muller: Connections
Series of drawings by a Los Angeles artist based on exhibition announcements and invitations.

Through January 5
Tomoko Takahashi
Installations that challenge our notions of order and discipline, featuring found and scavenged objects.

PERMANENT COLLECTION

Founded by Dr. Armand Hammer in 1990, the museum houses The Armand Hammer Collection of Old Master, Impressionist and Post-Impressionist paintings, including works by Rembrandt, Sargent, van Gogh, Monet, Pissarro and Cassatt; works by Daumier and his contemporaries; more than 40,000 works on paper from the Renaissance to the present; outdoor sculpture garden. **Architecture:** Designed by Michael Maltzan.

Admission: Adults, $5; seniors, $3; students and age 17 and under, free. Free on Thursday.

Hours: Tuesday through Saturday, 11 a.m.–7 p.m.; Thursday, until 9 p.m.; Sunday, 11 a.m.–5 p.m. Closed Monday, New Year's Day, July 4, Thanksgiving and Christmas Day.

Orange County Museum of Art

Newport Beach

850 San Clemente Drive, Newport Beach, Calif. 92660
(949) 759-1122
www.ocma.net

2003 EXHIBITIONS

Through January 5
Light Screens: The Leaded Glass of Frank Lloyd Wright
Most comprehensive exhibition ever of the leaded glass windows designed by the celebrated architect.

January 18–March 23
Iñigo Manglano-Ovalle
Video, sound, performance and installation works by this MacArthur Foundation award-winning artist exploring a range of social and political themes.

Continuing
Selections From the Permanent Collection
More than 50 works from the permanent collection in thematic groupings that juxtapose historical examples with contemporary ones.

South Coast Plaza branch

3333 Bristol Street, Costa Mesa, Calif. 92626
(949) 662-3366

PERMANENT COLLECTION

Paintings, sculptures and mixed-media art from the 20th century, including works by Duchamp, Diebenkorn, Warhol and

Beuys. Architecture: 1977 building remodeled in 1996 by
Archimuse.

Admission: Newport Beach: Adults, $5; students and seniors,
$4; children under 16 and members, free. Free on Tuesday.
South Coast Plaza: Free.

Hours: Newport Beach: Tuesday through Sunday, 11 a.m.–
5 p.m. Closed Monday. South Coast Plaza: Monday through
Friday, 10 a.m.–9 p.m.; Saturday, 10 a.m.– 7 p.m.; Sunday,
11 a.m.–6:30 p.m.

Oakland Museum of California

1000 Oak Street, Oakland, Calif. 94607
(888) 625-6873; (510) 238-2200
www.museumca.org

2003 EXHIBITIONS

Through January 12
Solo Flights: The Aerial Photographs of Robert Hartman
About 25 aerial color photographs by a Bay Area painter and
photographer that comment on land use and the environment.

Through January 26
Arte Latino: Treasures From the Smithsonian American Art Museum
Exhibition of 66 paintings, sculptures, photographs and

Patssi Valdez,
The Magic Room, 1994.

Courtesy of the Oakland Museum of California.

mixed-media works by 58 Latino artists from the United States. (Travels)

Through March 30
State of Emergency: Disaster Response in California
Some 50 color images of major natural and manmade disasters that have changed California over the past 13 years.

Through March 30
Wild Wings: The Waterfowl Art of Harry Curieux Adamson
About 45 oil paintings spanning the 60-year career of the California wildlife artist.

January 18–June 22
The Photography of Rondal Partridge
About 100 photographs by a California photographer, plus collages, mixed-media works and a reconstruction of his darkroom.

March 8–June 15
The Art of Seeing: Nature Revealed Through Illustration
Juried group show of biological and botanical works in various media depicting California species.

March 15–September 28
Iconic to Ironic: Fashioning California Identity
Explores how California's cultural identity, entertainment industry and leisure lifestyle have influenced clothing developed in the state.

June 7–August 31
Reflections in Black: Art and Activism
Some 143 works by African-American photographers from 1840 to the present, from the Smithsonian Institution.

July 19–October 12
Marvin Lipofsky Retrospective
Works by a founder of the California art glass movement.

August 2–December 28
The Art of Fred Martin
Works by an Oakland, Calif., abstract painter, writer and educator, spanning more than 40 years.

October–November
Días de los Muertos: Days of the Dead
Altars created by artists, community groups and students celebrating the Mexican and Mexican-American tradition of Days of the Dead.

Oakland/Palm Springs

November 22–March 14, 2004
The Art of David Ireland
Works by an Oakland, Calif., abstract painter, writer and
educator, spanning more than 40 years.

PERMANENT COLLECTION

The only museum devoted to the art, history and natural sci-
ences of California. Includes: Gallery of California Art, with
paintings, sculptures, prints, photographs and decorative arts
tracing the development of artistic expression in California;
Cowell Hall of California History, with more than 6,000 arti-
facts illustrating the events and trends that shaped California;
and the Natural Sciences Gallery, a simulated journey through
California's diverse ecosystems. **Architecture:** The 1969
Kevin Roche building is a three-tiered complex of galleries
and gardens.

Admission: Adults, $6; students and seniors, $4; under 6,
free. Free the second Sunday of each month.
Hours: Wednesday through Saturday, 10 a.m.–5 p.m.;
Sunday, noon–5 p.m.; the first Friday of each month, until 9
p.m. Closed Monday and Tuesday, New Year's Day,
Independence Day, Thanksgiving and Christmas Day.

The Palm Springs
Desert Museum

101 Museum Drive, Palm Springs, Calif. 92262
(760) 325-0189
www.psmuseum.org

2003 EXHIBITIONS

Through January 5
The Art of Nathan Oliveira
Paintings, monotypes, drawings, watercolors and sculptures
by a 20th-century American artist working in the European
figurative tradition.

Through November 6
Desert Tortoise
Exhibition designed to educate the public about this
endangered species.

January 22–March 9
Woven Worlds: Basketry From the Clark Field Collection
Some 125 baskets made by Native Americans, reflecting their
cultural and geographic diversity.

April 2–June 29
How-To: The Art of Deborah Oropallo
Paintings by a San Francisco area artist who incorporates how-
to manuals and everyday objects such doormats, bobby pins
and hangers into her work.

PERMANENT COLLECTION

Paintings, sculpture, furniture and movie-industry memorabilia
from the actor George Montgomery's collection; art and artifacts
collected by the actor William Holden; a collection of Western
American and American Indian art; about 100 works by 20th-
century artists, including Chagall, Modigliani, Giacometti,
Ellsworth Kelly, Robert Motherwell and Dale Chihuly.

Admission: Adults, $7.50; seniors, $6.50; students, active
military, children ages 6–17, $3.50; children under 6, free.
Free on the first Friday of the month.
Hours: Tuesday through Saturday, 10 a.m.–5 p.m.; Sunday,
noon–5 p.m. Closed Monday and holidays.

Norton Simon Museum

411 West Colorado Boulevard, Pasadena, Calif. 91105
(626) 449-6840
www.nortonsimon.org

2003 EXHIBITIONS

March 8–July 8
To Do Battle: Conflict, Struggle and Symbol in Art
Explores aggression as depicted in the visual arts, from
antiquity to the present.

Pasadena

April 19–August 5
Villains and Heroes: Japanese Kabuki Prints
More than 20 prints about the world of Japanese Kabuki theater.

August 2–November 4
The Art of Giving
Recent gifts to the museum, including several Asian masterpieces.

December 13–April 7, 2004
My Four Blue Kings: Galka Scheyer and the Blue Four
Paintings, prints, drawings and sculpture in the Galka Scheyer collection by Blue Four artists: Paul Klee, Vassily Kandinsky, Alexei Jawlensky and Lionel Feininger.

December 13–September 8, 2004
From Europe to the Americas: Galka Scheyer and the Avant Garde
Paintings, drawings, prints and photographs by European and North American artists from the collection of Galka Scheyer.

PERMANENT COLLECTION

European art from the Renaissance to the 20th century, including works by Raphael, Botticelli, Rubens, Rembrandt, Zurbarán, Watteau, Fragonard and Goya; sculpture from India and Southeast Asia spanning a period of 2,000 years; Impressionist and Post-Impressionist paintings by Manet, Renoir, Monet, Degas, van Gogh, Toulouse-Lautrec and Cézanne; 20th-century works by Picasso, Matisse and the

Courtesy of the Norton Simon Museum.
Kandinsky, Sketch for *Deluge I*, 1912.

German Expressionists. **Architecture:** 1969 building designed by Ladd and Kelsey for the Pasadena Art Museum; reorganized in 1974 under Norton Simon's direction; in 1999, gallery space redesigned by Frank O. Gehry and sculpture garden designed by Nancy Goslee Power.

Admission: Adults, $6; seniors, $3; students, free.
Hours: Wednesday through Monday, noon–6 p.m.; Friday, until 9 p.m.

Crocker Art Museum

216 O Street, Sacramento, Calif. 95814
(916) 264-5423
www.crockerartmuseum.org

2003 EXHIBITIONS

Through January 12
Hundred Meditations: Sculpture by Sam Hernandez

Through February 23
Legends and Unicorns: The Pilot Hill Collection of Contemporary Art

January 24–April 27
Beyond the Mines: The Art of Gold

January 24–April 27
California Gold

January 31–June 1
Contemporary Sculpture

February 14–May 25
Hatamiya Collection

March 8–May 4
Strange Fruit: New Paintings by Hung Liu

March 8–May 4
Pangaea: A Portfolio of Contemporary Photography

May 23–July 27
Great Masters of Mexican Folk Art

Sacramento/LaJolla

June 20–September 14
Just Another Poster? Chicano Graphic Arts in California

August 15–October 19
Kilns of Denmark

August 19–November 16
Stuart Allen: Photography & Sculpture

August 22–November 9
The California Farm

August 22–November 9
Remembering the Family Farm: 150 Years of American Prints

November 7–January 18, 2004
Icons or Portraits? Images of Jesus and Mary Across Ten Centuries

PERMANENT COLLECTION

Founded in 1885, the Crocker Art Museum was the first public art museum in the West. European Old Master paintings and drawings; 19th- and 20th-century California art; Asian art; ceramics; photography; Victorian decorative arts. **Highlights:** Wayne Thiebaud, *Boston Cremes;* Pieter Bruegel, *Peasant Wedding Dance;* Thomas Hill, *The Great Canyon of the Sierra, Yosemite;* drawings by Dürer, Rembrandt and David.

Admission: Adults, $6; seniors, $4; students, $3; children 6 and under, free.
Hours: Tuesday through Sunday, 10 a.m.–5 p.m.; Thursday, until 9 p.m. Closed Monday and major holidays.

Museum of Contemporary Art, San Diego

700 Prospect Street, La Jolla, Calif. 92037
(858) 454-3541
www.mcasandiego.org

2003 EXHIBITIONS
Through November 2004
The Garden Gallery

Sculpture garden with works by Vito Acconic, Roman de Salvo, Andy Goldsworthy and others.

Through January 5
Christo and Jeanne-Claude in the Vogel Collection From the National Gallery of Art
A look at the work of two artists who have wrapped and draped fabric over and around objects and land-scapes.

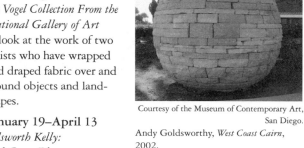
Courtesy of the Museum of Contemporary Art, San Diego.
Andy Goldsworthy, *West Coast Cairn*, 2002.

January 19–April 13
Ellsworth Kelly:
Red Green Blue
Explores the inspirations for Kelly's *Figure/Ground* paintings of the late 1950's through mid-1960's.

April 27–August 26
Andy Goldsworthy
Exhibition about the artist's *Cairn* series.

September 14–January 4, 2004
Manny Farber: Termite Art
Works from the past 15 years of the artist and critic's career.

Continuing
Andy Goldsworthy: West Coast Cairn
Sculpture carved from 20 tons of quarried stone that references ancient stone structures.

Downtown San Diego branch

1001 Kettner Boulevard, San Diego, Calif. 92101
(619) 234-1001

2003 EXHIBITIONS

Continuing
The Cerca Series
Works by regional artists, shown in seven-week installations. Artists include Helen Altman (January 1–February 16),

San Diego

Judith Barry (March 6–April 28), Celeste Bougenet Mougenot (May 8–June 25) and Dario Robleto (July–August).

PERMANENT COLLECTION

More than 3,000 works, including painting, sculpture, works on paper, photography, video and design, created in the latter half of the 20th century.

Admission: La Jolla: Adults and children over 12, $4; students, seniors and military personnel, $2. Downtown branch: Free. Free at both locations on the first Sunday and third Tuesday of each month.
Hours: La Jolla: Daily, 11 a.m.–5 p.m.; Thursday, until 8 p.m. Downtown branch: Thursday through Tuesday, 11 a.m.–5 p.m. Closed Wednesday. Both locations closed New Year's Day, Thanksgiving and Christmas Day.

San Diego Museum of Art

1450 El Prado, Balboa Park, San Diego, Calif. 92101
(619) 232-7931
www.sdmart.org

2003 EXHIBITIONS

Through January 19
American Watercolors From the Permanent Collection
Sixty-five works by leading watercolor artists.

Through January 26
Vital Forms: American Art and Design in the Atomic Age, 1940–1960
More than 200 works looking at American culture in this period through its architecture, furniture, design, painting, sculpture, textiles and other arts. (Travels)

Through March 9
Axis Mexico: Common Objects and Cosmopolitan Actions
Works by established and emerging Mexican artists.

March 8–May 18
*The Grandeur of Viceregal Mexico: Treasures From the
Museo Franz Mayer*
About 130 works of colonial Mexican art.

June 28–September 28
Degas in Bronze: The Complete Sculptures
A complete set of 73 bronze sculptures.

November 8–January 18, 2004
The World of Japan's Noh Drama Costumes
An exhibition of 20 Noh costumes from the Edo period
(1601–1868) in Japan, as well as modern Noh costumes.

PERMANENT COLLECTION

Renaissance and Baroque art, especially from Spain and Italy;
Indian miniature paintings; 19th- and 20th-century American
paintings and sculptures; contemporary art. **Architecture:**
Opened in 1926, the two-story Spanish colonial building is
located in the center of Balboa Park.

Admission: Adults, $8; seniors, college students, ages 18–24
and military personnel, $6; ages 6–17, $3; 5 and under, free.
Hours: Tuesday through Sunday, 10 a.m.–6 p.m.; Thursday,
until 9 p.m. Closed Monday and major holidays.

Timken Museum of Art

1500 El Prado, San Diego, Calif. 92101
(619) 239-5548
www.timkenmuseum.org

2003 EXHIBITIONS

Through March 30
Giambologna: Renaissance Master
More than 60 bronzes by the Flemish-born, 16th-century
Renaissance sculptor.

May 2–August 31
Benjamin West: Fidelia & Speranza
Finished oil paintings and preparatory sketches that West
based on Edmund Spencer's poem "The Faerie Queen."

San Diego/San Francisco

PERMANENT COLLECTION

European Old Masters, American paintings, Russian icons from 1200 through 1900.

Admission: Free.
Hours: Tuesday through Saturday, 10 a.m.–4:30 p.m.; Sunday, 1:30–4:30 p.m. Closed Monday and September.

Asian Art Museum of San Francisco

San Francisco Civic Center, 200 Larkin Street,
 San Francisco, Calif. 94102
(415) 379-8800
www.asianart.org

The museum is reopening in January 2003 in a new expanded space in the city's Civic Center.

2003 EXHIBITIONS

Through January 11
The Arts of Korea's Goryeo Dynasty
More than 100 artworks, many on view in the United States for the first time, from the Goryeo dynasty (918-1392), known for its exceptional artistic refinement. Includes celadon ceramics, Buddhist paintings and sculptures, and manuscripts.

Through January 11
Contemporary Korean Art
Works by seven Korean artists who have blazed new paths in a range of media.

January 23–September
The New Asian: An Introduction
Introduction to the museum and its new home, examining the transformation of the former library building.

January 23–July
An Honorable Tradition: The Art of the Book in Asia
More than 50 examples of secular and religious texts, albums, calligraphy and manuscripts from the 1100's to the 1900's.

June–September
*Indonesian Rod Puppets From the
Herbert Collection*
More than 200 puppets represent-
ing mythical kings and queens,
heroes, gods, monsters and servants.

PERMANENT COLLECTION

Chinese, Korean, Japanese, Indian,
Southeast Asian, Himalayan and
West Asian art. **Highlights:** The
oldest known dated Chinese
Buddha; Japanese netsukes; a
Shang-dynasty bronze vessel in the
shape of a rhinoceros.

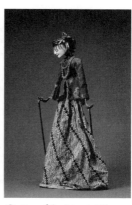

Courtesy of the Asian Art Museum
of San Francisco.
Indonesian rod puppet.

Architecture: The museum's new
home, a 1917 Beaux-Arts-style building that was formerly the
city's Main Library, was designed by Gae Aulenti (Musée
d'Orsay).

*The Fine Arts Museums
of San Francisco*

(415) 863-3330
www.thinker.org

*California Palace of the Legion of
Honor*

34th Avenue and Clement Street, Lincoln Park,
 San Francisco, Calif. 94122

2003 EXHIBITIONS

Through February 9
Casting a Spell: Winslow Homer, Artist and Angler
Exhibition of 65 paintings, mostly watercolors, that reflect the
artist's lifelong passion for fly-fishing.

San Francisco

M.H. de Young Memorial Museum

75 Tea Garden Drive, Golden Gate Park, San Francisco,
Calif. 94118

The museum is closed through 2005.

PERMANENT COLLECTION

Some 70,000 prints and drawings from the Achenbach
Foundation for Graphic Arts; 15th-century Spanish ceiling;
Roman, Greek and Assyrian art; paintings by Rembrandt,
Rubens, Watteau, de la Tour, Vigée Le Brun, Cézanne, Monet
and Picasso; noted collection of Rodin sculpture; American
paintings; art from the pre-Columbian Americas, Africa and
Oceania; world-renowned collection of textiles.

Admission: Adults, $8; seniors, $6; ages 12–17, $5; under
12 and San Francisco students, free. Free on second
Wednesday of the month.
Hours: Tuesday through Sunday, 9:30 a.m.–5 p.m. Closed
Monday.

The San Francisco Museum of Modern Art

151 Third Street, San Francisco, Calif. 94110
(415) 357-4000; (415) 357-4154 (for the deaf)
www.sfmoma.org

2003 EXHIBITIONS

Through January 5
Ellsworth Kelly in San Francisco
Bringing together the 22 pieces the museum acquired from
Kelly in 1999, including "Cité" (1951) and "Black over Blue"
(1963), with other paintings and sculptures from private
collections throughout the Bay Area.

Through February 14
Gerhard Richter: Forty Years of Painting
Some 150 works from the artist's career as both an abstract and representational painter.

Through February 23
August Sander: People of the 20th Century
More than 200 photographs by an early 20th-century German photographer who showed people in work clothing.

Through March 23
Architecture + Water
A look at five international building projects on the waterfront that integrate architecture, landscape and infrastructure.

Through March 23
Body Design
Works by innovative fashion, furniture, industrial and interior designers who have reconsidered the relationship of body to space and physiology to function.

Through March 23
No Ghost, Just a Shell: The Ann Lee Project
A computer animation project initiated by two French artists, Pierre Huyghe and Phillippe Parreno.

March 22–July 27
Irving Penn
Some 60 silver and palladium prints of the female nude by Penn, known for his fashion, still life and portraiture work. (Travels)

April 19–August 24
Framed: Film and the Construction of the American Modern Home
Examines the depiction of the American home through eight decades of cinema.

April 19–August 24
New Design: Lindy Roy
Groundbreaking designs by a South Africa-born architect.

July 12–September 28
Philip Guston
About 110 works from the 1940's and 1950's.

CALIFORNIA

San Francisco

Diane Arbus, *Patriotic Boy With Straw Hat, Buttons and Flag, Waiting to March in a Pro-War Parade*, 1963.

Courtesy of the San Francisco Museum of Modern Art.

August 23–January 1, 2004
Regan Louie
Large-scale color portraits of Asian women by a Chinese-American artist.

September–January 2004
Herzog+De Meuron
Explores the architectural work of Jacques Herzog and Pierre de Meuron and the artists who have influenced them.

October 18–February 15, 2004
Diane Arbus
Major retrospective of the work of Arbus (1923–1971), one of the foremost American photographers of the 20th century.

PERMANENT COLLECTION

Some 22,000 works of modern and contemporary painting, sculpture, photography, works on paper, architectural drawings and models, design objects and media art forms like video and multimedia installation work.

Admission: Adults, $10; seniors, $7; students, $6; 12 and under, free. Half price on Thursday, 6–9 p.m.; free the first Tuesday of the month.
Hours: Thursday through Tuesday, 11 a.m.–6 p.m. (opens one hour earlier Memorial Day to Labor Day); Thursday, until 9 p.m. Closed Wednesday, New Year's Day, Independence Day, Thanksgiving and Christmas Day.

Yerba Buena Center for the Arts

701 Mission Street, San Francisco, Calif. 94103
(415) 978-2787
www.yerbabuenaarts.org

2003 EXHIBITIONS

Through January 12
Bay Area Now 3
Works reflecting the artistic currents and recent developments in the Northern California arts community.

January 25–April 6
Charles LeDray
A survey of the artist's work, featuring 28 miniature sculptures of fabric, wire, wood and even human bone.

January 25–April 6
Seeing in the Dark
Works by established and newly emerging Swedish artists.

April 26–July 13
Time After Time: Asia and Our Moment
Contemporary art from Asia that addresses concepts of time, including painting, photography, sculpture and video.

July 26–October 12
Eye for An I: Birmingham circa 1960
Explores the civil rights movement in Birmingham, Ala., through photographs taken at the time.

July 26–October 12
Matmos
An installation featuring audio and video recordings of two grand pianos being dragged across the desert, by the San Francisco–based musical group Matmos.

July 26–October 12
New Work: Yunhee Min
Site-specific paintings by a Los Angeles–based artist.

July 26–October 12
Julie Mehretu
Renderings of public spaces, such as government buildings, airports, highways and street grids.

San Francisco

October 25–January 11, 2004
The End of the Start: 10 Years at the Center
A celebration of the multidisciplinary programming at the museum in the decade since its opening.

Admission: Adults, $6; seniors and students, $3.
Hours: Tuesday through Sunday, 11 a.m.–6 p.m.; first Thursday of the month, until 8 p.m. Closed Monday.

 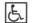

San Jose Museum of Art

110 South Market at San Fernando, San Jose, Calif. 95113
(408) 271-6840; (408) 294-2787 (recording)
www.SanJoseMuseumofArt.org

2003 EXHIBITIONS

Through February 16
Evocations: Sharon Ellis, 1991–2001
Works by a Los Angeles visionary artist who paints intricate floral patterns drenched in light.

Through October 26
Permanent Collection Highlights
Works by Manuel Ocampo, Gregory Barsamian, Joan Brown and others.

April 12–July 20
Tales of Yellow Skin: The Art of Long Nguyen
Works by a California painter, printmaker and sculptor whose Vietnamese heritage is reflected in his work.

April 12–July 20
Diaspora
Works by six contemporary artists examining the concept of diaspora.

August 9–November 2
Design for Optimism: Blobjects and Beyond
A look at consumer objects that favor biomorphic forms.

September 27–January 25, 2004
Robert Schwartz
Retrospective of this late Bay Area painter whose works have a
dreamlike quality.

November 22–February 15, 2004
*The Not-So Still Life: A Century of California Painting and
Sculpture*
Explores the evolution of still life in California.

PERMANENT COLLECTION

Twentieth- and 21st-century works, with an emphasis on post-
1980 Bay Area artists. Includes works by Milton Avery,
Manuel Ocampo, Willem de Kooning, Deborah Oropallo, Bill
Viola, Claes Oldenburg and Wayne Thiebaud.

Admission: Free.
Hours: Tuesday through Sunday, 11 a.m.–5 p.m.; Friday,
until 10 p.m. Closed Monday, New Year's Day, Thanksgiving
and Christmas Day.

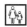 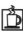 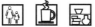

The Huntington Library, Art Collections and Botanical Gardens

1151 Oxford Road, San Marino, Calif. 91108
(626) 405-2100
www.huntington.org

2003 EXHIBITIONS

Through June 15
Gloriana! The Golden Legend of Elizabeth I
Exhibition of rare manuscripts, early printed books and
engravings tracing the creation of the legend of "Gloriana,"
marking the 400th anniversary of the death of Elizabeth I.

San Marino

August–January 2004
Perspectives: Art Education and the American Experience
Explores how art has been taught in America from the 1800's
through the 1940's, featuring vintage paint boxes, coloring
books, drawing manuals and sketchbooks.

January 15–May 25
Vision and Verse: William Blake at the Huntington
More than 190 works by the Romantic poet and artist,
including watercolors, drawings, manuscripts, engravings,
plates from his illuminated books and book illustrations.

January 15–April 4
*Mr. Huntington's Ranch, 1903–2003: A Century of
Transformation*
Examines the transformation of a Victorian estate into a
museum, as the Huntington celebrates the 100th anniversary
of Henry E. Huntington's purchase of the property.

June 25–October 5
Edward Weston: A Legacy
Some 150 photographs from a collection of more than 500
printed by the photographer for the museum.

November 5–April 4, 2004
The Beauty of Life: William Morris and the Art of Design
A look at Morris's place in the history of 19th-century design
through more than 200 works, including furnishings, stained
glass and textiles.

PERMANENT COLLECTION

In the former private estate of the railroad magnate Henry E.
Huntington, world-class collections of rare books, manuscripts
and art. **Highlights:** Gainsborough, *The Blue Boy;* a
Gutenberg Bible; Chaucer, *Canterbury Tales;* 150 acres of
botanical gardens.

Admission: Adults, $10; seniors, $8.50; students (12–18),
$7; youth (5–11), $4; under 5, free. Groups of 10 or more, $8.
Hours: Tuesday through Friday, noon–4:30 p.m.; Saturday
and Sunday, 10:30 a.m.–4:30 p.m. Slightly longer hours dur-
ing the summer.

Santa Barbara Museum of Art

1130 State Street, Santa Barbara, Calif. 93101
(805) 963-4364
www.sbmuseart.org

2003 EXHIBITIONS

Through February 9
PhotoGENESIS: Opus II
Optical-based images focusing on artists' responses to the
genetic revolution.

March 8–June 15
A Passionate Collaboration: Margrethe Mather and Edward Weston
Covering the dozen years of the two photographers'
association, just before and after World War I.

July 11–October 17
*Risking the Abstract: Mexican Internationalism and the Art of
Gunther Gerzso*
More than 130 paintings, sculptures and works on paper by
Mexico's premier abstract painter.

November 22–February 15, 2004
Worshiping the Ancestors: Chinese Commemorative Portraits
Features 34 large-scale paintings created during the Qing
Dynasty (1644–1911).

PERMANENT COLLECTION

Art spanning 43 centuries, from Greek and Roman sculpture
to contemporary works. Includes American art; 19th- and
early-20th-century French art; Asian art; classical antiquities;
photography; prints and drawings.

Admission: Adults, $6; seniors, $4; ages 6–17, $3; under 6,
free. Free on Thursday and the first Sunday of every month.
Hours: Tuesday through Saturday, 11 a.m.–5 p.m.; Friday,
until 9 p.m.; Sunday, noon–5 p.m. Closed Monday, New
Year's Day and Christmas Day.

Stanford

Iris & B. Gerald Cantor Center for Visual Arts at Stanford University

Lomita Drive and Museum Way, Stanford, Calif. 94305-0506

(650) 723-4177; (650) 723-1216 (for the deaf)

www.stanford.edu/dept/ccva/

2003 EXHIBITIONS

Through January 12
Distinctly American: The Photographs of Wright Morris
Eighty-seven works selected by the photographer from The Capital Group collection as best exemplifying his achievements, including scenes of his native Nebraska. (Travels)

January 15–April 20
Trabajo de Campo
Objects from the Chokwe, Lunda and Lavale peoples of Zambia, interpreted by the Cuban artist José Bedia and a curator for the Cantor center.

February 5–May 11
Time Stands Still: Muybridge and the Instantaneous Photography Movement
Explores the origin, significance and influence of Muybridge's work chronicling the development of instantaneous photography from its invention to the rise of cinema. (Travels)

June 11–September 7
The Artist and the Changing Garden: 400 Years of European and American Gardens
Prints, drawings, illustrated books, photographs, paintings and sculptures tracing changing tastes in gardens. (Travels)

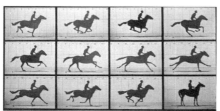

Eadweard Muybridge, *Sallie Gardner*, 1878.

Courtesy of the Iris and B. Gerald Cantor Center.

September 10–January 4, 2004
The Beginning of Seeing: Adolph Gottlieb and Tribal Art
Tribal sculptures collected by the Abstract Expressionist artist
as well as a selection of his paintings known as "Pictographs"
that were inspired by the sculptures.

October 8–January 18, 2004
Hudson River School Masterworks From Wadsworth Atheneum
Some 55 paintings by 19th-century American artists, includ-
ing Thomas Cole, Frederic Church and Albert Bierstadt.

PERMANENT COLLECTION

More than 25,000 objects from antiquity to the present,
including American and European drawings, prints, pho-
tographs and paintings and works from Asia, Africa, Oceania
and Native America. **Highlights:** The largest group of Rodin
sculpture outside the Musée Rodin in Paris. **Architecture:**
Renovated historic building with new wing, Rodin Sculpture
Garden and new gardens for contemporary sculpture.

Admission: Free.
Hours: Wednesday through Sunday, 11 a.m.–5 p.m.,
Thursday, until 8 p.m. Closed Monday and Tuesday,
Thanksgiving, Christmas Day and New Year's Day.

Colorado

Denver Art Museum

13th Avenue and Acoma Street, Denver, Colo. 80204
(720) 865-5000 (recording); (720) 865-5003 (for the deaf)
www.denverartmuseum.org

2003 EXHIBITIONS

Through January 12
Renaissance of Botanical Art: The Shirley Sherwood Collection
Some 166 botanical illustrations.

COLORADO

Denver

Through February 28
New Classics From the American Indian Collection
Works by contemporary artists.

Through March 23
African Renaissance: New Forms, Old Images
Works by a contemporary Nigerian artist, Moyo Ogundine, juxtaposed with works by old masters of Africa.

Through May 4
Fabulous Floral Fabrics
Textiles from America, Europe and Asia with floral motifs.

Through August 17
Retrospectacle: 25 Years of Collecting Modern and Contemporary Art
Paintings, photographs, sculptures and other works from the museum's collection.

Through March 2005
The Harmsen Collection: A Colorado Legacy
Thirty works of western and American Indian art from a 3,000-piece collection donated to the museum.

March 1–May 25
Bonnard
About 100 paintings, drawings, prints, sculptures and photographs by Pierre Bonnard (1867–1947), the colorist whose work bridges the 19th and 20th centuries. (Travels)

June 28–September 21
Sargent and Italy
More than 90 oil and watercolor paintings by the late-19th-century American artist who had a strong affection for Italy. (Travels)

October 4–January 4, 2004
El Greco to Picasso From the Phillips Collection
Some 53 European works by Renoir, Cezanne, Van Gogh, Matisse, El Greco, Picasso and others. (Travels)

Courtesy of the Denver Art Museum.
Dan Namingha, *Polacca* #6, 2001.

PERMANENT COLLECTION

Founded in 1893, the Denver Art Museum has more than 48,000 works of art, including collections of Asian art; modern and contemporary art; American Indian and New World arts; European and American painting and sculpture; architecture, design and graphics; textile art; art of the American West. **Architecture:** The 28-sided, two-tower building, designed by Gio Ponti of Italy in collaboration with James Sudler Associates of Denver, has seven floors of gallery space and is covered with more than one million gray tiles.

Admission: Adults, $6; seniors and students, $4.50; members and children 12 and under, free; Colorado residents, free on Saturdays.
Hours: Tuesday through Saturday, 10 a.m.–5 p.m.; Wednesday, until 9 p.m.; Sunday, noon–5 p.m. Closed Monday and major holidays.

Connecticut

Wadsworth Atheneum Museum of Art

600 Main Street, Hartford, Conn. 06103
(860) 278-2670
www.wadsworthatheneum.org

2003 EXHIBITIONS

Through February 9
Cloth of Kings
Thirty intricately patterned velvets from the 15th to 20th century.

January 17–April 13
Marsden Hartley
Retrospective showing the stylistic and thematic range of the

artist's innovative work, including landscapes and symbolic portraits. (Travels)

February 1–April 27
Catherine Sullivan/MATRIX 149
New work by a Los Angeles–based performance and video artist.

June 6–October 19
Wallace Nutting and the Invention of Old America
Works from a collection of Early American furniture donated to the museum by Nutting (1861–1941), an antiquarian, author, photographer and furniture maker. (Travels)

October 3–January 4, 2004
Benny Andrews
Focuses on the artist's Bicentennial Series (1970–1976), featuring six mural-size works and related paintings and drawings.

PERMANENT COLLECTION

America's oldest public art museum, founded in 1842, with nearly 50,000 works. Includes a Hudson River School collection; Baroque masterpieces; the Wallace Nutting Collection of Pilgrim-Century Furniture; Meissen and Sèvres porcelain; 19th- and 20th-century American and European art; the Amistad Foundation African-American Collection.

Admission: Adults, $9; seniors 62 and over, $7; students age 13 through college, $5; children 12 and under, free.
Hours: Tuesday through Friday, 11 a.m.–5 p.m.; Saturday and Sunday, 10 a.m.–5 p.m.; first Thursday of each month (except December), until 8 p.m. Closed Monday, New Year's Day, Independence Day, Thanksgiving and Christmas Day.

Yale Center for British Art

1080 Chapel Street, New Haven, Conn. 06520
(203) 432-2800; (203) 432-2850
www.yale.edu/ycba

2003 EXHIBITIONS

Through January 5
Romantic Watercolor, the Hickman Bacon Collection
Eighty-two works from the 1890's to the eve of World War I by
Turner and others. (Travels)

January 23–March 30
*Romantics and Revolutionaries: Regency Portraits From the National
Portrait Gallery, London*
More than 90 portraits of personalities from the Regency
period (1790–1830), including Lord Byron, Keats, Shelley,
Austen, Wordsworth, Lady Emma Hamilton, Lord Nelson and
the Regent himself, who later became George IV. (Travels)

January 23–March 30
The Romantic Print in the Age of Revolutions
Portrait, subject and narrative prints, including works by
Benjamin West, J.M.W. Turner and William Blake.

April 19–July 20
Bill Brandt, A Retrospective
Works by the British photographer (1904–1983), from his
early work documenting the social contrasts of 1930's Britain
to his later experimentation with surrealistic style. (Travels)

PERMANENT COLLECTION

The most comprehensive collection of British art outside the
United Kingdom. **Highlights:** The collection of British paint-
ings, drawings, prints, rare books and sculpture given to the
University by Paul Mellon (Yale Class of 1929). **Architecture:**
The Yale Center for British Art is the final building designed
by the American architect Louis I. Kahn (1901–1974). It
opened to the public in 1977 and stands across the street from
his first major commission, the Yale Art Gallery (1953).

Admission: Free.
Hours: Tuesday through Saturday, 10 a.m.–5 p.m.; Sunday,
noon–5 p.m. Closed Monday and major holidays.

New Haven

Yale University Art Gallery

1111 Chapel Street, New Haven, Conn. 06520
(203) 432-0600
www.yale.edu/artgallery

PERMANENT COLLECTION

Works from Ancient Egyptian dynasties to the present; Asian
art, including Japanese screens, ceramics and prints; artifacts
from ancient Dura-Europos; Italian Renaissance art; 19th- and
20th-century European paintings; American art through the
20th century. **Highlights:** Reconstructed Mithraic shrine; van
Gogh, *The Night Cafe*; Malevich, *The Knife Grinder*; Smibert,
The Bermuda Group; Trumbull, *The Declaration of Independence*;
works by Manet and Picasso; contemporary sculpture by
Moore, Nevelson and Smith. **Architecture:** Two connecting
buildings house the oldest university art museum in the U.S.:
1928 building by Edgerton Swartwout based on a gothic
palace in Viterbo, Italy, and 1953 landmark building by Louis
I. Kahn.

Admission: Free.
Hours: Tuesday through Saturday, 10 a.m.–5 p.m.; Thursday,
until 8 pm.; Sunday, 1–6 p.m. Closed Monday and major holi-
days.

Delaware

Delaware Art Museum

800 South Madison Street, Wilmington, Del. 19801
(302) 571-9590
www.delart.org

Courtesy of the Delaware Art Museum.
Cartland, *Wat, Dot, Teaser, Skip, Fly and Nip*, 1887.

2003 EXHIBITIONS

Through February 16

Lure of the West: Treasures From the Smithsonian Art Museum
More than 60 works by Catlin, Remington, Bierstadt and members of the Taos School reflecting the country's fascination with the Western landscape and people. (Travels)

March 7–May 4

A Thousand Hounds: A Walk With Dogs Through the History of Photography
Explores the role of dogs, from rescue workers to pampered celebrities, as subject matter in photography from the 19th to 21st century.

PERMANENT COLLECTION

Pre-Raphaelite art; American illustration; 19th- and 20th-century American art. **Highlights:** John Sloan, *Spring Rain;* Edward Hopper, *Summertime*; Winslow Homer, *Milking Time*; Dante Gabriel Rossetti, *Bella Mano*; Robert Motherwell, *Je t'Aime No. VIII (Mallarmé's Swan: Homage)*.

Admission: Adults, $7; seniors, $5; students, $2.50; 6 and under, free. Free on Saturday, 10 a.m.–noon and Wednesday, 4-9 p.m.
Hours: Tuesday, Thursday and Friday, 10 a.m.–6 p.m.; Wednesday, 10 a.m.–9 p.m.; Saturday, 10 a.m.–5 p.m.; Sunday, 1–5 p.m. Closed Monday.

District of Columbia

Corcoran Gallery of Art

500 17th Street NW, Washington, D.C. 20006
(202) 639-1700
www.corcoran.org

2003 EXHIBITIONS

Through January 6
The Shape of Color: Joan Miró's Painted Sculpture
Twenty polychrome sculptures and 60 related works on paper, as well as photographs and films of the artist at work. The exhibition focuses on the sculpture he produced during the 1960's and 70's.

Through January 6
Emmet Gowin: Changing the Earth
Landscape photographs shot fromthe air, including looks at natural beauty as well as nuclear facilities, irrigation systems, mines and battlefields.

Through February 3
Paul McCartney Paintings
Figure paintings and landscapes by the musician.

Through March 4
Fantasy Under Foot: The 47th Biennial Exhibition

February 1–April 29
Whistler and His Circle in Venice
Works that James McNeill Whistler created during the 14 months he spent in the Italian city. The exhibition explores the influence his work had on the imagery created by his followers and contemporaries.

February–April
American Falls: Video Installation by Philip Solomon
A multiple-projector project combining footage of Niagara Falls and the Atlantic and Pacific oceans with scenes from American history, displayed on the walls of the rotunda.

Late March–June
Robert Frank: Places
Approximately 80 photographs, from 1947 to 2001,
including two series made in London and Wales in 1951, as
well as a new video.

June–October
Dedicated to Art: The Best of the Corcoran
Some 75 works, including American and European paintings,
sculpture, photographs and works on paper.

June 20–July 16
*The Eyes of History, 2003: An Exhibition of Award-Winning
Photographs by White House Photojournalists*
Works by members of the White House News Photographers'
Association that documented the year's top news stories.

August–October
*Solid Impressions: The Latest Series of Sculptures by American Realist
J. Seward Johnson Jr.*
Nearly two dozen life-size vignettes inspired by Renoir,
Caillebotte, Manet, Monet and van Gogh masterpieces.

PERMANENT COLLECTION

A historically varied selection of paintings, sculpture,
photographs and drawings, ranging from Barye bronzes to the
decorative arts, and European Renaissance to contemporary
American paintings.

Admission: Adults, $5; seniors and members' guests, $3;
students, $1; families, $8; members and children under 12,
free. Free on Monday and on Thursday after 5 p.m.
Hours: Wednesday through Monday, 10 a.m.–5 p.m.;
Thursday, until 9 p.m. Closed Tuesday.

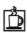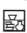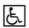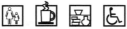

Folger Shakespeare Library

201 East Capitol Street SE, Washington, D.C. 20003
(202) 544-4600; (202) 544-7077 (box office and
 recording)
www.folger.edu

Washington

2003 EXHIBITIONS

Through March 1
"Thys Boke Is Myne"
Exploring markings left in books by famous people.

March 19–late July
Elizabeth I, Then and Now
Some 85 items, including portraits, letters and Elizabeth's Bible. Also a look at her legacy from the pamphlets, plays and novels of the 17th century to modern-day mysteries, movies and merchandise.

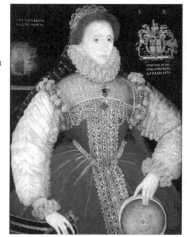

Courtesy of the Folger Shakespeare Library.
George Gower, *Sieve,* portrait of Elizabeth I, 1579.

Mid-August–December
Fakes, Forgeries, Facsimiles
Books, manuscripts, prints, maps, ephemera, works of art and Shakespearean memorabilia from the library's collection.

Continuing
The Seven Ages of Man
A multimedia installation that invites visitors to electronically browse through Shakespeare-related treasures.

PERMANENT COLLECTION

The Folger is home to the world's largest collection of Shakespeare's printed works, as well as a collection of other rare Renaissance books and manuscripts. It is a center for scholarly research and for the literary and performing arts.

Admission: Free.
Hours: Monday through Saturday, 10 a.m.–4 p.m. Closed Sunday and federal holidays.

Freer Gallery of Art and Arthur M. Sackler Gallery

Together, the Smithsonian Institution's Freer and Sackler galleries form the national museum of Asian art.

Freer Gallery of Art

Jefferson Drive at 12th Street SW, Washington, D.C. 20560
(202) 357-2700; (202) 357-1729 (for the deaf)
www.asia.si.edu

2003 EXHIBITIONS

Through March 30
Palaces and Pavilions: Grand Architecture in Chinese Painting
Scrolls, album leaves and three-dimensional objects dating from the second century through the 18th, illustrating how imperial structures and mythical palaces have been depicted.

Through May 4
Chinese Buddhist Sculpture in a New Light
Devotional objects and other sculpture, plus a look at imitations and forgery.

Through May 26
The Floating World Revealed: Ukiyo-e Paintings and Prints
Works depicting Japanese actors and courtesans during the Edo period (1615–1868).

Through May 26
Tea in the Floating World
Paraphernalia from the Edo period that helps demonstrate the tea ceremony's important role in the green rooms of Kabuki theaters as well as officially sanctioned pleasure quarters.

January 19–June 15
Whistler in Venice: The Pastels
Eighteen drawings James McNeill Whistler made during his first trip to Venice, along with several related etchings.

April 27–October 12
In Pursuit of Heavenly Harmony: Paintings and Calligraphy by Bada Shanren (1626–1705)
Works from all five stages of the artist's work.

<hr>

June 15–November 9
By Whistler's Design: Small Masterpieces
More than 50 works. The exhibition evokes an 1884 London
installation that was designed by the artist himself.

June 29–February 1, 2004
Whistler Rarities: Etchings From the Artist's 1888 Honeymoon
Twenty-five copper-plate etchings the artist completed while
on his honeymoon in France's Loire Valley.

Continuing
Arts of the Islamic World
Including works of calligraphy, illumination, glass, metal,
wood and ivory, from the ninth century to the 17th.

Continuing
James McNeill Whistler
Ten oil paintings that demonstrate the evolution of the artist's
style between 1860 and 1900.

PERMANENT COLLECTION

Art of China, Japan, Korea, South Asia, Southeast Asia and the
Near East, including Chinese paintings, Japanese folding
screens, Korean ceramics, Indian and Persian manuscripts,
Buddhist sculpture; 19th- and early-20th-century American
art, including the world's largest group of works by James
McNeill Whistler and his Peacock Room.

Admission: Free.
Hours: Daily, 10 a.m.–5:30 p.m.; Thursday, until 8 p.m. from
Memorial Day through Labor Day. Closed Christmas Day.

Arthur M. Sackler Gallery

1050 Independence Avenue SW, Washington, D.C. 20560
(202) 357-2700; (202) 357-1729 (for the deaf)
www.asia.si.edu

2003 EXHIBITIONS

Through March 9
The Sensuous and the Sacred: Chola Bronzes From South India
Sixty works produced between the ninth and 13th centuries in

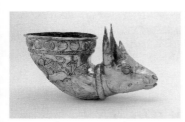

Rhyton, Iran, Sasanian
period, A.D. 300-400,
silver and gilt.

Courtesy of the Arthur M. Sackler Gallery and
Freer Gallery of Art Museum.

southern India, during the rule of the Chola dynasty. Photo
murals of temple bronzes in situ, as well as a single large
draped and ornamented figure, recreate the context in which
the icons are used.

February 16–July 27
*After the Madness: The Secular Life, Art and Imitation of Bada
Shanren*
A look at connoisseurship, copying and fakery.

March 9–August 10
A Way Into India: Photographs by Raghubir Singh (1942-1999)
Fifty landscape images as framed by or reflected in the mirrors
of the quintessentially Indian Ambassador car.

May 4–September 7
Isamu Noguchi and Modern Japanese Ceramics
Trailblazing clay works by the Japanese-American sculptor.

September 28–February 8, 2004
*Faith and Form: Selected Calligraphy and Painting From Japanese
Religious Traditions*
Illuminated texts, portraits of Zen masters and other works.

Continuing
Metalwork and Ceramics From Ancient Iran
Dozens of metal and clay artifacts, created in western Iran
between 2300 B.C. and 100 B.C.

PERMANENT COLLECTION

Chinese bronzes, jades and lacquerware; ancient Near Eastern
ceramics and metalware; South and Southeast Asian sculpture;
Islamic arts of the book; 19th- and 20th-century Japanese
prints and porcelain; Indian, Chinese, Japanese and Korean
paintings; photography.

Admission: Free.

Hours: Daily, 10 a.m.–5:30 p.m.; Thursday, until 8 p.m. from Memorial Day through Labor Day. Closed Christmas Day.

Hillwood Museum and Gardens

4155 Linnean Avenue NW, Washington, D.C. 20008
(202) 686-8500
www.hillwoodmuseum.org

2003 EXHIBITIONS

March 4–December
The Myths of St. Petersburg
More than 50 objects, illustrating the city's changing culture.

PERMANENT COLLECTION

Estate of the art collector Marjorie Merriweather Post, including the largest collection of imperial Russian art objects outside Russia; chalices and icons; 18th-century French furniture; 18th- and 19th-century Russian and French decorative and fine art. **Highlights:** Easter eggs by Fabergé; diamond wedding crown of Empress Alexandra; dinner services commissioned by Catherine the Great; Sèvres porcelain.

Admission: Adults, $10; children, $5. Reservations required. Children under 6 not admitted in mansion but may visit gardens.
Hours: Tuesday through Saturday, 9 a.m.–5 p.m. Closed Sunday (except certain Sundays in spring and fall), Monday, the month of January, Thanksgiving Day and the day after, Christmas Day, New Year's Day and all federal holidays.

Hirshhorn Museum and Sculpture Garden

Smithsonian Institution, Independence Avenue at
Seventh Street SW, Washington, D.C. 20560
(202) 357-2700
www.hirshhorn.si.edu

2003 EXHIBITIONS

Through January 12
Zero to Infinity: Arte Povera, 1962–1972
About 140 works by a group of artists that propelled Italy to
the center of the international art scene in the 1960's by fusing
process, materials, concepts and politics.

Through March 2
Directions: Cecily Brown
Seven large abstract paintings created from 1997 to 2001.

February 27–May 18
Gerhard Richter: Forty Years of Painting
A survey of the German artist's landscapes, portraits and other
photo-based paintings.

PERMANENT COLLECTION

Modern sculpture; contemporary art; postwar European
paintings; 20th-century American paintings. **Highlights:**
Outdoor sculpture garden on the National Mall includes
works by Matisse, Moore, Rodin and di Suvero. **Architecture:**
1974 building designed by Gordon Bunshaft. Sculpture plaza
redesigned by the landscape architect James Urban in 1993.

Admission: Free.
Hours: Open daily except Christmas Day. Museum: 10 a.m.–
5:30 p.m.; Thursday, until 8 p.m. during summer. Sculpture
garden: 7:30 a.m.–dusk. Plaza: 7:30 a.m.–5:30 p.m.

Washington

The Kreeger Museum

2401 Foxhall Road NW, Washington, D.C. 20007
(202) 338-3552
www.kreegermuseum.org

PERMANENT COLLECTION

Nineteenth- and 20th-century painting and sculpture,
including works by Monet, Renoir, Degas, Picasso, Miró and
van Gogh; traditional African art. **Architecture:** Former
home of the philanthropists Carmen and David Lloyd Kreeger,
designed by Philip Johnson.

Admission: Suggested donation, $5. Reservations required
for guided tours.
Hours: Saturday, 1-4 p.m. Tours of the museum are offered
Tuesday through Friday at 10:30 a.m. and 1:30 p.m. and
Saturday at 10:30 a.m.

Library of Congress

101 Independence Avenue SE, Washington, D.C. 20540
(202) 707-5000; (202) 707-8000 and (202) 707-4604
 (recordings); (202) 707-9956 (for the deaf)
www.loc.gov; www.americaslibrary.gov (for children)

2003 EXHIBITIONS

Through March
World Treasures: Beginnings
Explores accounts and depictions of the world's creation;
explanations of the earth and the heavens; and myths and
legends concerning the founding of civilizations and societies.

Through March
When They Were Young
Photographs of children, including works by Jack Delano,
Dorothea Lange, Russell Lee, Carl Mydans, Gordon Parks,
John Vachon and Marion Post Wollcott.

Courtesy of the Library of Congress.
Charles Dana Gibson, *The Weaker Sex*, 1903.

July 24–November 29
Rivers, Edens and Empires: Lewis and Clark and the Revealing of America
Maps, letters, documents and artifacts from Lewis and Clark's expedition, including President Thomas Jefferson's instructions to Meriwether Lewis.

September 9–November 14
The Dream of Flight: Romance and Realization
Documents, letters, prints, maps, photographs, motion pictures and artifacts from the Wright Brothers' 1903 flight.

Continuing
American Treasures
Some 300 historical items from the library's collections.

PERMANENT COLLECTION

Repository of the nation's books, manuscripts, films, sound recordings, photographs and maps — more than 120 million items in all. **Architecture:** 1897 Italian Renaissance-style Jefferson Building designed by John L. Smithmeyer and Paul J. Pelz. Art Deco 1938 Adams Building by Pierson and Wilson with Alexander Buel Trowbridge. Modern 1981 Madison Building by DeWitt, Poor and Shelton.

Admission: Free.
Hours: Monday through Saturday, 10 a.m.–5:30 p.m. Closed Sunday and federal holidays.

Washington

National Building Museum

401 F Street NW, Washington, D.C. 20001
(202) 272-2448
www.nbm.org

2003 EXHIBITIONS

Through August 10
Do It Yourself: Home Improvement in 20th-Century America
A study of America's fascination with home improvement and
the ways families reshape their domestic environment.

February 15–September 21
"Mount Vernon Is Ours": 150 Years of Historic Preservation
A look at George Washington's home and the commitment
of the Mount Vernon Ladies' Association to preserve and
interpret it. Included are objects used in the mansion during
Washington's time, plus maps and a miniature model.

Continuing
Tools as Art: The Hechinger Collection
A celebration of common tools' dignity and beauty.

PERMANENT COLLECTION

Photographs, drawings and objects celebrating American
achievement in urban planning, construction, engineering and
design. **Architecture:** 1880's Italian Renaissance building by
Montgomery C. Meigs.

Admission: Free.
Hours: Monday through Saturday, 10 a.m.–5 p.m.; Sunday,
noon–5 p.m.

National Gallery of Art and Sculpture Garden

The National Mall, between Third and Ninth Streets at
 Constitution Avenue NW, Washington, D.C. 20565
(202) 737-4215 (recording); (202) 842-6176 (for the deaf)
www.nga.gov

2003 EXHIBITIONS

Through March 2
Deceptions and Illusions: Five Centuries of Trompe L'oeil Painting
Approximately 115 works exploring the medium's origins in classical antiquity and its influence on 20th-century artists.

Through March 2
Drawing on America's Past: Folk Art and the Index of American Design
Approximately 80 watercolors from the New Deal project, along with three dozen of the original artifacts they represent, including quilts, toys, carousel animals and stoneware.

January 19–April 20
Édouard Vuillard (1868–1940)
A career retrospective featuring some 200 works, including Vuillard's earliest academic studies, Nabis paintings and work associated with avant-garde theater, as well as drawings, graphics and photographs. (Travels)

February 9–May 11
Thomas Gainsborough (1727–1788)
Approximately 75 paintings and 30 works on paper. (Travels)

March 2–June 1
Ernst Ludwig Kirchner (1880–1938)
More than 100 works by the German Expressionist, including paintings and sculpture. (Travels)

April 13–July 13
Frederic Remington: The Color of Night
More than 20 paintings that feature lots of color and moonlight, firelight and candlelight. (Travels)

May 4–September 7
Jean-Antoine Houdon: Sculptor of the Enlightenment
More than 70 works by the portraitist, including sculptures of intellectual, military and political figures; children; and historical and mythological subjects. (Travels)

September 14–January 4, 2004
Romare Bearden (1914-1988)
A retrospective featuring the collages and photomontages for which the artist is best known, as well as a selection of watercolors, gouaches and oils. (Travels)

Washington

Romare Bearden,
Palm Sunday Procession,
1967–1968.

Courtesy of the National Gallery of Art.

October 12–January 11, 2004
The Age of Watteau, Chardin and Fragonard: Masterpieces of French Genre Painting
Approximately 100 paintings spanning the 18th century, including works by Antoine Watteau, Jean Siméon Chardin, Jean-Honoré Fragonard, François Boucher, Jean-Baptiste Greuze and Louis-Léopold Boilly. (Travels)

PERMANENT COLLECTION
The National Gallery of Art and Sculpture Garden was created in 1937 with the gift of Andrew W. Mellon. The gallery's collection of some 100,000 paintings, drawings, prints, photographs, sculpture and decorative arts traces the development of Western art from the Middle Ages to the present. West Building: A comprehensive survey of Italian painting and sculpture, including the only painting by Leonardo da Vinci in the Western Hemisphere, along with Dutch masters and French Impressionists, and surveys of American, British, Flemish, Spanish and 15th- and 16th-century German art. East Building: Works by Alexander Calder, Henri Matisse, Joan Miró, Pablo Picasso, Jackson Pollock, Mark Rothko and other 20th-century artists. Sculpture Garden: Seventeen major works of post–World War II sculpture by Louise Bourgeois, Mark di Suvero, Roy Lichtenstein, Claes Oldenburg, Coosje van Bruggen, Tony Smith and others. **Architecture:** West Building: Opened

in 1941 and designed by John Russell Pope. East Building: Opened in 1978 and designed by I.M. Pei.

Admission: Free.
Hours: Monday through Saturday, 10 a.m.–5 p.m.; Sunday, 11 a.m.–6 p.m. Closed New Year's Day and Christmas Day.

National Museum of African Art

Smithsonian Institution, 950 Independence Avenue SW,
 Washington, D.C. 20560–0708
(202) 357-4600; (202) 357-4814 (for the deaf)
www.nmafa.si.edu

2003 EXHIBITIONS

Through January 5
Recent Acquisitions and Promised Gifts
Works by artists from across Africa who practice in a wide variety of media, including painting, printmaking, installation work, sculpture and photography.

Through March 16
In and Out of Focus: Images From Central Africa, 1885–1960
Examines how the widely disseminated images by Casimir Zagourski and other European and American photographers created and perpetuated ideas about the people of central Africa who lived under colonial rule.

January 31–October 5
Ethiopian Icons: Faith and Science
Five Ethiopian Orthodox icons that recently underwent technical analysis and conservation treatment. Offers insights into the creation of the icons and the museum's efforts to preserve them.

January 31–November 30
Journeys and Destinations: Contemporary African Artists on the Move
Explores the histories of migration and the negotiations of artistic, cultural, personal and group identities among African artists who now live in Europe and America.

Washington

Continuing
The Ancient Nubian City of Kerma, 2500–1500 B.C.
Ceramics, jewelry and ivory inlays in animal shapes reveal
Kerma's wealth and artistic traditions.

Continuing
The Ancient West African City of Benin, 1300–1897
Cast-metal heads, figures and architectural plaques that depict
kings and attendants from the royal court of Benin as it
existed before British colonial rule.

Continuing
The Art of the Personal Object
Chairs, stools, headrests, snuff containers, pipes, cups, a
drinking horn, bowls, baskets, combs, a Somali rose water
bottle and a Yoruba game board. Most items are from the late
19th century to the early 20th.

Continuing
Images of Power and Identity
Masks and figurative sculpture from sub-Saharan Africa,
including two 13th- to 15th-century terra-cotta figures from
Mali, a 19th-century Bamum royal figure and a 20th-century
palace door carved by the Nigerian artist Olowe of Ise.

PERMANENT COLLECTION

The museum collects the visual arts of Africa, from ancient to
contemporary. Noteworthy holdings include royal Benin art;
utilitarian objects, including stools, headrests and other personal
items; masks; textiles; ceramics; and contemporary paintings,
prints and sculpture. Photographic archives with 300,000
prints and transparencies, plus films and videos. Library has
more than 25,000 books.

Admission: Free.
Hours: Daily, 10 a.m.–5:30 p.m.; call about extended
summer hours. Closed Christmas Day.

The National Museum of Women in the Arts

1250 New York Avenue NW, Washington, D.C. 20005
(202) 783-5000
www.nmwa.org

2003 EXHIBITIONS

Through January 5
Book as Art XIV: Temptations
More than 70 paintings, drawings and books by 37 artists, looking at food, love, escape and self-destruction.

Through January 5
Judy Chicago
A retrospective covering four decades of the feminist artist's work, including selections from *The Dinner Party* and the *Holocaust Project*.

February 14–June 8
An Imperial Collection: Women Artists From the State Hermitage Museum
More than four dozen sculptures and paintings, including works by Marie-Anne Collot, Angelica Kauffman and Elisabeth Louise Vigée-Lebrun.

PERMANENT COLLECTION

Some 2,700 works, from the Renaissance to Modernism, by 800 artists, including Elizabeth Catlett, Camille Claudel and Georgia O'Keeffe. **Highlights:** Elizabeth Louise Vigée-Lebrun, *Portrait of Princess Belozersky*; Frida Kahlo, *Self-Portrait Dedicated to Leon Trotsky*; library and research center.
Architecture: 1908 Renaissance Revival building by Waddy Wood originally constructed as a Masonic temple.

Admission: Adults, $5; students and those age 60 and older, $3; members and those 18 and under, free.
Hours: Monday through Saturday, 10 a.m.–5 p.m.; Sunday, noon–5 p.m. Closed New Year's Day, Thanksgiving and Christmas Day.

Washington

National Portrait Gallery

Smithsonian Institution, Eighth and F Streets NW,
 Washington, D.C. 20560
(202) 357-2700
www.npg.si.edu

Closed for renovations through fall 2004.

PERMANENT COLLECTION

Paintings, sculpture, prints, drawings and photographs of
Americans who contributed to the history and development
of the United States — more than 18,000 works in all.
Highlights: Portrait sculptures by Jo Davidson; Civil War
gallery; one of the last photographs of Abraham Lincoln; the
Hall of Presidents, including portraits of Washington and
Jefferson by Gilbert Stuart. **Architecture:** Old Patent Office
Building by Mills, completed in 1867 by Thomas Ustick
Walter. Current renovations by Hartman-Cox Architects.

The Phillips Collection

1600 21st Street NW, Washington, D.C. 20009–1090
(202) 387-2151; (202) 387-2436
www.phillipscollection.org

2003 EXHIBITIONS

Through January 19
Pierre Bonnard: Early and Late
About 60 works, including paintings, drawings, prints,
photographs, decorative arts and sculpture. (Travels)

February 15–May 11
Margaret Bourke-White: Photography of Design, 1927–1936
Approximately 140 images.

June 7–September 7
Marsden Hartley: American Modernist
A retrospective featuring approximately 90 paintings and 12
drawings, including early impressionist Maine landscapes,
symbolic *Berlin* paintings, the cubistic *Provincetown* series,
landscapes and raw figurative works.

October 4–January 18, 2004

Surrealism and Modernism: Twentieth-Century Masterpieces From the Wadsworth Atheneum Museum of Art
European and American works.

Courtesy of the Phillips Collection.
Margaret Bourke-White, *Industrial Cable*, c. 1930.

PERMANENT COLLECTION

Impressionist paintings by van Gogh, Monet, Degas and Cézanne; works by Vuillard, Bonnard, Braque, Picasso, Matisse and Klee; American works by Homer, Eakins, Ryder, O'Keeffe, Marin, Dove, Rothko, Lawrence and Diebenkorn.
Highlights: Renoir, *Luncheon of the Boating Party.*

Admission: Adults, $7.50; seniors and students, $4; 18 and under, free.
Hours: Tuesday through Saturday, 10 a.m.–5 p.m.; Thursday, until 8:30 p.m.; Sunday, noon–7 p.m. Closed Monday and New Year's Day, Independence Day, Thanksgiving and Christmas Day. Sunday summer hours may differ.

Arthur M. Sackler Gallery

See Freer Gallery of Art and Arthur M. Sackler Gallery

Smithsonian American Art Museum

Eighth and G Streets NW, Washington, D.C.
 20560–0970
(202) 275-1500; (202) 357-2700
www.americanart.si.edu

Washington

The main building is closed for renovations through 2005.
The Renwick Gallery branch (below) remains open.

PERMANENT COLLECTION

The museum is home to the first federal art collection and the
largest collection of American art in the world, with more than
37,500 objects spanning more than 300 years of the nation's
visual heritage. **Architecture:** The museum shares the historic
Old Patent Office Building, a Greek Revival structure
completed in 1867, with the National Portrait Gallery.

The Renwick Gallery of the Smithsonian American Art Museum

Pennsylvania Avenue at 17th Street NW, Washington,
 D.C. 20560-0510
(202) 357-2531; (202) 357-2700
AmericanArt.si.edu

2003 EXHIBITIONS

Through January 19
George Catlin and His Indian Gallery
Some 400 paintings of American Indians that Catlin created
during his travels from 1830 to 1836. A recreation of Catlin's
original Indian Gallery is scheduled to remain on view in the
Grand Salon throughought the year.

March 14–July 20
Light Screens: The Leaded Glass of Frank Lloyd Wright
Nearly 50 windows, including some from private collections
that have never before been shown publicly; drawings;
commissioned architectural models; original plates from
Wright's Wasmuth portfolio; and 60 photographs.

PERMANENT COLLECTION

Works of contemporary American craft in glass, ceramic,
metal, wood and fiber. **Architecture:** 1858 French Second
Empire building by James Renwick. Transferred to the
Smithsonian Institution in 1965 and after renovations
reopened as the Renwick Gallery in 1972, it is located across
the street from the White House.

Admission: Free.

Hours: Daily, 10 a.m.–5:30 p.m. Closed Christmas Day.

Florida

Lowe Art Museum

University of Miami, 1301 Stanford Drive, Coral Gables, Fla. 33124

(305) 284-3535

www.lowemuseum.org

2003 EXHIBITIONS

Through January 19
Florida Visual Arts Fellowships: 25th Anniversary Exhibition

Through February 16
Catalyst: 50 Years of Collecting at the Lowe Art Museum, 1952–2002
Exhibition celebrating the 50th anniversary of Miami-Dade's first visual arts museum.

Through January 19
Artists of Barbizon: The Boone Collection
More than 150 graphics by the circle of artists who worked in the mid-19th century in and around Barbizon, outside Paris.

January 30–April 6
Paridise Lost? Aspects of Latin American Landscape in Art
Works reflecting developments in Latin American landscape painting, works on paper and photography.

March 6–April 27
Invasion, War and Conquest: Cultural Collision in 16th-Century Mexico
Paintings depicting the violent meeting of European and indigenous people in the Americas.

FLORIDA

Coral Gables

April 17–June 1
Cundo Bermudez: A Life in Art
Retrospective of works by the Cuban painter, who will
celebrate his 90th birthday in 2004.

June 12–July 27
The Beginning of Seeing: Adolph Gottlieb and Tribal Art
Explores the connection between Gottlieb's abstract paintings
and African, pre-Columbian and Native American art.

September 18–November 9
A Ceramic Continuum: Fifty Years of the Archie Bray Influence
Some 85 works, from the functional to the sculptural, from
the Archie Bray Foundation, which supports clay artists.

September 18–November 9
Rebecca Hutchinson: Connected
Site-specific installation by a clay artist.

November 20–January 18, 2004
Red Grooms: Selections From the Graphic Work
More than 100 works covering 40 years of printmaking.

PERMANENT COLLECTION

Greco-Roman antiquities; Italian Renaissance and Baroque
art; American and European art from the 17th century
through the 21st century; ancient and Native American art;
African art; Asian art.

Admission: Adults, $5; students, seniors, tours of 10 or more,
$3; school tours, $2; members, UM faculty, employees, stu-
dents with ID, children under 10, free.

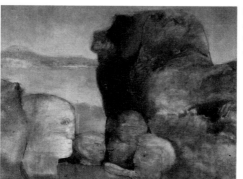

Guillermo Trujillo,
*Perfil y paisaje
(Profile and
Landscape).*

Courtesy of the Lowe Art Museum.

Hours: Tuesday, Wednesday, Friday and Saturday, 10 a.m.–
5 p.m.; Thursday, noon–7 p.m.; Sunday, noon–5 p.m. Closed
Monday, New Year's Day, Thanksgiving, Christmas Day and
other major national holidays.

Museum of Art, Fort Lauderdale

One East Las Olas Boulevard, Fort Lauderdale, Fla. 33301
(954) 525-5500
www.museumofart.org

2003 EXHIBITIONS

Through July
Picasso Ceramics: Revisited
Sixty-five ceramic works done by Picasso between 1947 and
1970.

January 17–March 30
Central American Visionaries
Works by painters from Central America who practice Magical
Realism, a blend of truth and fantasy.

May 2–July 13
The Tumultuous Fifties: Photography From The New York Times
A look at the 1950's through 200 photographs from the news-
paper, including images of Cold War politics, space travel,
Beat poetry and Abstract Expressionism. (Travels)

Continuing
The William Glackens Collection
Works by the American Impressionist drawn from the more
than 500 pieces of his work in the museum's collection.

PERMANENT COLLECTION

More than 5,400 works of 20th-century European and
American art. **Highlights:** Works by Picasso, Calder, Moore,
Dalí and Warhol; the largest collection of CoBrA art (works
from Copenhagen, Brussels and Amsterdam after World War
II) in the United States; new wing providing a permanent

home for the museum's collection of works by the American Impressionist Williams Glackens.

Admission: Adults, $10; seniors, $8; college students and youths 10–18, $6; children under 10, free.
Hours: Tuesday through Saturday, 10 a.m.–5 p.m.; Sunday, noon–5 p.m. Closed Monday and national holidays.

Miami Art Museum

101 West Flagler Street, Miami, Fla. 33130
(305) 375-3000
www.miamiartmuseum.org

2003 EXHIBITIONS

Through January 19
New Work: Teresita Fernandez
Large-scale sculptural environments by a Miami-born artist.

Through April 6
Linking Collection and Community
Overview of the museum's collection six years after its inception.

February 28–June 22
New Work at MAM: Charles LeDray
Small-scale, meticulously handmade sculptures.

March 20–June 1
Shirin Neshat
Five video environments and related photographs.

June 20–September 7
American Tableaux
Explores narrative tradition in American art from the 1920's to the present.

October 3–January 4, 2004
Museums for a New Millennium
Drawings, photographs and models of 25 architecturally significant museums from around the world.

PERMANENT COLLECTION

Paintings, sculpture, installations, works on paper, photographs and mixed-media pieces, including works by Jean Dubuffet, Marcel Duchamp, Adolph Gottlieb, Robert Rauschenberg, Susan Rothenberg and Frank Stella.

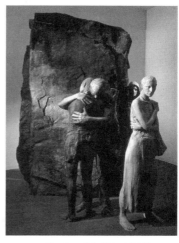

Courtesy of the Miami Art Museum.
George Segal, *Abraham's Farewell to Ishmael*, 1987.

Admission: Adults, $5; students and seniors, $2.50; members and children under 12, free. Free on Sunday and free for families on second Saturday of each month.

Hours: Tuesday through Friday, 10 a.m.–5 p.m.; Saturday and Sunday, noon–5 p.m.; third Thursday of each month, until 9 p.m. Closed Monday.

Bass Museum of Art

2121 Park Avenue, Miami Beach, Fla. 33139
(305) 673-7530
www.bassmuseum.org

2003 EXHIBITIONS

Through January 27
Yayoi Kusama
Sculpture, painting and mixed-media installations by a contemporary artist.

Through April 6
The Making of Miami Beach, 1933–1942: The Architecture of Lawrence Murray Dixon
Architectural renderings and vintage photographs showing

the work of an architect who helped develop the Tropical Art Deco style of Miami Beach.

February 15–May 10
U.S. Design, 1975–2000
Examines architecture, industrial design, graphics and decorative design of the last quarter of the 20th century, featuring works by Robert Venturi, Frank Gehry, Michael Graves, Steven Holl and Maya Lin.

April 19–June 15
Hannalore Baron: Works From 1969–1987
First national tour of the artist's work, featuring about 40 collages and five box assemblages.

PERMANENT COLLECTION

More than 2,000 works, including European art and decorative arts, as well as American, Asian and contemporary art; textiles, tapestries, and ecclesiastical vestments and artifacts; architectural photographs and drawings documenting the history of Miami Beach. **Architecture:** 1930's Mayan-inspired building renovated and expanded in 2000 by Arata Isozaki.

Admission: Adults, $6; seniors and students, $4; children under 6 and members, free.
Hours: Tuesday through Saturday, 10 a.m.–5 p.m.; Thursday, until 9 p.m.; Sunday, 11 a.m.–5 p.m. Closed Monday and federal holidays.

The Wolfsonian

Florida International University, 1001 Washington
 Avenue, Miami Beach, Fla. 33139
(305) 531-1001
www.wolfsonian.org

2003 EXHIBITIONS

Through May 11
From Emperors to Hoi Polloi: Portraits of an Era, 1851–1945
Portraits reflecting the economic, political and social character

of the times, in a broad range of styles and media.

April 26–July 6
Close Up in Black: African-American Film Posters
Examines African-American cinema through the movie poster.

Continuing
Selections From the Wolfsonian Collection
Works from the museum's collection of modern art and design.

PERMANENT COLLECTION

Courtesy of the Wolfsonian.
Profilo continuo del Duce (Continuous profile of Mussolini), 1933, designed by Renato Bertelli.

Art and design from the period 1885–1945, with more than 70,000 objects, predominantly from North America and Europe.

Admission: Adults, $5; seniors, students and ages 6–12, $3.50; members, children under 6, Florida state university system students, faculty and staff, free. Free on Thursday, 6–9 p.m.
Hours: Monday, Tuesday, Friday and Saturday, 11 a.m.–6 p.m.; Thursday, until 9 p.m.; Sunday, noon–5 p.m. Closed Wednesday.

Flagler Museum

Cocoanut Row and Whitehall Way, Palm Beach, Fla. 33480
(561) 655-2833
www.flagler.org

2003 EXHIBITIONS

January 16–April 13
Telling Tales: Classical Images From the Dahesh Museum of Art
Collection of 19th-century paintings depicting mythological events and characters.

Palm Beach

PERMANENT COLLECTION

Original and period fur-
nishings from the Gilded
Age as well as changing
exhibitions of period art
and history. **Architecture:**
Whitehall, 1902 Gilded
Age mansion of Henry
Morrison Flagler.

Admission: Adults, $8;
ages 6–12, $3.
Hours: Tuesday through
Saturday, 10 a.m.–5 p.m.;
Sunday, noon–5 p.m.
Closed Monday, New Year's
Day, Thanksgiving and
Christmas Day.

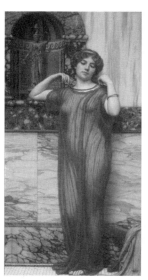

Courtesy of the Flagler Museum/
Dahesh Museum of Art.
John William Godward, *The
Necklace.*

The Society of the Four Arts

2 Four Arts Plaza, Palm Beach, Fla. 33480
(561) 655-7227
www.fourarts.org

PERMANENT COLLECTION

A small collection of paintings and drawings; sculpture gar-
den; a library, a children's library, horticultural gardens, a
gallery building with auditorium.

Admission: Suggested donation for galleries: $3. Libraries
and gardens, free.
Hours: Gallery open December through mid-April only.
Monday through Saturday, 10 a.m.–5 p.m.; Sunday, 2–5 p.m.
Closed major holidays and for brief periods between
exhibitions.

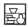

Museum of Fine Arts

255 Beach Drive N.E., St. Petersburg, Fla. 33701
(727) 896-2667
www.fine-arts.org

2003 EXHIBITIONS

Through January 5
Red Grooms: The Complete Graphic Works
A selection of 110 wall pieces and 15 pedestal pieces from the
collection of a high school classmate of the artist.

Through March 9
Robert Doisneau
Works by a 20th-century French photographer.

Through April 27
Artistry in Miniature: Antique Baby Rattles, 1650–1950
Rattles made in a range of materials, including gold, silver,
tin, ivory, coral and crystal.

January 25–March 30
*Drawn Toward the Avant-Garde: 19th and 20th-Century French
Drawings From the Royal Museum of Fine Arts, Copenhagen*
Eighty drawings from 1815 to 1975, including works by
Ingres, Rousseau, Millet, Pissarro, Cézanne, Manet, Degas,
Gauguin, Rodin, Matisse and Picasso.

December 21–February 15, 2004
*African-American Works on Paper From the Wes and Missy Cochran
Collection*
Seventy-five works on paper by 64 artists working since the
1930's, including Romare Bearden, Jacob Lawrence and Faith
Ringgold.

PERMANENT COLLECTION

Eighteenth- and 19th-century European paintings, particu-
larly by the French Impressionists, including Monet,
Gauguin, Renoir and Cézanne; 19th- to mid-20th-century
American art, including works by O'Keeffe; photography;
contemporary graphic works; sculpture; decorative arts,
including Steuben glass; pre-Columbian objects; Asian,
African and American Indian art. **Architecture:** neo-Palladian
design by John Volk & Associates.

St. Petersburg

Admission: Adults, $6; seniors, $5; students, $2; under 6, free.
Hours: Monday through Saturday, 10 a.m.–5 p.m.; Sunday,
1–5 p.m.; the third Thursday of each month (except during
the summer), until 9 p.m. Closed New Year's Day, Martin
Luther King Day, Thanksgiving and Christmas Day.

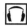 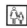 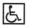

The Salvador Dalí Museum

1000 Third Street South, St. Petersburg, Fla. 33701
(727) 823-3767; (800) 442–DALI
www.salvadordalimuseum.org

2003 EXHIBITIONS

February 1–May 4
The Shape of Color: Joan Miro's Painted Sculpture
Playful sculptures based on found objects, which were cast in
bronze and painted bright colors.

PERMANENT COLLECTION

A comprehensive collection of Salvador Dalí's works spanning
his four artistic periods from 1914 to 1980 in a variety of
media, and changing special exhibits of works by other
Surrealist artists or on related themes.

Admission: Adults, $10; seniors, $7; students, $5; under
10, free.
Hours: Monday through Saturday, 9:30 a.m.–5:30 p.m.;
Thursday, until 8 p.m.; Sunday, noon–5:30 p.m. Closed
Thanksgiving and Christmas Day.

The John and Mable Ringling Museum of Art

5401 Bay Shore Road, Sarasota, Fla. 34243
(941) 359-5700; 941-351-1660 (recording)
www.ringling.org

2003 EXHIBITIONS

Through January 5
Rodin: A Magnificent Obsession
Survey of works by Rodin (1840–1917), including bronzes, drawings, photographs and a documentary about *The Gates of Hell.*

February 1–April 27
Masterpieces of Chinese Ceramics: The Koger Collection
Includes earthenware from China's Neolithic culture in 2500 B.C., T'ang dynasty horses from the eighth century and blue-and-white porcelain of the Ming dynasty.

May 30–August 10
Sacred Treasures: Early Italian Paintings From Southern Collections
About 50 paintings created between 1285 and 1510, including works by Botticelli, Gaddi, Fra Angelico and Rossini. (Travels)

PERMANENT COLLECTION

European Renaissance, Baroque and Rococo art; works by Peter Paul Rubens; antiquities, decorative arts, tapestries, photographs, drawings, prints; modern and contemporary art; circus costumes, wagons and props; circus-related fine art and memorabilia. **Highlights:** Italian Renaissance-style courtyard with full-size sculptural reproductions, including a bronze cast of Michelangelo's *David.* **Architecture:** 1924–26 Venetian Gothic Ringling residence; 1927–29 Renaissance-style villa art museum that was renovated 1989–90.

Admission: Adults, $15; seniors, $12; members and children under 12, free.
Hours: Daily, 10 a.m.–5:30 p.m. Closed New Year's Day, Thanksgiving and Christmas Day.

Tampa

Tampa Museum of Art

600 North Ashley Drive, Tampa, Fla. 33602
(813) 274-8701
www.tampamuseum.org

2003 EXHIBITIONS

Through January 5
Photography's Multiple Roles: Art, Document, Market, Science

Through January 19
Rafael Viñoly: The Tampa Museum of Art Project

Through February 2
I See the Rhythm

January 26–April 27
19th-Century Excursion Photographs From the Permanent Collection

February 2–April 20
Magna Graecia: Greek Art From South Italy and Sicily

May 11–July 6
underCURRENT/overVIEW 7

July 20–October 19
Voices From Our Latino Communities: Highlights From El Museo del Barrio's Permanent Collection

PERMANENT COLLECTION

Twentieth-century and contemporary art; Greek and Roman antiquities. **Architecture:** Construction begins in early 2003 on new building designed by Rafael Viñoly.

Admission: Adults, $5; seniors, $4; students and ages 6–17, $3; children under 6 and members, free. Free on Saturday, 10 a.m.–noon.
Hours: Tuesday through Saturday, 10 a.m.–5 p.m; Sunday, 1–5 p.m. Closed Monday.

Norton Museum of Art

1451 South Olive Avenue, West Palm Beach, Fla. 33401
(561) 832-5196
www.norton.org

2003 EXHIBITIONS

Through January 5
You Look Beautiful Like That: The Portrait Photographs of Seydou Keita and Malick Sidibé
Seventy-two black-and-white portraits taken by two commercial photographers from Mali, Africa, in the period before and after the country's 1960 fight for independence.

January 25–March 23
Fire and Form: The Art of Contemporary Glass
About 100 works by American and European glass artists working in different styles, including works by Dale Chihuly.

February 4–April 27
Picturing French Style: 300 Years of Art and Fashion
Explores the reciprocal influence of art and high fashion, featuring 60 paintings and bronzes as well as 18th-century court costumes and fashions by famous French designers.

April 12–June 15
My Reality: Contemporary Art and the Culture of Japanese Animation
Explores the influence of Japanese animation on art, through 31 works by 18 artists from around the world. (Travels)

PERMANENT COLLECTION

European, American, Chinese and contemporary art, photography and works on paper. Nineteenth- and 20th-century paintings and sculptures by European artists such as Monet, Gauguin, Matisse, Brancusi, Picasso and Miró, and by Americans such as Hassam, Hopper, O'Keeffe, Davis and Pollock.

Admission: Adults, $6; ages 13–21, $2; members and children under 13, free.
Hours: Tuesday through Saturday, 10 a.m.–5 p.m.; Sunday, 1–5 p.m. Closed major holidays.

Georgia

Georgia Museum of Art

University of Georgia, 90 Carlton Street, Athens, Ga.
 30602–6719
(706) 542-4662www.uga.edu/gamuseum

2003 EXHIBITIONS

Through January 5
Sacred Treasures: Early Italian Paintings From Southern Collections
Panel paintings from 1285 through 1510 by Botticelli, Fra
Angelico and others.

Through January 12
Earl McCutchen: Craftsmanship in Ceramics and Glass
Works by a former professor of art at the University of
Georgia.

January 18–March 23
There Is No Eye: Photographs by John Cohen
Some 120 photographs, including images of New York City in
the 1950's, Peru and rural life in the American South.

January 18–March 23
Visualizing the Blues: Images of the American South, 1862–1999
Photographic journey through the history, culture, people and
landscape of the American South.

April 5–June 15
Alfred H. Maurer: American Modern
Works by the modernist artist, including portraits, Fauvist
landscapes and still lifes.

July 3–August 31
*Becoming a Nation: Americana From the Diplomatic Reception
Rooms, U.S. Department of State*
Maps, paintings, prints and decorative arts of the Colonial and
Federal periods.

September–October
*Masters of Their Craft: Highlights From the Smithsonian American
Art Museum*

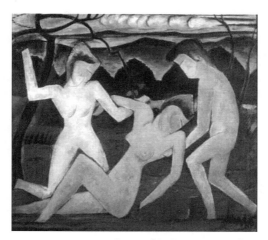

Courtesy of the Georgia Museum of Art.
Man Ray, *Departure of Summer*, 1914.

Fifty-one works in clay, fiber, class, metal and wood reflecting a renaissance in American studio crafts.

October 4–November 30
Conversion to Modernism: The Early Works of Man Ray
Nearly 100 paintings, works on paper and archival documents from 1907 to 1917, providing insight into Man Ray's artistic development.

December–February 2004
Ilonka Karasz
Works from a 50-year career of producing graphic and textile design, interiors and commissioned furniture.

PERMANENT COLLECTION

Paintings by Childe Hassam, Georgia O'Keeffe, Theodore Robinson, Jacob Lawrence, Robert Henri, John Henry Twachtman; decorative arts, with an emphasis on Southern furniture; works on paper.

Admission: Donation requested.
Hours: Tuesday through Saturday, 10 a.m.–5 p.m.; Wednesday, until 9 p.m.; Sunday, 1–5 p.m. Closed Monday.

Atlanta

The Michael C. Carlos Museum

Emory University, 571 South Kilgo Street, Atlanta, Ga. 30322
(404) 727-4282
www.carlos.emory.edu

2003 EXHIBITIONS

Through January 19
Treasures From the Royal Tomb of Ur
More than 200 objects of gold, stone, wood and other prized materials from the excavation at Ur, a third-millennium Sumerian city in Mesopotamia. (Travels)

Through January 26
Mel Bochner: If the Color Changes
Works by a conceptual artist.

February 1–June 1
George Platt Lynes: Ballet Photographs
Photographs by an artist known for his fashion photography and portraits of socialites, celebrities and artists.

May 3–April 2004
Ramses I: Science and the Search for the Lost Pharoah
The story of the pharoah whose empty coffin was recovered from tomb robbers in Egypt.

Opening July 19
Sub-Saharan Art Galleries: New Rotation
Objects primarily from West and Central Africa, including masks, figurative sculpture, pottery and ceremonial weapons.

Continuing
Art of the Americas: The New Galleries
Ceramics, textiles, jewelry and other art from the ancient era through the Colonial period.

PERMANENT COLLECTION

Some 16,000 objects, including art from Egypt, Greece, Rome, the Near East, the Americas, Asia, Africa and Oceania; works on paper from the Middle Ages to the 20th century.
Highlights: Egyptian funerary art, including several coffins

and mummies. **Architecture:** 1916 Beaux-Arts building by
Henry Hornbostel with marble facade and traditional clay tile
roof; major 1993 expansion and all interiors by Michael Graves.

Admission: Suggested donation: $5.
Hours: Tuesday through Saturday, 10 a.m.–5 p.m.; Thursday,
until 9 p.m.; Sunday, noon–5 p.m. Closed Monday and major
holidays.

Atlanta Contemporary Art Center

535 Means Street, Atlanta, Ga. 30318
(404) 688-1970
www.thecontemporary.org

2003 EXHIBITIONS

Through December 23
Face Time
Solo projects investigating the "time" of portraiture and the
relationship between artist and subject.

Through December 23
Nancy Floyd: Time's Relentless Melt
Multimedia installation dealing with memory and
photography.

January 24–March 22
Matinee
Film installations and projections by contemporary French
artists.

April 4–May 31
Atlanta Biennial

Admission: Adults, $3; students, seniors, students, $1; mem-
bers, free.
Hours: Tuesday through Saturday, 11 a.m.–5 p.m. Closed
Sunday and Monday.

Atlanta

High Museum of Art

1280 Peachtree Street NE, Atlanta, Ga. 30309
(404) 733-4444
www.high.org

2003 EXHIBITIONS

Through May 25
For This World and Beyond: African Art From the Fred and Rita Richman Collection
Explores the social and spiritual significance of African objects made for daily use as well as masks and figurative sculptures used to honor and communicate with ancestors.

April 5–June 29
Old Masters, Impressionists and Moderns: French Masterworks From the State Pushkin Museum, Moscow
Seventy-two of the Pushkin Museum's finest paintings, charting the major movements in French art from Classicism to Modernism. (Travels)

November 15–February 8, 2004
After Whistler: The Artist and His Influence on American Painting
First major exhibition to explore how and to what extent Whistler influenced the work of other artists. (Travels)

PERMANENT COLLECTION

Leading museum in the Southeastern United States, featuring African art; 19th- and 20th-century American art; American decorative arts; European art; folk art; modern and contemporary art; photography. **Architecture:** Award-winning design by Richard Meier; expansion designed by Renzo Piano.

Admission: Adults, $8; students and seniors, $6; children 6–17, $4; members and children under 6, free.

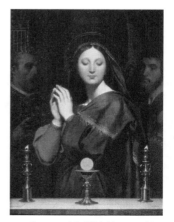

Courtesy of the High Museum of Art.
Jean Auguste Dominique Ingres,
Virgin with Chalice, 1841.

Hours: Tuesday through Saturday, 10 a.m.–5 p.m.; first Thursday of the month, until 8 p.m.; third Friday of the month, until 10 p.m.; Sunday, noon–5 p.m. Closed Monday.

High Museum of Art: Folk Art and Photography Galleries

133 Peachtree Street, (corner of John Wesley Dobbs and
 Peachtree Street at Georgia-Pacific Center,
 downtown), Atlanta, Ga. 30303
(404) 577-6940

2003 EXHIBITIONS

Through January 4
*In Response to Place: Photographs From the Nature Conservancy's
Last Great Places*

Admission: Free.
Hours: Monday through Saturday, 10 a.m.–5 p.m.; first
Thursday of every month, until 9 p.m. Closed Sunday.

Hawaii

The Contemporary Museum

2411 Makiki Heights Drive, Honolulu, Hawaii 96822
(808) 526-1322; (808) 526-0232 (recording)
www.tcmhi.org

2003 EXHIBITIONS

Through January 12
VOICE: A Decade of Work by Lesley Dill
Images and constructions exploring the boundaries between
mind, body and spirit by a New York artist.

Honolulu

January 31–March 30
Surf Culture
Survey of surfboard design from 1900 to the present, as well as a look at the myths and mystique of surfing. (Travels)

April 18–June 15
On Wanting to Grow Horns: The Little Theatre of Tom Knechtel
A 20-year survey of the paintings and drawings of a California artist.

April 18–June 15
Recent Work by Tony Berlant
Metal collages by a Los Angeles artist that incorporate found objects.

June 27–August 31
Sixth Biennial of Hawai`i Artists

Summer 2003
Patrick Dougherty Installation

September 19–November 16
Crossings 2003: Korea/Hawaii
Works by about 30 contemporary Korean artists to mark the 100th anniversary of Korean immigration to the United States.

December 5–January 25, 2004
Celebrating Fifteen Years: Works by Artists of Hawai`i From The Contemporary Museum's Collection

The Contemporary Museum at First Hawaiian Center

999 Bishop Street, Honolulu, Hawaii 96813

2003 EXHIBITIONS

Through February 4
Recent Work by David Kuraoka
Recent ceramic and bronze forms by a Hawaii-born artist.

Through February 4
Recent Paintings by Mary Mitsuda
Works in acrylic on canvas by a Hawaii-born artist.

Through February 4
Recent Work by Gaye Chan

Altered photographs based on found negatives made by
Hawaii photographers from the 1940's to 1970's.

February 14–May 13
*Paintings by Carl Jennings, Elizabeth Knoke-Dieckvoss and Birgitta
Leitner*

May 23–September 23
Volcanoes: Paintings and Prints by Louis Pohl

October 3–January 6, 2004
*Contemporary Korean-American Artists of Hawai`i: Recent Work by
Sean Browne and Photographs by Elaine Mayes*

PERMANENT COLLECTION

Some 1,900 works since 1940 by Robert Motherwell, Andy
Warhol, Josef Albers, Louise Nevelson, Jim Dine, Jasper
Johns, William Wegman and others. **Highlights:** David
Hockney's walk-in environment inspired by Ravel's opera
L'Enfant et les Sortilèges. **Architecture:** Former home of Alice
Cooke Spalding, built in the 1920's and most recently reno-
vated in 1988.

Admission: Makiki Galleries, adults, $5; students and seniors,
$3; 12 and under, free. TCM at First Hawaiian Center, free.
Hours: Makiki Galleries: Tuesday through Saturday, 10 a.m.–
4 p.m.; Sunday, noon–4 p.m. Closed Monday and major holi-
days. TCM at First Hawaiian Center: Monday through
Thursday, 8:30 a.m.–4 p.m.; Friday, until 6 p.m. Closed week-
ends and holidays.

The Honolulu Academy of Arts

900 South Beretania Street, Honolulu, Hawaii 96814
(808) 532-8700; (808) 532-8701 (recording)
www.honoluluacademy.org

2003 EXHIBITIONS

January 15–December 31
Grandfather's House: A Children's Exhibition on Korea
A simulated village home in Korea with typical furnishings.

Honolulu

February 13–March 16
100th Anniversary of Korean Immigration to Hawaii
An exhibition sponsored by the Korean Artists Society.

February 13–April 13
Sidney Yee: Recent Works
New works by a Maui painter.

March 13–May 4
Honolulu Printmakers: A 75th Anniversary Celebration
Works by members of Honolulu Printmakers.

April 17–June 29
Vertical Landscapes
Works by the Italy-based painter Filippo Marignoli, who lived in Hawaii for a time.

June 5–August 3
Artists of Hawaii 2003
An annual multimedia juried exhibition.

July 3–August 31
Gaye Chan

September 11–November 9
Crossings: Korea 2003
Works by contemporary Korean artists.

September 11–November 16
Komelia Okim

September 18–January 4, 2004
Brett Weston in Hawaii
Collection of photographs.

Opening in October
Korean Centennial Exhibition
About 60 works of textile art from the Museum of Korean Embroidery in Seoul.

November 20–January 11, 2004
Photography Invitational

December 4–January 11, 2004
Pierce Collection Exhibition
Photographs from the collection.

PERMANENT COLLECTION

Asian art; American paintings and decorative arts from the Colonial period to the present; works from Africa, Oceania,

the Americas; contemporary graphic arts; Hawaiian art.
Highlights: The James A. Michener collection of 5,400
Japanese Ukiyo-E prints, with the largest single grouping of
prints in the world by Utagawa Hiroshige; the Samuel H.
Kress Foundation collection of Italian Renaissance paintings;
Hawaiian Collection, chronicling the history of art in Hawaii.
Architecture: 1927 building by Bertram Goodhue; Luce
Pavilion Complex added in 2001.

Branch: The Academy Art Center, 1111 Victoria Street (across
the street from the academy), with free exhibitions by local
contemporary artists.

Admission: Adults, $7; students, seniors and military, $4;
children under 13, free. Free on first Wednesday of the month.
Hours: Tuesday through Saturday, 10 a.m.–4:30 p.m.;
Sunday, 1–5 p.m. Closed Monday, New Year's Day,
Independence Day, Thanksgiving and Christmas Day.

Idaho

Boise Art Museum

670 South Julia Davis Drive, Boise, Idaho 83702
(208) 345-8330
www.boiseartmuseum.org

2003 EXHIBITIONS
Through February 16
Gary Hill
Video installations dealing with the relationship between
images, language and consciousness.

Through June 29
Patrick Dougherty
Mammoth environmental sculptures weaving branches and
twigs by a North Carolina artist.

March 8–June 29
In the Fullness of Time: Masterpieces of Egyptian Art From American Collections
Explores Egyptian art over 3,500 years, including sculptural reliefs of Queen Nefertiti and King Akhenaten, the gold signet ring of Ramses IV and terra cotta pottery.

PERMANENT COLLECTION

Some 2,000 works focusing on 20th-century American art, especially artists of the Pacific Northwest, American Realism and ceramics. **Architecture:** Expansion in 1997 added 13,500 square feet, including a 2,800-square-foot interior sculpture court and 16 new galleries.

Admission: Adults, $5; college students and seniors, $3; grades K through 12, $1; children under 6 and members, free. Free on first Thursday of the month.
Hours: Tuesday through Friday, 10 a.m.–5 p.m.; Saturday and Sunday, noon–5 p.m. Closed Monday, except June through August.

Illinois

The Art Institute of Chicago

111 South Michigan Avenue, Chicago, Ill. 60603
(312) 443-3600
www.artic.edu

2003 EXHIBITIONS

Through February 2
The Medici, Michelangelo and the Art of Late Renaissance Florence
More than 200 rarely loaned works created between 1537 and 1631, telling the story of Florence's ruling family, Michelangelo's legacy and the artistic culture they inspired.

February 1–May 27
African American Art in the Art Institute of Chicago
More than 100 works by African-American artists, from
1800 to the present.

March 29–July 27
Himalayas: An Aesthetic Adventure
First major exhibition of art from the entire Himalayan
region, featuring about 185 works of mostly religious art
created between the fifth and 19th centuries.

April–August
Nazi Art Looting and Its Legacy
Explores the issues and implications of Nazi art looting for
museums today to mark Holocaust Remembrance Month.

June 28–September 21
*Chicago: Window on the West — Artists and Patrons of the New
Frontier, 1890–1940*
Some 80 paintings, sculptures, decorative arts and works on
paper from the museum and other regional collections,
examining patronage over this 50-year period.

August 2–February 8, 2004
*Aerospace Design: The Art of Engineering From NASA's
Aeronautical Research*
About 90 artifacts from NASA's collection, featuring the
rchitecture and engineering of wind tunnels and airplanes.

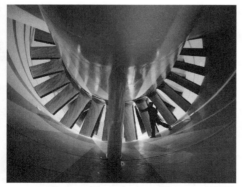

Courtesy of the Art Institute of Chicago and NASA.
Rehabilitation of the Fan Blades in the 16-foot
Transonic Wind Tunnel, Langley, Virginia.

Chicago

PERMANENT COLLECTION

A collection spanning 50 centuries includes everything from ancient Chinese bronzes to African wood carvings, textiles and photographs. Noteworthy are an acclaimed collection of Impressionist and Post-Impressionist paintings, an extensive collection of 20th-century European and American art and the Thorne Miniature Rooms. **Highlights:** Georges Seurat, *Sunday on La Grande Jatte;* Edward Hopper, *Nighthawks*; Grant Wood, *American Gothic.*

Admission: Suggested donation: adults, $10; children, students and seniors, $6. Free on Tuesday, except for certain special exhibitions.

Hours: Monday through Friday, 10:30 a.m.–4:30 p.m.; Tuesday, until 8 p.m.; Saturday and Sunday, 10 a.m.–5 p.m. Closed Thanksgiving and Christmas Day.

Museum of Contemporary Art

220 East Chicago Avenue, Chicago, Ill. 60611
(312) 280-2660
www.mcachicago.org

2003 EXHIBITIONS

February 22–June 2
Hiroshi Sugimoto
Photographs by the Tokyo-born artist known for his long-exposure series.

May 3–August 23
John Currin
About 30 recent paintings by the artist.

May 3–August 31
Paul Pfeiffer
Video and sculptural works challenging the role of media images in defining community.

Opening in June
Thomas Struth: Picturing the World
Survey of the artist's work. (Travels)

Opening in October
Kerry James Marshall
New paintings, sculptures, photograpy and video by the
Chicago-based artist, reflecting black history and culture.

PERMANENT COLLECTION

Painting, sculpture, photography, video, film and performance
art created since 1945, including Minimalism, post-
Minimalism, Conceptualism and Surrealism as well as works
by Chicago-based artists.

Admission: Adults, $10; students and seniors, $6; members
and children 12 and under, free. Free on Tuesday.
Hours: Tuesday, 10 a.m.–8 p.m.; Wednesday through Sunday,
10 a.m.–5 p.m. Closed Monday, New Year's Day,
Thanksgiving and Christmas Day.

Terra Museum of American Art

664 North Michigan Avenue, Chicago, Ill. 60611
(312) 664-3939
www.terramuseum.org

2003 EXHIBITIONS

Through March 2
*A Place on the Avenue: Terra Museum of American Art Celebrates
15 Years in Chicago*
Works collected by the museum's founder, Daniel J. Terra,
who had a passion for American art, assembling works by
Cassatt, Homer, Prendergast, Whistler and others.

August 30–November 30
*Debating American Modernism: Stieglitz, Duchamp and the New
York Avant Garde*
Explores the artistic debate among American modernists in
New York in the early 20th century. (Travels)

October 4–January 11, 2004
Leaving for the Country: George Bellow at Woodstock
First exhibition to focus on the artist's work while spending

part of the year in Woodstock, N.Y., from 1920 to 1924, a period that saw significant changes in his palette and style.

December 13–February 8, 2004
The Tumultuous Fifties: A View From the New York Times Photo Archive
Prints from the 1950's, whose subjects include McCarthyism, space travel, civil rights, Cold War politics and Beat poetry. (Travels)

PERMANENT COLLECTION

Founded by Daniel J. Terra in 1980, the museum offers works by Mary Cassatt, Winslow Homer, Maurice Brazil Prendergast, John Singer Sargent, James A. McNeill Whistler and others.

Admission: Free. Suggested donation of $5.
Hours: Tuesday through Saturday, 10 a.m.–6 p.m.; Tuesday, until 8 p.m.; Sunday, noon–5 p.m. Closed Monday.

Indiana

Indianapolis Museum of Art

1200 West 38th Street, Indianapolis, Ind. 46208
(317) 923-1331; (317) 920-2660 (recording)
www.ima-art.org

2003 EXHIBITIONS

Through February 23
The Print in the North: The Age of Albrecht Dürer and Lucas van Leyden
More than 80 engravings, etchings and woodcuts by Renaissance artists from Germany and the Netherlands.

May 11–August 3
In Response to Place: Photographs From the Nature Conservancy's Last Great Places

PERMANENT COLLECTION

American, African, Asian, European, contemporary and decorative art. **Highlights:** J.M.W. Turner Collection of watercolors and drawings; Gauguin and the School of Pont-Aven; neo-Impressionists; Japanese Edo period paintings; Clowes Collection of Old Master works.

Admission: Free; suggested donation for special exhibitions.
Hours: Tuesday through Saturday, 10 a.m.–5 p.m.; Thursday, until 8:30 p.m.; Sunday, noon–5 p.m. Closed Monday and major holidays.

Iowa

Davenport Museum of Art

1737 West 12th Street, Davenport, Iowa 52804
(563) 326-7804
www.art-dma.org

2003 EXHIBITIONS

Through April 6
The American Experience
Works on American themes, including exploration, urban expansion, industry, the "melting pot," holidays, ethnicity and the Native American experience.

April 26–July 6
Girl Culture: A Photographic Essay by Lauren Greenfield
Fifty photographs looking at the self-esteem crisis among girls through a look at what they do, think about and dream about.

July 26–September 21
2003 Bi-State Biennial Exhibition
Showcase for artists from Iowa and Illinois.

October 11–December 7
Walker Evans & James Agee: Let Us Now Praise Famous Men
Collaboration by the photographer and writer in which they

lived with a sharecropper family, documenting their lives. (Travels)

PERMANENT COLLECTION

Regional, national and international art from the 15th century to the present. Works by Grant Wood; one of the largest collections of Mexican colonial art and Haitian art.

Admission: Free.
Hours: Tuesday through Saturday, 10 a.m.–4:30 p.m.; Sunday, 1–4:30 p.m.

Des Moines Art Center

4700 Grand Avenue, Des Moines, Iowa 50312
(515) 277-4405
www.desmoinesartcenter.org

2003 EXHIBITIONS

Through January 12
Iowa Artists 2002
Yearly exhibition surveying the work of Iowa artists.

Through April 27
John Currin
First major solo exhibition of works by this contemporary American artist.

February 1–April 20
Magic Markers: Contemporary Constructed Objects
Works by Robert Gober, David Hammons, Robert Rauschenberg, Richard Tuttle and others, including Indian, Asian, African and aboriginal artists.

May 10–August 3
Debating American Modernism: Stieglitz, Duchamp and the New York Avant Garde
Eighty paintings, sculptures, photographs and drawings representing two rival schools: artists associated with Stieglitz who believed nature could revive the visual culture and

another camp that included Duchamp and Picabia that touted modern machinery and a more theoretical approach.

August 16–October 19
Mirror Stages: Modern Identity in Sports and Spectacle
Contemporary art exploring human identity through sports and spectacle.

November 1–January 17, 2004
Graciela Iturbide: Images of the Spirit
Photographs by a Mexican artist.

PERMANENT COLLECTION

Paintings and sculptures by Bacon, Brancusi, Cassatt, Dubuffet, Johns, Koons, Moore, Rodin, Oldenburg, Serra and Stella. **Architecture:** Three interconnected buildings designed by Eliel Saarinen, I. M. Pei and Richard Meier.

Admission: Free.
Hours: Tuesday through Saturday, 11 a.m.–4 p.m.; Thursday, until 9 p.m.; first Friday of each month, until 9 p.m.; Sunday, noon–4 p.m. Closed Monday.

Kansas

Spencer Museum of Art

University of Kansas, 1301 Mississippi Street, Lawrence, Kan. 66045
(785) 864-4710
www.ukans.edu/~sma

2003 EXHIBITIONS

Through March 15
Innovation/Imagination: Fifty Years of Polaroid Photography
Examines half a century of creative expression using a range of Polaroid materials. (Travels)

KANSAS

Lawrence

Spring 2003
*Spencer Museum of Art Celebrates
25 Years*
Exhibition of acquisitions over
the past 25 years, as well as
documentation of the history
and growth of the museum.

April 12–July 6
*Defining Craft I: Collecting for
the New Millennium*
Some 175 works in glass, clay,
metal, fiber and wood that
explore the changing meanings
of craft today. (Travels)

Late Spring 2003
Inspired by Japan
Some 50 American and
European works on paper
together with examples of Japanese ukiyoe color woodcut
prints that inspired many modern Western artists.

Courtesy of the Spencer Museum of Art.
Wendell Castle, *Music Rack*, 1964.

August 16–October 26
*The Orchid Pavilion Gathering: Masterpieces of Chinese Painting
From the University of Michigan Museum of Art*
Sixty works of Chinese painting from the 12th to the 20th
century, including rare works from the Ming and Qing
dynasties.

PERMANENT COLLECTION

American and European painting and sculpture; Edo period
(1615–1868) Japanese paintings; Korean ceramics; Japanese
prints; contemporary Chinese painting. **Highlights:** Homer,
Cloud Shadows; Kandinsky, *Kleine Welten VI*; Rossetti, *La Pia
de'Tolommei;* Fragonard, *Portrait of a Young Boy*; Benton, *The
Ballad of the Jealous Lover of Lone Green Valley.*

Admission: Free; $3 donation suggested.
Hours: Tuesday through Saturday, 10 a.m.–5 p.m.; Thursday,
until 9 p.m.; Sunday, noon–5 p.m. Closed Monday, New Year's
Day, Independence Day, Thanksgiving and Christmas Day.

The Wichita Art Museum

619 Stackman Drive, Wichita, Kan. 67203
(316) 268-4921
www.wichitaartmuseum.org

The museum will reopen in early 2003 upon completion of a
major expansion project.

PERMANENT COLLECTION

American art from Colonial times to the present. *An American
Homecoming,* an exhibition from the collection, presents 130
works in nine thematic sections, including pieces by Copley,
Eakins, Remington, O'Keeffe and Nevelson. **Highlights:**
Edward Hopper, *Sunlight on Brownstones;* Mary Cassatt, *Mother
and Child;* Winslow Homer, *In the Mowing*; Arthur Dove,
Noon; the John W. and Mildred L. Graves Collection of
American Impressionism; the M. C. Naftzger Collection of
works by Charles M. Russell. **Architecture:** Designed by
Edward Larrabee Barnes in 1977.

Admission: Free.
Hours: Tuesday through Saturday, 10 a.m.–5 p.m.; Sunday,
noon–5 p.m. Closed Monday.

Kentucky

The University of Kentucky Art Museum

Rose Street and Euclid Avenue, Lexington, Ky. 40506
(859) 257-5716
www.uky.edu/ArtMuseum

2003 EXHIBITIONS
Through March 9
University of Kentucky Art Department Faculty Exhibition

April 6–June 29
The Crow Collection of Asian Art
Objects made of jade, ivory, bronze, glass and semiprecious
stones, including carved boxes, vessels, figurines, wall panels
and shrines.

PERMANENT COLLECTION

Comprising over 3,500 objects, including Old Masters and
contemporary painting, as well as extensive regional holdings;
print collection; photography; art of Africa, the Americas and
Asia, and decorative and folk arts. **Highlights:** American
Impressionist and Pont-Aven school painters; Proskauer
bequest art glass.

Admission: Free.
Hours: Tuesday through Sunday, noon–5 p.m.; Friday, until 8
p.m. Closed Monday and university holidays.

The Speed Art Museum

2035 South Third Street, Louisville, Ky. 40208
(502) 634-2700
www.speedmuseum.org

2003 EXHIBITIONS

Through February 2
*Millet to Matisse: 19th- and 20th-Century French Painting From
Kelvingrove Art Gallery*
Sixty-four paintings, most rarely seen outside Scotland, sur-
veying major developments in French painting and featuring
works by Millet, Corot, Picasso, Monet, Renoir, Dufy, Matisse
and others.

April 15–June 29
The Light Within: Glass Sculpture From the Louisville Collections
Diverse, international group of glass sculptures, from monu-
mental works to small-scale works.

Fall 2003
The Lithographs of James McNeill Whistler From the Collection of Steven Block
Some 86 works executed between 1878 and 1903 by an artist better known for his portraits but who was an accomplished printmaker.

December 16–March 14, 2004
Calico & Chintz: Early American Quilts From the Smithsonian American Art Museum
Pieced, appliquéd and whole-cloth quilts created from 1818 to 1850 by American women.

PERMANENT COLLECTION

More than 8,000 pieces spanning 6,000 years, ranging from ancient Egyptian to contemporary art. Includes 17th-century Dutch and Flemish painting; 18th-century French art; Renaissance and Baroque tapestries; African and Native American works.

Admission: Free.
Hours: Tuesday through Friday, 10:30 a.m.–4 p.m.; Thursday, until 8 p.m.; Saturday, 10:30 a.m.–5 p.m.; Sunday, noon–5 p.m. Closed Monday.

Louisiana

New Orleans Museum of Art

City Park, 1 Collins Diboll Circle, New Orleans,
 La. 70179
(504) 488-2631
www.noma.org

2003 EXHIBITIONS

Through January 12
Raised to the Trade: Creole Building Arts of New Orleans
Recordings of oral histories, architectural drawings,

photographs and paintings telling the story of the
contributions of ethnic craftsmen to New Orleans buildings.

February 1–March 30
Frederich J. Brown: Portraits in Jazz, Blues and Other Icons
Forty paintings, including portraits of Ornette Coleman and
Thelonius Monk, influenced by German Expressionism and
African art.

April 12–August 31
*Louisiana Purchase Bicentennial Celebration: Jefferson's America and
Napoleon's France*
Major works of art created in the early 1800's when Jefferson
and Napoleon were in power.

October 19–February 25, 2004
The Quest for Immortality: Treasures of Ancient Egypt
About 115 objects from Egypt, the largest selection ever
loaned for exhibition in North America.

PERMANENT COLLECTION

European painting and sculpture from 16th century to present;
American painting and sculpture from 18th century to present;
European and American decorative arts, including the nation's
sixth-largest collection of glass; Asian art, particularly Japanese
painting from the Edo period (1615–1868); ethnographic art,
including African, Oceanic, pre-Columbian and Native
American photography. **Highlights:** Degas, *Portrait of Estelle
Muson Degas*; works by other Impressionists, including Monet,

Louisiana Purchase cover,
National Archives.

Courtesy of the New Orleans Museum of Art.

Renoir and Cassatt; Fabergé Imperial Easter eggs and the bejeweled Imperial Lilies of the Valley Basket; Vigée-Lebrun, *Marie Antoinette, Queen of France*. **Architecture:** 1911 Beaux-Arts structure by Samuel Marx in a 1,500-acre city park.

Admission: Adults, $6; seniors, $5; ages 3–17, $3.
Hours: Tuesday through Sunday, 10 a.m.–5 p.m. Closed Monday and legal holidays.

Maine

Bowdoin College Museum of Art

9400 College Station, Brunswick, Me. 04011
(207) 725-3275
academic.bowdoin.edu/artmuseum

2003 EXHIBITIONS

April 10–June 8
Power of Thought: The Prints of Jessie Oonark
Prints by a Canadian Inuit artist. (Travels)

PERMANENT COLLECTION

Portraits by Gilbert Stuart, Robert Feke and others; American landscape paintings; antiquities from the Mediterranean; European paintings; works on paper. **Architecture:** 1894 building by McKim, Mead and White.

Admission: Free.
Hours: Tuesday through Saturday, 10 a.m.–5 p.m.; Sunday, 2–5 p.m. Closed Monday and national holidays.

Portland

Portland Museum of Art

7 Congress Square, Portland, Me. 04101
(207) 775-6148; (207) 773–ARTS (recording); (800)
 639-4067
www.portlandmuseum.org

2003 EXHIBITIONS

April 10–June 1
2003 Portland Museum of Art Biennial
Works by emerging and established Maine artists.

June 19–September 7
Fairfield Porter: A Life in the Art, 1907–1975
Works by a 20th-century painter who produced realist works
in the midst of Abstract Expressionism.

June 28–October 19
Edward Weston: Life Work
Survey of five decades of work by this American artist.

PERMANENT COLLECTION

Decorative and fine arts from the 18th century to the present.
Includes the Joan Whitney Payson Collection, with works by
Degas, Monet, Picasso, Renoir and others, and the American
Galleries, with works by Hartley, Homer and Wyeth.

Courtesy of the Portland Museum of Art.
Sebastiao Salgado, *Church Gate Station*, Bombay, India, 1995.

Architecture: Built in 1983 and designed by Henry N. Cobb of I. M. Pei & Partners.

Admission: Adults, $8; seniors and students with ID, $6; ages 6–17, $2; children under 6, free. Free on Friday, 5–9 p.m.
Hours: Tuesday through Sunday, 10 a.m.–5 p.m.; Thursday and Friday, until 9 p.m.; Monday from Memorial Day through Columbus Day, 10 a.m.–5 p.m.

Farnsworth Art Museum

16 Museum Street, Rockland, Me. 04843
(207) 596-6457
www.farnsworthmuseum.org

2003 EXHIBITIONS

Through January 5
Capturing Nureyev: James Wyeth Paints the Dancer
Paintings and drawings of Nureyev.

Through January 19
Leonard Baskin
Sculpture and works on paper by Baskin (1922–2000), who was a summer resident of Maine.

Through April 27
N.C. Wyeth: Landscapes and Illustrations
Works from the museum's collection exploring two aspects of the artist's career.

January 19–May 11
Selections From the Ogunquit Museum
Works from the museum in Ogunquit, Maine, where an art colony thrived in the late 19th and early 20th centuries.

August 3–November 2
The Lucid Mark: 15 Years of Painting by Dennis Pinnette
Paintings of industrial plants as well as landscapes.

November 9–December 28
Winslow Homer the Illustrator: His Wood Engravings, 1857–1888
Some 145 engravings reflecting the spirit of the American people before, during and after the Civil War.

Continuing
Maine in America: Selections From the Permanent Collection
Works of American art, with an emphasis on those related to Maine.

PERMANENT COLLECTION

Works by Stuart, Sully, Eakins, Lane, Eastman Johnson; American Impressionists, including Benson, Hassam, Prendergast and Twachtman; works by N. C., Andrew and Jamie Wyeth in the Wyeth Center; a large collection of works by Louise Nevelson on view in the Nevelson-Berliawsky Gallery. **Architecture:** The museum complex includes the adjacent Farnsworth family homestead, a preserved 19th-century Victorian residence, and the historic Olson House in nearby Cushing.

Admission: Adults, $9; seniors, $8; students, $5; children under 17 and Rockland residents, free. There is a $1 discount for all during the winter. There is an additional charge for the Olson House.

Hours: Museum and Wyeth Center, daily, 9 a.m.–5 p.m. Homestead, daily, 10 a.m.–noon and 1–4 p.m. Olson House, daily, 11 a.m.–4 p.m. During the winter, the museum and Wyeth Center have shortened hours and the homestead and Olson House are closed.

Maryland

American Visionary Art Museum

800 Key Highway, Baltimore, Md. 21230
(410) 244-1900
www.avam.org

2003 EXHIBITIONS

Through May 4
Gems of the Permanent Collection
Sixteen works by nine self-taught artists, including several works by institutionalized artists.

Through September 1
High on Life: Transcending Addiction
Works by artists who have struggled with addiction, including tiny embroidered works by Ray Materson tracing his transformation from drug addict to drug counselor.

PERMANENT COLLECTION

More than 4,000 works by self-taught artists, including *Giant Whirligig*, a large outdoor sculpture by Vollis Simpson, a 76-year-old mechanic, farmer and visionary artist.

Admission: Adults, $8; children, seniors and students, $6.
Hours: Tuesday through Sunday, 10 a.m.–6 p.m. Closed Monday, Thanksgiving and Christmas Day.

The Baltimore Museum of Art

10 Art Museum Drive, Baltimore, Md. 21218
(410) 396-7100
www.artbma.org

2003 EXHIBITIONS

Through January 5
Painted Prints: The Revelation of Color in Northern Renaissance & Baroque Engravings, Etchings & Woodcuts
First major exhibition of hand-colored Renaissance and Baroque prints, featuring more than 100 works, including ones by Dürer and Brueghel. (Travels)

Through January 13
Radio City and a Century of Progress: 1930's American Modernism
An Art Deco wall covering from Radio City Music Hall.

Baltimore

Through February 16
Tom Miller
Brightly colored furniture reconstructed and painted by a Baltimore artist.

Through May 25
Parallel Tracks: The History of Photography in Two Brief Installments
More than 70 works chronicling how the classification of the art form into "studio" and "street" work has shaped our understanding and misunderstanding of the medium.

Through May 25
Common Places: Contemporary Photography From Germany and Northern Europe
Buildings, street corners, domestic interiors and other familiar places are the subject of these 20th-century photographs.

February 12–May 4
Art of the Ballets Russes
Lavish stage and costume designs, works of art, theatrical lighting and music associated with Ballets Russe.

February 12–May 4
The Ballets Russes in Baltimore: Designs of Leon Bakst
A theater set by the Russian painter and stage designer, who visited Baltimore in 1922–23 and created a theater at Evergreen House.

February 26–June 8
The Art and Music of Gregor Piatigorsky
Items from the personal art collection of a renowned cellist, including works by Picasso, Klee and Soutine.

April 9–September 20
William Morris: The Reactionary Revolutionary
Fifteen bold cotton prints and intricate woven woolens by the founder of the Arts & Crafts Movement.

PERMANENT COLLECTION

More than 85,000 objects, ranging from ancient mosaics to contemporary art. The Cone Collection of Modern Art features 500 works by Matisse and major examples by Picasso, Cézanne, van Gogh and others; contemporary art; arts of Africa; Old Master paintings and sculpture; European and American decorative arts, textiles and works on paper from the Renaissance to the present. **Architecture:** 1929 building

and 1937 addition by John Russell Pope; two outdoor sculpture gardens; 1994 West Wing by Bower Lewis Thrower.

Admission: Adults, $7; seniors and students, $5; members and ages 18 and under, free. First Thursday of each month, free.
Hours: Wednesday through Friday, 11 a.m.–5 p.m.; Saturday and Sunday, 11 a.m.–6 p.m.; first Thursday of every month, until 9 p.m. Closed Monday and Tuesday, New Year's Day, Independence Day, Thanksgiving and Christmas Day.

The Walters Art Museum

600 North Charles Street, Baltimore, Md. 21201
(410) 547-9000
www.thewalters.org

2003 EXHIBITIONS

Through September 30
Everyday Life and Love in Dutch and Flemish Painting of the 17th Century
Exhibition of 22 Dutch and Flemish paintings.

September 21–January 18, 2004
Eternal Egypt: Masterworks of Ancient Art From the British Museum

PERMANENT COLLECTION

Collection spanning 55 centuries, from ancient Egyptian art through 19th-century European art. Ancient and medieval art, manuscripts and rare books, decorative objects, Asian art, Old Master and 19th-century paintings.

Courtesy of Walters Art Museum
Faberge, *Polar Bear.*

Admission: Adults, $8; senior citizens, $6; ages 18–25, $5; ages 17 and under, free.
Hours: Tuesday through Sunday, 10 a.m.–5 p.m. Closed Monday.

Massachusetts

Addison Gallery of American Art

Phillips Academy, Andover, Mass. 01810
(978) 749-4015
www.addisongallery.org

2003 EXHIBITIONS

Through January 5
Trisha Brown: Dance and Art in Dialogue, 1961–2000

PERMANENT COLLECTION

More than 12,000 works, including pieces by Stuart, Copley, Eakins, Homer, Whistler, Sargent, Twatchman, O'Keeffe and Stella, as well as extensive photographic holdings.

Admission: Free.
Hours: Tuesday through Saturday, 10 a.m.–5 p.m.; Sunday, 1–5 p.m. Closed Monday, federal holidays and the month of August.

The Institute of Contemporary Art

955 Boylston Street, Boston, Mass. 02115
(617) 266-5152
www.icaboston.org

2003 EXHIBITIONS

January 22–April 27
Carsten Holler
Works by an artist whose light installations, interactive playground slides and sculptures explore the theme of doubt.

January 22–April 27
Diller + Scofidio

Drawings and models of the architect's design for a new Institute of Contemporary Art, scheduled to open in 2005.

May 14–August 31
Art, Healing and Transformation
Works by 13 international contemporary artists who explore the role of ritual, narrative and movement to promote healing.

PERMANENT COLLECTION

None. For more than 65 years the ICA has presented exhibitions by national and international contemporary artists.

Admission: Adults, $7; seniors and students, $5; children under 12, free. Free on Thursday after 5 p.m.
Hours: Wednesday and Friday, noon–5 p.m.; Thursday, noon–9 p.m.; Saturday and Sunday, 11 a.m.–5 p.m. Closed Monday, Tuesday, major holidays and for two weeks between exhibitions.

Isabella Stewart Gardner Museum

280 The Fenway, Boston, Mass. 02115
(617) 566-1401
www.gardnermuseum.org

In 2003 the museum will hold exhibitions and programs to mark its centennial.

2003 EXHIBITIONS

January 24–April 6
Joseph Kosuth, Conceptual Artist
Juxtaposes text and images from the museum's archives dealing with the artist James Whistler, the art adviser Bernard Berenson and the art collector Isabella Stewart Gardner.

April 22–August 21
Centennial Exhibition: The Making of a Museum — Isabella Stewart Gardner as Collector, Architect and Designer
Photographs and artifacts chronicling the realization of Gardner's vision and the creation of the museum 100 years ago.

Boston

April 26–May 10
Elaine Reichek: Virtual Exhibition, Adam and Eve
Twenty embroideries depicting scenes from the story of Adam and Eve.

August 27–September 11
Boston Drawing Project: Special Exhibition
Some 150 drawings in a range of media from the Boston Drawing Project, an effort to support artists working on paper.

October 8–January 11, 2004
Art, Banking and Power in the Renaissance: Bindo Altoviti as Patron
Examines the distinct artistic visions of the Renaissance artists Cellini and Raphael to the banker and patron Bindo Altoviti.

PERMANENT COLLECTION

More than 2,500 objects spanning 30 centuries and representing many cultures. Works by Titian, Botticelli, Raphael, Rembrandt, Matisse, Sargent and Whistler. **Highlights:** Titian, *Europa*; Botticelli, *Madonna and Child of the Eucharist* and *Tragedy of Lucretia*; Giotto, *Presentation of the Child Jesus at the Temple*; Raphael, *Pietà*; a 1629 Rembrandt self-portrait. **Architecture:** Built from 1899 to 1902 in the style of a 15th-century Venetian palace, the museum centers on an interior courtyard filled with sculpture and flowering plants and trees.

Admission: Adults, $10 ($11 on weekends); seniors, $7; college students, $5; members and children under 18, free.
Hours: Tuesday through Sunday, 11 a.m.–5 p.m. Closed Monday, Thanksgiving Day and Christmas Day.

Museum of Fine Arts, Boston

Avenue of the Arts, 465 Huntington Avenue, Boston,
 Mass. 02115
(617) 267-9300
www.mfa.org

2003 EXHIBITIONS

Opening December 2002
RSVP: Sarah Sze
Installation by an artist known for grand sculptures
constructed of found objects.

Through February 2
The Photographs of Charles Sheeler: American Modernist
About 140 works done between 1925 and the 1950's.

Through April 13
Impressions of Light: The French Landscape From Corot to Monet
More than 80 paintings and 70 works on paper by Monet,
Renoir, Degas and their contemporaries, as well as by artists
before and after who inspired or were inspired by them.

May 14–August 10
Portraiture
Familiar and unfamiliar works from the permanent collection.

June 15–September 14
Thomas Gainsborough
Explores the full range of the 18th-century English artist's
work, including his innovations in landscape painting and his
signature full-length portraits of the English aristocracy.

October 26–January 18, 2004
Rembrandt's Journey: Painter/Draftsman/Etcher
Some 200 works, including more than 100 etchings, revealing
the evolution of the artist's work over 40 years.

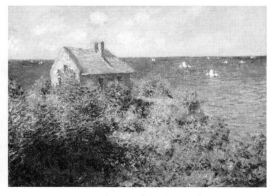

Courtesy of the Museum of Fine Arts, Boston.
Claude Monet, *Fisherman's Cottage on the Cliffs at Varengeville*,
1882.

November 12–February 8, 2004
Classics From the American Studio Furniture Movement
Documents the beginnings and evolution of the movement
from the 1930's to 1990.

Continuing
18th-Century French Art Featuring the Swan Collection
Installation of a complete set of 18th-century French royal
furniture as well as other decorative arts and paintings.

PERMANENT COLLECTION

Art of the Americas, include paintings by Cassatt, Copley,
Homer, O'Keeffe and Sargent, as well as decorative, Native
American and South America arts; European art, include one
of the finest collections of English silver in the world, paint-
ings by Degas, Gauguin, Manet, Renoir and van Gogh, the
largest group of paintings by Claude Monet outside Paris,
and the world's most extensive collection of paintings and
pastels by Jean-François Millet; contemporary art, including
works by Hockney, Kiefer, Sherman, Warhol and LeWitt;
Asian art; Egyptian art, Classical art; prints, drawings and
photographs from the 15th century to the present; musical
instrument collection; textile and costume collection.
Architecture: 1909 building by Guy Lowell; 1915 Evans
Wing; 1928 White Wing by Stubbins; 1981 West Wing by
I. M. Pei. The museum has a sister museum in Nagoya,
Japan.

Admission: Adults, $15; seniors and college students, $13;
17 and under, free (except during school hours, when admis-
sion is $8 until 3 p.m.); members, free; Thursday and Friday
after 5 p.m., $2 discount; Wednesday after 4 p.m., admission
by voluntary contribution. Additional fees for some shows.
Hours: Sunday through Friday, 10 a.m.–4:45 p.m.;
Wednesday through Friday, until 9:45 p.m. Closed
Independence Day, Thanksgiving and Christmas Day.

Harvard University Art Museums

(617) 495-9400
www.artmuseums.harvard.edu

Fogg Art Museum Busch-Reisinger Museum

32 Quincy Street, Cambridge, Mass. 02138

Arthur M. Sackler Museum

485 Broadway, Cambridge, Mass. 02138

2003 EXHIBITIONS

Through January 5 (Sackler)
Plum, Orchid, Chrysanthemum and Bamboo: Botanical Motifs and Symbols in East Asian Painting

Through January 19 (Sert Gallery, Carpenter Center)
Oliver Jackson/Marty Ehrlich: Making Place

Through February 16 (Fogg)
Lois Orwell, David Smith and Modern Art
A look at the collection and life of Lois Orswell, who was active from the 1940's to the 1960's. Works by Seurat, Rodin, Cézanne, Matisse, Picasso, Smith, deKooning and others.

Through February 23 (Busch-Reisinger)
Wolfgang Tillmans: Still Life

Through March 9 (Fogg)
Prints From the Serenissima: Connoisseurship and the Graphic Arts in 18th-Century Venice
Highlights the last 100 years of the Venetian Republic, focusing on prints.

Through March 23 (Sackler)
Byzantine Women and Their World
More than 200 objects exploring the representation of women during the Byzantine Empire.

Cambridge

Courtesy of the Fogg Art Museum, Harvard.
Canaletto, *The Prison in Venice*, ca. 1740.

February 15–May 4 (Sert Gallery, Carpenter Center)
Beauford Delaney: The Color Yellow

March 22–July 6 (Fogg)
*Brueghel to Rembrandt: Dutch and Flemish Drawings From the
Maida and George Abrams Collection*

April 5–June 29 (Fogg)
Dream With Me: The Drawings of Christopher Wilmarth

April 26–July 20 (Fogg)
Jean Fautrier, 1898–1964

PERMANENT COLLECTION

The approximately 150,000 objects in the art museums' collec-
tions range from antiquity to the present and come from
Europe, North America, North Africa, the Middle East, South
Asia, East Asia and Southeast Asia. **Highlights:** Early Italian
Renaissance paintings, 19th-century French paintings and
drawings, and Impressionist and Post-Impressionist works at
the Fogg; ancient Chinese jades and bronzes, Japanese wood-
block prints, Korean ceramics; Greek and Roman sculpture and
coins, Greek vases at the Sackler; and German Expressionist
paintings, Vienna Secession art, 1920's abstraction, Bauhaus,
Joseph Beuys and the Walter Gropius archives, at the Busch-
Reisinger.

Admission: Adults, $5; seniors, $4; students, $3; children
under 18, free. Free Saturday until noon and all day
Wednesday. Admission includes all three museums.
Admission to Sert Gallery (in Carpenter Center, adjacent to
museums) is free.

Hours: Monday through Saturday, 10 a.m.–5 p.m.; Sunday, 1–5 p.m. Closed national holidays.

Massachusetts Museum of Contemporary Art (Mass MOCA)

1040 Mass MOCA Way, North Adams, Mass. 01247
(413) 662-2111
www.massmoca.org

2003 EXHIBITIONS

March 1–February 2004
Fantastic!
Includes works by Gregory Crewdson, an American photographer, Miguel Calderón, a Mexican artist, Nils Norman, a British utopian designer, and Chicago-based Temporary Services.

June 24–April 2004
Project Yankee
Works by eight artists commissioned by the museum in collaboration with the Society for the Preservation of New England Antiquities.

PERMANENT COLLECTION

Several long-term installations. **Highlights:** Sound art by Bruce Odland and Sam Auinger, Walter Fähndrich and Christina Kubisch; Ron Kuivila, *Visitations*; Natalie Jeremijenko, *Tree Logic.* **Architecture:** Restored 13-acre, 19th-century factory campus.

Admission: Adults, $8 ($9 in summer); children, $3; members and children under 6, free.
Hours: June through October, daily, 10 a.m.–6 p.m.; November through May, daily except Tuesday, 11 a.m.–5 p.m.

Springfield

Springfield Art Museum

The Quadrangle, 220 State Street, Springfield, Mass. 01103
(413) 263-6800
www.quadrangle.org

Four museums are located on the Quadrangle: two art muse-
ums, a historical museum and library and a science museum.

Springfield Museum of Fine Arts

2003 EXHIBITIONS

Through February 2
Game Face: What Does a Female Athlete Look Like?
Exhibition of 182 photographs of girls and women participat-
ing in sports from the 1890's through the present, including
works by Ansel Adams and Annie Leibovitz.

March 5–June 15
Reigning Cats and Dogs: The Tales Behind the Art
Explores the depiction of dogs and cats in European and
American paintings, Japanese prints, Oriental and European
sculpture and American photographs.

July 5–September 21
Feelin' Groovy: Rock and Roll Graphics, 1966–1970
About 100 posters and handbills created during the heyday of
the Haight-Ashbury music scene.

October 15–December 7
*Reflections in Black: Smithsonian African-American Photography,
the First 100 Years, 1842–1942*
Images that form a technical history of the medium and a pic-
torial history of African-American life.

PERMANENT COLLECTION

American art from the 18th through 20th centuries; 14th to
20th-century European paintings, including works by Degas,
Pissarro, Gauguin, Monet and Gericault. **Architecture:**
Opened in 1933, Art Deco style.

George Walter Vincent Smith Art Museum

2003 EXHIBITIONS

January 15–January 6, 2004
Ancient Egypt
Three-dimensional re-creation of the interior of an Egyptian temple complex.

PERMANENT COLLECTION

Japanese arms and armor, screens, lacquers and ceramics; Middle Eastern rugs and decorative arts; Chinese cloisonné; a Shinto wheel shrine and American paintings. Opened in 1896; built in the style of an Italian palazzo.

Admission (for both museums): Adults, $6; seniors and college students, $3; ages 6–18, $1; children under 6, free. Includes entry into all four Quadrangle museums.
Hours (for both museums): Wednesday through Sunday, noon–5 p.m.; Saturday and Sunday, 11 a.m.–4 p.m. Closed Monday and Tuesday (open Tuesday in July and August), New Year's Day, Independence Day, Thanksgiving, Christmas Day.

Davis Museum and Cultural Center

Wellesley College, 106 Central Street, Wellesley, Mass. 02140
(781) 283-2034
www.wellesley.edu/DavisMuseum/davismenu.html

2003 EXHIBITIONS

January 9–February 16
The Last Expression: Art and Auschwitz
Artwork created by inmates of concentration camps, including art commissioned by the Nazis and subversive works created by inmates.

February 13–June 8

Fazal Sheikh: The Victor Weeps, Ramadan Moon, A Camel for the Son

Works by an American photographer who spent the last 11 years working with refugees from east African countries and Afghanistan.

PERMANENT COLLECTION

More than 7,000 works covering the history of visual arts, with emphasis on European and American art of the 20th century, medieval, ancient and pre-Columbian art, African art and works by women. Works by Monet, Cézanne, de Kooning, Calder and Krasner. **Architecture:** 1993 design by Rafael Moneo.

Admission: Free.

Hours: Tuesday through Saturday, 11 a.m.–5 p.m.; Wednesday and Thursday from February through May and from September through December, until 8 p.m.; Sunday, 1–5 p.m. Closed Monday and major holidays.

Sterling and Francine Clark Art Institute

225 South Street, Williamstown, Mass. 01267
(413) 458-9545; (413) 458-2303 (recording)
www.clarkart.edu

2003 EXHIBITIONS

February 16–May 11

Renoir and Algeria

Studio paintings as well as landscapes and portraits created during Renoir's trips to Algeria in 1881 and 1882. The centerpiece of the show is *Mlle. Fleury in Algerian Costume.*

June 15–September 7

Turner: The Late Seascapes

Includes Turner's masterpiece *Rockets and Blue Lights.*

October 11–January 4, 2004

Edouard Baldus: Landscape and Leisure in Early French Photography
Examines the phenomenon of photographing leisure in the French countryside through a series by the pioneering 19th-century French photographer. (Travels)

PERMANENT COLLECTION

French Impressionist paintings by Renoir, Monet and Degas; American works by Homer, Sargent, Remington and Cassatt;

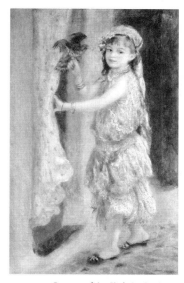

Courtesy of the Clark Art Institute.
Pierre-Auguste Renoir, *Mlle. Fleury in Algerian Costume*, 1882.

Old Master paintings; English and American silver, porcelain, furniture, sculpture, prints, drawings and photographs.
Highlights: Renoir, *At the Concert*; Sargent, *Fumée d'Ambergris*; Homer, *Undertow*; Fragonard, *The Warrior;* Piero della Francesca, *Virgin and Child Enthroned With Four Angels.*

Admission: November through mid-June, free. Mid-July through October, adults, $10; students and children 18 and under, free.

Hours: Tuesday through Sunday, 10 a.m.–5 p.m. (also Monday, July through August and President's Day, Memorial Day, Labor Day and Columbus Day). Closed New Year's Day, Thanksgiving and Christmas Day.

Williamstown

Williams College Museum of Art

15 Lawrence Hall, Main Street, Williamstown,
 Mass. 01267
(413) 597-2429
www.williams.edu/WCMA

2003 EXHIBITIONS

Through March 30
HA! Cartoons, Caricatures and Satire From the Williams College Museum of Art Collection
About 30 works on paper, paintings and sculpture, including works by Rube Goldberg and Thomas Nast and World War I posters.

Through April 6
From the Collection: New York, New York
More than 50 photographs, drawings and prints from the collection featuring images of New York City.

Through April 13
American Dreams: American Art to 1950 in the Williams College Museum of Art
Paintings, sculpture and decorative arts from the collection.

Through April 27
Influences: New Architectural Work by Ben Benedict
Works by a member of the Williams College faculty.

March 1–August 3
Tibet: Mountains and Valleys, Castles and Tents From the Newark Museum Collection
Tibetan art, including examples of official regalia, jewelry, castle furnishings, horse gear and weapons from the country's warrior elite.

June 29–August 31
You Look Beautiful Like That: The Portrait Photographs of Seydou Keïta and Malick Sidibé
Portraits by two commercial photographers from Mali.

August 30–December 6
Narratives by a Negress: Kara Walker
Black paper cut silhouettes depicting Civil War–era scenes filled with visual stereotypes, sex and violence.

Continuing
African Dance Masks
Sixteen ceremonial masks.

Continuing
Stones of Assyria: Ancient Spirits From the Palace of Ashurnasirpal II
Pairs Assyrian reliefs with computer-animated renderings of
their original ninth-century B.C. context.

Continuing
Medieval Art From the Permanent Collection
Paintings, textiles and sculpture from the medieval France,
Spain, Italy and the Low Countries.

Continuing
Masterpieces Ancient to Modern
Survey of the museum's holdings.

PERMANENT COLLECTION

Includes some 12,000 works spanning the history of art.
Contemporary and modern art; American art from the late
18th century to the present; art of world cultures.
Architecture: The neo-Classical rotunda of the original struc-
ture was designed by Thomas S. Tefft in 1846; extensive addi-
tions in 1983 and 1986 by Charles Moore.

Admission: Free.
Hours: Tuesday through Saturday, 10 a.m.–5 p.m.; Sunday,
1–5 p.m. Closed Monday except Memorial Day, Labor Day
and Columbus Day.

Worcester Art Museum

55 Salisbury Street, Worcester, Mass. 01609
(508) 799-4406
www.worcesterart.org

2003 EXHIBITIONS

Continuing
Wall at WAM: Julian Opie
Works by a British artist who depicts pets, buildings, land-
scapes and people in a simplified linear style.

Worcester

Through January 26
Mask or Mirror?: A Play of Portraits
Explores how artists reveal or conceal the identities of their subjects, featuring contemporary works by Nan Goldin and Cindy Sherman and masterworks by Goya, Whistler and Gainsborough.

January 18–April 13
The Harlem Renaissance and Its Legacy
Paintings, sculptures and illustrated books by African-Americans from the Harlem Renaissance in the 1920's and 1930's to the present.

March 1–May 11
Ambreen Butt
Recent paintings and drawings by a Pakistani native whose work reflects the tension between her traditional past and her American lifestyle.

April 5–June 22
Samurai Spirit
Woodblock prints and paintings chronicling the exploits of Japanese samurai.

April
Bill Viola: Union
Video of a man and a woman gesturing in slow motion.

May 17–August 9
English Color Prints
Survey of three centuries of British printmaking.

June 8–August 10
Richard Yarde: Ringshout
Works by a New England artist, including a floor sculpture, large-scale watercolors and a fabric canopy.

September 6–November 30
Nineteenth-Century European Photographs From the Janos Scholz Collection
Rare prints from the first years of photography and early travel photographs.

October 5–February 1, 2004
French and American Barbizon and Impressionist Landscapes
A look at the Barbizon and Impressionist traditions in France and their influence in America, with landscapes by Corot, Monet, Sargent and others.

PERMANENT COLLECTION

Fifty centuries of art. **Highlights:** Egyptian artifacts, Roman mosaics and works by Judith Leyster and Claude Monet.

Admission: Adults, $8; seniors and students, $6; members and children under 17, free. Free on Saturday, 10 a.m.–noon. **Hours:** Sunday and Wednesday through Friday, 11 a.m.–5 p.m.; Thursday, until 8 p.m.; Saturday, 10 a.m.–5 p.m. Closed Monday and Tuesday, Easter, Independence Day, Thanksgiving, Christmas Day and New Year's Day.

Michigan

The University of Michigan Museum of Art

525 South State Street, Ann Arbor, Mich. 48109
(734) 763–UMMA; (734) 764-0395
www.umich.edu/~umma

2003 EXHIBITIONS

Through January 5
Masterworks of Chinese Painting: In Pursuit of Mists and Clouds
Eight centuries of Chinese painting, with emphasis on landscape paintings of the Ming and Qing periods.

Through January 26
Japanese Visions of China
Japanese painting and calligraphy in the 18th and early 19th centuries influenced by Chinese culture.

Through January 26
Contemporary Arabic Calligraphy by Khaled al-Saa-i
First one-man show in North America of the work of the Syrian calligrapher.

Ann Arbor

Through October 19
Chinese Mortuary Art
More than 50 funerary jars, buried heirlooms, ritual objects
and rubbings from tomb walls.

January 25–April 6
German and Austrian Expressionism
Some 80 prints, drawings and watercolors from the early 20th
century.

February 1–April 13
Andy Goldsworthy: Mountain and Comet, Autumn Into Winter
Features 68 photographs, two sculptures and two installation
pieces.

February 15–June 15
Arts of Zen
Explores the relationship between artistic style and religious
meaning through Chinese and Japanese portraits, landscapes,
prints and ritual objects of the 15th through 20th centuries.

Late April–Early September
Surrealism From the UMMA Collections
Examines the evolution of Surrealist art through 70 prints,
drawings, photographs, paintings and sculptures from the
museum's collection.

May 10–July 20
Max Klinger's A Glove
A ten-image set of etchings about a woman who loses a glove.

July 19–September 7
Innovation/Imagination: 50 Years of Polaroid Photography
Works by Ansel Adams, Andy Warhol, Chuck Close and
others invited by Polaroid to consult on technical aspects and
produce photographs using a Polaroid camera.

July 26–October 5
Old Master Dutch and Flemish Prints
Recent additions to the museum's strong holdings in 16th and
17th-century Dutch and Flemish art.

September 6–May 2
Masterworks of African Art From Private Collections
Works rarely on public view.

September 21–November 23
Treasures of the Romanovs: 200 Years of Imperial Collecting in St. Petersburg
Explores the history of the Romanov dynasty as collectors of European fine and applied arts.

October 11–January 4, 2004
Eighteeth-Century French Prints and Drawings
Includes a pastel portrait by Maurice Quentin de La Tour, a Frogonard chalk drawing and an array of prints.

December 13–February 29, 2004
The Time in Between: Betye Saar and the Persistence of Photography
Examines the artist's use of stereotypical imagery and her relationship to political and feminist movements. (Travels)

December 20–February 29, 2004
Gods, Warriors and Lovers: Indian Paintings From the University of Michigan Museum of Art and Michigan Collections
First formal display of the museum's extensive collection of Indian paintings.

PERMANENT COLLECTION

Nearly 14,000 works of art from around the world, including European paintings from the 14th to 19th centuries; Chinese and Japanese paintings and ceramics; the Curtis Gallery of African and African-American Art; an authentic Japanese tea-house; Old Master prints and drawings; contemporary paintings, sculpture and works on paper.

Admission: Suggested donation: $5.
Hours: Tuesday through Saturday, 10 a.m.–5 p.m.; Thursday, until 9 p.m.; Sunday, noon–5 p.m. Closed Monday and most major holidays.

The Detroit Institute of Arts

5200 Woodward Avenue, Detroit, Mich. 48202
(313) 833-7900; (313) 833-2323 (tickets)
www.dia.org

2003 EXHIBITIONS

Through January 12
Degas and the Dance
Explores Degas' paintings, drawings and sculptures of dance in the context of 19th-century ballet. (Travels)

Through June
Dance of the Forest Spirits: A Set of Native American Masks at the DIA
Masks commissioned by a family of Kwakwaka-wakw Native Americans for ceremonial use.

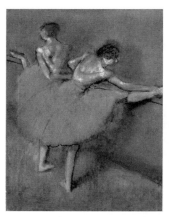

Courtesy of the Detroit Institute of Arts. Edgar Degas, *Dancers at the Barre*, ca. 1900.

March 16–June 8
Magnificenza! The Medici, Michelangelo and the Art of Late Renaissance Florence
Drawings and sculptures by Michelangelo and Cellini, paintings by Bronzino, Pontormo and Salviati and decorative arts by Buontalenti.

October 5–January 4, 2004
Anselm Kiefer
A survey of the artist's work over the last decade, including paintings, sculptures, drawings and books.

PERMANENT COLLECTION

More than 65,000 works from ancient to modern times, including collections of German Expressionist and French Impressionist paintings, Italian Renaissance art and modern and contemporary art. **Highlights:** Diego Rivera's *Detroit Industry* occupies four walls of the museum's central court. **Architecture:** The central 1927 building, in Italian Renaissance style, was enlarged in 1966 and 1971.

Admission: Suggested donation: adults, $4; children and members, free.
Hours: Wednesday and Thursday, 10 a.m.–4 p.m.; Friday, 10 a.m.–9 p.m.; Saturday and Sunday, 10 a.m.–5 p.m. Closed Monday, Tuesday and some holidays.

Grand Rapids Art Museum

155 Division North, Grand Rapids, Mich. 49503
(616) 831-1000; (616) 831-1001
www.gramonline.org

2003 EXHIBITIONS

February 14–May 18
Paris 1890: The Art of Modern Life
Paintings, posters and prints by Toulouse-Lautrec, Pierre
Bonnard, Mary Cassatt and James Tissot documenting daily
life in Paris.

February 14–May 18
Martin Ryerson: A Collector's Passion
Works from the Ryerson collection.

February 14–April 23
Vietnam: Journey of the Heart
About 50 large-scale color photographs by a Vietnam veteran
and photographer depicting postwar Vietnam.

June 20–September 14
Chris Stoffel Overvoorde: A Life in Art
Works by a regional artist.

PERMANENT COLLECTION

European and American painting, sculpture and works on
paper from Renaissance to contemporary art, with addi-
tional collections in 20th-century design and decorative
arts. **Highlights:** Richard Diebenkorn, *Ingleside.*
Architecture: 1895 Beaux-Arts building listed in the
National Register.

Admission: Adults, $5; students and seniors, $2; children
6–17, $1; children under 5, free. Prices may vary for ticketed
shows.
Hours: Tuesday through Sunday, 11 a.m.–6 p.m.; Friday,
until 9 p.m. Closed Monday.

Minnesota

The Minneapolis Institute of Arts

2400 Third Avenue South, Minneapolis, Minn. 55404
(612) 870-3131; (888) MIA-ARTS
www.artsMIA.org

2003 EXHIBITIONS

Through March 16
Eternal Egypt: Masterworks of Ancient Art From the British Museum
About 135 objects spanning Egyptian history from the First Dynasty at about 3100 B.C. to the Roman occupation of the fourth century A.D.

Through April 13
Up the Nile: Egypt in 19th-Century Photographs
Early images taken along the Nile River, depicting the country's ancient monuments.

April 12–June 8
Shaped With a Passion: The Carl A. Weyerhauser Collection of Japanese Ceramics From the 1970's
Some 120 pieces reflecting the influence of the tea ceremony on Japanese ceramics.

May 10–September 14
Walker Evans
About 50 photographs, many depicting the vernacular architecture and rural poor of the Deep South in the 1930's.

June 1–August 31
Romantic Paintings in England and France
Explores the relationship between French and British painting during the 1820's and 1830's, featuring works by Turner, Constable, Delacroix, Gericault and Corot.

July 12–October 5
Three Centuries of Tradition: The Renaissance of Custom Sporting Arms in America
Arms by contemporary American gunmakers who adapt

traditional European and American styles from 1640 to 1940, including carving, inlay and engraving of wood and metal.

August 1–November 30
George Washington: A National Treasure
The *Landsdowne* portrait of the president by Gilbert Stuart, on tour from the National Gallery. (Travels)

October 12–December 28
The Saint John's Bible
More than 200 Bible pages being created by Welsh scribes for the first handwritten, illuminated Bible from the modern era.

December–April 2004
Beauty, Honor and Tradition: The Legacy of Plains Indian Shirts
Explores shirt designs, symbols and adornment techniques through 40 examples from 1830 to 2000.

PERMANENT COLLECTION

The newly expanded museum houses nearly 100,000 objects spanning 5,000 years. **Highlights:** Lorrain, *Pastoral Landscape;* a Plains Indian tepee; terra-cotta shrine head from Nigeria; Ch'ing Dynasty Jade Mounain; Chinese period rooms; Rembrandt's *Lucretia.*

Admission: Free; fees for special exhibitions.
Hours: Tuesday through Saturday, 10 a.m.–5 p.m.; Thursday and Friday, 10 a.m.–9 p.m.; Sunday, noon–5 p.m. Closed Monday, Thanksgiving, Christmas Day and Independence Day.

Walker Art Center

725 Vineland Place, Minneapolis, Minn. 55403
(612) 375-7622
www.walkerart.org

2003 EXHIBITIONS

February 8–May 4
How Latitudes Become Forms
Works by 30 artists from many countries exploring how globalization has affected art in different parts of the world.

Minneapolis

March 9–June 15
Elemental: Selections From the Permanent Collection

April 6–July 6
Julie Mehretu
Works by a New York painter who combines signs and symbols with architectural imagery.

June 8–September 7
Strangely Familiar: Design and Everyday Life

July 13–October 12
The Squared Circle: Boxing in Contemporary Art

October 12–January 4, 2004
The Last Picture Show: Conceptualism and Photography, 1960–1985

November 9–February 8, 2004
Past Things and Present: Jasper Johns Since 1985

PERMANENT COLLECTION

Primarily 20th-century art of all major movements. The Minneapolis Sculpture Garden has more than 40 sculptures on 11 acres. At its center is the playful fountain sculpture *Spoonbridge and Cherry* by Claes Oldenburg and Coosje van Bruggen. **Highlights:** Matthew Barney, *Cremaster 1*; Lucio Fontana, *Concetto Spaziale* (Spatial Concept); Jasper Johns, *Flashlight*; Ellsworth Kelly, *Yellow, Red*; Charles Ray, *Unpainted Sculpture*; Kazuo Shiraga, *Untitled*; Kara Walker, *Endless Conundrum, an African Anonymous Adventuress.*

Admission: Adults, $6; children 12–18, students and seniors, $4; members and children under 12, free. Free on Thursday and the first Saturday of each month.
Hours: Tuesday through Saturday, 10 a.m.–5 p.m.; Thursday, until 9 p.m.; Sunday, 11 a.m.–5 p.m. Closed Monday.

Minnesota Museum of American Art

Landmark Center, 75 West Fifth Street, Second Floor,
 St. Paul, Minn. 55102
(651) 292-4380; (651) 292-4355 (recording)
www.mmaa.org

2003 EXHIBITIONS

January 18–March 16
Lifting the Rose-Colored Glasses: Three Social Realists
Nearly 100 works by three prominent Social Realists in the
1920's and 1930's, Ben Shahn, Raphael Soyer and William
Gropper.

April 5–June 15
The Minnesota Landscape: A Natural History
Explores the development of Minnesota's artistic heritage
through a focus on landscapes and changes to the land.

September 6–November 2
Dard Hunter: Master of Graphic and Book Arts
Works by Hunter (1883–1966), a graphic designer for the
Arts & Crafts Movement's Roycroft Colony.

November 22–January 11, 2004
Tools as Art
A lighthearted exhibition of 20th-century art that depicts or
incorporates tools and hardware.

PERMANENT COLLECTION

Nineteenth and 20th-century American paintings, prints and
sculpture, including works by Evelyn Raymond, a
Minnesotan, and Paul Manship, a St. Paul native. **Highlights:**
Paintings by Thomas Hart Benton, Robert Henri and Jacob
Lawrence, as well as the Minnesotans Doug Argue, George
Morrison, Elsa Jemne and Cameron Booth. **Architecture:**
1902 Landmark Center, originally a federal courthouse and
post office.

Admission: Free.

Hours: Tuesday through Saturday, 11 a.m.–4 p.m.; Thursday, until 7:30 p.m.; Sunday, 1–5 p.m. Closed Monday and major holidays.

Mississippi

Mississippi Museum of Art

201 East Pascagoula Street, Jackson, Miss. 39201
(601) 960-1515
www.msmuseumart.org

2003 EXHIBITIONS

Through January 5
Mississippi Watercolor Society Grand National Watercolor Exhibition
Works in various water-based media.

Through January 12
Paradox in Paradise: Paintings by Lea Barton
Mixed-media paintings by a Mississippi artist.

Through February 9
Mary Lovelace O'Neal
Survey of the large-scale abstract paintings by a Mississippi native.

Courtesy of Mississippi Art Museum.
Mary Lovelace O'Neal, *Running Freed More Slaves Than Lincoln Ever Did*, 1997.

PERMANENT COLLECTION

More than 3,600 works, many by and relating to Mississippians and their culturally diverse heritage. The collection is strong in 19th- and 20th-century American and European art, Japanese prints, photographs by Southerners and about the South, folk art and pre-Columbian and Oceanic artifacts.

Admission: Adults, $5; seniors, $4; college students, $3; students, $2; children under 5 and members, free.
Hours: Monday through Saturday, 10 a.m.–5 p.m.; Tuesday, until 8 p.m.; Sunday, noon–5 p.m. Closed major holidays.

Missouri

The Nelson-Atkins Museum of Art

4525 Oak Street, Kansas City, Mo. 64111-1873
(816) 561-4000; (816) 751-1ART (recording)
www.nelson-atkins.org

2003 EXHIBITIONS

Through May 4
Art of the Lega: Meaning and Metaphor in Central Africa
Masks, spoons, baskets, hats and other objects from the Lega people of the Democratic Republic of the Congo.

June 28–September 7
A Magnificent Age: French Paintings From the Walters Art Museum
About 46 works from the 19th century by Academic painters, members of the Barbizon School, Realists, Romanticists and Impressionists.

October 11–January 4, 2004
Marsden Hartley (1877–1943): American Painter
Retrospective of the career of one of the first American artists to experiment with Cubism and other European movements.

PERMANENT COLLECTION

More than 28,000 works, including 5,000 objects of Asian art; European paintings; modern sculpture. **Highlights:** Kansas City Sculpture Park, featuring monumental bronzes by Henry Moore; the largest public collection of works by Thomas Hart Benton; Caravaggio, *St. John the Baptist*; Monet, *Boulevard des*

Capucines; de Kooning, *Woman IV*. **Architecture:** 1933 building by Wight & Wight; addition by Steven Holl under construction, with galleries set to open in 2006.

Admission: Free.
Hours: Tuesday through Thursday, 10 a.m.–4 p.m.; Friday, until 9 p.m.; Saturday, until 5 p.m.; Sunday, noon–5 p.m. Closed Monday, Independence Day, Thanksgiving, Christmas Eve, Christmas Day and New Year's Day.

Saint Louis Art Museum

Forest Park, 1 Fine Arts Drive, St. Louis, Mo. 63110
(314) 721-0072; (314) 721-4807 (for the deaf)
www.slam.org

2003 EXHIBITIONS

Through February 16
Currents 87: Christina Schmigel
Sculptures by a St. Louis–based artist whose work is inspired by industrial elements of the landscape.

Through March 2
Wrapped in Beauty: The Art of African Cloth

Through April 20
Treasury of the World: Jeweled Arts of India in the Age of the Mughals
More than 300 works from the Mughal period (1526–1858), including items for personal adornment, weapons, carved jade and crystal bowls set with precious stones.

February 14–May 18
Painted Prints: The Revelation of Color in Northern Renaissance and Baroque Engravings, Etchings and Woodcuts
More than 100 works from American and European collections.

Spring 2003
Currents 88: Ellen Gallagher
Paintings and drawings by an African-American artist living in New York who uses images abstracted from racial and gender stereotypes.

October–January 2004
Beyond Boundaries: Art From Germany in the Second Half of the 20th Century
Includes works by Baselitz, Beuys, Kiefer and Richter.

Fall 2003
Currents 89: Frances Stark
Intimate drawings featuring repetitive texts by a young Los Angeles–based artist.

November 21–February 29, 2004
Second Impressions: The Sculpture of Medardo Rosso

PERMANENT COLLECTION

Ancient to contemporary art. Includes pre-Columbian, Renaissance, Impressionist and German Expressionist works; American, European and Asian art; period rooms.
Architecture: A historic landmark designed by Cass Gilbert as the only permanent structure for the 1904 World's Fair.

Admission: Free; fee for special exhibitions, except on Friday.
Hours: Tuesday through Sunday, 10 a.m.–5 p.m., Friday, until 9 p.m. Closed Monday (except Memorial Day and Labor Day), New Year's Day, Thanksgiving and Christmas Day.

Montana

Yellowstone Art Museum

401 North 27th Street, Billings, Mont. 59101
(406) 256-6804
www.yellowstone.artmuseum.org

2003 EXHIBITIONS

Through January 12
The Altered Landscape
Contemporary landscape photographs that focus on the human presence in the environment. (Travels)

Billings/Lincoln

Through January 19
In Situ: Sandra Dal Poggetto
Abstract paintings.

March 14–June 29
In Response to Place: Photographs From The Nature Conservancy's Last Great Places
Photographs illustrating the beauty of the natural world. (Travels)

March 14–June 29
Hydrolibros
Works by Basia Irland, a sculptor who has integrated her art with her interest in the environment.

PERMANENT COLLECTION

Contemporary and historical regional, national and international art. Montana collection features Deborah Butterfield and John Buck. Virginia Snook collection by Will James.

Admission: Adults, $7; students and seniors, $5; children, $3.
Hours: Tuesday through Saturday, 10 a.m.–5 p.m.; Thursday, until 8 p.m.; Sunday, noon–5 p.m.

Nebraska

Sheldon Memorial Art Gallery and Sculpture Garden

University of Nebraska, 12th and R Streets, Lincoln, Neb. 68588–0300
(402) 472-2461
sheldon.unl.edu

The museum will be closed for renovation through February 2003.

2003 EXHIBITIONS

February 14–March 31
Wild by Design: Contemporary Quilts From the International Quilt Study Center, University of Nebraska

March 8–May 10
Ann Truitt: Recent Sculpture

March 8–May 10
Still Small Voice: The Minimalist Impulse in Contemporary American Prints From the Permanent Collection

April–August
The Big Canvas: Paintings From the Permanent Collection

June–August
Nancy Friedemann

August 29–November 9
Edwin Dickinson: Dreams and Realities

September–November
Losing Our Instructions: An Aesthetic Intervention by Tim Van Laar and Barbara Kendrick

November 3–February 2004
Patricia Olynyk: Recent Prints

November 21–February 2004
Real Presence: The Black Paintings of Enrique Martinez Celaya

PERMANENT COLLECTION

American art from the 18th century to the present, with an emphasis on the 20th century, including works by Albert Bierstadt, Robert Henri, Edward Hopper, Georgia O'Keeffe, Mark Rothko, Frank Stella, Joseph Stella, Clyfford Still, John Twachtman and Andy Warhol. Sculpture garden with *Torn Notebook,* by Claes Oldenburg and Coosje van Bruggen, and works by Gaston Lachaise, Jacques Lipchitz, David Smith and Richard Serra.

Admission: Free.
Hours: Tuesday through Saturday, 10 a.m.–5 p.m.; Friday, until 8 p.m.; Sunday, noon–5 p.m. Closed Monday and major holidays.

Omaha

Joslyn Art Museum

2200 Dodge Street, Omaha, Neb. 68102
(402) 342-3300
www.joslyn.org

2003 EXHIBITIONS

Through January 5
Artists at Work: French Oil Sketches From the Los Angeles County Museum of Art
More than 50 18th- and 19th-century sketches by Simon Vouet, François Boucher, Jean Bernard Restout and others.

Through January 5
A Faithful and Vivid Picture: Karl Bodmer's North American Prints
Images of the American West created to illustrate the book "Travels in the Interior of North America 1832–1834."

January 18–March 9
Albrecht Dürer Prints From the Montgomery Museum of Fine Art
Woodcuts and engravings by Dürer (1471–1528).

February 15–May 11
Distinctly American: The Photographs of Wright Morris
A look at the career of the photographer, including images of his native Nebraska and other American locales.

March 15–May 18
Howard Buffett
More than 50 photographs by an Omaha native taken around the globe.

March 22–May 18
Jun Kaneko
Recent work in ceramics, glass, painting and drawing as well as a site-specific wall installation.

June 21–September 14
Millet to Matisse: 19th- and 20th-Century French Painting From Kelvingrove Art Gallery, Glasgow
Works by van Gogh, Millet, Courbet, Corot, Rousseau, Pissarro, Monet, Sisley, Renoir, Gauguin and others. (Travels)

October 18–January 4, 2004
Magnum Cinema
Images of well-known directors like Woody Allen, Charlie

Chaplin, Federico Fellini and Orson Welles by Magnum photographers.

November 15–January 11, 2004
Feast the Eye, Fool the Eye: Still Life and Trompe-l'oeil Paintings From the Oscar and Maria Salzer Collection
Works spanning three centuries and nine countries, including ones by Alexander Pope, James Peale and John Peto.

December 13–March 7, 2004
Tony Fitzpatrick: Max and Gaby's Alphabet
Suite of 24 etchings for children spelling out the alphabet. (Travels)

PERMANENT COLLECTION

Works from antiquity to the present. **Highlights:** The museum is noted for art of the American West and the Swiss artist Karl Bodmer's watercolors and prints documenting his 1832-34 journey to the Missouri River frontier. **Architecture:** 1931 Art Deco building by John and Alan McDonald; 1994 addition by Sir Norman Foster and Partners.

Admission: Adults, $6; students and seniors, $4; ages 5–17, $3.50. Free on Saturday, 10 a.m.–noon.
Hours: Tuesday through Saturday, 10 a.m.–4 p.m.; Sunday, noon–4 p.m. Closed Monday and major holidays.

New Hamsphire

The Currier Gallery of Art

201 Myrtle Way, Manchester, N.H. 03104
(603) 669-6144
www.currier.org

2003 EXHIBITIONS
Through January 13
New York, New Work, Now!

Cutting-edge work by more than 30 New York artists, including painters, sculptors and video artists.

April 6–June 16
Jan Miense Molenaer: Painter of the Dutch Golden Age
First comprehensive exhibition featuring more than 40 works by the Dutch painter.

October 3–January 4, 2004
Lotte Jacobi: A Retrospective
Works by a New Hampshire photographer who worked in Germany and the United States. (Travels)

Courtesy of the Currier Gallery of Art.
Lotte Jacobi, *Portrait of Albert Einstein*, 1938.

PERMANENT COLLECTION

European and American paintings and sculpture from the 14th century to the present. **Highlights:** The Zimmerman House, designed in 1950 by Frank Lloyd Wright; early American furniture; decorative arts; works by Picasso, Monet, Sargent, Homer, Wyeth, Rothko and O'Keeffe; sculpture by Matisse, Remington and Saint-Gaudens.

Admission: Adults, $5; students and seniors, $4; children under 18, free. Free on Saturday, 10 a.m.–1 p.m.
Hours: Monday, Wednesday, Thursday and Sunday, 11 a.m.– 5 p.m.; Friday, until 8 p.m.; Saturday 10 a.m.–5 p.m. Closed Tuesday.

Hood Museum of Art

Dartmouth College, Hanover, N.H. 03755
(603) 646-2808
www.dartmouth.edu/~hood/Menu.html

2003 EXHIBITIONS

January 4–March 9
Ambassadors of Progress: American Women Photographers in Paris, 1900–1901
Partial reconstruction of an exhibition held in Paris at the turn of the last century demonstrating the advances made by women photographers despite Victorian mores.

January 18–March 9
Carrie Mae Weems: The Hampton Project
Works by Weems, a contemporary photographer, and photographs from Frances Benjamin Johnson's Hampton Album of 1900, both focusing on the Hampton Normal and Agricultural Institute, now Hampton University. (Travels)

March 25–May 25
Inside the Floating World: Japanese Prints From the Lenoir C. Wright Collection
One hundred prints from the Weatherspoon Art Museum explore Japanese popular culture.

April 12–May 25
They Still Draw Pictures: Children's Art in Wartime
More than 50 drawings chronicling children's experience of war, from the Spanish Civil War of the 1930's to the present.

August 23–December 14
Coming of Age in Ancient Greece
Explores childhood in ancient Greece through such objects as painted vases, sculpture, grave monuments, toys and baby bottles. (Travels)

PERMANENT COLLECTION

19th- and 20th-century American painting; early American silver; European paintings and prints; contemporary art; African, Oceanic and Native North American art. **Highlights:** Six limestone reliefs from the palace of the Assyrian King Ashurnasirpal II (883–859 B.C.); José Clemente Orozco, *The Epic of American Civilization*. **Architecture:** 1985 building by Charles Moore and Chad Floyd.

Admission: Free.
Hours: Tuesday through Saturday, 10 a.m.–5 p.m.; Wednesday, until 9 p.m.; Sunday, noon–5 p.m. Closed

Monday, New Year's Day, Independence Day, Labor Day, Thanksgiving, Christmas Eve and Christmas Day.

New Jersey

The Montclair Art Museum

3 South Mountain Avenue, Montclair, N.J. 07042
(973) 746-5555; (973) 783-8716 (for the deaf)
www.montclair-art.org

2003 EXHIBITIONS

Through January 5
On the Edge of Your Seat: Popular Theater and Film in Early-20th-Century American Art
Posters, playbills, song sheets, postcards and vintage lighting and motion picture equipment, including works by Charles Demuth, John Sloan, Edward Hopper, Robert Henri and other American modernists.

Through January 12
Observing the Spectacle: Prints and Drawings by Adolph Dehn
Works from the 1920's through 1940's by an artist who took a satirical look at audiences and performers.

Through April
Betty Woodman Ceramics
Vividly colored ceramic and paint installations as well as bronze benches.

January–June
Jonathan Santlofer: The Man Ray Series
Eight drawings of Man Ray by a New York artist.

February 16–August 3
Conversion to Modernism: The Early Works of Man Ray
Eighty paintings and works on paper done between 1907 and 1924, including figure studies, Cézannesque landscapes and Cubist still lifes.

May–November
Tom Nussbaum Installation
Small-scale figurative sculptures by a Montclair artist.

PERMANENT COLLECTION

About 15,000 objects, focusing on American and American Indian art and artifacts, mid-18th century to the present, including paintings, works on paper, sculptures and costumes. **Architecture:** Neo-Classical building in an arboretum setting.

Admission: Adults, $8; seniors and students, $6; members and children under 12, free. Free on Saturday, 11 a.m.– 2 p.m. **Hours:** Tuesday through Sunday, 11 a.m.–5 p.m. Closed Monday and major holidays.

The Newark Museum

49 Washington Street, Newark, N.J. 07101–0540
(973) 596-6550; (973) 596-6355 (for the deaf);
(800) 7MUSEUM
www.newarkmuseum.org

2003 EXHIBITIONS

Through January 2
Christmas in the Ballantine House: Feasting With Family and Friends
A traditional Victorian holiday is recreated in this 1885 house, a restored National Historic Landmark.

Through November
Amber: Frozen Windows on Ancient Worlds
Explores how scientists use natural history collections to learn about nature.

Through April 15, 2004
Honoring the Living and the Dead
Portrait busts of two ancient Romans, the emperor Lucius Verus and a middle-aged man.

February–May
Great Pots! Contemporary Ceramics From Function to Fantasy
Ceramic art from the 1930's to the present by American,

European, Asian, African and
Native American artists.

February 14–June 15
*Quilt Masterpieces From Folk Art
to Fine Art*
A look at the cultural and social
meanings of quilts from colonial
America to the present.

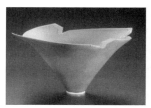
Courtesy of the Newark Museum
Elsa Rady, *En Deco*, 1986.

June 4–August 17
Half Past Autumn: The Art of Gordon Parks
First major retrospective of an American artist who has
worked in many media.

June–December
The History of Flight
Works depicting flight, including Arshile Gorky's two
1935–1936 murals from the Newark Airport.

October 17–December
The Wonders of Portugal: 600 Years of Opulent Objects
Ceramics, tiles, silver, jewelry, diamonds, textiles and furniture
from the 1400's to the 1900's.

PERMANENT COLLECTION

American painting and sculpture from the 18th, 19th and 20th
centuries; decorative arts collection; the arts of Africa, the
Americas and the Pacific; Asian art collection; Egyptian,
Greek, Etruscan and Roman antiquities; ancient glass collec-
tion; numismatic collection. **Highlights:** American works on
permanent display include paintings by Bearden, Cassatt,
O'Keeffe, Sargent and Stella; Hiram Powers, *Greek Slave*
(1847); contemporary outdoor sculptures in the Alice Ransom
Dreyfuss Memorial Garden; Tibetan Buddhist altar consecrated
by the Dalai Lama; 1885 Ballantine House, a restored national
historic landmark. **Architecture:** Renovation and expansions
designed by Michael Graves and completed in 1989.

Admission: Free; tour groups pay $5 per person (reservations
required).
Hours: Wednesday through Sunday, noon–5 p.m. Closed
Monday and Tuesday, New Year's Day, Independence Day,
Thanksgiving and Christmas Day.

New Mexico

Museum of New Mexico

www.museumofnewmexico.org
(505) 827-6463

Museum of Fine Arts

107 West Palace Avenue on the Plaza, Santa Fe,
 N.M. 87501
(505) 476-5072

2003 EXHIBITIONS

Through January 19
Idea Photographic: After Modernism

Through April 7
New Histories of Photography From the Collection: Brett Weston
Selected works from the collection reflecting the boldness and
technical precision of contemporary photography.

Through April 28
Mind Over Matter: Reworking Women's Work
Explores the categorization of art into men's and women's
work, featuring quilting, embroidery, waving, basketry,
ceramics, glassblowing, blacksmithing and other crafts.

September 19–January 2, 2004
Portrait of the ART World: A Century of ARTNews Photographs

Through October 26
From Realism to Abstraction: Art in New Mexico, 1917–2002
Selections from the permanent collection in various media.

PERMANENT COLLECTION

More than 20,000 works of historical and contemporary fine
art of the Southwest, including painting, photography and
sculpture. **Architecture:** 1917 building patterned after mis-
sion churches.

Santa Fe

Museum of International Folk Art

Camino Lejo, off Old Santa Fe Trail,
 Santa Fe, N.M. 87501
(505) 476-1200
www.moifa.org

2003 EXHIBITIONS

Through January 26
Dressing Up: Children's Clothes From Around the World
A look at children's clothing, both historical and
contemporary, from India, Mexico, China and other countries.

Through March
Flor y Canto: Reflections From Nuevo México
Works by New Mexico folk artists based on iconography from
before the arrival of the Europeans.

Through July 6
Cerámica y Cultura: The Story of Spanish and Mexican Mayólica
Explores how Moorish ceramic art spread around the world
and evolved into Mexican talavera.

Through September 7
Gathering Threads: The Heart of the Neutrogena Collection
Textiles from more than 25 countries, including everyday and
ceremonial pieces, both ancient and contemporary.

June 1–December 31
Fiftieth Anniversary Exhibition

PERMANENT COLLECTION

Traditional art from more than 100 countries, with toys, tex-
tiles, household goods and religious art.

Museum of Indian Arts and Culture/Laboratory of Anthropology

Camino Lejo, off Old Santa Fe Trail, Santa Fe,
 N.M. 87501
(505) 476-1250
www.miaclab.org

2003 EXHIBITIONS

Through January 12
Touched by Fire: The Art, Life and Legacy of Maria Martinez
A look at the influence of the artist on Indian art.

Through January 12
Inspirations: Contemporary Paintings and Sculpture

March 15–January 11, 2004
Tewa Thematic Exhibit

PERMANENT COLLECTION

More than 70,000 items of Southwest Native American culture from ancestral to contemporary times.

The Palace of Governors

105 West Palace Avenue, on the Plaza,
 Santa Fe, N.M. 87501
(505) 476-5100
www.palaceofthegovernors.org

2003 EXHIBITIONS

Continuing
Jewish Pioneers of New Mexico
Photographs, artifacts and diaries that mark the history of Jewish settlers in the state, through World War I.

Continuing
Art of Ancient America, 1500 BC–AD 1500
Middle American and Andean objects from pre-European contact.

PERMANENT COLLECTION

New Mexico's state history museum, located in the oldest continuously occupied public housing building in the United States.

ALL FOUR MUSEUMS:

Admission: $15 four-day, five-museum pass includes the newly opened, privately owned Museum of Spanish Colonial

Art; one-day, one-museum pass, $7 for nonresidents, $5 for
residents; 16 and under, free. Free on Friday, 5–8 p.m. at
Palace and Fine Arts. New Mexico residents, free on Sunday.
Hours: Tuesday through Sunday, 10 a.m.–5 p.m. Closed
Monday and major holidays.

Georgia O'Keeffe Museum

217 Johnson Street, Santa Fe, N.M. 87501
(505) 995-0785
www.okeeffemuseum.org

2003 EXHIBITIONS

Through January 14
*Georgia O'Keeffe and the Calla Lily
in American Art, 1860–1940*
About 50 works by 33 artists
depicting the calla lily, with a
focus on the art of O'Keeffe,
Charles Demuth and Marsden
Hartley. (Travels)

January–April
*Debating American Modernism:
Stieglitz, Duchamp and the New
York Avant-Garde*

September–January 2004
Kenneth Noland at the O'Keeffe

PERMANENT COLLECTION

Approximately 140 works by
Georgia O'Keeffe that provide an
overview of her work from 1904
to 1970. **Highlights:** *Black Lines,*
1916; *From the Plains,* 1919;
Petunia, No. 2, 1924; *Abstraction,
White Rose II,* 1927; *Black
Hollyhock, Blue Larkspur,* 1929;
Jimson Weed, 1932; *Belladonna-*

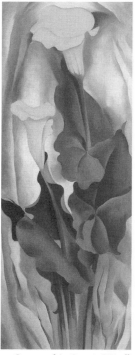

Courtesy of the Georgia O'Keeffe
Museum.
Georgia O'Keeffe, *Yellow Calla,*
1927.

Hana, 1939; *Pelvis Series Red and Yellow,* 1945; *My Last Door,* 1954. **Architecture:** The building was originally a Baptist church in the 1950's. In 1997, an addition was built in the Santa Fe vernacular style.

Admission: Adults, $8; New Mexico residents, $4; seniors, $7 on Thursdays; students, free. Free on Friday, 5–8 p.m.; **Hours:** Daily except Wednesday, 10 a.m.–5 p.m.; Friday, until 8 p.m. (Open Wednesday July through October.) Closed New Year's Day, Easter Sunday, Thanksgiving and Christmas Day.

New York

Brooklyn Museum of Art

200 Eastern Parkway, Brooklyn, N.Y. 11238
(718) 638-5000
www.brooklynart.org

2003 EXHIBITIONS

Through January 5
Exposed: The Victorian Nude
Paintings, drawings, sculpture, illustrations, caricatures and advertising items.

Through January 12
The Dinner Party
A feminist installation by Judy Chicago, in which Ishtar, Theodora of Byzantium, Sojourner Truth, Sacajawea, Susan B. Anthony, Emily Dickinson, Georgia O'Keeffe and Virginia Woolf share a table with 31 other women.

Through January 12
Bam! Bam! Bam! Catching the Next Wave for 20 Years
A multimedia exhibition — featuring translucent scrims, comfortable furniture and video and slide imagery — that celebrates the 20th anniversary of the Brooklyn Academy of Music's avant-garde Next Wave Festival.

Through January 26
The Adventures of Hamza
Brings together 70
dispersed pages of the
Hamzanama, a manuscript
created by Persian and
Indian artists and
commissioned by the
Indian Mughal emperor
Akbar when he was a
teenager. The paintings
portray the exploits of
Amir Hamza, uncle of the
prophet Muhammad.

Courtesy of the Brooklyn Museum.
Zumurrud Shah in his tent, Mughal School,
Akbar Period, 1562-77.

March 7–June 15
*The Last Expression: Art
From Auschwitz*
Some 200 works created by Jews, resistance fighters and
Gypsies who were interned at Auschwitz and other
concentration camps. Art retrieved from German archives.

Opening in March
Egyptian Galleries Reinstallation
More than 550 objects, some not on view since the early 20th
century, dating from the Predynastic Period (4400 B.C.) to the
reign of Amenhotep III (1353 B.C.), in seven newly designed
galleries.

March 21–July 20
Gilbert and George
Approximately 80 works by the long-term collaborators, who
produce photo installations, videos and performance pieces.

September 19–January 4, 2004
Pulp Art From the Collection of Robert Lesser
More than 100 paintings reflecting American popular culture
of the 1930's and 40's, in many cases along with the magazine
covers to which they relate. Includes western, science-fiction
and detective art and The Shadow, Tarzan and other characters.

October 3–January 18, 2004
Frederic Brenner
Photographs by the social anthropologist chronicling the
Jewish Diaspora in more than 40 countries on five continents
since 1978.

October 31–January 18, 2004
Magic: The Supernatural and the Fantastic
Approximately 150 works from the museum's collection.

Continuing
American Identities: A New Look
Nearly 200 paintings, sculptures and works on paper by
Albert Bierstadt, Thomas Eakins, Childe Hassam, John
Singer Sargent and others, as well as 20th-century paintings
by Stuart Davis, Georgia O'Keeffe, Ad Reinhardt and others.

PERMANENT COLLECTION

More than 1.5 million works of art. **Highlights:** Egyptian
collection; American paintings and sculpture. **Architecture:**
560,000-square-foot Beaux-Arts structure by McKim, Mead
and White completed in 1897.

Admission: $6; students and seniors, $3; members and
children under 12, free.
Hours: Wednesday through Friday, 10 a.m.–5 p.m.; Saturday
and Sunday, 11 a.m.–6 p.m.; first Saturday of each month, 11
a.m.–11 p.m. Closed Monday and Tuesday, New Year's Day,
Thanksgiving and Christmas Day.

Albright-Knox Art Gallery

1285 Elmwood Avenue, Buffalo, N.Y. 14222
(716) 882-8700
www.albrightknox.org

2003 EXHIBITIONS

Through January 12
Modigliani and the Artists of Montparnasse
Approximately 45 Modigliani paintings, sculptures and works
on paper, plus art by Brancusi, Matisse, Picasso and other
contemporaries.

January 11–April 6
Laylah Ali: Recent Work
Small gouache drawings that address race, politics and power.

February 1–April 20
Frank Moore: Green Thumb in a Dark Eden
A wide range of paintings in which fantasy and reality commingle, including several from the *Niagara Falls* series.

April 12–July 6
The Drawings of Rube Goldberg
More than 50 works, including those depicting some of the contraptions for which Goldberg was best known.

May 24–September 1
European Masterworks From the Phillips Collection
More than four dozen examples, primarily from the 19th and 20th centuries, including Renoir's *Luncheon of the Boating Party* and works by Cézanne, Degas, van Gogh, Goya, El Greco, Matisse, Monet and Picasso.

October 4–January 4, 2004
Material, Metaphors, Narratives
New works by seven contemporary artists who defy traditional categories of painting, sculpture, photography and ceramic art.

PERMANENT COLLECTION

Art through the centuries, starting from 3000 B.C. It is rich in 19th- and 20th-century American and European works.

Admission: Adults, $5; seniors and students (13–18), $4; children, free. Saturday, 11 a.m.–1 p.m., free.
Hours: Tuesday through Saturday, 11 a.m.–5 p.m.; Friday until 9 p.m.; Sunday, noon–5 p.m. Closed Monday, Thanksgiving, Christmas Day and New Year's Day.

Herbert F. Johnson Museum of Art

Cornell University, Ithaca, N.Y. 14853
(607) 255-6464
www.museum.cornell.edu

2003 EXHIBITIONS

Through January 5
Chinese Paintings From the Henricksen Collection
Ming and Ching dynasty paintings from an upstate New York collection present four centuries of artistic traditions.

Through January 12
The David Solinger Collection: Masterworks of 20th-Century Art
Works by Giacometti, Hofmann, Kandinsky, Klee, Picasso and others.

Through January 12
Lynn Stern: Photography

Through January 12
Rachid Koraïchi: Path of Roses
An Algerian artist creates Arabic calligraphy in sculpture and textiles, exploring mystical aspects of Islam.

January 12–March 9
Classical Works From Cornell's Collections
Roman and Greek pottery, sculpture, coins and artifacts.

March 22–June 5
Musical Instruments From the Time of Mozart
Keyboards and other instruments from the late 18th century.

March 29–May 11
The Shatzman Collection of Chinese Ceramics

March 29–June 15
The Bennett Collection of Contemporary Art
Paintings and sculpture, mostly American works since 1960.

April 5–July 5
Ah Leon
Contemporary ceramics by a Taiwanese sculptor.

April 5–August 17
Connections: Southeast Asian and Chinese Art

June 4–July 5
Elsie Dinsmore Popkin
Works by a Cornell graduate known for her pastel landscapes.

Summer
Francesca Woodman
Photography.

Ithaca/Long Island City

Opening early fall
Byrdcliffe: An American Arts and Crafts Colony

Opening early fall
Surrealist Drawings From the Drukier Collection

November 8–February 17, 2004
Alice in Wonderland
Illustrations and objects from a private collection.

Opening late fall
Nicole Eisenmann
Drawings.

PERMANENT COLLECTION

Asian, American and European art; prints, drawings and photographs. **Architecture:** 1973 building by I.M. Pei, overlooking Lake Cayuga and the Cornell campus.

Admission: Free.
Hours: Tuesday through Sunday, 10 a.m.–5 p.m. Closed Monday, New Year's Day, Independence Day and Thanksgiving.

Museum for African Art

36-01 43rd Avenue, Long Island City (Queens), N.Y. 11101
(212) 966-1313
www.africanart.org

The museum moved to its Long Island City home in September 2002 and plans to return to Manhattan, on Museum Mile, in 2005.

2003 EXHIBITIONS

Through February
Facing the Mask
Approximately 70 examples of masks from across the continent, as well as interactive components, including a shrine reconstruction and mask-making workshops.

April–August
Status Symbols: Material Differences in African Art
Examining the range of materials used by African artists. About 100 object on display.

Opening in September
Pride and Preservation: Fear, Protection and Beauty in the Urhobo Art of Nigeria
Never-before-displayed art, plus footage of cultural performances.

PERMANENT COLLECTION

Collection under development.

Admission: Adults, $5; seniors, students and children, $2.50; members, free. Sunday and 5:30–8:30 p.m. the third Thursday of each month, free.

Hours: Monday, Thursday and Friday, 10 a.m.–5 p.m.; Saturday and Sunday, 11 a.m.–6 p.m. Closed Tuesday, Wednesday and major holidays.

Courtesy of Museum for African Art.
Helmet Mask.

MoMA QNS
See Museum of Modern Art in New York

Isamu Noguchi Garden Museum

36-01 43rd Avenue, Second Floor, Long Island City
 (Queens), N.Y. 11101
(718) 204-7088
www.noguchi.org

The museum's home at 32-27 Vernon Boulevard, Long Island City, is closed for a major renovation. The museum is

exhibiting works from the permanent collection at its temporary space on 43rd Avenue and is expected to return to its Vernon Boulevard location by 2004.

2003 EXHIBITIONS

January
The Bolligen Journey
Photographs and drawings that tell the story of Noguchi's travels from 1949 to 1951.

PERMANENT COLLECTION

Works by Noguchi (1904–1988). More than 250 stone, wood and clay pieces, as well as his Akari light sculptures, dance sets and documentation of his gardens and playgrounds.

Admission: $4 suggested donation; students and seniors, $2.
Hours: Monday, Thursday and Friday, 10 a.m.–5 p.m.; Saturday and Sunday, 11 a.m.–6 p.m. Closed Tuesday and Wednesday.

P.S. 1 Contemporary Art Center

22–25 Jackson Avenue, at 46th Avenue, Long Island City (Queens), N.Y. 11101
(718) 784-2084
www.ps1.org

PERMANENT COLLECTION

P.S. 1, an affiliate of the Museum of Modern Art, is a noncollecting institution that maintains long-term, site-specific installations throughout its 125,000 square feet of gallery space by artists including James Turrell, Pipilotti Rist, Richard Serra, Lucio Pozzi, Julian Schnabel and Richard Artschwager. A branch, the Clocktower Gallery at 108 Leonard Street in the TriBeCa section of Manhattan, is open for special shows and events. **Architecture:** Romanesque Revival school building, finished in 1906 and renovated by

Frederick Fisher with the addition of a courtyard and a two-story project space.

Admission: $4 suggested donation; students and seniors, $2; members, free.

Hours: Wednesday through Sunday, noon–6 p.m. Closed Monday, Tuesday and major holidays.

Storm King Art Center

Old Pleasant Hill Road, Mountainville, N.Y. 10953
(845) 534-3115
www.stormking.org

2003 EXHIBITIONS

Continuing
Grand Intuitions: Calder Monumental Sculpture
Largest exhibition ever of the artist's monumental sculptures, 18 in all.

PERMANENT COLLECTION

A 500-acre outdoor sculpture park and museum featuring post-1945 works, many on a monumental scale. **Highlights:** Isamu Noguchi, *Momo Taro*; Alexander Calder, *The Arch*; Mark di Suvero, *Pyramidian*; Richard Serra, *Schunnemunk Fork*; Louise Nevelson, *City on the High Mountain*; Andy Goldsworthy, *Storm King Wall*; Kenneth Snelson, *Free Ride Home*; Magdalena Abakanowicz, *Sarcophagi in Glass Houses*; 13 sculptures by David Smith. **Architecture:** 1935 Normandy-style museum building by Maxwell Kimball.

Admission: $9; seniors, $7; students, $5; members and children under 5, free.

Hours: April 1–October 27, daily, 11 a.m.–5:30 p.m.; October 28–November 15, 11 a.m.–5 p.m. Closed November 16–March 31.

American Craft Museum

40 West 53rd Street, New York, N.Y. 10019
(212) 956-3535
www.americancraftmuseum.org

2003 EXHIBITIONS

Through January 5
Elegant Fantasy: The Jewelry of Arline Fisch

January 17–March 23
Tapio Wirkkala: Eye, Hand and Thought
Retrospective that celebrates the Finnish industrial designer
(1915–1985), who specialized in anonymous utility objects,
including bank notes and vodka bottles.

April 3–June 8
Stanislav Libensky and His Students
Glassworks created by the Czech painter with his wife, the
sculptor Jaroslava Brychtová, and his students.

June 19–September 28
Design, 1975–2000
Works by 35 glass artists from around the world.

October 9–January 18, 2004
Body and Soul: Fiber as Metaphor
New works created by 50 international artists exploring the
use and potential of fiber as a metaphor for the human body
and spirit.

PERMANENT COLLECTION

Handcrafted 20th- and 21st-century works in the fields of
craft, decorative arts and design.

Frank O. Gehry, *Bubbles Chaise Lounge*, 1979-82.

Courtesy of the American Craft Museum.

Admission: $8; students and seniors, $5; members and
children under 12, free. Thursday, 6–8 p.m., pay what you
wish.
Hours: Daily, 10 a.m.–6 p.m.; Thursday, until 8 p.m. Closed
major holidays.

American Folk Art Museum

45 West 53rd Street, New York, N.Y. 10019
(212) 265-1040
www.folkartmuseum.org

2003 EXHIBITIONS

January 22–April 20
Adolf Wölfli
Approximately 100 works by the Art Brut practitioner.

May 8–September 14
A Perfect Game: Folk Artists Look at Baseball
Trade figures and signs, weather vanes, textiles, toys,
presentation bats and score cards, as well as contemporary
depictions of ballgames.

September–December
Tools of Her Ministry: The Art of Sister Gertrude Morgan
A retrospective devoted to the painter and street missionary.

PERMANENT COLLECTION

More than 4,500 works from the 18th, 19th, 20th and 21st
centuries. Traditional folk paintings; sculpture, including
weather vanes, carousel animals and shop figures; painted and
embellished furniture; pottery; decorative objects; and works
by contemporary and self-taught artists from the United States
and abroad. **Highlights:** *Girl in Red Dress With Cat and Dog* by
the 19th-century folk painter Ammi Phillips; *Bird of Paradise,*
a circa 1860 quilt; *St. Tammany*, a nine-foot-high molded
copper weather vane; *Episode 3 Place Not Mentioned/Battle Scene
and Approaching Storm,* a double-sided painting by the 20th-
century self-taught artist Henry Darger. **Architecture:** The

museum's new home is a 30,000-square-foot building by Tod Williams, Billie Tsien Architects.

Admission: $9; students and seniors, $5; members and children under 12, free. Friday, 6–8 p.m., free.
Hours: Tuesday through Sunday, 10 a.m.–6 p.m., Friday, until 8 p.m. Closed Monday.

Eva and Morris Feld Gallery at Lincoln Square

2 Lincoln Square, New York, NY 10023
(212) 595-9533
www.folkartmuseum.org

2003 EXHIBITIONS

Through June
Jacob Kass: Painted Saws
Sixty saws with vignettes of landscapes and cityscapes.

Admission: Free.
Hours: Tuesday through Sunday 11 a.m.–7:30 p.m. Monday, 11 a.m.–6 p.m.

Asia Society

725 Park Avenue, New York, N.Y. 10021
(212) 327-9273
www.asiasociety.org

2003 EXHIBITIONS

Through January 5
The Native Born: Contemporary Aboriginal Art From Ramingining, Australia
Sculptures and paintings by Australian Aboriginal artists from a small settlement in northern Australia known for its arts

community, with a focus on the relationship between the people and the land.

Through February 9
China Refigured: The Art of Ah Xian
Porcelain busts decorated with traditional Chinese motifs and patterns made by a Chinese artist between 1998 and 2001.

February 5–May 11
Montien Boonma: Temple of the Mind
More than 70 works by a Thai artist, tracing his artistic development and the influence of Buddhism on his art.

March 11–August 17
Buddhist Visions From the Golden Land: Burmese Lacquer Art
Explores the role of lacquer as a medium in Burmese Buddhist art.

June 4–August 31
The Art of Mu Xin: Landscape Paintings and Prison Notes
Landscape paintings and inscribed sheets created by a Chinese artist while imprisoned during the Cultural Revolution.

September
Hunt for Paradise: Court Arts of Safavid Iran, 1501–1576
Explores the origins of the Safavid style through carpets, ceramics, metalwork, lacquer and the book arts.

PERMANENT COLLECTION

One of the leading collections of Asian art in the United States, donated by John D. Rockefeller 3rd, including Chinese and Japanese metalwork, ceramics and lacquer; South and Southeast Asian sculpture in metal and stone; scroll paintings, prints and miniatures. **Architecture:** Granite building designed by Edward Larrabee Barnes; 2001 redesign by Bartholomew Voorsanger.

Admission: Adults, $7; seniors and students, $5; members and persons under 16, free. Free on Friday, 6–9 p.m.
Hours: Tuesday through Sunday, 11 a.m.–6 p.m.; Friday, until 9 p.m. Closed Monday and major holidays.

Cooper-Hewitt, National Design Museum

Smithsonian Institution, 2 East 91st Street, New York,
N.Y. 10128
(212) 849-8400
www.ndm.si.edu

2003 EXHIBITIONS

Through March 2
New Hotels for Global Nomads
Combining architecture, interior design, photography, film
and works of art, the exhibition showcases more than 35 real
and conceptual examples of modern hotels and their services,
as well as legendary historic hotels.

PERMANENT COLLECTION

The only American museum devoted exclusively to design,
with more than 250,000 items, including drawings, prints,
textiles, furniture, metalwork, ceramics, glass, wallcoverings
and woodwork spanning 3,000 years and cultures from around
the world; a 60,000-volume library includes 5,000 rare books.
Architecture: Landmark 1902 Andrew Carnegie mansion by
Babb, Cook and Willard.

Admission: $8; students and seniors, $5; members and
children under 12, free. Tuesday, 5–9 p.m., free.
Hours: Wednesday through Saturday, 10 a.m.–5 p.m.;
Tuesday, until 9 p.m.; Sunday, noon–5 p.m. Closed Monday
and federal holidays.

The Dahesh Museum of Art

601 Fifth Avenue, New York, N.Y. 10017
(212) 759-0606
www.daheshmuseum.org

2003 EXHIBITIONS

January–May
From Vernet to Gérôme
Works from the museum's collection, with an emphasis on new acquisitions, exploring the themes of religion, literature, orientalism and sculpture.

Summer
Masterpieces by Léon Bonnat From the Collection of the Musée Bonnat, Bayonne
Paintings by the portraitist (1833–1922).

Courtesy of the Dahesh Museum.
Jean-Léon Gérôme: *"Bethsabée,"* c. 1895.

PERMANENT COLLECTION

European academic art from the 19th and early 20th centuries. **Highlights:** Works by William Bouguereau, Lord Leighton and Alexandre Cabanel.
Architecture: 1911 commercial building.

Admission: Free.
Hours: Tuesday through Saturday, 11 a.m.–6 p.m. Closed Sunday, Monday, New Year's Day, Independence Day, Thanksgiving and Christmas Day.

Dia Center for the Arts

548 West 22nd Street, New York, N.Y. 10001
(212) 989-5566
www.diacenter.org

2003 EXHIBITIONS

Through March
Diana Thater: Knots and Surfaces
Large-scale, multiprojection video installation.

New York

Through June 21
Jo Baer: Reconciliation Withheld
Some 20 works from 1962 to 1975, when Baer lived in New York City.

Through June 21
Jorge Pardo and Gerhard Richter
An installation that interweaves Richter's window panes, mirrors and reflective aluminum sphere into Pardo's glass-and-tile redesign of Dia's ground floor.

Through the fall
Rosemarie Trockel
Video projections connected by cantilevered aluminum walls.

Opening in March
Robert Whitman
Retrospective of the performance artist's career, including sculpture that incorporates projected film, a laser work from 1967, graphic drawings, a multiprojection film installation and a new presentation of a 1965 performance.

PERMANENT COLLECTION

Works by artists who came to maturity in the 1960's and 70's, including Joseph Beuys, John Chamberlain, Walter De Maria, Dan Flavin, Donald Judd, Imi Knoebel, Blinky Palermo, Fred Sandback, Cy Twombly, Andy Warhol and Robert Whitman.
Architecture: Industrial spaces renovated by Richard Gluckman Architects: a four-story warehouse at 548 West 22nd Street and a one-story garage at 545 West 22nd Street.

Admission: $6; students and seniors, $3; members and children under 10, free.
Hours: Wednesday through Sunday, noon–6 p.m. Closed Monday and Tuesday.

Dia: Beacon

3 Beekman Street, Beacon, N.Y. 12508
(212) 989-5566
www.diabeacon.org

PERMANENT COLLECTION

The Beacon branch of the Dia Center for the Arts is scheduled to open in May 2003, with works from the 1960's to the present. **Highlights:** Andy Warhol's 1978 *Shadows,* a multipart work comprising 102 paintings; recent monumental sculptures by Richard Serra; a suite of On Kawara's *Today* paintings. **Architecture:** 1929 printing plant, designed by Louis N. Wirshing Jr., with more than 34,000 square feet of skylights. Renovation by OpenOffice and the artist Robert Irwin. **Hours:** Wednesday through Sunday. Closed Monday and Tuesday.

The Frick Collection

1 East 70th Street, New York, N.Y. 10021
(212) 288-0700
www.frick.org

2003 EXHIBITIONS

Through January 5

Masterpieces of European Painting From The Toledo Museum of Art
Twelve works, by Jacopo Bassano, Paul Cézanne, Gustave Courbet, El Greco, Piero di Cosimo, James Tissot and others.

Through March 23

Anne Vallayer-Coster: Painter to the Court of Marie Antoinette
A retrospective featuring approximately 40 paintings by Vallayer-Coster (1744–1818), plus works by her

Anne Vallayer-Coster, *Bouquet of Flowers in a Blue Porcelain Vase*, 1776.

Courtesy of the Frick Collection.

contemporaries, including Jean-Baptiste-Siméon Chardin and Elisabeth Vigée-Lebrun. (Travels)

April 22–July 13
Whistler, Women and Fashion
Eight full-length portraits of women by James McNeill Whistler, plus watercolors, etchings, lithographs, pastel studies and other works on paper.

October 24–January 4, 2004
The Drawings of François Boucher

PERMANENT COLLECTION

The holdings of a private collector. Works by Bellini, El Greco, Rembrandt, Titian, Turner, Vermeer and Whistler. **Highlights:** Bellini, *St. Francis in Ecstasy*; della Francesca, *St. John the Evangelist*; van Eyck, *Virgin With Child, With Saints and Donor*; Vermeer, *Officer and Laughing Girl*; Holbein, *Sir Thomas More and Thomas Cromwell*; Rembrandt, *Self-Portrait*; Stuart, *George Washington*. **Architecture:** 1913–1914 Gilded Age mansion by Thomas Hastings; 1931–1935 addition by John Russell Pope; 1977 garden by Russell Page.

Admission: $10; students and seniors, $5. Children under 10 are not admitted, and those under 16 must be accompanied by an adult.

Hours: Tuesday through Saturday, 10 a.m.–6 p.m.; Friday until 8:45; Sunday, 1–6 p.m.; Lincoln's Birthday, Election Day and Veterans Day, 1–6 p.m. Closed Monday, New Year's Day, Independence Day, Thanksgiving, Christmas Eve and Christmas Day.

Solomon R. Guggenheim Museum

1071 Fifth Avenue, New York, N.Y. 10128
(212) 423-3500
www.guggenheim.org

2003 EXHIBITIONS

Through January 12
Moving Pictures
Explores a 1960's and 70's trend in which photography and the moving image were absorbed into art. Features works by Vito Acconci and other pioneers, as well as more recent works.

Through January 12
Bill Viola: Going Forth by Day
A projection-based installation that examines cycles of birth, death and rebirth.

January 30–April 27
Boccioni's Materia: A Futurist Masterpiece and the Parisian Avant-Garde
Focuses on *Materia,* a seminal painting by the Italian Futurist Umberto Boccioni, and related works.

February 14–May 11
Matthew Barney: The Cremaster Cycle
A five-part film project accompanied by related sculptures, photographs and drawings.

February–May
Hugo Boss Prize: 2002
Works by the winner of the biennial prize.

May 22–September 4
Kazimir Malevich: Suprematism
About 120 paintings and drawings in which the artist sought to create a pure form of abstract art that was universally comprehensible regardless of culture or ethnicity.

October 2–January 4, 2004
James Rosenquist: A Retrospective
Works by a leading figure in the American Pop art movement who uses advertising images in his large-scale canvases.

PERMANENT COLLECTION

Significant holdings of Brancusi, Chagall, Kandinsky and Picasso, as well as major works by Arp, Beuys, Bourgeois, Cézanne, Flavin, van Gogh, Mapplethorpe, Pollock, Rothko, Rauschenberg, Serra and Warhol. **Architecture:** Landmark 1959 building by Frank Lloyd Wright; 1992 wing by Gwathmey Siegel and Associates.

Admission: $12; students and seniors, $8; children under 12, free. Friday, 6–8 p.m., pay what you wish.

Hours: Sunday through Wednesday, 9 a.m.–6 p.m.; Friday and Saturday, until 8 p.m. Closed Thursday and Christmas Day.

International Center of Photography

1133 Avenue of the Americas, New York, N.Y. 10036
(212) 860-1778
www.icp.org

2003 Exhibitions

Through February 16
Weegee's Trick Photography
Distorted images of Marilyn Monroe, Richard Nixon, the Mona Lisa and other subjects, from the center's collection. The photos, made from the late 1940's to the late 60's, anticipate digitally manipulated images of exaggerated body parts, with multiple eyes and heads and enlarged noses and breasts.

Through February 16
First Photographs: William Henry Fox-Talbot and the Birth of Photography
More than 100 original prints, negatives and daguerreotypes.

February 28–June 8
Bronzeville: Black Chicago in Pictures, 1941–43
More than 120 documentary images of Chicago's South Side, made in the early 1940's by American Farm Security Administration photographers Jack Delano, Russell Lee, Edwin Rosskam and John Vachon.

February 28–June 8
How Human: Life in the Post-Genomic Era
Fifteen contemporary artists from the United States, Europe and Australia explore the ways in which biotechnology discoveries affect our concepts of humanity.

June 20–August 31
Gustav Klutsis and Valentina Kulagina: Between the Public and the Private
Photographs, graphic and exhibition designs, collages and other works by Klutsis and his wife and colleague. Together they pioneered political photomontages in the Soviet Union. Includes personal papers from the 1920's through the late 30's, when Klutsis was executed by the state.

June 20–August 31
Symbolic Logic: The Photographs of Lewis Carroll
Eighty prints by Carroll, the pseudonym used by the Rev. Charles Dodgson. Like Carroll's writing, his photographs are provocative and sometimes troubling explorations of childhood and the imagination.

September 12–November 30
Strangers: Contemporary Photography and Video
Images from around the globe. The first in what is planned as a regular series of triennial exhibitions.

December 12–February 29, 2004
Only Skin Deep: Changing Visions of the American Self
Explores how photography has created and transformed ideas about race and national identity.

PERMANENT COLLECTION

More than 55,000 prints, including works by Berenice Abbott, Cornell and Robert Capa, Alfred Eisenstadt and Weegee, as well as contemporary photographs. **Architecture:** Modern building designed by Gwathmey Siegel and Associates.

Admission: $9; students and seniors, $6; members and children under 12, free; Friday, 5–8 p.m., pay what you wish. **Hours:** Tuesday through Thursday, 10 a.m.–5 p.m.; Friday, until 8 p.m.; Saturday and Sunday, 10 a.m.–6 p.m. Closed Monday, New Year's Day, Independence Day, Thanksgiving and Christmas Day.

The Jewish Museum

1109 Fifth Avenue, New York, N.Y. 10128
(212) 423-3200
www.jewishmuseum.org

2003 EXHIBITIONS

Through January 5
*The City of K: Franz Kafka
and Prague*
Manuscripts, diaries, books
and photographs, enhanced
with audio and video
components, in a series of
installations.

Through March 2
*Adolph Gottlieb: A Survey
Exhibition*
Paintings that demonstrate
Gottlieb's sense of Cubism,
Constructivism and
Surrealism.

Courtesy of the Jewish Museum.
Max Weber, *The Talmudists*, 1934.

February 21–September 14
Entertaining America: Jews, Movies and Broadcasting

October 23–March 2, 2004
Schoenberg, Kandinsky and the Blue Rider
More than 60 paintings by Wassily Kandinsky and Blue Rider
contemporaries, plus letters, photographs and the music of
Arnold Schoenberg and others in the Second Viennese School.
Charts the parallel movements in art (toward abstraction) and
music (toward atonality) in the early part of the 20th century.

Continuing
Culture and Continuity: The Jewish Journey
Art, archaeology, ceremonial objects, video and interactive
media shed light on 4,000 years of history.

PERMANENT COLLECTION

More than 28,000 objects that span 4,000 years, from ancient
artifacts to contemporary art. Includes Israeli archaeological

artifacts; textiles; ceremonial objects; paintings, drawings and prints by Marc Chagall, David Bomberg, Max Weber and Deborah Kass. **Highlights:** George Segal's sculpture *The Holocaust*. **Architecture:** 1908 Warburg mansion by Gilbert; 1959 sculpture court; 1963 List Building; 1993 renovation and expansion by Roche, Dinkeloo and Associates.

Admission: $8; students and seniors, $5.50; children under 12, free. Thursday, 5–8 p.m, pay what you wish.
Hours: Sunday, 10 a.m.–5:45 p.m. Monday through Thursday, 11 a.m.–5:45 p.m.; Thursday, until 8 p.m. Friday, 11 a.m.–3 p.m. Closed Saturday and major legal and Jewish holidays.

The Metropolitan Museum of Art

1000 Fifth Avenue (at 82nd Street), New York, N.Y.
 10028
(212) 879-5500; (212) 535-7710 (recording)
www.metmuseum.org

2003 EXHIBITIONS

Through January 5
Richard Avedon: Portraits
Approximately 180 works, from the photographer's earliest portraits in the late 1940's through his most recent work.

Through January 5
Théodore Chassériau (1819–1856): The Unknown Romantic
A retrospective featuring approximately 50 paintings and 80 works on paper.

Through January 5
Nomadic Art From the Eastern Eurasian Steppes
More than 200 works in bronze, gold and silver, including harness fittings, belt ornaments, garment plaques, weapons, and vessels, from the first millennium B.C. Drawn largely from the collection of Eugene V. Thaw.

Through January 12
The Forgotten Friezes From the Castle of Vélez Blanco
Six pinewood reliefs, each approximately 20 feet long.

Through January 12
Portraits
Forty works representing the first hundred years of photographic portraiture, from early American and French daguerreotypes through the work of Diane Arbus.

Through January 19
French 19th-Century Drawings in the Robert Lehman Collection
Works by Degas, Delacroix, Renoir, Seurat, Signac and others.

Through February 9
Blithe Spirit: The Windsor Set
French couture gowns and formal attire dating from 1935 to 1940, including designs by Coco Chanel, Jeanne Lanvin, Elsa Schiaparelli and Madeleine Vionnet. Features photographs, murals and the Mainbocher gown worn by Wallis Simpson upon her marriage to the Duke of Windsor.

Through February 9
Cultivated Landscapes: Reflections of Nature in Chinese Painting
More than 75 works drawn largely from the museum's holdings and featuring selections from the collection of Marie-Hélène and Guy Weill.

Through February 9
The Janice H. Levin Collection of Impressionist Paintings
Some 35 works that graced Levin's Manhattan apartment, including Monet's views of his garden at Argenteuil and the cliffs at Pourville; pastels and sculpture by Degas; landscapes by Bonnard, Boudin, Pissarro, Renoir, Sisley and Toulouse-Lautrec; and interiors by Morisot and Vuillard.

Through February 16
The Legacy of Genghis Khan: Courtly Art and Culture in Western Asia, 1256–1353
Some 200 objects, equally divided among illustrated manuscripts, the decorative arts and architectural decoration.

Through March 2
The Written Image: Japanese Calligraphy and Painting From the Sylvan Barnet and William Burto Collection
Nearly 60 works. Traces the evolution of Japanese calligraphy from the Nara period (710–784) through the 19th century,

with examples of both the Chinese script (kanji) and the
Japanese script (kana). Also included are Buddhist and Shinto
mandalas and a portrait of a Zen monk.

Through April 13
Genesis: Ideas of Origin in African Sculpture
Forty Chi Wara headdresses as well as 35 works from across
sub-Saharan Africa inspired by myths of origin, including
examples by the Dogon of Mali, the Yoruba of Nigeria, the
Chokwe of Angola and the Ntwane of South Africa.

Through June 29
Arms and Armor for the Permanent Collection
European, Japanese, Islamic and Tibetan acquisitions made
since the reinstallation of the museum's Arms and Armor
Galleries in 1991.

January 14–May 4
African-American Artists, 1929–1945
Prints, drawings and paintings from the museum's collection.
The 75 works are by more than 35 artists, including Romare
Bearden, Palmer Hayden, Lois Mailou Jones, Jacob Lawrence,
Horace Pippin and Bill Traylor. Also included are original
Works Progress Administration prints.

January 14–July 13
Chinese Export Art
More than 60 works from the museum's collection, primarily
highlighting porcelain made for American and European
markets. The objects, dating from the early 16th century to
the late 19th, include bowls, vases, tureens, reverse glass
paintings and an ivory pagoda.

January 22–March 30
Leonardo da Vinci, Master Draftsman
Some 130 drawings that help demonstrate Leonardo's
influence as an artist, scientist, theorist and teacher.

February 4–May 18
Thomas Struth
A retrospective featuring more than 70 photographs by the
contemporary artist, ranging from early black-and-white
cityscapes in the United States and Europe to recent, large-
scale views of jungles and forests in Asia and South America.
Includes the 1978 *Streets of New York* series.

New York

February 11–July 13
Korean Ceramics From the Fitzwilliam Museum at Cambridge University
Nearly 80 works, including many examples of Koryo-period celadon ware, made from 918 to 1392.

February 18–May 25
Italian Manuscripts in the Collection of Robert Lehman

March 4–June 8
Manet/Velázquez: The French Taste for Spanish Painting
Some 150 paintings by masters of Spain's Golden Age (El Greco, Murillo, Ribera, Velázquez and Zurbarán) and the 19th-century French artists they influenced (including Courbet, Degas, Delacroix, Manet and Millet).

April 29–August 3
Goddess

May 8–August 17
In the Beginning: The Art of Mesopotamia's Golden Age
Works by the Sumerians, Trojans and other early urban societies, found mainly in temple, palace and elite burial contexts.

Mid-May–August
Manet's Battle of the Kearsarge and the Alabama

May 20–August 17
The Photographs of Charles Sheeler
A retrospective composed of 140 rare images, from all the artist's major series, including views of barns and skyscrapers, images of American industry shot for Fortune magazine in the 1930's and a group of New York City scenes from the 50's.

May 20–August 17
Charles Sheeler's Contemporaries
Approximately 40 photographs inspired by American cities, machines and European modernism.

June–Early September
Summer Selections: American Drawings and Watercolors

June 26–September 7
Hendrick Goltzius: Prints, Drawings and Paintings
Works by the Mannerist (1558–1617).

September 8–December 14
The Responsive Eye: Ralph T. Coe and the Collecting of American Indian Art
Approximately 200 items, including art of the Northwest, the Northeast and the Great Lakes; archaeological objects from the Southeast and Midwest; beadwork; and baskets.

September 23–January 4, 2004
Sanford Gifford
A 60-painting retrospective of the Hudson River School artist's work.

September 30–January 11, 2004
El Greco
A retrospective encompassing some 70 paintings.

October 15–January 4, 2004
The Art of Oribe and Momoyama Culture

Continuing
Significant Objects From the Modern Design Collection
Approximately 30 works in various media, from the late 19th century to the early 21st.

PERMANENT COLLECTION

One of the world's largest and most comprehensive museums.
Highlights: New Greek Galleries; New Cypriot Galleries; Mary and Michael Jaharis Galleries for Byzantine Art; Temple of Dendur; Chinese Astor Court; American Wing; European Paintings; the Cloisters, in Fort Tryon Park, Manhattan, devoted to medieval art. **Architecture:** Vaux and Mould (1880); Richard Morris Hunt and son (1902); McKim, Mead and White (1911, 1913); Kevin Roche John Dinkeloo and Associates (recent wings).

Admission: $10 suggested donation; seniors and students, $5; children under 12 accompanied by an adult, free.
Hours: Sunday, Tuesday through Thursday, 9:30 a.m.–5:30 p.m.; Friday and Saturday, until 9 p.m. Closed Monday, New Year's Day, Thanksgiving and Christmas Day. The Cloisters: Tuesday through Sunday, November through February, 9:30 a.m.–4:45 p.m.; March through October, until 5:15 p.m.

The Morgan Library

29 East 36th Street, New York, N.Y. 10016
(212) 685-0610
www.morganlibrary.org

2003 EXHIBITIONS

Through January 12
The Thaw Collection: Drawings and Oil Sketches
More than 100 works that have been acquired by Eugene V.
and Clare E. Thaw since 1994, including examples by
Carpaccio, Degas, Morandi, Palmer, Redon and Seurat.

January–April
Picturing Natural History: Flora and Fauna in Drawings,
Manuscripts and Printed Books

PERMANENT COLLECTION

Rare books, manuscripts and drawings that focus mainly on
the history, art and literature of Western civilization from the
Middle Ages to the 20th century; drawings by Degas,
Leonardo, Rubens and others. **Highlights:** The ninth-century
Lindau Gospels; three copies of the Gutenberg Bible; the
Hours of Catherine of Cleves; Dürer's *Adam and Eve*; an
autographed manuscript of Mozart's "Haffner" Symphony;
original manuscripts by Charlotte Brontë and John Steinbeck;
several hundred letters from George Washington and Thomas
Jefferson; the Carter Burden Collection of American Literature
and the Pierre Matisse Gallery Archives.

Admission: $8 suggested donation; students and seniors, $6;
children 12 and under accompanied by an adult, free.
Hours: Tuesday through Saturday, 10:30 a.m.–5 p.m.; Friday,
until 8 p.m.; Saturday, until 6 p.m.; Sunday, noon–6 p.m.
Closed Monday and major holidays.

El Museo del Barrio

1230 Fifth Avenue, New York, N.Y. 10029
(212) 831-7272
www.elmuseo.org

PERMANENT COLLECTION

Some 8,000 objects of Caribbean and Latin American art,
including 20th-century prints, drawings, paintings,
sculptures, installations, photographs, films and videos, as
well as pre-Columbian Taino artifacts. **Architecture:** Neo-
Classical Heckscher Building.

Admission: $5 suggested donation; students and seniors, $3;
members and children under 12 accompanied by adult, free.
Hours: Wednesday through Sunday, 11 a.m.–5 p.m.;
Thursday during the summer, until 8 p.m. Closed Monday,
Tuesday, New Year's Day, Thanksgiving and Christmas Day.

Museum for African Art
See listing under Long Island City

Museum of Modern Art

11 West 53rd Street, New York, N.Y. 10019
(212) 708-9400; (212) 247-1230 (for the deaf)
www.moma.org

While the museum is being renovated, all its exhibitions are
at its temporary home in Long Island City. The museum is
scheduled to return to its Manhattan home in 2005.

PERMANENT COLLECTION

More than 100,000 paintings, sculptures, drawings, prints,
photographs, architectural models and drawings and design
objects as well as some 14,000 films and four million film
stills and more than 200,000 books and periodicals.
Highlights: Cézanne, *The Bather*; Chagall, *I and the Village*;

van Gogh, *Portrait of Joseph Roulin* and *The Starry Night*; Hopper, *House by the Railroad*; Matisse, *The Blue Window*; Mondrian, *Broadway Boogie-Woogie*; Monet, *Waterlilies*; Picasso, *Les Demoiselles d'Avignon* and *Three Musicians*; Rauschenberg, *Bed*; Rousseau, *The Sleeping Gypsy*; sculpture garden. **Architecture:** 1939 building by Goodwin and Stone. New expansion project designed by Yoshio Taniguchi.

MoMA QNS

45-20 33rd Street, at Queens Boulevard,
 Long Island City (Queens), N.Y. 11101
(212) 708-9400; (212) 247-1230 (for the deaf)

2003 EXHIBITIONS

Courtesy of the Museum of Modern Art.
Pablo Picasso, *Bather*, 1908-09.

February 13–May 19
Matisse Picasso
A exploration of the complex relationship between Henri Matisse and Pablo Picasso.

June 26–September 29
Max Beckmann
A retrospective that includes includes Beckmann's paintings, drawings, prints and sculpture.

July 10–November 3
Ansel Adams at 100
More than 100 prints, some of them unfamiliar.

November 6–February 3, 2004
Armando Reverón
Some 100 works, including paintings, drawings and a small selection of objects made by the Venezuelan modernist.

December 4–February 9, 2004
Kiki Smith: Prints, Books and Things
Approximately 90 contemporary works.

Continuing
To Be Looked At: Selections From the Painting and Sculpture Collection
Key examples from the museum's holdings of midcentury and contemporary art, including van Gogh's *The Starry Night* and Picasso's *Les Demoiselles d'Avignon.*

Admission: Adults, $12; full-time students and seniors, $8.50; children under 16 accompanied by an adult, free. Friday, 4–7:45 p.m., pay what you wish.
Hours: Thursday through Monday, 10 a.m.–5 p.m.; Friday, until 7:45 p.m. Closed Tuesday and Wednesday.

National Museum of the American Indian

George Gustav Heye Center, Smithsonian Institution,
 1 Bowling Green, New York, N.Y. 10004
(212) 514-3700
www.americanindian.si.edu

2003 EXHIBITIONS

Through March 15
Great Masters of Mexican Folk Art From the Collection of Fomento Cultural Banamex
Approximately 200 contemporary works, by artists from all of Mexico's 31 states.

PERMANENT COLLECTION

The Heye center is named for the collector who amassed more than one million Indian artifacts in his travels through the Americas. Wood, horn and stone carvings from the Northwest Coast of North America; Navajo weaving and blankets; archaeological objects

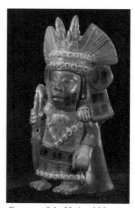

Courtesy of the National Museum of the American Indian. Mixteca/Puebla style painted ceramic figurine, A.D. 900–1521.

from the Caribbean; textiles from Peru and Mexico; basketry from the Southwest; gold works from Colombia, Mexico and Peru; Aztec mosaics; painted hides and garments from the North American Plains Indians. **Architecture:** Landmark 1907 Beaux-Arts building by Cass Gilbert, originally the Alexander Hamilton U.S. Custom House.

Admission: Free.
Hours: Daily, 10 a.m.–5 p.m.; Thursday, until 8 p.m. Closed Christmas Day.

New Museum of Contemporary Art

583 Broadway, New York, N.Y. 10012
(212) 219-1222
www.newmuseum.org

2003 EXHIBITIONS

Through January 19
Nalini Malani: Hamletmachine
Four video projections that recontextualize words from the late German writer Heiner Mueller's play of the same name.

Through February 2
Carroll Dunham
More than 40 paintings and drawings by an American whose work combines biomorphism, cartooning and figuration.

February 23–April 13
Digital Architecture
Projects by architects who have charted new directions. Includes user-navigable digital tours of spaces as well as drawings and models.

February 23–June 15
Living Inside the Grid
Several large-scale installations, plus paintings, sculpture, video and digital works by 22 artists from around the globe who are examining the challenges of living in a world increasingly driven by technology.

May 7–June 29
Jun Nguyen-Hatsushiba
A video installation, *Memorial Project Nha Trang, Vietnam*, plus a new work.

July 3–September 21
José Antonio Hernández Diez
Ten major works by the Venezuelan artist, who addresses cultural clichés. Includes *Soledad Miranda*, giant fingernails made from fiberglass.

Continuing
Jason Middlebrook: Dig
Fake layers of earth, stones, plants and roots come together to mimic an excavation site — as if a hole were cut directly through the museum floor, revealing the ground beneath.

Admission: Adults, $6; students and seniors, $3; children under 19, free. Thursday, 6–8 p.m., $3.
Hours: Tuesday through Saturday, noon–6 p.m.; until 8 p.m., Thursday. Closed Monday.

Studio Museum in Harlem

144 West 125th Street, New York, N.Y. 10027
(212) 864-4500
www.studiomuseuminharlem.org

2003 EXHIBITIONS

Through January 5
Gary Simmons
Erasure drawings on paper, canvas and blackboard, as well as two new large-scale sculptures, photographs, videos and a site-specific wall drawing.

January 29–March 30
The Challenge of the Modern: African-American Artists, 1925–45
Approximately 75 paintings, drawings, sculptures, photographs and related documentary materials. Includes works by Romare Bearden, Aaron Douglass, Palmer Hayden and Sargeant Johnson.

April 23–July 29
Frederick J. Brown: Portraits in Jazz, Blues and Other Icons
Forty paintings, depicting Stagger Lee, John Henry, Crazy
Horse, Geronimo, Martin Luther King and others.

Summer
Harlem Envisioned
Contemporary African-American architects present ideas and
proposals for multiple sites around Harlem.

Summer
From the Studio: Artists in Residence, 2002–03
Annual exhibition.

PERMANENT COLLECTION

Traditional and contemporary African art and artifacts, 19th-
and 20th-century African-American art and 20th-century
Caribbean art. **Highlights:** Works by Romare Bearden,
Elizabeth Catlett, Jacob Lawrence and Norman Lewis; the
James Van Der Zee photographic archives. **Architecture:**
19th-century building renovated by Max Bond in 1982;
extensive renovations 1998–99.

Admission: Adults, $5; seniors and students, $3; children
under 12, $1; members, free. Free the first Saturday of each
month.
Hours: Wednesday through Friday, noon–6 p.m.; Saturday 10
a.m–6 p.m.; Sunday, noon–6 p.m. Closed Monday, Tuesday
and major holidays.

Whitney Museum of American Art

945 Madison Avenue, New York, N.Y. 10021
(212) 570-3676; (877) WHITNEY
www.whitney.org

2003 EXHIBITIONS

Through January 5
Sanctuaries: John Hejduk
A tribute to the architect and designer, who died in 2000.

Through January 12
New Photographic Works by Lorna Simpson

Through January 19
Images Between Images: The Film Works of Lorna Simpson
Works that reveal the importance of Jean-Luc Godard, Chantal Akerman and other filmmakers in shaping Simpson's approach to narrative and the moving image.

Through March 2
The Quilts of Gee's Bend
Some 70 quilts made between the 1920's and the 90's by the women of a small Alabama town.

March–July
Elie Nadelman
A retrospective of the sculptor's bronze, marble, wood and plaster figures, demonstrating his embrace of American folk art.

August–November
Ellsworth Kelly: Red Green Blue

PERMANENT COLLECTION

Some 12,000 works representing more than 1,900 artists — especially 20th-century and contemporary American art.
Highlights: The artistic estate of Edward Hopper; significant works by Calder, Gorky, Hartley, Johns, Marsh, O'Keeffe, Rauschenberg and others. **Architecture:** 1966 building by Marcel Breuer.

Admission: Adults, $10; seniors and students, $8; members and children under 12, free. Friday, 6–9 p.m., pay what you wish.
Hours: Tuesday through Thursday and Saturday and Sunday, 11 a.m.–6 p.m.; Friday, 1–9 p.m. Closed Monday.

New York/Purchase

Whitney Museum of American Art at Philip Morris

120 Park Avenue at 42nd Street, New York, N.Y. 10017
(917) 663-2453

2003 EXHIBITIONS

Through January 4
Alex Katz: Small Paintings
Approximately 75 works, from the mid-1950's to the present.

Admission: Free.
Hours: Gallery: Monday through Friday, 11 a.m.–6 p.m.;
Thursday, until 7:30 p.m. Sculpture court: Monday through
Saturday, 7:30 a.m.–9:30 p.m.; Sunday and holidays, 11 a.m.–7
p.m.

Neuberger Museum of Art

Purchase College, State University of New York,
 735 Anderson Hill Road, Purchase, N.Y. 10577
(914) 251-6100
www.neuberger.org

2003 EXHIBITIONS

January 12–March 23
*Hannelore Baron: Works
From 1969 to 1987*
More than 40 collages and
assemblages by a self-
taught artist.

January 12–August 3
Milton Avery
Twenty-five figurative
works and landscapes from
the museum's collection.
The exhibition documents
the painter's development
from 1929 to 1961.

Courtesy of the Neuberger Museum of Art.
Milton Avery, *Cello Player in Blue*, 1944.

January 26–April 13
Andy Goldsworthy: Three Cairns
Large-scale photographs and site-specific works by a British
environmental artist who uses local and natural materials.

May 4–July 20
Alexander Rodchenko: Modern Photography, Photomontage and Film
Portraits of the artist's contemporaries during the years of the
Russian avant-garde.

May 4–August 17
Tobi Kahn: Sea and Sky
Sky and water paintings embodying a range of emotions.

August 13–November 16
Murray Zimiles: Twenty-Five-Year Retrospective
Works by a Purchase College professor, including his *Artist in
the Studio, The Holocaust* and *The Animal* series.

June 15–September 7
Biennial Exhibition of Public Art
Works by artists nationwide.

Continuing
Selections From the Roy R. Neuberger Collection
More than 60 pieces of American art, including works by
Avery, Diebenkorn, Frankenthaler, Hartigan, Hopper,
Noguchi and Pollock.

Continuing
African Art
Forty-four objects from the museum's collection, including
masks and figures from western and central Africa.

PERMANENT COLLECTION

Major holdings of 20th-century European and American art,
African art and ancient art. More than 6,000 paintings,
sculptures, prints, photographs and works on paper, including
works by Avery, Bearden, Diebenkorn, Frankenthaler, Graves,
Hopper, de Kooning, Lawrence, O'Keeffe, Pollock and
Rothko; works in the constructivist tradition; outdoor
sculpture, including works by Andy Goldsworthy, Robert
Indiana and Henry Moore. **Architecture:** 1974 building by
Philip Johnson and John Burgee.

Admission: $4; seniors and students, $2; children under 13,
free.

Hours: Tuesday through Friday, 10 a.m.–4 p.m.; Saturday and Sunday, 11 a.m.–5 p.m. Closed Monday and major holidays.

Memorial Art Gallery of the University of Rochester

500 University Avenue, Rochester, N.Y. 14607
(585) 473-7720
mag.rochester.edu

2003 EXHIBITIONS

Through January 5
Degas in Bronze
Little Dancer and 73 other sculptures, plus selected paintings and works on paper.

Through May 27
About Face: Copley's Portrait of a Colonial Silversmith
An interactive installation in which families can learn about the artists John Singleton Copley and Nathaniel Hurd, who lived through the Boston Massacre. Not recommended for children younger than 7.

April 13–June 22
Leaving for the Country: George Bellows at Woodstock
More than 50 works Bellows created during the last five summers of his life while at the Woodstock, N.Y., artists'

George Bellows, *Autumn Brook*, 1922.

Courtesy of the Memorial Art Gallery of the University of Rochester.

colony. Includes Hudson Valley landscapes and portraits of
friends and family.

August 3–October 5
Rochester-Finger Lakes Exhibition
The 59th biennial juried show.

October 26–January 4, 2004
Modern Masters: From Corot to Kandinsky

Continuing
New Acquisitions for a New Millennium
Two dozen works, including a Walter Goodman painting, a
Dale Chihuly glass sculpture and the coffin of an Egyptian
nobleman from the fourth century B.C.

PERMANENT COLLECTION

Some 10,000 works spanning 50 centuries, including works
by Monet, Cézanne, Matisse, Homer, Cassatt, Wendell Castle,
Albert Paley and Helen Frankenthaler. **Architecture:** 1913
neo-Renaissance building by Foster, Gade and Gram; 1927
addition by McKim, Mead and White; 1987 sculpture
pavilion by Handler, Grosso.

Admission: Adults, $7; students and senior citizens, $5;
children 6–18, $3; members and children under 6, free.
Thursday, 5–9 p.m., $2.
Hours: Tuesday, noon–4 p.m.; Wednesday through Saturday,
10 a.m.–4 p.m.; Thursday until 9 p.m.; Saturday until 5 p.m.;
Sunday, noon–5 p.m. Closed Monday, Independence Day,
Christmas Day and New Year's Day.

The Tang Teaching Museum and Art Gallery

815 North Broadway, Saratoga Springs, N.Y. 12866
(518) 580-5069
www.skidmore.edu/tang

2003 EXHIBITIONS

Through January 7
Fred Wilson, Objects and Installations, 1985–2000
Mock museum installations that explore how museums consciously or unconsciously perpetuate racist beliefs. (Travels)

January 18–June 1
Kara Walker: Narratives of a Negress

February 1–June 1
Trisha Brown: Dance and Art in Dialogue, 1965–2000

June 21–October 5
Marcel Duchamp and the Handmade Readymade

June 21–December
Arline Fisch

November–February 2004
Opener 3: Some King of Love — Nayland Blake, Performance Video, 1989–2001

PERMANENT COLLECTION

More than 4,200 works, including extensive print collection featuring works by Rembrandt, Whistler, Dürer, Warhol, Dufy, Kandinsky and Motherwell; pre-Columbian art from Latin America; photography; paintings; sculpture.

Admission: Free.
Hours: Tuesday through Saturday, 11 a.m.–5 p.m. Closed Monday and major holidays.

Munson-Williams-Proctor Arts Institute

310 Genesee Street, Utica, N.Y. 13502
(315) 797-0000
www.mwpi.edu

PERMANENT COLLECTION

More than 25,000 works, mainly American and European paintings and sculptures from the 18th century through the 20th; decorative arts; Western and Asian graphic arts; Asian

and pre-Columbian antiquities. **Highlights:** Proctor watch, thimble, manuscript and rare book collections; Thomas Cole, *The Voyage of Life.* **Architecture:** 1960 gallery building by Philip Johnson with connecting wing to Fountain Elms, a restored 1850 Italianate mansion.

Admission: Free.

Hours: Tuesday through Saturday, 10 a.m.–5 p.m.; Sunday, 1–5 p.m. Closed Monday, New Year's Day, Thanksgiving and Christmas Day.

North Carolina

Mint Museum of Art

2730 Randolph Road, Charlotte, N.C. 28207

(704) 337-2000

www.mintmuseum.org

2003 EXHIBITIONS

Through January 26

Furniture of the American South, 1680–1830: The Colonial Williamsburg Collection

Fifty-two examples of Southern furniture from Colonial Williamsburg, which has the nation's largest collection.

March 1–May 25

Hopper: The Paris Years

Paintings and works on paper created during three trips to Paris between 1906 and 1910.

November 2–January 25, 2004

Raphael to Monet: European Masterworks From the Walters Art Museum

Fifty-five masterpieces from the Baltimore museum, including works by Raphael, Brueghel the Younger, Van Dyck, Millet, Manet, Monet, Sisley and Degas.

PERMANENT COLLECTION

American and European paintings, furniture and decorative arts; African, pre-Columbian and Spanish Colonial art; porcelain and pottery; regional crafts; historic costumes.
Architecture: The 1836 building was originally the first branch of the United States Mint.

Admission: Adults, $6; students and seniors, $5; children 6–11, $2.50; members and 5 and under, free. Group rates are available.
Hours: Tuesday, 10 a.m.–10 p.m.; Wednesday through Saturday, 10 a.m.–5 p.m.; Sunday, noon–5 p.m. Closed Monday, Thanksgiving Day, Christmas Eve, Christmas Day and New Year's Day.

Mint Museum of Craft + Design

220 North Tryon Street, Charlotte, N.C. 28202
(704) 337-2000
www.mintmuseum.org

2003 EXHIBITIONS

Through February 23
Point of View: Public and Private Collecting, Part I
A look at how materials, techniques and themes guide collectors in their quest to shape meaningful collections.

March 15–July 27
Point of View: Public and Private Collecting, Part II

May 10–August 3
Raymon Elozua
First retrospective of the artist's work, including ceramics, photographs and three-dimensional computer-generated art and sculpture.

PERMANENT COLLECTION

Traces the development of craft from utilitarian objects of America's 19th-century rural economy to the contemporary art of today's studio craft. Includes objects made of ceramics, fiber, glass, metal and wood.

Admission: Adults, $6; students and seniors, $5; children 6–11, $2.50; members and children 5 and under, free.
Hours: Tuesday through Saturday, 10 a.m.–5 p.m.; Sunday, noon–5 p.m. Closed Monday, Thanksgiving, Christmas Eve, Christmas Day and New Year's Day.

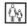 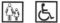

The Weatherspoon Art Museum

University of North Carolina at Greensboro, Spring Garden and Tate Streets, Greensboro, N.C. 27402
(336) 334-5770
www.uncg.edu/wag

2003 EXHIBITIONS

Through January 19
Art on Paper 2002
Works by emerging and established artists from throughout the United States and a juried selection of North Carolina artists.

Through February 16
The Cone Family Legacy: Selected Gifts to the Weatherspoon Art Museum
Includes works from the 240 prints and drawings, among them 67 by Matisse, given to the museum by the Cone family.

January 12–March 9
Jane Hammond: Falk Visiting Artist

February 9–April 20
Seeing and Believing: The Art of Nancy Burson
Photographs, drawings and computer installations that explore the nature of perception, identity, beauty and race in an age of digital technology and genetic engineering. (Travels)

March 2–May 11
Georgia O'Keeffe in Southern Collections
About 10 paintings by the artist.

Greensboro/Raleigh

March 2–May 11
Women Artists in the Permanent Collection
Works by female artists influenced by Georgia O'Keeffe.

May 11–August 3
One Word: Plastic

June 15–August 17
There Is No Eye: John Cohen
Photographs of New York City in the 1950's, the Beats, Peru and rural life in the American South, among other subjects.

August 17–December 21
American Art, 1900–1960

PERMANENT COLLECTION

More than 5,000 works, primarily contemporary American art. Includes works by Willem de Kooning, Robert Rauschenberg, Eva Hesse, Sol LeWitt, Robert Colescott, Mel Chin, Alex Katz, Jagdalena Abakanowicz and Alison Saar.
Highlights: Dillard Collection of Art on Paper; the Claribel and Etta Cone Collection of prints and bronzes by Henri Matisse; the Lenoir C. Wright Collection of Japanese woodblock prints; a sculpture courtyard; a site-specific sculptural frieze by Tom Otterness. **Architecture:** 1989 building by Ronaldo Giurgola.

Admission: Free.
Hours: Tuesday through Friday, 10 a.m.–5 p.m.; Thursday, until 9 p.m.; Saturday and Sunday, 1–5 p.m. Closed Monday.

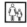 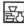

The North Carolina Museum of Art

2110 Blue Ridge Road, Raleigh, N.C. 27607
(919) 839-6262
www.ncartmuseum.org

2003 EXHIBITIONS

Through January 5
Jan Miense Molenaer: Painter of the Dutch Golden Age
About 45 paintings from the 1660's, both better-known and little-known works.

Through February 23
Dutch Biblical Paintings and *Rembrandt Etchings*
Selection of 17th-century Dutch biblical paintings and etchings by Rembrandt, some of biblical scenes.

February 23–May 11
Augustus Stain-Gaudens: A Master of American Sculpture
More than 100 works, both in cast bronze and numerous studies, by a preeminent sculptor of the Gilded Age.

April 6–August 10
Accent on Africa: Recent Acquisitions
New acquisitions of historical and contemporary African art.

October 19–February 22, 2004
Defying Gravity
About 70 works of art created during the last 25 years, exploring how aerial perspective has affected contemporary art.

PERMANENT COLLECTION

Spanning more than 5,000 years, from ancient Egypt to the present. Egyptian, Classical, European, American, African, Ancient American, Oceanic and Jewish ceremonial art.
Highlights: European paintings and sculpture from the Renaissance through Impressionism. **Architecture:** 1983 building by Edward Durell Stone and Associates, New York, and Holloway-Reeves, Raleigh.

Admission: Free; fees for some exhibitions.
Hours: Tuesday through Saturday, 9 a.m.–5 p.m.; Friday, until 9 p.m.; Sunday, 10 a.m.–5 p.m. Closed Monday, New Year's Day, Martin Luther King Day, Memorial Day, Independence Day, Labor Day, Thanksgiving and Christmas Day.

Winston-Salem

Reynolda House, Museum of American Art

2250 Reynolda Road, Winston-Salem, N.C. 27106
(336) 725-5325; (888) 663-1149
www.reynoldahouse.org

PERMANENT COLLECTION

American art from 1755 to the present, including painting,
sculpture, paper, photography and decorative arts.
Architecture: 1917 country estate of R.J. Reynolds, founder
of Reynolds Tobacco Company, designed by Charles Barton
Keen.

Admission: Adults, $6; seniors, $5; students and children,
free.
Hours: Tuesday through Saturday, 9:30 a.m.–4:30 p.m.;
Sunday, 1:30–4:30 p.m. Closed Monday, New Year's Day,
Thanksgiving and Christmas Day.

Southeastern Center for Contemporary Art

750 Marguerite Drive, Winston-Salem, N.C. 27106
(336) 725-1904
www.secca.org

2003 EXHIBITIONS

Through January 12
Yoko Ono: EN/TRANCE
A large, roomlike, minimalist sculpture that allows the
audience to investigate its numerous openings.

Through January 12
Picture Show
Second of a three-part series exploring the relationship of film
and photography, this time focusing on the actor.

January 25–April 13
Bonk Business, Inc.

Gregory
Barsamian,
The Scream.

Courtesy of the Southeastern Center for Contemporary Art.

Using hoax, simulation and artificial devices, this exhibition traces the 150-year history of Bonk Business, Inc.

January 25–April 13
Southern Pinhole Photography
Works created by Southern artists using pinhole photography.

May 2–July
Homegrown
Works by North Carolina artists, filmmakers and writers.

May 2–July 6
Home House Project Design Invitational
A joint project with Habitat for Humanity and architects nationwide to design and build creative housing.

Admission: Adults, $5; students and seniors, $3; members and children under 12, free.
Hours: Tuesday through Saturday, 10 a.m.–5 p.m.; Sunday, 2–5 p.m. Closed Monday and national holidays.

 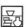

Ohio

Cincinnati Art Museum

953 Eden Park Drive, Cincinnati, Ohio 45202
(513) 639-2995
www.cincinnatiartmuseum.org

A new Cincinnati Wing opens in the spring of 2003.

2003 EXHIBITIONS

Through January 5
Uncommon Legacies: Native American Art From the Peabody Essex Museum
About 120 works by Native American artists working in the early to mid-19th century.

Through January 12
The Golden Age of Costume and Set Design for the Ballet Russe de Monte Carlo, 1938–1944
More than 100 designs for costumes and sets for the ballet.

Through March 30
A Window on the Past: Early Native American Dress From the John Painter Collection
More than 60 objects reflecting Native American craftsmanship, including a Cree hide costume, consisting of matching coat, leggings and mittens, from around 1780.

Through March 30
Ay-O Rainbow Prints
Color screen prints by a leading Japanese artist who uses vivid rainbow colors.

February 1–April 27
Panoramic Ohio: Photographs by Thomas R. Schiff
In celebration of Ohio's bicentennial, color panoramic images of cities, towns and villages in Ohio.

April 5–September 21
Out at Home! The Negro Baseball League by Joseph Norman
Nine lithographs that use a baseball and bat impaled with

Courtesy of the Cincinnati Art Museum.
Joseph Henry Sharp, *Fountain Square Pantomime*, 1892.

bent screws and nails and seized by chains and rope as
metaphors for lynching, chain gangs and segregation.

Opening May 3
The Cincinnati Wing: The Story of Art in the Queen City
Opening of an 18,000-square-foot space for permanent
installations and rotating exhibitions telling the story of
Cincinnati art from 1788 to the present. Includes more than
400 sculptures, paintings and decorative arts from the
permanent collection.

May 17–August 3
*Making Their Mark: Drawings and Watercolors by Cincinnati
Artists*
Some 100 drawings, watercolors and pastels from the
museum's collection, spanning 173 years.

June 19–September 14
*A Brush With Nature: The Gere Collection of Landscape Oil
Sketches*
Small-scale landscape oil sketches by Europeans from the 17th
to 19th centuries intended to hone the artist's skills. (Travels)

July 19–October 12
The Editorial Eye: Cartoons by Jim Borgman & Jeff Stahler
Recent editorial cartoons by Jim Borgman of The Cincinnati
Enquirer and Jeff Stahler of The Cincinnati Post.

October 12–January 4, 2004
*A Separate Sphere: Dressmakers in Cincinnati's Golden Age,
1877–1922*
A look at the fashions and lives of Cincinnati's women
couturiers.

PERMANENT COLLECTION

Ancient art of Egypt, Greece and Rome; Near and Far Eastern
art; furniture, glass and silver; paintings by Titian, Hals,
Rubens, Gainsborough and other European Old Masters;
19th-century works by Cézanne, van Gogh, Cassatt and
Monet; 20th-century works by Picasso, Modigliani, Miró and
Chagall; American works by Cole, Wyeth, Wood, Hopper and
Rothko. **Highlights:** The Herbert Greer Rench collection of
Old Master prints; European and American portrait minia-
tures. **Architecture:** 1886 Romanesque building by James
MacLaughlin; early 1890's Greek Revival addition by Daniel

Cincinnati

Burnham; 1930 Beaux-Arts wings by Garber and Woodward; 1937 addition by Rendings, Panzer and Martin; 1965 International Style addition by Potter, Tyler, Martin and Roth; 1993 renovation by Glaser and Associates.

Admission: Adults, $5; seniors and students, $4; children under 18, free; Saturday, donation suggested. Additional fees for some exhibitions.
Hours: Tuesday, Thursday and Friday, 11 a.m.–5 p.m.; Wednesday, 11 a.m.–9 p.m.; Saturday, 10 a.m.–5 p.m.; Sunday, noon–6 p.m. Closed Monday, Thanksgiving and Christmas Day.

The Contemporary Arts Center

115 East Fifth Street, Cincinnati, Ohio 45202
(513) 345-8400
www.spiral.org

The center is moving into a new space in the spring of 2003.

2003 EXHIBITIONS
Through January 5
Loop
Works by 18 artists who use the loop — a repeated gesture or event — as metaphor and as a basis for investigating our perceptions of time.

Through May 24
The Architecture of Zaha Hadid
Drawings and models of the architect's design for the new museum.

Admission: Adults, $3.50; students and seniors, $2; children under 12 and members, free. Free on Monday.
Hours: Monday through Saturday, 10 a.m.–6 p.m.; Sunday, noon–5 p.m.

Contemporary Arts Center at the Lois & Richard Rosenthal Center for Contemporary Art

44 East 6th Street, Cincinnati, Ohio 45202

2003 EXHIBITIONS

May 23–November 9
Somewhere Better Than This Place: Alternative Social Experience in the Spaces of Contemporary Art
Works by artists who explore the potential of a contemporary arts museum as a "heterotopia," a place where troubling aspects of a dominant culture are represented and critiqued.

Architecture: New 85,000-square-foot building designed by Zaha Hadid.

Admission: To be decided.
Hours: Monday and Friday, 11 a.m.–9 p.m.; Tuesday through Thursday and Saturday, 11 a.m.–6 p.m.; Sunday, noon–6 p.m.

Taft Museum of Art

316 Pike Street, Cincinnati, Ohio 45202
(513) 241-0343
www.taftmuseum.org

The museum is closed for renovation and expansion and is scheduled to reopen in the summer of 2003.

PERMANENT COLLECTION

Old Master paintings; Chinese ceramics from the Qing dynasty; French Renaissance Limoges enamels; antique watches. **Highlights:** Gothic ivory virgin and child from the Abbey Church of St. Denis; Turner, *Europa and the Bull;* Whistler, *At the Piano;* Rembrandt, *Man Rising From His Chair.* **Architecture:** Former Baum-Taft House, circa 1820, a National Historic Landmark house.

OHIO

Cleveland

The Cleveland Museum of Art

11150 East Boulevard, Cleveland, Ohio 44106
(216) 421-7350; (888) 262-0033
www.clevelandart.org

2003 EXHIBITIONS

Through January 5
Elizabeth Catlett: Prints and Sculptures
Fifth prints and 10 sculptures spanning the artist's 70-year career portraying African-American women.

Through January 5
Magna Graecia: Greek Art From South Italy and Sicily
About 80 works of Greek art, including vase painting and sculpture in terracotta, stone and bronze, many of which have never been seen before in the United States. (Travels)

Through January 26
A City Seen: Photographs From the George Gund Foundation Collection
Photographs of the Cleveland area and its people by 12 artists.

Through February 12
Photographs by John Szarkowski
Photographs by the former director of the department of photography at the Museum of Modern Art in New York.

Through February 24
Challenging Structure: Frank Gehry's Peter B. Lewis Building
Working drawings, photographs and models tracing the evolution of the new headquarters of the Weatherhead School of Management at Case Western Reserve University.

Through April 23
Gifts From the CMA Friends of Photography
First of a two-part survey of photographs acquired by the museum in the past decade. The first part will highlight 19th- and early 20th-century photographs.

February 15–April 23
Zwelethu Mthethwa Photographs: Portraits
Portraits of people in their shantytown homes in post-apartheid South Africa.

February 23–May 18
The Gilded Age: Treasures From the Smithsonian American Art Museum
Works from the 1870's to the 1920's by John Singer Sargent, Augustus Saint-Gaudens, Albert Pinkham Ryder and Winslow Homer, among others. (Travels)

April 26–July 2
Tokihiro Sato Photographs
About 20 black-and-white conceptual photographs by a Japanese artist who reflects light into his lens during long timed exposures.

May 25–July 20
The History of Japanese Art Photography, 1854–2000
First exhibition in the West to chronicle Japan's contribution to the history of photography, featuring about 150 images by 60 photographers.

July 5–September 10
Masumi Hayashi: Photographs of Indian Temples
Color images, created during three trips to India from 2000 to 2002, focusing on sites of ancestral worship.

July 6–September 14
The Sensuous and the Sacred: Chola Bronzes From South India
About 60 sculptures produced under the Chola dynasty between the ninth and 13th centuries. (Travels)

October 26–January 11, 2004
Modern Masterworks on Paper From the Collection of Agnes Gund
Works by some of the 20th century's most important artists, including Gorky, Klee, Lichtenstein, Johns, Kelly, Bourgeois, Nauman and Twombly.

October 26–January 11, 2004
Jasper Johns: Numbers
About 25 works from between 1955 and 1963, including his series of paintings of numbers on a rectangular field.

Courtesy of the Cleveland Museum of Art. Jasper Johns, *Ten Numbers* (detail: 2), 1960.

OHIO

Cleveland/Columbus

November 16–January 25, 2004
Time Stands Still: Eadweard Muybridge and the Instantaneous Photography Movement
First comprehensive exhibition on the landmark motion photographs of Muybridge (1830–1904) and the development of instantanous photographs. (Travels)

PERMANENT COLLECTION

Spanning five millennia, collection includes Asian art, with some 4,800 pieces; medieval European art; pre-Columbian art; paintings by Caravaggio, Poussin, Turner, Church, Monet and Picasso. Recent acquisitions include Salvador Dalí's *The Dream*, a large Tang dynasty tomb guardian pair, a Greek bronze statuette of an athlete, Frans Hals's portrait of Tieleman Roosterman, Andy Warhol's *Marilyn x 100* and Louise Bourgeois's *Blind Man's Buff.* **Architecture:** 1916 Beaux-Arts building by Hubbell and Benes; additions by Hays & Ruth (1958), Marcel Breuer (1970) and Peter van Dijk (1984).

Admission: Free; fees for some exhibitions and programs. **Hours:** Tuesday through Sunday, 10 a.m.–5 p.m.; Wednesday and Friday, until 9 p.m. Closed Monday, New Year's Day, Independence Day, Thanksgiving and Christmas Day.

Columbus Museum of Art

480 East Broad Street, Columbus, Ohio 43215
(614) 221-6801; (614) 221-4848 (recording)
www.columbusart.mus.oh.us

2003 EXHIBITIONS

Through 2004
Eye Spy: Adventures in Art
Interactive exhibition for children and families giving a behind-the-scenes look at museums.

Through April 20
Symphonic Poem: the Art of Aminah Robinson
Retrospective of the work of this Ohio African-American artist

236

and book illustrator, featuring more than 100 sculptures, paintings, works on paper, books and journals.

January 11–May 4
Tony Mendoza's World View: Photographs, Videos, Words
Works by an Ohio State University professor.

May 10–September 21
The American Tintype
Examples of this early form of photography, which was invented in 1855 in Ohio.

May 23–August 31
American Expressionism
First major show devoted to American Expressionism in the 1920's through 1940's, which dwelled on issues of social concern such as the marginalized and mistreated.

May 31–August 3 and August 16–October 19
Bringing Modernism Home: Ohio Decorative Arts, 1890–1960
Two-part exhibition showcasing the contributions of Ohio artists to the decorative arts.

September 27–January 11, 2004
From Prairie to Field: Photographs by Terry Evans
Images by a Chicago photographer who has documented prairie environments in North America as well as animal and plant specimens from the Field Museum.

October 12–January 4, 2004
Fabergé's Menagerie: Animal Creations From the Fabergé Workshops
Miniature animals carved from semiprecious stones.

October 12–January 4, 2004
BLACK: Constant Power in 20th-Century Dress
Examines the history of the black dress in the 20th century, including suits from Balenciaga from the 1950's, the "little black dress" and long dresses by Givency and Chanel.

PERMANENT COLLECTION

Impressionist, German Expressionist, Cubist and American Modernist art, including works by Degas, Monet, Matisse, Picasso, Bellows, Demuth, Hopper, Marin and O'Keeffe; contemporary art, including a recent commission by Alison Saar and works by Dale Chihuly, Mark Tasey and Mel Chin; Ross Photography Center; Russell Page Sculpture Garden.

Architecture: 1931 Italian Renaissance revival building;
1974 new wing; 1979 sculpture garden.

Admission: Adults, $6; students, seniors and age 6 and older,
$4; members and children under 6, free. Free on Thursday,
5:30–8:30 p.m.
Hours: Tuesday through Sunday, 10 a.m.–5:30 p.m.;
Thursday, until 8:30 p.m. Closed Monday.

Wexner Center for the Arts

The Ohio State University
1871 North High Street, Columbus, Ohio 43210
(614) 292-3535
www.wexarts.org

Exhibitions for 2003 will be held offsite while the galleries are
renovated.

2003 EXHIBITIONS

**Through October 2004 (outdoors at Ohio State
University campus)**
Notations: Lawrence Weiner
Outdoor project by a conceptualist artist: black brick in a
walkway inlaid with fragmentary statements.

Gregory Green,
*M.I.T.A.R.B.U.
(Mobile Internet,
Television, and
Radio Broadcast
Unit)*, 2000.

Courtesy of the Wexner Center For the Arts.

Through April 20 (at Columbus College of Art & Design)
Away From Home
Group exhibition featuring artists from five continents on the themes of displacement, travel, home and sense of place.

May 2–September 5 (at COSI Columbus)
Hiro Yamagata
High-tech installation featuring changing multicolored display of lights, lasers and reflective surfaces.

PERMANENT COLLECTION

None. Contemporary arts center and laboratory for the arts, with exhibitions, films, performing arts in a variety of venues and educational programs. **Architecture:** 1989 postmodern building by Peter Eisenman and Richard Trott.

The Dayton Art Institute

456 Belmonte Park North, Dayton, Ohio 45405–4700
(937) 223-5277; (937) 223-0800 (recording)
www.daytonartinstitute.org

2003 EXHIBITIONS

Through January 5
Clement Greenberg: A Critic's Collection
The art critic's private collection, which includes 60 paintings, drawings and sculptures by Pollock, Frankenthaler, Noland, Olitski, Caro, Hofmann and others.

Through February 9
Go Figure! Exploring the Human Body in Art
Interactive exhibition with videos and computer programs about the art history of the human figure.

February 8–May 11
Glory of the Silk Road: Art From Ancient China
About 120 objects from China of gold, silver, ceramic, textiles and stone, many never before seen in the United States.

July–September
Orville and Wilbur: The Wright Brothers' Legacy
More than 100 images celebrating the 100th anniversary of the first powered flight. (Travels)

July–September
Soaring: The Sculpture of John Safer
Sculptures in metal, stone and Lucite, including the permanent installation of a monumental sculpture titled *Pathway*.

October 11–January 4, 2004
Glass of the Avant-Garde: From Secession to Bauhaus
More than 200 examples of early modern glass from Europe created between 1900 and 1930, drawn from the National Museum of Decorative Art in Madrid.

PERMANENT COLLECTION

More than 12,000 objects covering 5,000 years of art history. Includes an Asian collection; 17th-century Baroque paintings; 18th- and 19th-century American art; contemporary works.
Architecture: 1930 Italian Renaissance-style building; $17 million renovation and expansion in 1997; Eilleen Dicke Gallery of Glass in 1999.

Admission: Free; fees for some exhibitions.
Hours: Daily, 10 a.m.–5 p.m.; Thursday, until 9 p.m.

Allen Memorial Art Museum

Oberlin College, 87 North Main Street, Oberlin, Ohio
 44074
(440) 775-8665
www.oberlin.edu/allenart

2003 EXHIBITIONS

Through March 9
European Master Drawings From the Allen Memorial Art Museum
More than 90 works from 1500 to 1900 by European artists, including Lippi, Rubens, Delacroix, Degas and Klimt.

January 2–June 9
Chinese and Japanese Art From Antiquity to the Present
Paintings, prints, stone and wood sculptures, bronzes and ceramics in many different genres.

January 2–December 21
Sacred and Noble Patronage: Late Medieval and Renaissance Art
Traces the evolution of patronage from the church to the nobility and merchant class, beginning with early 15th-century Italian gold ground paintings to the Renaissance.

January 2–December 21
From Baroque to Neoclassicism: European Paintings, 1625–1825
Includes works by Giordano, Rubens, Ter Brugghen, Chardin and Hogarth.

January 2–December 21
The First Century of Modern Art in Europe and North America, 1850–1950
Examples from the leading movements, including Realism, the Barbizon and Hudson River Schools, Impressionism, Fauvism, Cubism and Abstract Expressionism.

January 2–December 21
The Object Revisited: Four Centuries of European and American Decorative Arts
Survey of four centuries, starting with Renaissance bronzes and maiolica and ending with Tiffany art glass and Art Deco sculpture.

January 3–June 9
Late Modern and Contemporary Art
Works from 1970 to the present.

PERMANENT COLLECTION

More than 11,000 objects, including 17th-century Dutch and Flemish paintings; European paintings of the late 19th and early 20th centuries; Old Master and Japanese Ukiyo-E prints; contemporary American works. **Highlights:** Monet, *Garden of the Princess;* Rubens, *The Finding of Erichthonius*; Gorgy, *The Plough and the Song*; Modigliani, *Nude With Coral Necklace.* **Architecture:** Landmark 1917 building by Cass Gilbert; 1976 addition by Venturi, Rauch and Associates.

Admission: Suggested donation: $3.

Hours: Tuesday through Saturday, 10 a.m.–5 p.m.; Sunday, 1–5 p.m. Closed Monday and major holidays.

Toledo Museum of Art

2445 Monroe Street, Toledo, Ohio 43620
(419) 255-8000; (800) 644-6862
www.toledomuseum.org

2003 EXHIBITIONS

Through January 5
Virtue and Violence: Portrayals of Lucretia and Achilles by Giuseppe Cades
Unites a work by the Roman artist Giuseppe Cades (1750–1799), *The Virtue of Lucretia,* recently acquired by the Toledo Museum, with a companion work, *Ulysses, Achilles and Patroclus,* on loan from the Louvre.

Through January 5
Tamarind: Forty Years
Works representing the 40-year history of Tamarind Press, a major lithography center, including prints by Joseph Albers and Louise Nevelson. (Travels)

Through March
Devotional Splendor: Gold Ground Paintings From Detroit and Toledo
Early religious paintings from the Detroit Institute of Arts and the Toledo Museum, including works by Fra Angelico.

February 14–May 11
Splendid Pages: The Molly and Walter Bareiss Collection of Modern Illustrated Books
Prints, drawings and photographs by some 150 artists, including Picasso, Ernst, Chagall, Arp and Bonnard, to accompany works of literature.

February 14–May 11
Magical Miró: Prints and Books From the Bareiss Collection
Works on paper from all phases of Joan Miró's career.

February 14–May 11
Motherwell's "El Negro"
Framed pages from Rafael Alberti's epic poem "El Negro,"
printed with Robert Motherwell's black-and-white images.

February 23–May 18
Van Gogh: Fields
About 20 paintings examining one of the artist's favorite
themes, the representation of a field. (Travels)

PERMANENT COLLECTION

Objects from ancient Egypt, Greece and Rome, and from
Africa and Asia; European and American art; glass and decora-
tive arts. Work by Rubens, El Greco, Rembrandt and Monet.
Architecture: 1912 neo-Classical marble building by Edward
Green; 1992 arts school addition by Frank O. Gehry.

Admission: Free; fees for some exhibitions.
Hours: Tuesday through Saturday, 10 a.m.–4 p.m.; Friday, until
10 p.m.; Sunday 11 a.m.–5 p.m. Closed Monday, New Year's
Day, Independence Day, Thanksgiving and Christmas Day.

The Butler Institute of American Art

524 Wick Avenue, Youngstown, Ohio 44502
(330) 743-1711
www.butlerart.com

2003 EXHIBITIONS

Fall 2002–Winter 2003
Chris Rauschenberg: Photographs
Works using digital photography.

Fall 2002–Winter 2003
Ronald Davis: Paintings
Retrospective including constructions as well as new digitally
mastered works.

Youngstown

Fall 2002–Winter 2003
Ben Schonzeit: Drawings
Works on paper by a photorealist artist.

Fall 2002–Winter 2003
Jennifer and Kevin McCoy: Installation
Site-specific installation combining digital imagery with digital sound.

Fall 2002–Winter 2003
Edward Lucie Smith: Photographs
Works by the art historian.

Spring-Summer
Manolo Valdes: Paintings
Works by the Spanish painter.

Summer
Legends & Unicorns: The Pilot Hill Collection of Contemporary Art
Rarely seen works from private California collections.

Summer
Paul Jenkins Face to Face: Portraits of the Artist
Portraits of Jenkins by fellow artists, including Andy Warhol, George Segal and Al Hirschfeld.

Fall
Robert Natkin: Portraits
Portrait heads by a lyrical painter.

PERMANENT COLLECTION

Three centuries of American art, from the Colonial period to the present. **Highlights:** 19th-century works by Homer, Eakins and Harnett; Marine Collection, featuring Lane, Waugh and Bricher; American Western Collection, including works by Burbank, Sharp and Higgins; American Impressionist works by Cassatt, Vonnoh and Chase; 20th-century works by Motherwell, Nevelson, Frankenthaler, Close and Rauschenberg.
Architecture: Designed by McKim, Mead and White; additions in 1931, 1968, 1987 and 1999. Sculpture terrace, Beecher high-tech wing.

Admission: Free.
Hours: Tuesday through Saturday, 11 a.m. to 4 p.m.; Wednesday, until 8 p.m.; Sunday, noon–4 p.m. Closed Monday and major holidays.

Trumbull County Branch

9350 East Market Street, Howland, Ohio
(330) 609-9900
Hours: Wednesday through Sunday, 11 a.m.–4 p.m.

Salem Branch

343 East State Street, Salem, Ohio
(330) 332-8213
Hours: Thursday through Sunday, 11 a.m.–4 p.m.

Oklahoma

Gilcrease Museum

1400 Gilcrease Museum Road, Tulsa, Okla. 74127
(918) 596-2700; (888) 655-2278
www.gilcrease.org

2003 EXHIBITIONS

Through February 7
Works by Warhol From the Cochran Collection
Works from Warhol's Cowboys and Indians series, as well as
images depicting other American icons like Mickey Mouse.

February 22–April 6
Art & Soul: Fritz Scholder
Images of Native Americans and other subjects by a leader in
the American Indian Fine Art Movement of the 20th century.

April 25–June 22
Rendezvous 2003
Works by four award-winning artists.

August 10–November 9
Frederic Remington: The Color of Night
More than 20 paintings from some 60 oils done between 1900

Tulsa

Courtesy of the Gilcrease Museum.
Frederic Remington, *The Hungry Moon.*

and 1909 depicting various aspects of night. Bronze sculptures made during the same period as Remington produced his night paintings will also be on view, as will night paintings by other artists in the Gilcrease collection.

PERMANENT COLLECTION

Largest collection of fine art, artifacts and archives about the American West. Paintings, drawings, prints and sculpture by more than 400 artists, including Frederic Remington, Charles Russell and Thomas Moran; American Indian art and artifacts as well as historical manuscripts, documents and maps.
Architecture: Original structure was built in 1949 in the style of an American Indian longhouse; expansion and renovation in 1987.

Admission: Free.
Hours: Tuesday through Sunday, 10 a.m.–4 p.m. Closed Monday and Christmas Day.

Philbrook Museum of Art

2727 South Rockford Road, Tulsa, Okla. 74114
(918) 749-7941; (800) 324-7941
www.philbrook.org

2003 EXHIBITIONS

January 19–March 16
Changing Hands Without Reservation, Part I (Southwest)
Native American arts in the Southwest, particularly cutting-edge work in clay, glass, fiber, metal and wood.

April 6–June 29
Modern Masters: From Corot to Kandinsky
Fifty-one works by Millet, Renoir, Pissarro, Gauguin, Picasso, Chagall, Kandinsky and others from the Foundation Juntos Actuandos por la Superacion of Mexico City.

November 21–December 7
Festival of Trees
Trees, wreaths, decorations and gingerbread houses created by Tulsa residents.

PERMANENT COLLECTION

More than 8,500 works from around the world, including Italian paintings and sculpture; 19th-century French paintings and sculpture; 18th- and 19th-century decorative arts; American art, especially 19th-century landscape paintings and 20th-century works; African, Asian and American Indian art and artifacts. **Architecture:** 1928 Italianate villa by Edward Buehler Delk; 1990 wing by Urban Design Group in association with Michael Lustig.

Admission: Adults, $5.40; seniors, students and groups, $3.25; members and children12 and under, free.
Hours: Tuesday through Saturday, 10 a.m.–5 p.m.; Thursday, until 8 p.m.; Sunday, 11 a.m.–5 p.m. Closed Monday and major holidays.

Oregon

Portland Art Museum

1219 Southwest Park Avenue, Portland, Ore. 97205
(503) 226-2811
www.portlandartmuseum.org

2003 EXHIBITIONS

Through January 5
Grandma Moses in the 21st Century
Retrospective featuring 87 paintings, from her "discovery" as a septuagenarian to her last finished painting.

January 18–March 23
Paris to Portland: Impressionist and Post-Impressionist Masters in Portland Collections
Works by Monet, Renoir, Pissarro, Cézanne, Sisley, Bonnard, Monet, Fantin-Latour and others.

January 18–March 23
Paris to Portland: Toulouse-Lautrec, A Private Collection
Drawings, posters and lithographs of circuses, dance halls, nightclubs and racetracks by the 19th-century Parisian artist.

April 12–June 8
Becoming a Nation: Americana From the Diplomatic Reception Rooms, U.S. Department of State
More than 120 paintings, furniture, silver, porcelain, rugs and other decorative arts.

Courtesy of the Portland Art Museum.
Henri de Toulouse-Lautrec, *Divan Japonais*, 1892-3.

June 21–August 31
The 2003 Oregon Biennial
Works by new and established Oregon artists.

October 21–January 4, 2004
Masterpieces of 17th-Century French Painting From the Museums of FRAME
Works from a consortium of nine American and nine French museums known as the French Regional and American Museum Exchange.

PERMANENT COLLECTION

Works spanning 35 centuries of Asian, European, American and contemporary art. **Highlights:** The new Centers for Northwest Art and Native American Art; Brancusi, *Muse*; Monet, *Waterlilies*; Renoir, *Two Girls Reading*; Tlingit, *Wolf Hat*. **Architecture:** 1932 Petro Belluchi building, which has been newly renovated.

Admission: Adults, $10; seniors and students, $9; children 5–18, $6; children 4 and under and members, free.
Hours: Tuesday through Saturday, 10 a.m.–5 p.m.; Sunday, noon–5 p.m.; every Wednesday and the first Thursday of every month, until 8 p.m. Closed Monday.

Pennsylvania

Brandywine River Museum

Brandywine Conservancy, Route 1, Chadds Ford, Pa. 19317
(610) 388-2700
www.brandywinemuseum.org

2003 EXHIBITIONS

January 18–May 18
Capturing Nureyev: James Wyeth Paints the Dancer
More than 35 paintings and drawings of Nureyev, as well as

costumes, photographs and archival material related to his life and career.

March 15–May 18
Monsters, Mickey and Mozart: The Drawings of Maurice Sendak

May 24–August 10
Smoking Pipes

May 31–September 1
Summers in Maine: Paintings by N.C. Wyeth For a quarter century beginning in 1920, Wyeth spent summers in Port Clyde, Maine, painting in a variety of styles.

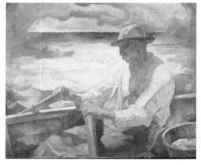

September 5–November 23
Art of the West From a Private Collection

Courtesy of the Brandywine River Museum. N.C. Wyeth, *Captain Brown*, Port Clyde, Maine, c. 1934.

PERMANENT COLLECTION

American art with an emphasis on the Brandywine region. Landscapes by Cropsey, Doughty, Moran and Richards; trompe l'oeil works by Cope, Harnett and Peto; illustrations by Darley, Pyle, Parrish, Gibson and Dunn. **Highlights:** Paintings by three generations of Wyeths; Andrew Wyeth Gallery; Brandywine Heritage Galleries. **Architecture:** 1864 grist mill renovated in 1971 by James Grieves; 1984 addition by Grieves features glass-walled lobbies with views of countryside.

Admission: Adults, $6; seniors, students, children 6–12, $3; members, free.
Hours: Daily, 9:30 a.m.–4:30 p.m. Closed Christmas Day.

James A. Michener Art Museum

138 South Pine Street, Doylestown, Pa. 18901
(215) 340-9800
www.michenerartmuseum.org

2003 EXHIBITIONS

Through January 12
The Berenstain Bears Celebrate: The Art of Stan and Jan Berenstain
Historical and artistic perspectives on a beloved series of children's books written by Pennsylvania residents.

January 11–April 27
Randall Exon
Works by a contemporary landscape painter from the Philadelphia area.

January 25–April 13
Levittown: A Home of Our Own
Photographs and objects in celebration of the 50th anniversary of Levittown, the famous suburb created in 1953.

April 26–July 6
Six Continents of Quilts: The American Crafts Museum Collection
Quilts by award-winning artists from the United States, Japan and Russia.

May 10–August 31
Japanese Prints From the Michener Collection
Selection from the nearly 5,400 Japanese prints that James A. Michener donated to the Honolulu Academy of the Arts.

July 19–October 12
Jazz en clave
Explores cultural connections between African, Caribbean and European music.

September 13–December 28
Camera Work
Exhibition of original editions, photogravures and related objects in celebration of the 100th anniversary of Alfred Stieglitz's quarterly.

October 25–January 25, 2004
Alan Magee: Monotypes

Doylestown/Merion

PERMANENT COLLECTION

Pennsylvania Impressionist paintings; 19th- and 20th-century American paintings; regional contemporary and figurative art; Patricia D. Pfundt Sculpture Garden; featuring American sculpture; exhibition on the author James A. Michener; multimedia interactive exhibition, "Creative Bucks County: A Celebration of Art and Artists." **Highlights:** Daniel Garber's mural *A Wooded Watershed.* **Architecture:** Renovated 1884 Bucks County Prison.

Admission: Adults, $6; seniors, $5.50; students, $3; members and children under 6, free.

Hours: Tuesday through Friday, 10 a.m.–4:30 p.m.; Wednesday, until 9 p.m.; Saturday and Sunday, 10 a.m.–5 p.m. Closed Monday.

The Barnes Foundation

300 North Latch's Lane, Merion, Pa. 19066
(610) 667-0290
www.barnesfoundation.org

PERMANENT COLLECTION

Extensive collection of early French Modern and Post-Impressionist paintings. Works by Picasso, Renoir, Cézanne, Monet and Degas. Museum established by Dr. Albert C. Barnes in 1922 to "promote the advancement of education and the appreciation of the fine arts." The collection spans 3,000 years and is one of the first purposely multicultural collections in the nation, featuring African sculpture,

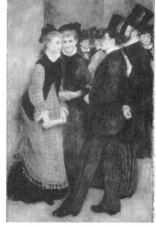

Courtesy of the Barnes Foundation.
Renoir, *After the Concert*, 1877.

American Indian art, Chinese painting, Egyptian, Greek and Roman antiquities and 18th- and 19th-century decorative arts. Arboretum noted for its diversity of species and rare specimens. **Architecture:** 1925 French limestone structures; 1994 renovations.

Admission: $5. Reservation required.

Hours: September–June: Friday through Sunday, 9:30 a.m.-5 p.m.; July and August, Wednesday through Friday, 9:30 a.m.–5 p.m.

Institute of Contemporary Art

University of Pennsylvania, 118 South 36th Street, Philadelphia, Pa. 19104
(215) 898-7108
www.icaphila.org

2003 EXHIBITIONS

January 18–April 6
Edna Andrade
First large-scale survey of the Pennsylvania artist's work, which is based on geometric abstraction and opticality.

January 18–April 6
Intricacy
Works by artists, designers and architects reflecting "intricacy," referring to a visual language of folding, interweaving and layering heralded by the digital revolution.

January 18–April 6
Justine Kurland
Large-scale, richly colored and theatrically staged photographs of adolescence girls in American landscapes.

May 3–July 27
Polly Apfelbaum
"Fallen paintings," often arranged on the floor, that are a hybrid of painting, sculpture and installation.

Admission: Adults, $3; students, artists and seniors, $2; children under 12, free. Free on Sunday, 11 a.m.–1 p.m.
Hours: Wednesday through Friday, noon–8 p.m.; Saturday and Sunday, 11 a.m.–5 p.m. Closed Monday and Tuesday.

Pennsylvania Academy of the Fine Arts

118 North Broad Street, Philadelphia, Pa. 19102
(215) 972-7600
www.pafa.org

School Gallery

1301 Cherry Street, Philadelphia, Pa. 19107

2003 EXHIBITIONS

Through February 2
Jane Irish
An installation, *History Lesson,* by a regional artist.

February 8–April 20
On the Edge of Your Seat: Popular Theater and Film in Early 20th-Century Art
More than 200 works of art, posters, playbills, song sheets, postcards and vintage theater and film equipment.

February 22–April 22
Marcel Dzama, Andrew Jeffrey and Michael Dumontier
Drawings, screen prints, felt dolls and an animated film by artists who share a similar whimsical aesthetic.

PERMANENT COLLECTION

America's first art museum and school of fine arts. The museum covers more than two centuries of American art, including works by Benjamin West, Charles Willson Peale and Cecilia Beaux. **Architecture:** 1876 Gothic Victorian building by Frank Furness and George Hewitt.

Admission: Adults, $5; seniors and students, $4; ages 5–18, $3. School Gallery, free.
Hours: Tuesday through Saturday, 10 a.m.–5 p.m.; Sunday, 11 a.m.–5 p.m. Closed Monday. School Gallery: Daily, 9 a.m.–7 p.m., or by appointment.

The Philadelphia Museum of Art

26th Street and Benjamin Franklin Parkway,
 Philadelphia, Pa. 19101
(215) 763-8100; (215) 684-7500 (recording)
www.philamuseum.org

2003 EXHIBITIONS

Through January 5
Giorgio de Chirico and the Myth of Ariadne
Exhibition of the Italian artist's haunting series of eight Ariadne paintings, depicting a reclining statue of the princess of Greek mythology in an empty piazza, shown together for the first time. (Travels)

Through March 2
Taken by Design: Photographs From the Institute of Design, 1937–1971
Examines the contributions of Chicago's Institute of Design to photography in America, featuring works by Laszlo Moholy-Nagy, Harry Callahan and Aaron Siskind. (Travels)

February 12–May 11
Degas and the Dance
Some 150 works in various media explore Degas's fascination with the dance world over 40 years, from his depictions of actual performance in the 1860's and 1870's to his behind-the-scenes portrayals of rehearsals and lessons in the 1880's. (Travels)

June 14–September 7
Louis Faurer Retrospective
Photographs of city life, particularly in New York and Philadelphia, taken over 40 years. (Travels)

Summer
Warren Rohrer
Some 35 paintings from 1972 to 1994 by an abstract painter who lived in Pennsylvania.

Fall
Shocking! The Art and Fashion of Elsa Schiaparelli
Examines how a leading Paris fashion designer in the 1930's mirrored the social, political and cultural climate of the times.

PERMANENT COLLECTION

Architectural installations and period rooms, including a 12th-century French Romanesque facade, a 16th-century carved granite Hindu temple hall and a Japanese tea house, temple and garden; Robert Adams's drawing room from Lansdowne House; modern sculpture; German folk art; Kretzschmar von Kienbusch collection of arms and armor. **Highlights:** Cézanne, *Large Bathers*; Duchamp, *Nude Descending a Staircase*; Picasso, *The Three Musicians*; van Gogh, *Sunflowers*; Rubens, *Prometheus Bound*. **Architecture:** 1928 neo-Classical building by Horace Trumbauer and Zantzinger, Borie, and Medary, housing more than 200 galleries across an expanse of 600,000 square feet.

Admission: Adults, $10; students, ages 13–18 and seniors, $7; 12 and under, free. Pay what you wish, Sunday.
Hours: Tuesday through Sunday, 10 a.m.–5 p.m.; Wednesday and Friday, until 8:45 p.m. Closed Monday and major holidays.

University of Pennsylvania Museum of Archaeology and Anthropology

33rd and Spruce Streets, Philadelphia, Pa. 19104
(215) 898-4000
www.museum.upenn.edu

PERMANENT COLLECTION

Materials from ancient Egypt, Asia, Africa, Polynesia, the
Americas and the ancient Greco-Roman world. **Highlights:** A
12-ton sphinx and architectural remnants from the palace of
Merenptah, circa 1200 B.C.; samples of the world's oldest
written language; Chinese sculpture; ancient Mayan stelae;
Nigerian Benin bronzes. **Architecture:** 1899 American Arts
and Crafts building by Wilson Eyre, Cope and Stewardson and
Frank Miles Day and Brother; 1915 rotunda addition; 1926
Coxe Memorial Wing by Charles G. Klauder; Sharpe Wing
completed in 1929.

Admission: Suggested donation: Adults, $5; seniors and stu-
dents, $2.50; members, children under 6 and PENNcard
holders, free.
Hours: Tuesday through Saturday, 10 a.m.–4:30 p.m.;
Sunday, 1–5 p.m. Closed Sunday from Memorial Day through
Labor Day; closed Monday and holidays.

Carnegie Museum of Art

4400 Forbes Avenue, Pittsburgh, Pa, 15213
(412) 622-3131; (412) 622-3172
www.cmoa.org

2003 EXHIBITIONS

Through January 9
Neapolitan Presepio
A Nativity scene in a detailed panorama of an 18th-century
Italian village, with more than 100 human and angelic
figures, created by Neapolitan artists between 1700 and 1830.

Through February 2
*Out of the Ordinary: The Architecture and Design of Robert Venturi,
Denise Scott Brown and Associates*
First retrospective of the influential design firm's work,
featuring more than 150 drawings, models, photographs and
decorative arts objects. (Travels)

Pittsburgh

Through Summer 2003
Ceramics: Highlights From the Permanent Collection
Ceramic works from Greek vases to creations by modern-day masters.

Through August 17
Panopticon: An Art Spectacular
Like early exhibitions that were jammed with art, Panopticon will show more than 500 paintings, sculptures, works on paper and chairs, with works displayed from floor to ceiling.

Summer 2003
The Architecture of Herzog and de Meuron: Natural History
Explores how the contemporary Swiss architects Jacques Herzog and Pierre de Meuron draw upon the art of the past and present.

PERMANENT COLLECTION

Nineteenth-century American, French Impressionist and Post-Impressionist, modern and contemporary collections, including film and video, European and American decorative arts, and architectural drawings and models. Rotating exhibitions. Home of the Carnegie International. **Highlights:** Monet's *Waterlilies*; the Chariot of Aurora from the ocean liner Normandie; de Kooning's *Woman VI*; one of the world's three architectural cast courts. **Architecture:** 1907 building by Alden and Harlow; 1974 wing by Edward Larrabee Barnes.

Admission: Adults, $8; seniors, children and students, $5; members, free.
Hours: Tuesday through Saturday, 10 a.m.–5 p.m.; until 9 p.m. Thursday; Sunday, noon–5 p.m. Closed Monday and major holidays.

The Frick Art and Historical Center

7227 Reynolds Street, Pittsburgh, Pa. 15208
(412) 371-0600
www.frickart.org

2003 EXHIBITIONS

Through January 5
19th and 20th-Century French Drawings From the Royal Museum of Fine Arts, Copenhagen
Works by Ingres, Millet, Rousseau, Rodin, Toulouse-Lautrec, Manet, Degas, Gauguin and others.

February 26–May 25
Millet to Matisse: 19th and 20th-Century French Painting From Kelvingrove Gallery, Glasgow, Scotland
Works by Monet, Renoir, Cézanne, Van Gogh, Picasso and others.

June 15–August 10
Sights Once Seen: Daguerrotyping Frémont's Last Expedition Through the Rockies
A contemporary daguerreotype artist's re-creation of the Western panorama as seen by the explorer John Charles Frémont during his 1853–1854 journey.

Opening September 2003
The Early Work of Henry Koerner: 1945–1955
About 30 paintings tracing Koerner's development as an artist.

Opening September 2003
Valentin Lustig: Hoka Neni, Seven Paintings
A nephew's depiction of the life of his aunt, who was killed at Auschwitz.

November 29–February 8, 2004
Empire of the Sultans: Ottoman Art From the Khalili Collection
Art of the Ottoman Empire (13th through early 20th century), including calligraphy, mosque decorations, arms and armor, ceramics, carpets and paintings.

Pittsburgh

PERMANENT COLLECTION

Italian Renaissance and French 18th-century works acquired by Henry Clay Frick's daughter, Helen Clay Frick. **Highlights:** Art collection in Clayton, the restored Gilded Age residence of Henry Clay Frick; collection of pre-1940 vehicles in the Car and Carriage Museum. **Architecture:** 1969 building by Pratt, Schafer and Slowik.

Admission: Frick Art Museum and Car and Carriage Museum, free. Clayton: Adults; $10; senior and students, $8; reservations required.
Hours: Tuesday through Saturday, 10 a.m.–5 p.m.; Sunday, noon–6 p.m. Closed Monday and major holidays.

The Andy Warhol Museum

117 Sandusky Street, Pittsburgh, Pa. 15212
(412) 237-8300
www.warhol.org

PERMANENT COLLECTION

Andy Warhol drawings, prints, paintings, sculpture, film, audio and videotapes, with archives that range from ephemera to records, source material for works of art and other documents from the artist's life. **Architecture:** Industrial warehouse built in 1911; renovated by Richard Gluckman.

Admission: Adults, $8; seniors, $7; students and age 4 and older, $4; members and 3 and under, free.
Hours: Tuesday through Sunday, 10 a.m.–5 p.m.; Friday, until 10 p.m. Closed Monday.

Rhode Island

Museum of Art, Rhode Island School of Design

224 Benefit Street, Providence, R.I. 02903
(401) 454-6500
www.risd.edu/museum.cfm

2003 EXHIBITIONS

Through January 12
Crisis Response
Artwork from the last 40 years that reacts to national and global conflicts.

Through February 16
A Tribute to Miss Lucy III: Kesa From the Permanent Collection
Four-part exhibition of textiles given to the museum by Lucy Truman Aldrich. Part III features vestments worn by Buddhist priests.

Through March 2
Tradition and Innovation in Meiji-Period Prints
Works reflecting Japanese fascination with Western things after the opening of Japan to foreign trade in the 1850's.

February 7–April 20
On the Wall
Installations created for the museum by artists who use wallpaper as an art form, as well as a selection of contemporary wallpaper designed by artists.

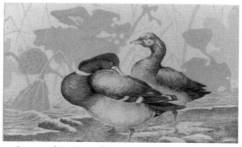

The Kiyochika print of *Ducks and Withered Lotus*.

Courtesy of the Museum of Art, Rhode Island School of Design.

February 7–April 20
20th-Century Decorative Art and Furniture

February 21–June 22
A Tribute to Miss Lucy IV: Noh Robes From the Aldrich Collection
Japanese theatrical costumes whose designs and brilliant colors reflect the magnificence of ancient Japanese court life.

March 7–June 1
Hiroshige: Selections From the Collection
Works by a leading 19th-century Japanese printmaker who specialized in landscape and bird-and-flower prints.

June–September
Attention Span
Explores how art forms respond to changing notions of time, duration, attention and distraction.

PERMANENT COLLECTION

Nearly 80,000 works of art from antiquity to the present, including Greek and Roman sculpture, Chinese stone and terra cotta sculpture, French Impressionist paintings and contemporary art in various media, including textiles, ceramics, glass and furniture. **Highlights:** Ancient Pamphylian sarcophagus; 12th-century sculpture from the Third Abbey Church of Cluny, France; coffin and mummy of the Egyptian priest Nesmin; 9-foot Buddha Dainichi Nyorai from a medieval temple near Kyoto. **Architecture:** 1897 original building; 1906 Colonial Revival addition by Stone, Carpenter and Wilson, called Pendleton House; 1926 Radeke Building by William T. Aldrich; 1983 Contemporary Daphne Farago Wing by Tony Atkin and Associates.

Admission: Adults, $6; seniors, $5; college students, $3; youth 5–18, $2; members, RISD and Brown students, children under 5, free. Free on Friday, noon–1:30 p.m.; Sunday, 10 a.m. –1 p.m.; third Thursday of the month, 5–9 p.m.; last Saturday of the month.
Hours: Tuesday through Sunday, 10 a.m.–5 p.m.; third Thursday of each month, until 9 p.m. Closed Monday, New Year's Day, Independence Day, Thanksgiving and Christmas Day.

South Carolina

Gibbes Museum of Art

135 Meeting Street, Charleston, S.C. 29401
(843) 722–2706
www.gibbes.com

2003 EXHIBITIONS

Through February 23
The Kindness of Friends: A Century of Giving at the Gibbes
Exhibition of objects bequeathed to the museum from 1905 to
the present.

Through March 23
Middleton Manigault: Visionary Modernist
Looks at the artist's brief career as an early Modern artist in
America. (Travels)

Through May 4
*Passing the Time: Depictions of Daily Life From the Read-Simms
Collection of Japanese Wood Block Prints*
Focuses on the quiet, unassuming images of the daily routine
common in Japanese wood block prints.

Through August 24
Reality and Imagery: Selections From the Photography Collection
Explores the differences between documentary photographers
who capture spontaneous moments and studio photographers
who create scenes to evoke an idea or sentiment.

January 18–July 20
Miniatures Portraits Survey
Examples of the miniature portrait tradition in Charleston,
S.C., from 1730 to the early 20th century.

February 2–January 4, 2004
Art in America: A Southern Perspective
Significant works with a Southern perspective, beginning with
the works of Henrietta Johnston, the first professional woman
artist in America.

April 11–August 24
The Sight of Music: From the Collecton of Reba and Dave Williams
Works on the theme of music.

July 25–December 7
Works by Warhol: From the Cochran Collection
Includes an oil, a drawing and 23 silkscreen prints from 1974 to 1986.

September 19–December 14
Red Grooms: Selections From the Graphic Work

PERMANENT COLLECTION

Portraits of notable South Carolinians; views of Charleston and landscapes; photography; miniature portraits; Japanese wood-block prints. **Architecture:** Beaux-Arts building, built as a memorial to James Shoolbred Gibbes and designed by Frank P. Milburn.

Admission: Adults, $7; seniors, students and members of the military, $6; ages 6–18, $3; under 6 and members, free.
Hours: Tuesday through Saturday, 10 a.m.–5 p.m.; Sunday, 1–5 p.m; until 9 p.m., second Tuesday of the month. Closed Monday and holidays.

The Greenville County Museum of Art

420 College Street, Greenville, S.C. 29601
(864) 271-7570
www.greenvillemuseum.org

2003 EXHIBITIONS

Through January 5
Ezra Jack Keats
Mixed-media collages by the children's book author.

Through January 5
From the Studio
Works by Greenville artists.

January 15–March 30
Tony Fitzpatrick: Max and Gaby's Alphabet
Twenty-six etchings made by a Chicago artist to help the artist's children learn the alphabet. (Travels)

Courtesy of the Greenville County Museum of Art.
Fern Isabel Coppedge, *Road to Lumberville*, 1938.

April 9–June 15
Susan Page: Ties That Bind
Recent work by a North Carolina photographer who takes instant photographs and applies them to various media.

May 28–September 21
So Far: Paintings by Bo Bartlett, 1978–2002
A survey of the artist's realist work in the last 25 years.

October 1–January 4, 2004
A Carnival of Animals
Children's exhibition featuring book illustrations.

November 19–January 18, 2004
Earth, River and Light: Masterworks of Pennsylvania Impressionism
Images of Bucks County by a colony of artists known as the Pennsylvania Impressionists.

PERMANENT COLLECTION

American art from the colonial period to the present, focusing on artists and art related to the South. **Highlights:** Twentieth-century works by Georgia O'Keeffe, Hans Hofmann, Josef Albers and Andy Warhol; 26 paintings by Andrew Wyeth. **Architecture:** 1974 building by Craig, Gaulden & Davis.

Admission: Free.

Hours: Tuesday through Saturday, 10 a.m.–5 p.m.; Sunday, 1–5 p.m. Closed Monday and major holidays.

Tennessee

Knoxville Museum of Art

1050 World's Fair Park Drive, Knoxville, Tenn. 37916
(423) 525-6101
www.knoxart.org

2003 EXHIBITIONS

Through January 5
Victorian Visionary: The Art of Elliott Daingerfeld

Through March 2
Richard Jolley: Sculptor of Glass

January 17–April 27
A Century of Progress: Tennessee Artists of the 20th Century

May 9–August 10
Michiko Kon: Still Lifes

September 5–January 4, 2004
William Morris: Myth, Object and Animal

September 26–January 11, 2004
An Artistic Friendship: Beauford Delaney and Lawrence Calcagno

PERMANENT COLLECTION

American painting, sculpture, photography and works on paper during and after the 1960's. **Architecture:** 1990 Edward Larrabee Barnes steel-and-concrete building, faced in Tennessee pink marble.

Admission: Adults, youths 12–17, $3; children under 12, free.

Hours: Tuesday through Saturday, 10 a.m.–5 p.m.; Friday, until 9 p.m.; Sunday, noon–5 p.m. Closed Monday, New Year's Day, Thanksgiving and Christmas Day.

The Dixon Gallery and Gardens

4339 Park Avenue, Memphis, Tenn. 38117
(901) 761-5250
www.dixon.org

2003 EXHIBITIONS

January 19–April 13
A Brush With Nature: The Gere Collection of Landscape Oil Sketches
Improvisational 18th- and 19th-century oil sketches of landscapes usually intended as training exercises and later emulated by the Impressionists.

April 27–August 17
The Devonshire Inheritance: Five Centuries of Collecting at Chatsworth
A look at the most famous private collection in England, built over 500 years, including Old Master drawings, gold and silver, gems, jewelry, furniture and sculpture.

October 19–January 11, 2004
The Changing Garden: European and American Gardens From 1550–2000
More than 150 paintings, prints, illustrated books, drawings, photographs and sculptures examining the evolution of European and American gardens.

PERMANENT COLLECTION

French and American Impressionists; Post-Impressionists and related schools; the Montgomery H. W. Ritchie Collection, which includes French and American art from the 19th and early 20th centuries; the Stout Collection of 18th-century

German porcelain; the Adler Pewter Collection; the Dixon gardens. Works by Monet, Renoir, Degas, Braque, Cassatt, Cézanne, Chagall, Daumier, Gauguin, Matisse and Rodin. **Architecture:** Georgian-style residence and gallery complex surrounded by 17 acres of gardens and woodlands.

Admission: Adults, $5; seniors, $4; students, $3; children under 12, $1; groups of 20 or more, $4; members, free. **Hours:** Tuesday through Saturday, 10 a.m.–5 p.m.; Sunday, 1–5 p.m.; Monday, gardens only, for half-price admission, 10 a.m.–5 p.m.

Memphis Brooks Museum of Art

1934 Poplar Avenue, Memphis, Tenn. 38104
(901) 544-6200
www.brooksmuseum.org

2003 Exhibitions

Through February 2
Speak Softly and Carry a Beagle: The Art of Charles Schulz
Explores the artistic development and process of the creator of the popular Peanuts comic strip.

Through February 2
Memphis Barkitecture
In conjunction with the Charles Schulz exhibition, a group of doghouses designed by regional architects.

February 23–May 4
Georgia O'Keeffe and the Calla Lily in American Art, 1860–1940
Explores the popularity of the lily in American art, particularly in the work of Georgia O'Keeffe, Charles Demuth and Marsden Hartley.

June 7–September 7
Glory of the Silk Road: Art From Ancient China
More than 170 works of art and artifacts, including sculpture, ceramics, gold and silver, textiles, paintings and manuscripts.

August 31–November 9

In the Spirit of Martin: The Living Legacy of Dr. Martin Luther King Jr.

First major exhibition using the visual arts to explore the life and legacy of the civil rights leader.

September 14–November 1

Romanino's Mystic Marriage of St. Catherine

Exhibition surrounding one of Girolamo Romanino's master-pieces.

November 30–February 29, 2004

U.S. Design: 1975–2000

Comprehensive analysis of the major cultural and theoretical issues that shaped the design arts during this period.

PERMANENT COLLECTION

Largest fine arts museum in Tennessee, featuring Italian Renaissance and Baroque paintings; decorative arts, including period furniture and textiles; African art; works by Carroll Cloar, a regionalist artist. **Architecture:** 1916 Beaux-Arts building by James Gamble Rogers; 1973 and 1990 expansions and renovations.

Admission: Adults, $5; seniors, $4; students, $2. Free on Wednesday.

Hours: Tuesday through Friday, 10 a.m.–4 p.m.; Saturday, until 5 p.m.; Sunday, 11:30 a.m.–5 p.m. Closed Monday, New Year's Day, Independence Day, Thanksgiving and Christmas Day.

Cheekwood — Tennessee Botanical Garden and Museum of Art

1200 Forrest Park Drive, Nashville, Tenn. 37205

(615) 356-8000

www.cheekwood.org

Nashville

2003 EXHIBITIONS

February 4–May 12
Glass of the Avant Garde
More than 200 examples of early modern glass from Austria, Bohemia and Germany.

May 31–June 15
19th- and 20th-Century American Drawings: From the Cheekwood Permanent Collection

Summer 2003
Dinosaurs in the Gardens
Exhibition for children of life-size dinosaurs spread throughout the museum gardens.

June 28–September 7
African-American Masters: Highlights From the Smithsonian American Art Museum
Paintings, sculptures and photographs exploring historical evetns, political issues, personal memories, music and folklore traditions and spirituality.

October–December
Furniture of the American South 1680–1830, The Colonial Williamsburg Collection
Explores Southern furniture and the social history of the colonial and republican South.

PERMANENT COLLECTION

Nineteenth- and 20th-century American art; sculpture by William Edmondson; Woodland Sculpture Trail featuring works by James Turrell, Sophie Ryder, Ian Hamilton Finlay and Jenny Holtzer; decorative arts collection, showcasing more than 200 pieces of Worcester porcelain and 650 works in silver.

Admission: Adults, $10; seniors and college students, $8; youth/college students, $5; children under 6 and members, free. After 3 p.m., half-price.
Hours: Tuesday through Saturday, 9:30 a.m.–4:30 p.m.; Sunday, 11 a.m.–4:30 p.m. Closed Monday except federal holidays, New Year's Day, Thanksgiving, Christmas Day and the second Saturday in June.

Texas

Austin Museum of Art

Downtown

823 Congress Avenue, Austin, Tex. 78701
(512) 495-9224
www.amoa.org

Interim space until the opening of the museum's new building, scheduled for 2004.

PERMANENT COLLECTION

Small collection of post–World War II paintings, sculpture, photographs, prints and drawings from the United States, Mexico and the Caribbean. **Architecture:** 1916 Mediterranean-style villa.

Admission: Adults, $5; seniors and students, $4; members and children under 12; free; Thursday, $1.
Hours: Tuesday through Saturday, 10 a.m.–6 p.m.; Thursday, until 8 p.m.; Sunday, noon–5 p.m. Closed Monday, New Year's Day and Christmas Day.

Austin Museum of Art — Laguna Gloria

3809 West 35th Street, Austin, Tex. 78703
(512) 458-8191

Temporarily closed for restoration. Sculpture garden remains open.

Admission: Adults, $2; seniors and students, $1; members and children under 12, free.

Hours: Tuesday through Saturday, 10 a.m.–5 p.m.; Thursday, until 8 p.m.; Sunday, noon–5 p.m. Closed Monday.

Jack S. Blanton Museum of Art

The University of Texas at Austin
23nd and San Jacinto Streets, Austin, Tex. 78712
(512) 471-7324
www.blantonmuseum.org

PERMANENT COLLECTION

More than 16,000 works of art, from antiquity to the present. Suida-Manning Collection of Renaissance and Baroque art; Michener Collection of 20th-century American art; contemporary Latin American art.

Admission: Free.
Hours: Monday through Friday, 9 a.m.–5 p.m.; Thursday, until 9 p.m.; Saturday and Sunday, 1–5 p.m.

Dallas Museum of Art

1717 N. Harwood St. at Woodall Rodgers Freeway,
 Dallas, Tex. 75201
(214) 922-1200
www.DallasMuseumofArt.org.

2003 EXHIBITIONS

Through Winter 2003
Boomerangs and Baby Boomers: Design, 1945–2000
American and European design in furniture, silver, ceramics, glass and textiles from the end of World War II to the present.

Through January 5
Anne Vallayer-Coster: Painter to the Court of Marie-Antoinette
First retrospective of the work of the 18th-century still life

painter, one of the favorite painters of Marie-Antoinette. (Travels)

Through January 12
The Gilded Age
Sixty paintings, sculptures and decorative objects from the late 1800's and early 1900's from the Smithsonian American Art Museum.

Through January 13
The Voyage of The Icebergs: *Frederic Church's Arctic Masterpiece*
Celebrates the Church work on the eve of the museum's centennial.

Through February 16
Fantastic Fibers: Design, 1945–2000
Complement to the *Boomerangs and Baby Boomers* exhibition focusing on fiber design.

Through March 1
Sigmar Polke: New Work
Nearly 50 paintings by the artist over the last four years.

Opening Spring 2003
Coming Forward: Emerging Artists in Texas
Kickoff of the museum's centennial celebration.

April 6–June 15
The Sensuous and the Sacred: Chola Bronzes From South India
About 60 South Indian sculptures from between the ninth and 11th centuries.

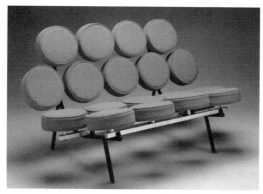

Courtesy of the Dallas Museum of Art.
George Nelson Associates, *Marshmallow sofa,* c. 1954-55.

October 12–January 11, 2004
The Sculpture of Henri Matisse
Sculptures by the artist that challenged traditional representational forms. (Travels)

Opening Fall 2003
100 Works for 100 Years: Dallas Museum of Art Centennial
Works from the permanent collection from 1903 to the present, focusing on defining moments in the museum's development.

PERMANENT COLLECTION

Western art from classical to contemporary times, Indonesian tribal art, African objects, ancient American objects and South Asian art. **Architecture:** Minimalist buildings by Edward Larrabee Barnes, 1983 and 1993.

Admission: Adults, $6; seniors and students 12 and over, $4; children under 12, free.
Hours: Tuesday through Sunday, 11 a.m.–5 p.m.; Thursday, until 9 p.m. Closed Monday, New Year's Day, Thanksgiving and Christmas Day.

El Paso Museum of Art

One Arts Festival Plaza, El Paso, Tex. 79901
(915) 532-1707
www.elpasoartmuseum.org

2003 EXHIBITIONS

Through February 16
Idol of the Moderns: Pierre-Auguste Renoir and American Painting
Works by Renoir and American painters such as Cassatt, Hassam and Bellows reflecting the French Impressionists' impact on American art.

Through February 23
Crossing Over: Photographs by Willie Varela
Twenty-five photographs by an El Paso native observing the rawness of contemporary reality on the U.S.-Mexico border.

February 17–March 14
True Grit: Seven Female Visionaries Before Feminism
Works by seven female artists working between 1951–1975, including Louise Bourgeois and Louise Nevelson.

March 31–June 20
Stories Your Mother Never Told You: Celia Alvarez Muñoz 1982–2002
A 20-year survey of the work of an El Paso native who blends personal memories with her family's oral history.

PERMANENT COLLECTION

More than 5,000 works of art, including European art from the 13th to 18th century; American art from the 19th and 20th centuries; Mexican colonial art and retablos from the 18th and 19th centuries; works on paper; contemporary art from the American Southwest and Mexico. **Highlights:** Canaletto's *View of the Molo*; Sam Gilliam's *Beyond the Blue Door.*
Admission: Free.
Hours: Tuesday through Sunday, 9 a.m.–5 p.m.; Sunday, noon-5 p.m. closed Monday and major holidays.

Amon Carter Museum

3501 Camp Bowie Boulevard, Fort Worth, Tex. 76107
(817) 738-1933
www.cartermuseum.org

2003 EXHIBITIONS

Through March 23
Eliot Porter: The Color of Wildness
Examines the role of the photographer in forging an acceptance of color prints, featuring 165 prints.

April 19–June 29
Casting a Spell: Winslow Homer, Artist and Angler
Some 65 paintings, mostly watercolors, in this first exhibition to look at Homer's passion for fly-fishing.

Fort Worth

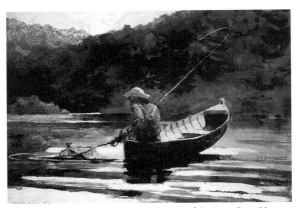

Courtesy of the Amon Carter Museum.

Winslow Homer, Boy Fishing, 1892.

March 29–September 14
Stamped With a National Character: 19th-Century American Color Plate Books
Traces the development of the use of color illustration from its beginnings to the invention of chromatic halftones.

July 19–September 28
A Faithful and Vivid Picture: Karl Bodmer's North American Prints
Prints by the Swiss artist Karl Bodmer from the book *Travels in the Interior of North America,* published in the mid-19th century.

PERMANENT COLLECTION

American paintings, sculpture, works on paper from the 19th and early 20th centuries, including works by Cole, Moran, Chase, Bunker, Sargent, Davis, Demuth, Harnett, Homer, Marin, Nadelman, O'Keeffe, Hartley, Calder, Dove. Extensive collection of American photographs spanning the history of the medium. Art of the American West, including works by Remington and Russell. **Highlights:** Grant Wood, *Parson Weems' Fable*; Eakins, *Swimming*; Remington, *A Dash for the Timber*; Sargent, *Alice Vanderbilt Shepard;* Hartley, *American Indian Symbols;* O'Keeffe, *Dark Mesa and Pink Sky.*
Architecture: Original 1961 building and 2001 expansion by Philip Johnson.

Admission: Free.

Hours: Tuesday through Saturday, 11 a.m.–5 p.m.; Thursday, until 8 p.m.; Sunday, noon–5 p.m. Closed Monday and major holidays.

Kimbell Art Museum

3333 Camp Bowie Boulevard, Fort Worth, Tex. 76107
(817) 332-8451
www.kimbellart.org

2003 EXHIBITIONS

February 9–May 25
Modigliani and the Artists of Montparnasse
About 60 paintings, sculptures and works on paper by Modigliani and 22 works by his contemporaries, including Brancusi, Matisse, Picasso and Soutine. (Travels)

March 10–June 2
Bartolomé Esteban Murillo (1617–1682): Paintings From American Collections
First major U.S. retrospective of the Spanish artist, featuring 35 paintings. (Travels)

May 4–September 14
The Quest for Immortality: Treasures of Ancient Egypt
Largest selection of antiquities ever loaned by Egypt, featuring 115 objects reflecting ancient Egyptian beliefs and practices regarding the afterlife. (Travels)

PERMANENT COLLECTION

Works from antiquity to the present, including masterpieces from Fra Angelico and Caravaggio to Cézanne and Matisse; Asian art; Mesoamerican and African art; Mediterranean antiquities. **Architecture:** Classic modern building by Louis I. Kahn.

Admission: Free. Special exhibitions: $6–$10; discounts for children, seniors and students; members, free.
Hours: Tuesday through Thursday and Saturday, 10 a.m.–5 p.m.; Friday, noon–8 p.m.; Sunday, noon–5 p.m. Closed.

Monday, New Year's Day, Independence Day, Thanksgiving and Christmas Day.

Modern Art Museum of Fort Worth

3200 Darnell Street, Fort Worth, Tex. 76107
(817) 738-9215
www.the modern.org

As of December 2002 the museum has moved into a new building designed by the Japanese architect Tadao Ando.

2003 Exhibitions

Through February
110 Years: The Permanent Collection of the Modern Art Museum of Fort Worth
Inaugural exhibition of works from the permanent collection.

Permanent Collection

Some 3,600 paintings, sculptures, photographs, drawings and prints, focusing on American and European art after 1945; works by Diebenkorn, Guston, Baselitz, Kiefer, Sherman and Gilbert & George; contemporary sculpture on museum grounds. **Highlights:** Large Robert Motherwell collection, including *Spanish Picture With Window;* Jackson Pollock, *Masqued Image;* Andy Warhol, *Twenty-Five Colored Marilyns.* **Architecture:** Five long, flat-roofed pavilions on a pond, designed by Tadao Ando.

Admission: Free.
Hours: Tuesday–Saturday, 10 a.m.–8 p.m.; Sunday, 11 a.m.–5 p.m. Closed Monday and major holidays.

Contemporary Arts Museum

5216 Montrose Boulevard, Houston, Tex. 77006
(713) 284-8250
www.camh.org

2003 EXHIBITIONS

Through January 12
Roxy Paine/Second Nature
Computer-driven art-making machines and botanical
sculptures and installations by a Brooklyn artist.

Through February 2
Sanford Biggers: Afrotemple
Installations by an emerging New York–based artist.

February 1–March 30
Juan Muñoz
First U.S. retrospective of the work of the Spanish sculptor
(1953–2001), featuring nearly 60 sculptures, installations
and drawings, including major cast-resin figure ensembles.

March 28–May 18
Strange Messenger: The Art of Patti Smith
Drawings that fuse image and text by an artist better known
as a musician and poet.

April 12–June 29
*Splat Boom Pow! The Influence of Comics in Contemporary Art,
1970–2000*
More than 80 works by 35 artists who have incorporated
techniques of the comics into their work.

July 12–September 14
Trisha Brown: Dance and Art in Dialogue
Paintings, sculptures, drawings, prints, sets, costumes,
models, video and sound installations tracing the evolution of
Brown's work from the 1960's to the present.

October 4–November 30
Shirin Neshat
Video and photographic work exploring the social roles of men
and women in Islamic society. (Travels)

December 13–February 1, 2004
Matthew Ritchie — Proposition: Player

Includes a large-scale fabric and metal sculpture, a suite of monumental paintings, an evolving wall and floor drawing and animated digital films. (Travels)

PERMANENT COLLECTION

None. Changing exhibitions. **Architecture:** 1972 stainless-steel parallelogram designed by Gunner Birkerts and Assocates of Michigan; 1997 renovation by William F. Stern & Associates.

Admission: Free.
Hours: Tuesday through Saturday, 10 a.m.–5 p.m.; Thursday, until 9 p.m.; Sunday, noon–5 p.m. Closed Monday, New Year's Day, Thanksgiving and Christmas Day.

The Menil Collection

1515 Sul Ross, Houston, Tex. 77006
(713) 525-9400
www.menil.org

2003 EXHIBITIONS

January 31–April 27
Donald Judd: Early Work, 1956–1968
First comprehensive exhibition of the artist's early work, featuring paintings and drawings from the late 1950's and early 1960's.

January 31–May 4
Jasper Johns: Drawings
Works on paper by the artist.

May 23–August 31
Sanctuaries: John Hejduk
Drawings and architectural models by the late architect.

May 16–August 17
James Rosenquist: A Retrospective
First comprehensive survey of the artist's work since 1972, featuring works in many media spanning four decades. (Travels)

October 3–January 11, 2004
Kasimer Malevich
About 100 paintings by one of the founders of nonobjective art in the 20th century and the creator of a system of abstract painting called Suprematism. (Travels)

Courtesy of the Menil Collection.
James Rosenquist, *Promenade of Merce Cunningham*, 1963.

PERMANENT COLLECTION

Opened in 1987 to preserve and exhibit the collection of the patrons Dominique and John de Menil. More than 15,000 works from Paleolithic to contemporary times, including treasures from antiquity, the medieval and Byzantine worlds; works by Magritte, Ernst and other Surrealists; tribal art from Africa, Oceania and the Pacific Northwest. **Highlights:** The Cy Twombly Gallery, devoted to paintings, sculpture and works on paper by the American artist; a fluorescent light environment by Dan Flavin. **Architecture:** Main museum building and Twombly Gallery designed by Renzo Piano.

Admission: Free.
Hours: Wednesday through Sunday, 11 a.m.–7 p.m. Closed Monday, Tuesday and major holidays.

The Museum of Fine Arts

Caroline Wiess Law Building: 1001 Bissonnet
Audrey Jones Beck Building: 5601 Main Street
Glassell School of Art: 5101 Montrose Street
Houston, Tex. 77265
(713) 639-7300; (713) 639-7379 (Spanish); (713) 639-7390 (for the deaf)
www.mfah.org

Houston

2003 EXHIBITIONS

Through January 5
Over the Line: The Art and Life of Jacob Lawrence
Paintings of historical and contemporary subjects. (Travels)

Through January 5
Art Beyond Isms: Masterworks from El Greco to Picasso in The Phillips Collection
More than 50 European works, from past masters like El Greco to more modern masters like Renoir, Daumier and Picasso. (Travels)

Through January 5
Alfred Stieglitz: Known and Unknown
More than 100 photographs spanning his career, with an emphasis on lesser-known works.

Through January 26
19th-Century Texas Pottery
Explores the development of a pottery industry in Texas, largely through the labor of slaves.

Through February 17
Leonardo da Vinci and the Splendor of Poland
Da Vinci's *Portrait of the Lady with the Ermine*, Rembrandt's *Portrait of Martin Soolmans,* views of Warsaw by Bernardo Bellotto and other works.

Through March 9
Old Masters, Impressionists and Moderns: French Masterworks From the State Pushkin Museum, Moscow
The first such exhibition in America drawn exclusively from the Pushkin, including works never before exhibited outside Russia. More than 70 major paintings from the 17th century through the early 20th.

January 16–March 2
Annette Lawrence — Theory
Site-specific installation and drawings.

February 9–May 4
American Modern: 1920's and '30s Design

February 22–May 19
Dreaming in Pictures: The Photographs of Lewis Carroll

About 75 small-scale vintage prints by the author, who was an important Victorian photographer before turning to writing.

March 2–April 27
The History of Japanese Photography
First major survey of Japanese photography outside Japan, featuring more than 150 photographs from the 19th and 20th centuries.

April 6–June 29
Paris in the Age of Impressionism: Masterworks From the Musée Orsay
Paintings, sculpture, decorative arts, architectural drawings and photographs from the Paris museum.

April 27–July 20
Ellsworth Kelly: Red Green Blue
Focuses on three iconic canvases from a series of works the artist began in the late 1950's.

May 18–August 11
Pioneers of Studio Craft

May 18–August 17
James Rosenquist: A Retrospective
More than 100 works created after 1970, including paintings, prints, drawings and collages.

September 21–January 4, 2004
Kermit Oliver
About 80 paintings and drawings by a Texas native whose work harks back to the neoclassical and romantic styles of Ingres and Delacroix.

Courtesy of the Museum of Fine Arts, Houston.
Nagano Shigeichi, *An Elderly Couple on Pilgrimage in Mourning for Their Son Killed in War*, 1956.

September 21–January 4, 2004
Masterworks From the Museum of Modern Art

PERMANENT COLLECTION

More than 45,000 works from six continents, spanning 5,000 years of art history. Includes Impressionist and Post-Impressionist art; Renaissance and Baroque works; African gold; the Cullen Sculpture Garden; American and European decorative arts. **Architecture:** Original 1924 Beaux-Arts museum building designed by William Ward Watkin; glass-walled International Style addition by Mies van der Rohe; new Beck Building, opened in 2000, by Rafael Moneo.

Admission: Adults, $7; students, seniors and children 6–18, $3.50; children 5 and under, free. Free on Thursday.
Hours: Tuesday and Wednesday, 10 a.m–5 p.m.; Thursday, 10 a.m.–9 p.m.; Friday and Saturday, 10 a.m.–7 p.m.; Sunday, 12:15–7 p.m.

Marion Koogler McNay Art Museum

6000 North New Braunfels Avenue, San Antonio, Tex.
 78209
(210) 824-5368
www.mcnayart.org

2003 EXHIBITIONS

February 4–April 27
Jesse Amado
Multimedia, site-specific installation by an artist known for using unusual materials.

February 4–March 23
Estampas Nuevas: Recent Mexican Print Acquisitions
Includes prints by José Clemente Orozco, Diego Rivera and Sarah Jimenez, one of the rare women artists of the golden age of Mexican printmaking.

February 28–May 11
Mary Cassatt: An American in Paris
Suite of ten color aquatints by the artist.

April 5–June 22
Charles Biederman: Abstract Modernist
Retrospective of the work of the abstract painter and theorist
who began making reliefs in 1934 and was later known in the
1950's for painted aluminum geometric wall structures.

April 15–June 15
Francisco Toledo's Fantastic Zoology
Watercolors by a contemporary Mexican artist with imagery
based on Jorge Luis Borges's *Fantastic Zoology*.

June 3–August 24
Scott Burton: Sculpture Equals Furniture
Indoor/outdoor exhibition of the artist's minimalist furniture
as well as a large-scale sculpture.

July 15–September 21
Alfred H. Maurer: American Modern
More than 30 paintings and 20 drawings by a pioneering
American Modernist, including Fauvist and Cubist-influenced
still lifes and figure paintings.

July 15–September 21
The Moderns: 20th-Century American Prints
Includes works by Charles Sheeler, Stuart Davis, John Marin,
Howard Cook, Fannie Hillsmith, Max Weber and Marsden
Hartley.

October 5–January 4, 2004
Fairfield Porter: A Life in Art, 1907–1975
Works by the American representational painter with a style
reminiscent of Impressionism.

PERMANENT COLLECTION

Nineteenth- and 20th-century European and American art,
including French Post-Impressionist paintings and pre-World
War II American paintings; medieval and Renaissance
European sculpture and painting; 19th- and 20th-century
prints, drawings and sculpture; theater arts. Works by
Cézanne, Picasso, Gauguin, Matisse, O'Keeffe, Cassatt and
Hopper. **Architecture:** 1926–28 Spanish-Mediterranean-style
residence by Atlee B. and Robert M. Ayres.

Admission: Free; fees for special exhibitions.

San Antonio

Hours: Tuesday through Saturday, 10 a.m.–5 p.m.; Sunday, noon–5 p.m. Closed Monday, New Year's Day, Independence Day, Thanksgiving and Christmas Day.

San Antonio Museum of Art

200 West Jones Avenue, San Antonio, Tex. 78215
(210) 978-8100
www.samuseum.org

2003 EXHIBITIONS

Through January 5
Maestros de Plata: William Spratling and the Mexican Silver Renaissance
More than 400 silver objects from the 1920's to the present by 20 silver designers living in Mexico. (Travels)

February 15–June 15
Treasures From Ancient America: Highlights From the Donald Judge Collection
Objects of earthenware, wood, gold, jade, bronze, silver and other materials from Mesoamerica and Central and South America.

February 22–April 20
American Impressionism: Treasures From the Smithsonian American Art Museum
Works by Hassam, Cassatt, Whistler, Twatchman and others.

June 7–September 7
Dale Chihuly: Installation SA
Site-specific installation by the glass artist.

PERMANENT COLLECTION

Greek, Roman and Egyptian antiquities; American and European paintings; Asian art; modern art; Oceanic art, Near Eastern art and Islamic art. **Highlights:** The Nelson A. Rockefeller Center for Latin American Art. **Architecture:** A historic brewery building along the banks of the San Antonio River.

Admission: Adults, $6; seniors, $5; college students with I.D., $4; children 4–11, $1.75; children 3 and under, free. Free on Tuesday, 3–9 p.m.
Hours: Tuesday, 10 a.m.–9 p.m.; Wednesday through Saturday, 10 a.m.–5 p.m.; Sunday, noon–5 p.m. Closed Monday, Easter, Battle of Flowers Parade Day, Thanksgiving and Christmas Day.

Virginia

Chrysler Museum of Art

245 West Olney Road, Norfolk, Va. 23510
(757) 664-6200
www.chrysler.org

2003 EXHIBITIONS

Through January 5
American Impressionism: Treasures From the Smithsonian American Art Museum
Works by John White Alexander, Mary Cassatt, Childe Hassam, Maurice Brazil Prendergast and others. (Travels)

Through Spring 2003
Gentle Modernist: The Art of Susan Watkins
Paintings, oil studies, academic drawings and sketches by Watkins (1875–1913), from her student days in Paris to her return to America.

Through August 24
A Lens to the World: Photographs by Bob Lerner
Some 130 works by a photographer for Look magazine from 1951 to 1971 who covered popular culture in 50 countries and all 50 states.

April 11–July 20
La Bella Macchina: The Art of Ferrari
First American exhibition devoted to Ferrari automobiles, documenting the evolution of the design.

PERMANENT COLLECTION

More than 30,000 objects spanning 5,000 years, including
European and American painting and sculpture; glass; decorative arts; photography; pre-Columbian, African and Asian art.
The museum administers two historic houses in Norfolk: the
Moses Myers House, 331 Bank Street, and the Willoughby-
Baylor House, 601 East Freemason Street.

Admission: Adults, $7; students, seniors and military, $5;
children 12 and under, free. Voluntary contribution on
Wednesday.
Hours: Wednesday, 10 a.m.–9 p.m.; Thursday through
Saturday, 10 a.m.–5 p.m.; Sunday, 1–5 p.m. Closed Monday,
Tuesday and major holidays.

Virginia Museum of Fine Arts

2800 Grove Avenue, Richmond, Va. 23221
(804) 340-1400; (804) 340-1401 (for the deaf)
www.vmfa.state.va.us

2003 EXHIBITIONS

Through January 19
Celebrating Art Nouveau: The Kreuzer Collection
About 480 pieces from a recently acquired collection of Art
Nouveau jewelry from around 1900.

Piel Frères, Buckle,
c. 1900.

Courtesy of the Virginia Museum of Fine Arts.

Through March 30
Bill Viola: The Quintet of the Unseen
Work by a leading video artist that transfer the passions in
Renaissance paintings to the contemporary world.

Permanent Collection

French Impressionist and Post-Impressionist art; Art
Nouveau and Art Deco decorative arts; American and
European art; Russian Easter eggs by Peter Carl Fabergé;
African art; Byzantine and Medieval art; ancient Egyptian,
Greek and Roman art; British sporting art; art from India,
Nepal and Tibet; European art from the Renaissance to the
20th century. **Architecture:** Original 1936 Georgian build-
ing with four additions.

Admission: Suggested donation, $5; fees for some exhibitions.
Hours: Tuesday through Sunday, 11 a.m.–5 p.m.; Thursday,
until 8 p.m. Closed Monday, New Year's Day, Independence
Day, Thanksgiving and Christmas Day.

Washington

Frye Art Museum

704 Terry Avenue, Seattle, Wash. 98104
(206) 622-9250
www.fryeart.org

2003 Exhibitions

Through January 19
Fairfield Porter: A Life in Art, 1907–1975
Forty works that reflect the American Realist painter's home
life, family and friends.

Through February 9
Recent Paintings of Jim Phalen

Seattle

Through March 2
Groundbreaking Women Photographers of the Northwest: Imogen Cunningham, Ella McBride, Myra Wiggins, Adelaide Hanscom

February 1–April 20
In Line With Al Hirschfeld
Drawings by the cartoonist.

February 14–May 11
Teng Chiu
Works by an artist who was born in China and lived and painted in the United States and Europe, embracing both Eastern and Western traditions.

Courtesy of the Frye Art Museum.
Teng Chiu, *Balinese Dancer*, 1932.

March 7–June 1
New Temperaments

May 3–July 13
Photographs of Art Wolfe
Images of wildlife by an internationally known wildlife photographer.

May 16–August 3
Avard Fairbanks
Works by an American sculptor known for his historical monuments.

June 6–September 7
Tony Foster's River Scenes
Series of river scenes by a British watercolor artist.

July 26–November 30
Imperial Collection: Women Artists From the State Hermitage Museum
Forty-eight works by 15 western European women artists from the Hermitage Museum in St. Petersburg.

August 8–November 9
Del Gish
Watercolors by an artist from the Northwest.

September 12–November 16
Alex Katz Woodcuts
Woodcut prints by an artist better known for his billboard-size figure paintings and portrait heads.

November 14–February 1, 2004
Jeanette Pasin Sloan
Works by an artist who takes a modernist approach to the still-life tradition of Western art.

PERMANENT COLLECTION

More than 1,200 paintings by 19th- and 20th-century American and European Representational artists. Works by contemporary American artists, including William Beckman, Richard Diebenkorn, Graham Nickson and Alice Neel, as well as traditional American artists, including Copley, Sargent, Hassam and Whistler. Extensive collections of late-19th-century German art from the Munich School Secession.
Architecture: 1952 International Modernist building by Paul Thiry; 1997 renovation by Olson Sundberg Architects, Seattle.

Admission: Free.
Hours: Tuesday through Saturday, 10 a.m.–5 p.m.; Thursday, until 8 p.m.; Sunday, noon–5 p.m. Closed Monday, New Year's Day, Independence Day, Thanksgiving and Christmas Day.

Henry Art Gallery

15th Avenue Northeast and Northeast 41st Street,
Seattle, Wash. 98195
(206) 543-2280
www.henryart.org

2003 EXHIBITIONS

Through January 5
Mexico Ahora: Recent Art From the Gelman Collection
Contemporary art from Mexico, ranging from wrestler posters to conceptual works.

Seattle

Through February 2
Out of Site: Fictional Architectural Spaces
Works on paper, paintings, digital photography, sculpture and installations exploring how digital technology and urban and suburban growth affect contemporary culture.

Through March 2
The Dream of an Audience: Theresa Hak Kyung Cha (1951–1982)
Retrospective of the work of a Korean artist who explores geographic, cultural and linguistic displacement.

January 2003–January 2004
Kori Newkirk: Artist Residence Project
Large-scale mural by a Los Angeles artist for the museum's central stairwell.

March 7–June 15
James Turrell
Works by a light and space artist who has been commissioned to do a site-specific project at the museum.

March 28–May 11
Short Stories
Rotating series of small exhibitions showcasing bold new curatorial methods and cutting-edge art.

May 30–June 22
University of Washington Master of Fine Arts 2003
Annual exhibition of student art.

Admission: Adults, $6; seniors, $4.50; students, members and children under 14, free. Pay what you wish, Thursday 5–8 p.m.
Hours: Tuesday through Sunday, 11 a.m.–5 p.m.; Thursday, until 8 p.m. Closed Monday, New Year's Day, Independence Day, Thanksgiving and Christmas Day.

Seattle Art Museum

100 University Street, Seattle, Wash. 98101
(206) 654-3100
www.seattleartmuseum.org

2003 EXHIBITIONS

Through January 5
Frida Kahlo, Diego Rivera and Mexican Modernism: The Jacques and Natasha Gelman Collection
Works by Kahlo, Rivera, Maria Izquierdo, José Clemente Orozco, Carlos Mérida, Rufino Tamayo and David Alfaro Siqueiros over the past century.

Through March 9
Expressions of the Brush: Painting by Dutch and British Masters
Works by Franz Hals, Jan Steen and others on loan from the Taft Museum of Art.

Through April 6
Documents Northwest: The PONCHO Series, Anthony Hernandez
Photographs from his Landscapes for the Homeless series as well as large-scale images of abandoned urban spaces.

Through April 27
Traditional Arts of Mexico: Beauty From the Hand
Textiles and dance masks of indigenous communities in Mexico.

Through July 7
Kilengi: African Art From the Bareiss Family Collection
Works from various African countries.

Through August 17
Hero/Antihero
Explores the notion of the hero and antihero through the museum's collection of European and African art.

February 6–May 4
Over the Line: The Art and Life of Jacob Lawrence
Most comprehensive exhibition to date of the artist's work.

March 21–July 20
George Washington: A National Treasure
Exhibition focusing on the famed Lansdowne portrait of the president by Gilbert Stuart.

April 24–July 27
Documents Northwest: The PONCHO Series, Charles LeDray
Miniature sculptures by a Seattle-born artist.

May 22–November 30
Preston Singletary
Glass works that use traditional Native American forms.

Seattle

June 12–September 8
Intimate Worlds: Indian Paintings From the Alvin O. Bellak Collection
About 90 miniature paintings from 1375 to 1890.

June 12–September 8
Conversations With Traditions: Nilima Sheikh/Shahzia Sikander
Miniature paintings by an Indian artist and a Pakistani artist.

Continuing
An American Sampler
American decorative arts, including furniture, needlework and paintings.

Seattle Asian Art Museum

Volunteer Park, 1400 East Prospect, Seattle, Wash. 98102
(206) 654-3100
www.seattleartmuseum.org

2003 EXHIBITIONS

Through March 16
Rabbit, Cat and Horse: Endearing Creatures in Japanese Art
Paintings, textiles and crafts depicting animals, used both as sacred symbols and popular motifs.

April 10–June 15
An Enduring Vision: 17th to 20th-Century Japanese Painting From the Manyo'an Collection
Hanging scrolls, folding screens and albums representing numerous Japanese painting schools.

Continuing
Timeless Grandeur: Art From China
Sculptures, ritual bronze vessels, ceramics and paintings.

Continuing
Tangible Grace: Chinese Furniture From the Museum Collection
Furniture from the last several hundred years of Imperial China.

PERMANENT COLLECTION

Some 23,000 objects, primarily Asian, African, Northwest Coast Native American, modern art and European painting

and decorative arts. The Volunteer Park building houses the majority of the Asian art collection. **Architecture:** 1991 building by Robert Venturi. Asian Art Museum: 1933 Art Moderne structure in Volunteer Park, designed by the Seattle architect Carl Gould.

Admission: Suggested donation: Adults, $7; seniors and students, $5. Suggested donation at the Asian Art Museum: $3. **Hours:** Tuesday through Sunday, 10 a.m.–5 p.m.; Thursday, until 9 p.m. (closed Tuesday from Labor Day through Memorial Day). Closed Monday, Thanksgiving, Christmas Day and New Year's Day.

Wisconsin

Milwaukee Art Museum

700 North Art Museum Drive, Milwaukee, Wis. 53202
(414) 224-3200; (414) 224-3220 (recording)
www.mam.org

2003 EXHIBITIONS

Through February 9
Edward Weston: Life Work
Works by the modernist American photographer (1886–1956) from rarely exhibited early works to late landscapes of the California coast.

Through March 2
Bill Brandt: A Retrospective
Images spanning his career, from his early Paris photographs to his documentary work of the 1930's and 1940's to his later landscapes, nudes and portraits.

February 28–May 11
From Pop to Now: Selections From the Sonnabend Collection
Works by more than 45 artists shown at the Sonnabend Galleries in Paris and New York, including Jasper Johns, Andy Warhol, Bruce Nauman and Jeff Koons.

March 21–June 8
African Sculpture: Bamana Art From Mali
More than 100 objects from the Bamana people of Africa.

June 6–September 6
Industrial Strength Design: How Brooks Stevens Shaped Your World
A look at one of the most inflential industrial designers of the 20th century, whose creations include the wide-mouthed peanut butter jar, the rotary lawnmower and numerous auto designs.

June 27–August 31
Made in Japan: The Postwar Creative Print Movement
Japanese prints produced from 1945 to 1970.

September 19–December 14
Tom Uttech
Landscape paintings by the Wisconsin artist.

September 26–December 31
Impressionists Along the River
Explores the emergence of Impressionism along the banks of France's rivers, featuring paintings by Monet, Renoir, Caillebotte, Pissarro and Sisley.

PERMANENT COLLECTION

Nearly 20,000 works spanning antiquity to the present. 19th- and 20th-century American and European art, contemporary art, American decorative arts, Old Master works, and American and European folk art.

Architecture: Built in 1957 by Eero Saarinen; 1975 addition by David Kahler; 2001 expansion by Santiago Calatrava.

Admission: Adults, $6; students and seniors, $4; children under 12 and members, free.

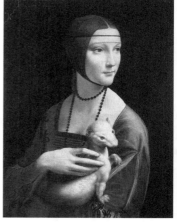

Courtesy of the Milwaukee Art Museum.
Leonardo da Vinci, *Lady with an Ermine (Portrait of Cecilia Gallerani)*, ca. 1490.

Hours: Tuesday through Sunday, 10 a.m.–5 p.m.; Thursday, until 8 p.m. Closed Monday, New Year's Day, Thanksgiving and Christmas Day.

Wyoming

Buffalo Bill Historical Center

720 Sheridan Avenue, Cody, Wyo. 82414
(307) 587-4771
www.bbhc.org

PERMANENT COLLECTION

Western heritage center composed of the Buffalo Bill Museum, the Whitney Gallery of Western Art, the Plains Indian Museum, the Cody Firearms Museum, the brand new Draper Museum of Natural History and the McCracken Research Library.

Admission: Adults, $15 (two consecutive days to all museums); seniors, $13; students, $6; children over 5, $4; children under 5, free.
Hours: June through September 15, 7 a.m.–8 p.m.; call for seasonal hours.

National Museum of Wildlife Art

2820 Rungius Road, Jackson, Wyo. 83001
(800) 733-5328
www.wildlifeart.org

2003 EXHIBITIONS

January 7–May 25
Framing the Wild: Animals on Display

June 5–December 25
The Hole Range: Wildlife and Landscape of the Tetons, Yellowstone and the Wind Rivers

May 22–September 4
A Trip to Yosemite With Ansel Adams and Georgia O'Keeffe

November 20–January 25, 2004
Land Through the Lens From the Smithsonian Art Museum

PERMANENT COLLECTION

More than 3,000 works of art from 2000 B.C. to the present, focusing primarily on European and American painting and sculpture. Works by Delacroix, Dürer, Peale, Catlin, Bierstadt and Audubon. **Highlights**: Carl Rungius Collection, featuring works by the American Impressionist who painted wildlife; John Clymer Collection; American Bison Collection.

Admission: Adults, $8; students and seniors, $7; family rate, $16.
Hours: Daily, 9 a.m.–5 p.m. Closed Thanksgiving Day and Christmas Day.

Puerto Rico

Museo de Arte de Ponce

2325 Avenida de las Americas, Ponce, P.R. 00717
(787) 848-0505; (787) 641-3129
www.museoarteponce.org

PERMANENT COLLECTION

More than 2,500 works, including paintings and sculptures by Rubens, Velazquez, Murillo, Strozzi, Delacroix and Bougereau; 18th-century paintings from Peru and South America as well as 18th- and 19th-century works by Puerto Rico's José

Campeche and Francisco Oller. Contemporary artists include Fernando Botero, Claudio Bravo, Myrna Baez, Jesús Rafael Soto and Antonio Martorell. **Highlights:** Collection of Pre-Raphaelites and Leighton's *Flaming June.* **Architecture:** 1965 building by Edward Durrell Stone.

Admission: Adults, $4; seniors and children under 12, $2; students, $1; members, free.
Hours: Daily, 10 a.m.–5 p.m. Closed Christmas Day, New Year's Day, January 6 and Good Friday.

Museo de Arte de Puerto Rico

Former Municipal Hospital, 299 De Diego Avenue,
 Santurce, San Juan, P.R. 00940–2001
(787) 977-6277
www.mapr.org

PERMANENT COLLECTION

Puerto Rican art from the 17th century to the present. Modern works include paintings by Olga Albizu and Rafael Tufino, portraits by José Campeche and murals and still lifes by Francisco Oller y Cestero. **Architecture:** West wing: Neo-classical structure from the 1920's designed by William H. Shimmelphening. East wing: modern structure designed by Otto Reyes and Luis Gutierrez.

Admission: Adults, $5; children, students and seniors, $3.
Hours: Tuesday through Saturday, 10 a.m.–5 p.m.; Wednesday, until 8 p.m.; Sunday, 11 a.m.–6 p.m. Closed Monday, New Year's Day, January 6, Good Friday, Thanksgiving and Christmas Day.

The Tourist Lifeline

By Alan Riding

Let's face it, tourists can be a bother, with their coaches blocking traffic outside the Louvre, their tour leaders leading gaggles of visitors through the museum's atrium, their flashing cameras adding astonishment to *Mona Lisa*'s mysterious smile. But wait, what if there were no tourists? Well, that would be a great deal worse. Without tourists paying entrance fees, buying post-cards and T-shirts, and lunching in the restaurant, many museums would go out of business.

In Europe, the slump in American tourism following the Sept. 11, 2001, terror attacks in the United States brought this reality into sharp focus. The fall-off in visitors varied from city to city, from museum to museum, but it was felt across the board. At the Louvre in Paris, where foreigners normally account for 65 percent of its six million annual visitors, attendance fell by 36 percent in the four months after Sept. 11 and was down 15 percent for 2001.

Tourism to Britain was battered twice that year, first by an outbreak of foot-and-mouth disease, then by the terror attacks. At the British Museum, the opening of its new Great Court drew more British visitors, but fewer foreigners brought lower sales in its gift shop. The resulting budget squeeze forced it to cut staff.

Yet even in normal times, these and other museums survive thanks to tourists. As with the Louvre, for instance, two-thirds

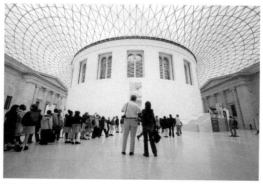

The British Museum's Great Court is drawing more British tourists, but the number of foreign tourists has declined.

of visitors to the Musée d'Orsay in Paris are foreigners. It could almost be argued that European museums exist *for* tourists since tourists — both foreign and national — invariably represent over half their visitors (and still more, if school groups are excluded). Indeed, one of the peculiarities of modern travel is that people who rarely set foot in a museum in their home city will cheerfully head for a museum when vacationing abroad. Good museums are therefore important pluses for many cities, with hotels and restaurants among the beneficiaries.

Blockbuster shows are key variables. Art critics may turn up their noses at the annual competition for the most popular temporary exhibition, arguing that attendance is no guarantee of quality. Yet splashy shows, like *Matisse Picasso* at the Tate Modern in London and Grand Palais in Paris in 2002, draw tens of thousands of visitors who might not be attracted by a museum's permanent collection. Well-promoted shows also bring coachloads of visitors from neighboring countries. And thanks to sales of tickets, catalogs and spin-off products, they are major moneymakers. The Royal Academy of Arts in London, for instance, lifted itself out of the red in 1999 thanks to a single Monet blockbuster.

Of course, in capital cities like London, Paris, Amsterdam and Madrid, museums have the advantage of long-standing reputations. For first-time visitors to Paris, for example, a glimpse of *Mona Lisa* or *Venus de Milo* in the Louvre or the Impressionists at the Musée d'Orsay is as much an imperative as a ride to the top of the Eiffel Tower. For provincial cities, though, it is more of a challenge to persuade tourists to visit museums that inevitably have more modest collections. One favored strategy is not to compete with the metropolitan museums but instead to focus on some popular local artist.

Nonetheless, provincial cities across Europe continue to have faith in museums as magnets of tourism. Not all are as lucky as Bilbao in northern Spain: since it opened in 1997, Frank Gehry's dramatic Guggenheim Museum Bilbao has drawn hundreds of thousands of tourists who have traveled to the city only to see the museum. Also in Spain, Barcelona built a Museum of Contemporary Art and Valencia is building a $300 million City of Arts and Sciences with many of the same hopes in mind.

In fact, even smaller European cities and towns now regard a new or renovated museum as central to their identity. In France alone, towns like Besançon, Bayonne, Saint-Etienne,

Roubaix and Toulouse have all inaugurated new museums in the past three years. They may lack the funds to build a classical collection, but a timely donation of a private collection often provides a foundation.

Manchester in northern England is the latest city to gamble that new cultural institutions can transform its image from a rundown industrial backwater. The Lowry Center, comprising two theaters and an art gallery, has proven its popularity since it opened in 2000. Then, in 2002, the city added the Imperial War Museum North, a stunning sculptural composition designed by the Polish-born American Daniel Libeskind, architect of the new Jewish Museum in Berlin, itself a major tourist attraction. Simultaneously, a new urban-life museum called Urbis opened in downtown Manchester, while the Manchester Art Gallery inaugurated a large new extension. Whether tourists to London will suddenly start traveling to Manchester is arguable, but the cultural makeover has done wonders for the city's pride.

Still, too many tourists can be trying. With blockbusters, even when crowding is limited by selling tickets for specific times, the crush of visitors often prevents quiet contemplation of a single work of art. With permanent collections, on the other hand, the main problem tends to be distribution of visitors: some galleries, like the Rembrandt Room in the Rijksmuseum in Amsterdam and the hall housing the Elgin Marbles in the British Museum, are invariably full; others in the same museums may be deserted. Understandably, museums would like fewer visitors in some rooms and more in others. But, no less reasonably, tourists are first drawn by what is most popular.

For Pierre Rosenberg, former director of the Louvre, overcrowding is now endangering the aesthetic experience of visiting the museum. The problem is aggravated by the popularity of *Mona Lisa*. Today, tour groups account for 22 percent of the Louvre's visitors, while 52 percent of people entering the museum are doing so for the first time. And no one, it seems, leaves the building without first admiring — and photographing — Leonardo da Vinci's masterpiece. Managing the flow of human traffic around the *Mona Lisa* has long been a headache. As of 2003, however, the painting will have its own space in the Salle des États and, in theory, it should cause less disruption to the rest of the museum.

But if *Mona Lisa* is the exception, the rule is that European museums are eager for tourists. Museums outside Britain, for

Two-thirds of the visitors to the Louvre Museum are tourists.

instance, now routinely offer information in English, Japanese and other languages on their web sites. And they usually include publicity for their gift shops, with Internet sales mentioned as an option. The fact is that, even though European museums invariably depend for their existence on government subsidies, the rising cost of administration and security and the additional expense of special exhibitions are forcing them to boost their own sources of income. And for that, they need those tourists. Today, an empty and silent museum is one that could be in trouble.

Alan Riding, who is based in Paris, is the European cultural correspondent of The New York Times.

Exhibition Schedules for Museums Outside the United States

Thomas Gainsborough, *Mrs. Richard Brinsley Sheridan,* 1785-1787.

Argentina

Centro Cultural Recoleta

1930 Junin, Buenos Aires 1113, Argentina
(54-114) 803-1041; (54-114) 803-1040
www.centroculturalrecoleta.org

PERMANENT COLLECTION

None. **Architecture:** Built in the 17th century by the Jesuit architects Juan Kraus and Juan Wolf and the Italian Andrés Blanqui as a convent for Franciscan friars; 1870 renovations by Testa, Bedel and Benedit; mid-20th-century facade by Buschiazzo; neo-Gothic chapel.

Admission: Free.
Hours: Tuesday through Friday, 2–9 p.m.; Saturday, Sunday and holidays, 10 a.m.–9 p.m. Closed Monday, New Year's Day, May 1 and Christmas Day.

Fundación Proa

1929 Avenida Pedro de Mendoza, Buenos Aires 1169,
 Argentina
(54-114) 303-0909
www.proa.org

Architecture: A converted residence in a historic immigrant neighborhood; renovated in 1996 by the Italian architectural group Caruso-Torricella.

Admission: Adults, $3; students, $2; seniors, $1.
Hours: Tuesday through Sunday, 11 a.m.–7 p.m. Closed Monday, New Year's Day and Christmas Day.

Museo de Arte Hispanoamericano Isaac Fernández Blanco

1422 Suipacha, Buenos Aires 1011, Argentina
(54-114) 327-0272; (54-114) 327-0228
www.buenosaires.gov.ar/cultura/museos/html

PERMANENT COLLECTION

South American colonial silver, as well as paintings from the schools of Lima, Cuzco and Upper Peru and furniture and decorative arts from the 18th and 19th centuries. **Highlights:** Alto Peruvian tabernacle with engraved flora and fauna; Baroque votive lamp in repoussé and chiseled cast silver.

Admission: $1. Thursday, free.
Hours: Tuesday through Sunday, 2–7 p.m. Closed Monday, the month of January, May 1 and Christmas Day.

Museo de Arte Moderno

350 Avenue San Juan, Buenos Aires, Argentina
(54-114) 361-1121
www.buenosaires.gov.ar/cultura/museos/html

PERMANENT COLLECTION

Contemporary Argentine art by Ernest Deira, Alberto Greco, Kenneth Kemble, Gyula Kosice, Tomás Maldonado, Jorge de la Vega and others; works by Matisse, Miró, Picabia and Picasso. **Architecture:** Renovated 19th-century cigarette factory in the historic San Telmo neighborhood.

Admission: $1.
Hours: Tuesday through Friday, 10 a.m.–8 p.m.; Saturday and Sunday, 11 a.m.–8 p.m. Closed Monday, New Year's Day, May 1 and Christmas Day. Renovations are under way, and some wings are closed to the public.

Museo Nacional de Arte Decorativo

1902 Avenue del Libertador, Buenos Aires 1425,
 Argentina
(54-114) 801-8248; (54-114) 802-6606
www.mnad.org

PERMANENT COLLECTION

European paintings, sculpture, furniture, tapestries and glass
ranging from the 16th century to the 20th. **Architecture:**
French neo-Classical style building by René Sergent built
between 1911 and 1917.

Admission: $1. Tuesday, free.
Hours: Tuesday through Sunday, 2–7 p.m. Closed Monday,
Good Thursday, May 1, Christmas Day and New Year's Day.

Museo Nacional de Bellas Artes

1473 Avenue del Libertador, Buenos Aires 1425,
 Argentina
(54-114) 803-0802; (54-114) 803-8814

PERMANENT COLLECTION

Works from the medieval period to the present; 20th-century
Latin American art; 19th-century French art, including works
by Corot, Courbet, Degas, Manet, Millet and Toulouse-Lautrec.

Admission: Free.
Hours: Tuesday through Friday, 12:30–7:30 p.m.; Saturday,
Sunday and holidays, 9:30 a.m.–7:30 p.m. Closed Monday,
New Year's Day and Christmas Day.

Australia

National Gallery of Australia

Parkes Place, Canberra ACT 2601, Australia
(61-26) 240-6502
www.nga.gov.au

2003 EXHIBITIONS

Through January
Royal Africa: Kings and Chiefs
Objects evoking the splendor and diversity of the royal courts
in West and Central Africa over 600 years.

Through January 19
Seeing the Center: The Art of Albert Namatjira, 1902–1959
Reassessment of the life and art of the Western Aranda artist,
whose work was dismissed as derivative by many art critics.

Through January 27
Jackson Pollock's Blue Poles
Exhibition celebrating the 50th anniversary of the Pollock
painting.

Through January 27
*The Big Americans: Albers, Frankenthaler, Hockney, Johns,
Lichtenstein, Motherwell, Rauschenberg, Stella*
Works by significant artists who worked with Kenneth Tyler, a
major figure of the postwar "Print Renaissance" in the United
States.

Through March 9
Moving Images
Works by international artists who explore the possibilities of
new media.

January 25–April 21
The Spread of Time: The Photography of David Moore
Works from the photographer's long career, from the 1940's to
the present.

March 7–June 9
Pierre Bonnard: Observing Nature
Seventy works, including interiors, nudes, landscapes and large
decorative paintings, by Bonnard (1867–1947).

March 21–June 9
National Sculpture Prize and Exhibition

March 22–June 9
First Impressions
Works from the early period of lithography to the present, by artists such as Goya, Daumier, Fantin-Latour, Cheret, Picasso and Rosenquist.

April 26–July 20
Tactility
Aboriginal art from the permanent collection.

July 11–October 5
Asian Textiles
Focuses on Indonesian and Indian textiles.

July 21–September 14
Andy Warhol

July 26–October 19
A Thoroughly Professional Practice
Prints by Australian artists since 1980.

October 25–January 18, 2004
Grace Crowley
Survey of the artist's work, which assimilated French ideas such as Cubism.

PERMANENT COLLECTION

Spans 5,000 years of international art and more than 30,000 years of indigenous Australian culture. Major holdings include works by Monet, Pollock and Rubens. New acquisitions include Lucian Freud's *After Cézanne* and Luca Giordano's *The Rape of Sabines*. **Architecture:** Building designed by Colin Madigan; sculpture garden by Harry Howard and Associates.

Admission: Free. Fees for special exhibitions.
Hours: Daily, 10 a.m.–5 p.m. Closed Christmas Day.

Queensland Art Gallery

Queensland Cultural Center, Melbourne Street, South
Brisbane, Queensland 4101, Australia
(61-73) 840-7303
www.qag.qld.gov.au

2003 EXHIBITIONS

Through January 27
Asia-Pacific Triennial of Contemporary Art
Works by 16 innovative artists from Asia, Australia and the
Pacific.

March 4–May 25
Color
Exhibition for children exploring how artists have used color to
convey emotions and moods.

June 27–September 28
Indigenous Art of Cape York
Explores the links between the artwork, ceremonies, dances
and beliefs of the people of Cape York.

PERMANENT COLLECTION

Established in 1895, the gallery features Australian, Asian-
Pacific and international art, including painting, sculpture,
decorative arts, prints, photographs, installations and videos.
Among the Australian and indigenous artists represented are
Rupert Bunny, Russell Drysdale, Ian Fairweather, Emily Kame
Kngwarreye and Arthur Streeton. **Architecture:** Designed by
Robin Gibson and Partners and opened in its present premises
in the Queensland Cultural Center in 1982. A special feature is
the Water Mall, with its natural light and rippling sound.

Admission: Free. Fees for special exhibitions.
Hours: Monday–Friday, 10 a.m.–5 p.m.; Saturday–Sunday, 9
a.m.–5 p.m. Closed Good Friday and Christmas Day.

Museum of Contemporary Art

Circular Quay West, Sydney 1223, Australia
(61-29) 241-5876; (61-29) 241-5892 (recording)
www.mca.com.au

2003 EXHIBITIONS

Through February 2
Australian Directions in Contemporary Art
Works by Australian contemporary artists in diverse media,
including painting, drawing, sculpture, installation art,
photography and moving images.

Through February 2
Dorothy Napangardi
Works by an Warlpiri artist.

PERMANENT COLLECTION

More than 8,000 works, including approximately 1,000
drawings and paintings by the museum's founding benefactor,
John Power; contemporary Australian and international art,
including indigenous art from Arnhem Land; works by
Australian and international artists.

Admission: Free. Fees for some exhibitions.
Hours: Daily, 10 a.m.–5 p.m. Closed Christmas Day.

Austria

Kunsthistorisches Museum

Maria-Theresien-Platz, Vienna 1010, Austria
(43) 152-5240
www.khm.at

2003 EXHIBITIONS

Through March
Thesauri Poloniae: The Treasures of Poland
Survey of Polish treasures from the late Middle Ages to the
Enlightenment, including paintings, tapestries, carpets,
centerpieces and armor.

Through April 27
The Art of Gem Cutting: From the Middle Ages to the Baroque
Comprehensive exhibition of lapidary art from all the
important periods and production centers, including Lower
Italy, Venice, Paris and Milan.

March 17–June 29
Money From China

March 20–May 18
Calatrava

April 11–August 31
Emperor Ferdinand I
Paintings, drawings, miniatures, engravings, woodcuts and
armor to mark the 500th anniversary of the emperor's birth.

June 4–September 15
Parmigianino
About 20 paintings and more than 60 drawings and graphic
works marking the 500th anniversary of the birth of Girolamo
Francesco Maria Mazzola Parmigianino (1503–1540).

September 15–January 31, 2004
Francis Bacon and the Old Masters
Retrospective of the English artist's work, with a focus on the
influence of high and low art on his paintings.

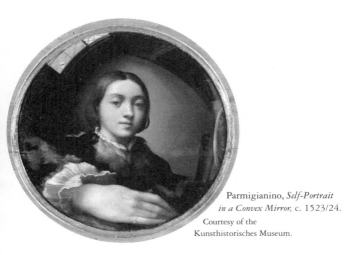

Parmigianino, *Self-Portrait
in a Convex Mirror,* c. 1523/24.
Courtesy of the
Kunsthistorisches Museum.

Opening September 23
Artemis From Ephesus
Objects relating to one of the Seven Wonders of the Ancient
World, the sanctuary of Artemis From Ephesus, discovered
in 1869.

PERMANENT COLLECTION

Paintings by the Flemish, Dutch, German, Italian, Spanish and
French schools, including works by Dürer, Rubens, Rembrandt
and Titian; Bruegel collection; antiquities. **Architecture:**
Neo-Renaissance building by Gottfried Semper and Karl
Hasenauer, 1871–91. Together with its companions across the
square, the Natural History Museum and the Hofburg, the
museum was planned as part of the Imperial Forum on the
Ringstrasse, which was never completed.

Admission: Adults, 9 euros; reduced rate, 6.50 euros;
students, 2 euros.
Hours: Tuesday through Sunday, 10 a.m.–6 p.m.; Thursday,
until 10 p.m. Closed Monday.

Palais Harrach

Freyung 3, Vienna 1010, Austria
(43-1) 533-7811
www.khm.at

2003 Exhibitions

Through January 6
Devotional Articles and Artist's Relics

January 27–April 15
Time of Awakening: Vienna and Budapest Between Historicism and the Avant-Garde

Opening in July
Manfred Hebenstreit

Opening in Fall
Eleonora Duse

September 2–30
A Memory of Spain

October 2–19
Markowitsch

October 21–November 30
Robert Pipal

December 1–January 2004
Maria Moser

December 22–April 12, 2004
Flemish Landscapes

Architecture: Baroque palace restored in the 1990's.

Admission: Adults, 7 euros; reduced rate, 5 euros; students, 2 euros.
Hours: Daily, 10 a.m.–6 p.m.

KunstHausWien

13 Untere Weissgerberstrasse, Vienna A-1030, Austria
(43-1) 712-0495; (43-1) 712-0496
www.kunsthauswien.com

2003 EXHIBITIONS

Through February 9
In Praise of Painting
Works by six Austrian painters of the 1960's and 1970's that were part of the group known as Wirklichkeiten (Realities).

February 20–June 1
Daniel Spoerri

June 12–August 31
Hundertwasser-Bernhard
Photo exhibition about Thomas Bernhard, an Austrian author, and Friedensreich Hundertwasser, the Austrian painter who designed the museum.

PERMANENT COLLECTION

Paintings, graphics, drawings and tapestries examining the philosophy, ecology and architecture of the Austrian artist Friedensreich Hundertwasser. **Architecture:** 1892 factory building redesigned by Hundertwasser between 1989 and 1991 in his distinctive playful and ecological style, including trees growing out of walls and undulating floors.

Admission: 8 euros; reduced admission, 6 euros.
Hours: Daily, 10 a.m.–7 p.m.

Belgium

Royal Museum of Fine Arts

Leopold De Wawlplaats, Antwerp 2000, Belgium
(32-3) 238-7809
www.dma.be/cultuur/kmska/

2003 EXHIBITIONS

Through March
Illustrators
Works by 12 children's book illustrators.

PERMANENT COLLECTION

Art produced in the region since the 14th century, including
works by Van Dyck, Meunier and Titian. **Highlights:** Van
Eyck, *Saint Barbara;* Rubens, *Adoration of the Magi.*

Admission: Adults, 5 euros; seniors, students and groups, 4
euros; children under 18, free. Free on Friday. Fees for special
exhibitions.
Hours: Tuesday through Sunday, 10 a.m.–5 p.m. Closed
Monday, New Year's Day, January 2, May 1, Ascension Day
and Christmas Day.

Royal Museums of Fine Arts of Belgium

3 Rue de la Régence, Brussels 1000, Belgium
(32-2) 508-3211
www.fine-arts-museum.be

PERMANENT COLLECTION

Belgium's largest art complex encompasses the Museum of
Ancient Art (paintings and sculpture from the 15th century
to the 18th), the Museum of Modern Art (from early 19th
century to Conceptual art) and museums dedicated to

Constantin Meunier and Antoine-Joseph Wiertz. Primitive Flemish art; works by Bruegel the Elder, Rubens, van Dyck, Cranach, Tiepolo and Rembrandt; Delvaux and Magritte rooms.

Admission: Adults, 5 euros; seniors and students, 3.5 euros; children, 2 euros. Free on the first Wednesday afternoon of each month.
Hours: Tuesday through Sunday, 10 a.m.–5 p.m. Closed Monday, New Year's Day, May 1, November 1, November 11 and Christmas Day.

Brazil

Eva Klabin Rapaport Foundation

2480 Avenida Epitácio Pessoa, Lagoa, Rio de Janeiro
 22471, Brazil
(55-21) 2523-3471

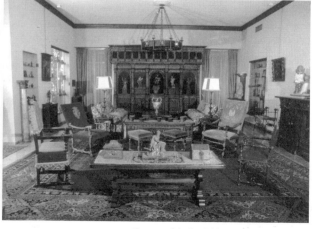

Courtesy of the Eva Klabin Rapaport Foundation.
Renaissance Room.

PERMANENT COLLECTION

An eclectic collection assembled by Eva Klabin. Antiquities, including Greek and Chinese examples; paintings by Gainsborough, Laurencin, Pissarro, Tintoretto and others; decorative arts such as carpets, furniture and silverware. Works of art are kept as they were arranged by the founder in the house where she lived from 1960 until her death.

Admission: 10 reals. Reservations required.
Hours: Monday through Friday, 1–6 p.m. Closed Saturday and Sunday.

International Museum of Naïve Art From Brazil

561 Cosme Velho Street, Rio de Janeiro 22241-090, Brazil
(55-21) 2205-8612
www.museunaif.com.br

PERMANENT COLLECTION

Around 8,000 paintings by Brazilian artists from throughout Brazil and from 30 other countries, providing a historical record of naïve art from the 15th century to the present.

Admission: Adults, 8 reals; seniors, students and children, 4 reals.
Hours: Tuesday through Friday, 10 a.m.–6 p.m.; Saturday and Sunday, noon–6 p.m. Closed Monday, New Year's Day, Christmas Day and May 1.

Museum of Contemporary Art of the University of Niterói

Mirante da Boa Viagem, s/n
CEP 24.210-390, Rio de Janeiro, Brazil
(55-21) 2620-2400
www.macnit.com.br

PERMANENT COLLECTION

Collection of contemporary Brazilian art from the 1950's to the present.

Admission: Adults, 2 reals; students, 1 real; seniors and children under 7, free.
Hours: Thursday through Monday, 11 a.m.–6 p.m.

National Museum of Fine Arts

199 Avenida Rio Branco, Rio de Janeiro, 20040-008,
 Brazil
(55-21) 2240-0068; (55-21) 2262-0891

PERMANENT COLLECTION

More than 15,000 paintings, sculptures, prints and drawings from Brazil and other countries, including Italian and Rococo paintings from the 16th to 18th centuries; 19th- and 20th-century Brazilian art. **Highlights:** Largest collection of Eugène Boudin paintings outside France; eight Brazilian landscapes by the Dutch painter Frans Post.

Admission: 4 reals. Seniors and children under 10, free. Free on Sunday.
Hours: Tuesday through Friday, 10 a.m.–6 p.m.; Saturday and Sunday, 2–6 p.m. Closed Monday.

Museum of Contemporary Art of the University of São Paulo

160 Rua da Reitoria, Cidade Universitária 05508-900,
 São Paulo, Brazil
(55-11) 3091-3027; (55 11) 3091-3028
www.mac.usp.br

PERMANENT COLLECTION

Some 8,000 items from 1906 to the present. Significant works by Brazilian and international modern artists, including Tarsila

do Amaral, De Chirico, Boccioni, Picasso, Calder, Di Cavalcanti, Anita Malfatti. **Highlights:** Paper's Cabinet, an exhibition space with vertical hanging storage for 400 works on paper.

Admission: Free.
Hours: Tuesday through Friday, 10 a.m.–7 p.m.; Thursday, 11 a.m.–8 p.m.; Saturday and Sunday, 10 a.m.–4 p.m. Closed Monday.

MAC/*Centro Cultural FIESP*

Galeria de Arte do SESI
1313 Avenida Paulista
(55-11) 3284-3639

Admission: Free.
Hours: Tuesday through Saturday, 10 a.m.–8 p.m.; Sunday, 10 a.m.–7 p.m. Closed Monday.

Museum of Modern Art of São Paulo

3 Parque do Ibirapuera Gate, São Paulo 04094, Brazil
(55-115) 549-9688
www.mam.org.br

PERMANENT COLLECTION

More than 3,300 paintings, sculptures, objects, installations, drawings and engravings by Brazilian artists.

Admission: Adults, 5 reals; students, 2.50 reals; seniors and under 12, free. Free on Tuesday and on Thursday after 5 p.m.
Hours: Tuesday through Friday, noon–6 p.m.; Thursday, until 10 p.m.; Saturday and Sunday, 10 a.m.–6 p.m. Closed Monday.

Canada

Glenbow Museum

130 Ninth Avenue S.E., Calgary, Alberta T2G 0P3,
 Canada
(403) 268-4100; (403) 777-5506 (recording)
www.glenbow.org

2003 EXHIBITIONS

March 8–May 25
Canvas of War: Masterpieces From the Canadian War Museum
Seventy oil paintings and three large sculptural groups that
were created for the Vimy Memorial in France after the First
World War.

PERMANENT COLLECTION

Some 28,000 works of art, primarily from the 19th century to
the present, mainly from the northwest quadrant of North
America. Native North American collections, particularly of
the Plains natives; Canadian paintings, prints, drawings and
illustrations; Asian art; cultural artifacts; military history;
minerals and precious gems. Archives include more than a
million photographs. Library with more than 100,000 books,
newspapers, periodicals, maps and pamphlets.

Admission: $11 (Canadian); seniors, $8.50; students and
children ages 6–15, $7; under 6, free; family (two adults and
up to four children), $35.
Hours: Monday through Saturday, 9 a.m.–5 p.m.; Sunday,
noon–5:30 p.m. Closed New Year's Day and Christmas Day.

Edmonton Art Gallery

2 Sir Winston Churchill Square, Edmonton, Alberta
 T5J 2C1, Canada
(780) 422-6223
www.eag.org

Admission: $5 (Canadian); seniors and students, $3; ages 6–12, $2; members and children under 6, free.
Hours: Monday through Friday, 10:30 a.m.–5 p.m.; Thursday, until 8 p.m.; Saturday and Sunday, 11 a.m.–5 p.m. Closed major holidays.

Canadian Museum of Civilization

(Musée Canadien des Civilisations)

100 Laurier Street, P.O. Box 3100, Station B, Gatineau, Quebec J8X 4H2, Canada
(800) 555-5621; (819) 776-7000 (recording)
www.civilization.ca

2003 EXHIBITIONS

Through March 9
The Lands Within Me: Expressions by Canadian Artists of Arab Origin
Works by 26 artists.

Through March 30
Timeless Treasures: The Story of Dolls in Canada
More than 450 Canadian dolls, including antiques, Inuit and First Nations dolls, Eaton's Beauties of the 20th century and 46 unique creations made by modern artists.

Through September 8
Nuvisavik: The Place Where We Weave
Fifty tapestries and 10 drawings, examples of Baffin Island Aubusson weaving, an ancient technique in which weavers interpret drawings by local artists.

Through October 26
Souvenirs of Canada

Opening April 4
Beads of Life: African Adornments From the Canadian Collections
Beadwork, headdresses, clothing, headrests, tobacco boxes and other personal items of the Oromo, Masai, Zulu and others.

PERMANENT COLLECTION

More than 3.5 million artifacts, including ethnological and historical pieces, folk art and fine art; the Grand Hall, devoted to Pacific Native peoples, with a large collection of totem poles; the Canada Hall, a series of walk-through settings illustrating 1,000 years of Canadian history; Canadian Children's Museum; Canadian Postal Museum.
Architecture: 1989 building by Douglas Cardinal and Michel Languedoc.

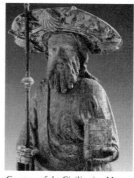

Admission: $10 (Canadian); seniors, $7; students, $6; ages 3–12, $4; families (four people, with a maximum of two adults), $22. Members and children under 3, free. Half-price on Sunday. Free on Thursday, 4–9 p.m.

Courtesy of the Civilization Museum.
St. James the Apostle, 15th century.

Hours: Tuesday through Sunday, 9 a.m.–5 p.m.; Thursday, until 9 p.m. Closed Monday and Christmas Day. May 1 through October 14: Daily, 9 a.m.–6 p.m.; Thursday, until 9 p.m. (also Friday until 9 p.m. July 1–September 2).

Canadian Center for Architecture

(Centre Canadien d'Architecture)

1920 Baile Street, Montreal, Quebec H3H 2S6, Canada
(514) 939-7026
www.cca.qc.ca

2003 EXHIBITIONS

Through January 20
Architecture Remembered: Souvenir Buildings From the CCA Collection

Through February 16
Hal Ingberg
An installation by the Montreal architect.

Through April 6
Herzog and de Meuron: Archaeology of the Mind
An exploration of the visual world that nurtured the work of the Swiss architects Jacques Herzog and Pierre de Meuron.

March 26–July 13
Tangent 1: Alain Paiement

PERMANENT COLLECTION

Some 65,000 prints and drawings, from the late 15th century to the present; approximately 50,000 photographs; architectural archives; library with nearly 200,000 volumes; sculpture garden. **Architecture:** 1989 building by Peter Rose, Phyllis Lambert and Erol Argun, integrated with the 1874 Shaughnessy House by W.T. Thomas, with renovations by Denis Saint-Louis. Garden by Melvin Charney.

Admission: $6 (Canadian); seniors, $4; students, $3; members and children under 12, free. Free on Thursday after 5:30.
Hours: Tuesday through Sunday, 11 a.m.–6 p.m.; Thursday until 9 p.m. Closed Monday. January 21 through April 18: Wednesday through Sunday, 11 a.m.–5 p.m.; Thursday until 8 p.m. Closed Monday and Tuesday.

The Montreal Museum of Fine Arts

(Musée des Beaux-Arts de Montréal)

1379–1380 Sherbrooke Street West, Montreal, Quebec
 H3G 2T9, Canada
(514) 285-1600; (514) 285-2000 (recording)
www.mmfa.qc.ca

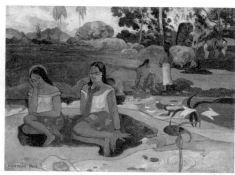

Paul Gauguin,
*Nave Nave Moe
(Sacred Spring/Sweet
Dreams)*, 1894.

Courtesy of the Montreal Museum of Fine Arts.

2003 EXHIBITIONS

Through January 5
Richelieu: Art and Power
Some 240 works exploring the patronage of Cardinal
Richelieu and his use of the visual arts to advance his vision
for France.

February 4–April 27
*Voyage Into Myth: French Painting, From Gauguin to Matisse, From
the Hermitage Museum*
Some 75 works, examining the transition to modernism that
marked the beginning of the 20th century. (Travels)

May 15–August 24
Édouard Vuillard
A retrospective featuring some 400 works by the French
painter (1868–1940). (Travels)

May 15–August 24
Maurice Denis, Photographer
Eighty photographs by the French painter (1870–1943)
exhibited for the first time, plus 15 paintings that show the
links between the two mediums.

June 19–October 5
Françoise Sullivan
A retrospective devoted to the Canadian modern artist,
spanning more than five decades of her varied work.

October 1–January 18, 2004
Global Village: The Vision of the 60's

More than 200 works from around the world, including examples of art, design, photography, fashion and architecture.

PERMANENT COLLECTION

More than 30,000 objects, from antiquity to the present. Decorative arts; Canadian arts; prints and drawings; Old Master paintings; modern and contemporary art; African, Oceanian, Asian, Islamic and pre-Columbian art; textiles; Japanese incense boxes. **Architecture:** 1912 building by Edward and William S. Maxwell; 1976 pavilion by Fred Lebensold; 1991 pavilion by Moshe Safdie.

Admission: Free; fees for special exhibitions.
Hours: Tuesday through Sunday, 11 a.m.–6 p.m. Longer hours for some exhibitions. Closed Monday (except holidays), New Year's Day and Christmas Day.

Canadian Museum of Contemporary Photography

1 Rideau Canal, Ottawa, Ontario, K1N 9N6, Canada
(613) 990-8257
cmcp.gallery.ca

2003 EXHIBITIONS

Through January 12
Ken Lum Works With Photography
Explores the relationship of the Canadian's photographic work to his painting and sculpture.

January 18–May 11
Confluence: Contemporary Canadian Photography
More than 50 works, including industrial landscape views by Robert Bourdeau and Edward Burtynsky; conceptual works by Arnaud Maggs, Jeff Wall and Geneviève Cadieux; theatrical photos by Janieta Eyre and Damian Moppett; and poetic images by Raymonde April and Charles Gagnon.

May 17–September 7
Bill Vazan

September 13–January 8, 2004
Melvin Charney

PERMANENT COLLECTION

More than 158,000 images by Canadian photographers.
Architecture: Constructed in 1992 in an abandoned railway tunnel in downtown Ottawa.

Admission: Suggested donation.
Hours: Wednesday through Sunday, 10 a.m.–5 p.m.; Thursday, until 8 p.m. Closed Monday and Tuesday. May through September: daily, 10 a.m.–6 p.m.; Thursday until 8.

National Gallery of Canada

380 Sussex Drive, Ottawa, Ontario, K1N 9N4, Canada
(800) 319-2787; (613) 990-1985
www.national.gallery.ca

2003 EXHIBITIONS

Through January 5
The Print in Italy, 1550–1620
Works by Agostino and Annibale Carraci and others, including prints with original artistic inventions and those reproducing the work of painters, sculptors and architects.

Through January 5
Jade, The Ultimate Treasure of Ancient China
Some 120 carvings, ranging from the Neolithic period to the 20th century.

Through January 12
Marion Tuu'luq
Wall hangings featuring embroidered and appliquéd surfaces.

Through February 2
Bartolomeo Montagna: St. Jerome in Penitence

January 24–April 27
Edward Burtynsky
In altered landscapes, the photographer presents images of earth excavations, including mines, quarries and scrap yards.

January 24–May 11
Marc-Aurèle de Foy Suzor-Coté: Light and Subject Matter
Paintings, sculptures and drawings produced between 1890 and 1927. (Travels)

March 21–June 1
Christopher Pratt: Places I Have Been
Approximately 25 prints by the Newfoundland artist.

May 23–August 31
Dutch and Flemish Drawings
Works from the gallery's collection.

June 6–September 7
The Age of Watteau, Chardin and Fragonard: Masterpieces of French Genre Painting
Includes works by Boilly, Greuze, Lancret, de Troy and Vernet.

June 20–September 14
Tony Urquhart

September 26–February 8, 2004
Lucius O'Brien: Sunrise Over the Saguenay

October 3–January 4, 2004
A Beautiful and Gracious Manner: The Art of Parmigianino
Some 60 drawings by the Italian (1503–40), together with his major pioneering prints and a small selection of paintings.

October 10–January 4, 2004
Group of Seven in Western Canada
Paintings made from 1914 through the 1960's, including landscapes of the Rocky Mountains, British Columbia and the Northwest Territories, as well as portraits and abstracts.

November–February 2004
David Rabinovitch
Sculpture and drawings largely inspired by the relationships between science, literature and philosophy.

PERMANENT COLLECTION

Canadian art; European art, including Gothic, Renaissance, Baroque and 19th- and 20th-century works; Inuit and American art; international contemporary film and video. **Highlights:** Canadian works by the Group of Seven painters (1920–1932), Borduas, Colville and Riopelle; paintings and sculpture by Bacon, Bernini, Constable, Matisse, Moore,

Murillo, Pollock, Poussin, Rembrandt, Rubens and Turner;
photography by Arbus, Atget, Cameron and Sander.
Architecture: 1988 building by Moshe Safdie.

Admission: Free. Fee for special exhibitions.
Hours: Daily, 10 a.m.–6 p.m.; Thursday, until 8 p.m. During
the winter, open until 5 p.m. and closed Monday and Tuesday.

The Civilization Museum

(Musée de la Civilisation)

85 Rue Dalhousie, C.P. 155 succursale B, Quebec City,
 Quebec G1K 7A6, Canada
(418) 673-2158
www.mcq.org

2003 EXHIBITIONS

Through March 16
Cowboy at Heart
Follows the trail of North American pioneers, heroes and
legends, including Davy Crockett, Laura Ingalls Wilder,
Buffalo Bill, Willie Lamothe and Renée Martel.

Through September 1
Skin Talks
An exploration of what our skin means to us.

May 21–January 4, 2004
Gratia Dei: A Journey Through to Middle Ages

Continuing
Memories
Objects, stagecraft and personal testimonials help explain
Quebec's history.

PERMANENT COLLECTION

More than 200,000 objects reflecting Quebec history, with
four broad sections: ethnology, science, the fine arts and
archaeology. The museum comprises three unlinked pavilions:
the Musée de la Civilisation (at 85 Rue Dalhousie), which

features exhibitions on historical and contemporary subjects; the Musée de l'Amérique Française (2 Côte de la Fabrique), a history museum that reflects the establishment of French culture in North America; and the Centre d'Interprétation de Place-Royale (27 Rue Notre-Dame), which offers a multimedia show, exhibitions and other activities.

Admission: $7 (Canadian); seniors, $6, students, $4; ages 12–16, $2; members and children under 12, free. Tuesday, except during the summer, free.
Hours: Tuesday through Sunday, 10 a.m.–5 p.m. Closed Monday and Christmas Day. Late June through early September: Daily, 9:30 a.m.–6:30 p.m.

Quebec Museum
(Musée du Québec)

Parc des Champs-de-Bataille, Quebec City, Quebec
 G1R 5H3, Canada
(418) 643-2150; (866) 220-2150
www.mdq.org

2003 EXHIBITIONS

Through January 5
Marc-Aurèle de Foy Suzor-Coté: Light and Subject Matter
Paintings, sculptures and drawings produced between 1890 and 1927. (Travels)

PERMANENT COLLECTION

More than 20,000 works, produced mainly in Quebec since the beginning of the colony. **Architecture:** Situated in Battlefields Park overlooking the St. Lawrence River, the museum comprises three linked pavilions: the Gérard-Morisset Pavilion, a neo-Classical structure; the Great Hall, a new central building crowned with a cross of skylights; and the Charles Baillairgé Pavilion, which was built between 1861 and 1871 and served as the Quebec City prison for nearly a century.

Admission: Free. Fees for special exhibitions: Adults, $10 (Canadian); seniors, $9; students, $5; ages 12–16, $3; children under 12, free.

Hours: Tuesday through Sunday, 10 a.m.–5 p.m.; Wednesday, until 9 p.m. Closed Monday. June through August: Daily, 10 a.m.–6 p.m.; Wednesday, until 9 p.m.

The Art Gallery of Ontario

317 Dundas Street West, Toronto, Ontario M5T 1G4, Canada

(416) 979-6648

www.ago.net

2003 EXHIBITIONS

Through January 5
Voyage Into Myth: French Painting, From Gauguin to Matisse, From the Hermitage Museum
Some 75 works, examining the transition to modernism that marked the beginning of the 20th century. (Travels)

Through January 19
Paradise Revisited
French prints and drawings from the gallery's collection.

Through February 2
Tissot and the Victorian Woman
Paintings and prints by the Frenchman J.J. Tissot.

Through March 2
Provisional Worlds
Contemporary art by Canadian and international artists who use mass-produced objects and synthetic materials to shift our perception of our environment.

Continuing
In Light
Contemporary video works.

PERMANENT COLLECTION

More than 26,000 works of European, American and Canadian art since the Renaissance, including Impressionist, Post-Impressionist, Modernist and contemporary works; Inuit art. Works by Hals, Rembrandt, Rubens, Chardin, Gainsborough, Degas and Pissarro; the world's largest public collection of sculpture by Henry Moore. **Architecture:** The Grange, an 1817 brick Georgian private home, fully restored to the 1830's period; 1936 expansion, Walker Memorial Sculpture Court; 1974 Henry Moore Sculpture Center, and Sam and Alaya Zacks Wing; 1977 Canadian Wing and Gallery School; 1993 additions by Marton Myers, in joint venture with Kuwabara Payne McKenna Blumberg Architects.

Admission: $12 (Canadian). Reduced rate for seniors, students and children. Free on Wednesday, 6–8:30 p.m.
Hours: Tuesday through Friday, 11 a.m.–6 p.m.; Wednesday, until 8:30 p.m.; Saturday and Sunday, 10 a.m.–5:30 p.m. Closed Monday.

Royal Ontario Museum

100 Queen's Park, Toronto, Ontario M5S 2C6, Canada
(416) 586-5549; (416) 586-8000 (recording);
(416) 586-5550 (for the deaf)
www.rom.on.ca

2003 EXHIBITIONS

Through May
Elite Elegance: Couture in the Feminine 50's
Clothing from the museum's collection, along with original designer sketches and archival film footage, all exploring haute couture in Toronto during the 1950's.

Continuing
Renaissance ROM: Views of Our Future
Ideas by the three architecture firms under consideration for the design of the museum's renovation and expansion project.

PERMANENT COLLECTION

Canada's largest museum of natural and human history, with more than one million art and archaeology artifacts and nearly five million science specimens. The Samuel European Galleries; The Ancient World; the Sigmund Samuel Canadiana Gallery; the T.T. Tsui Galleries of Chinese Art. Cypriote and Greek art; Roman and Etruscan art; terra-cotta figurines; Byzantine art; arms and armor; North American sculpture; European decorative arts; furniture; metalwork; historical Canadian paintings. **Architecture:** 1914 building expanded over the years; 1978 renovations by Gene Kinoshita.

Admission: Adults, $18 (Canadian); seniors and students, $14; ages 5–14, $10; children under 5, free. Free on Friday, 4:30–9:30 p.m., but fee for special exhibitions.
Hours: Monday through Saturday, 10 a.m.–6 p.m.; Friday, until 9:30 p.m.; Sunday, 11 a.m.–6 p.m. Closed New Year's Day and Christmas Day. Closes at 4 p.m. Christmas Eve and New Year's Eve.

The Power Plant Contemporary Art Gallery at Harbourfront Centre

231 Queens Quay West, Toronto, Ontario M5J 2G8, Canada
(416) 973-4949
www.thepowerplant.org

2003 EXHIBITIONS

Through March 2

Live Forever: New Works by Lee Bul
Three functional, soundproof karaoke pods complete with a selection of pop songs that visitors can perform, plus a new video work. (Travels)

Architecture: 1926 power plant; 1980's renovations by Peter Smith with restored smokestack and industrial facade.

Admission: $4 (Canadian); students and seniors, $2; children under 13, free. Free on Wednesday, 5–8 p.m.

Hours: Tuesday through Sunday, noon–6 p.m.; Wednesday, until 8 p.m. Closed Monday, except on holidays.

The Vancouver Art Gallery

750 Hornby Street, Vancouver, British Columbia V6Z
 2H7, Canada
(604) 662-4700; (604) 662-4719 (recording)
www.vanartgallery.bc.ca

2003 EXHIBITIONS

Through January 5
Emily Carr: Drawing the Forest
Charcoal drawings that Carr executed in the late 1920's and early 30's. The works reveal the role of drawing in her work and show the influence of Mark Tobey and other modernists.

Through January 5
Tom Thomson
A retrospective featuring more than 140 paintings. (Travels)

Through January 12
This Place
More than 75 works from the gallery's collection, by British Columbians or artists who have visited British Columbia and depicted its land or its people. Includes works by Vikky Alexander, Roy Arden, Emily Carr, Tony Hunt, Jin-me Yoon, George Pepper, Bill Reid and Ian Wallace.

Through February 23
Liz Magor
Sculpture, installations and photographic projects created during the last 14 years.

January 30–Spring
E.J. Hughes
Works by the painter, who grew up in Vancouver.

PERMANENT COLLECTION

Nearly 7,000 works of contemporary and international art, including examples by British Columbians and other Canadians. American and British prints; British and Dutch paintings; Emily Carr paintings. **Architecture:** 1910 neo-Classical courthouse building by F.M. Rattenbury, renovated in the 1980's by Arthur Erickson; Robson annex by Thomas Hooper.

Admission: $12.50 (Canadian); seniors, $9; students, $8; children under 13, free; family (two adults), $30; Thursday 5–9 p.m., $5 suggested donation.
Hours: Daily, 10 a.m.–5:30 p.m.; Thursday, until 9 p.m. Closed Monday during the winter.

Czech Republic

Brno Moravian Gallery
(Moravska Galerie v Brne)

www.moravska-galerie.cz

Prazak Palace
(Prazakuv Palác)

18 Husova, Brno 662 26, Czech Republic
(420-54) 216-9111

2003 EXHIBITIONS
Through February
Predecessors of Modernism in Hungarian Photography
Including images by Brassaï and László Moholy-Nagy.

March–May
Frantisek Tichy
Works by the Czech painter and graphic artist.

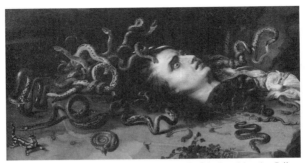

Courtesy of the Brno Moravian Gallery.

Peter Paul Rubens and Frans Snyders, *Head of Medusa*.

September–November
Josef Capek: The Humblest of Arts
A retrospective of the Czech avant-garde artist's career.

PERMANENT COLLECTION

Czech art from the 20th century, including works by members of the Osma group and the Group of 42. **Architecture:** Neo-Renaissance structure created by the Austrian architect Theophil von Hansen by connecting two buildings.

Admission: 70 koruna. Free on the first Friday of the month.

Governor's Palace
(Mistodrzitelsky Palác)

1a Moravske Namesti, Brno 662 26, Czech Republic
(420-54) 232-1100

The palace is slated to close in July 2003, as renovations begin.

2003 EXHIBITIONS
Through February 9
Light
Paintings, drawings, graphics, sculpture, photographs and films by some 100 artists, from the Gothic period to the present, exploring the meaning of light in Central European and particularly Czech art.

March 13–June 15
Venetian Drawings

PERMANENT COLLECTION

European art from the 14th century through the 19th;
medieval statues, paintings on wood and crafts; Baroque works
by Moravians and Austrians; Italian, Flemish and Dutch
paintings. **Architecture:** 14th-century building, with
reconstructions in the 17th and 18th centuries.

Admission: 50 koruna.

Museum of Applied Arts
(Umeleckoprumyslove muzeum)

14 Husova, Brno 66226, Czech Republic
(420-53) 216-9111

2003 EXHIBITIONS

Through May 11
Surface Born to Be Decorated
Approximately 250 examples of Japanese lacquerwork from
the 16th century to the 19th.

June 19–September 14
Art as Abstraction: Czech Visual Culture of the 1960's
Paintings, sculptures, photographs, books and objects.

October–January 2004
Viennese Art Nouveau and Modernism in Bohemia and Moravia
Photographs and furniture, glasswork, textiles, ceramics,
jewelry and other applied arts from the first 25 years of the
20th century, as well as paintings by Gustav Klimt, Oskar
Kokoschka, Egon Schiele and others.

PERMANENT COLLECTION

Glass, ceramics, porcelain, metals, textiles, furniture,
photography and graphics from antiquity to the 20th century.
Architecture: Neo-Renaissance building by the Austrian
architect Johan G. Schon. Reopened in 2002 after a three-year
reconstruction.

Admission: 50 koruna.

For all museums
Hours: Wednesday through Sunday, 10 a.m.–6 p.m.;
Thursday, until 7 p.m. Closed Monday and Tuesday.

Egon Schiele Art Center
(Egon Schiele Art Centrum)

70-72 Siroka, 38101 Cesky Krumlov, Czech Republic
(420-33) 771-1224
www.schieleartcentrum.org
www.ckrumlov.cz/uk/mesto/soucas/i_schiel.htm

2003 Exhibitions
Through April
Salvador Dalî

Permanent Collection

Drawings and watercolors by the Austrian Expressionist Egon
Schiele (1890–1918). **Architecture:** Renovated 16th-century
Baroque and Renaissance brewery building, with Baroque and
industrial additions.

Admission: 120 koruna.
Hours: Daily, 10 a.m.–6 p.m.

City Gallery of Prague
(Galerie Hlavniho Mesta Prahy)

3 Mickiewiczova, Prague 6, Hradcany, 16000, Czech
 Republic
(420-23) 332-1200
www.citygalleryprague.cz

Gallery headquarters. No exhibition space.

The Old Town Hall *(Second Floor)*
(Staromestska Radnice)

1 Staromestske Namesti, 11000, Prague 1,
 Czech Republic
(420-22) 448-2751

2003 EXHIBITIONS

Through February 2
Hanne Darboven

Architecture: Much-renovated 14th-century building with a
Gothic tower that dominates the town square.

Admission: Varies.
Hours: Tuesday through Sunday, 10 a.m.–6 p.m. Closed
Monday. October through April: Saturday and Sunday, 10
a.m.–5 p.m. Closed Monday through Friday.

The Stone Bell House
(Dum u Kamenneho Zvonu)

13 Staromestske Namesti, Prague 1, 11000,
 Czech Republic
(420-22) 482-7526

2003 EXHIBITIONS

Through March 2
Frantisek Tichy
Modern works by the Czech painter and graphic artist.

May–September
Mikolas Ales
Late 19th-century works by the romantic Czech painter.

Architecture: 14th-century Gothic house.

Admission: Varies.
Hours: Tuesday through Sunday, 10 a.m.–6 p.m. Closed
Monday.

The Golden Ring House
(Dum u Zlateho Prstenu)

6 Tynska, Prague 1, Ungelt, 11000, Czech Republic
(420-22) 482-7022

2003 EXHIBITIONS
Through February 16
Rosemarie Trockel

PERMANENT COLLECTION

Twentieth-century Czech art. **Architecture:** Gothic palace
with late Renaissance reconstruction.

Admission: 80 koruna; students and seniors, 40 koruna.

Municipal Library
(Mestska Knihovna)

1 Marianske Namesti, Prague 1, 11000, Czech Republic
(420-22) 231-0489

2003 EXHIBITIONS

Through January 5
Slovak Photography

Late February–April
Artistic Dialogues

June–September
About Bodies and Other Matters

November–January 2004
British Art

Architecture: Functionalist building constructed 1925–28.

Admission: Varies.

Villa Bilek
(B'lkova Vila)

1 Michiewiczova 1, 16000, Prague 6, Czech Republic
(420-22) 432-2021

PERMANENT COLLECTION

Sculpture, drawings and prints by the Czech Art Nouveau
artist Frantisek Bilek (1872–1941). **Architecture:** 1911 villa
built based on Bilek's plans.

Admission: 50 koruna; students and seniors, 20 koruna.

Hours: Tuesday through Sunday, 10 a.m.–6 p.m. Closed
Monday. November through March: Saturday and Sunday,
10 a.m.–5 p.m. Closed Monday through Friday.

The Troja Chateau
(Trojsky Zámek)

1 U Trojskeho Zamku, 17000, Prague 7, Czech Republic
(420-28) 385-1614

Admission: Varies.

Hours: Tuesday through Sunday, 10 a.m.–6 p.m. Closed
Monday. November through March: Saturday and Sunday,
10 a.m.–5 p.m. Closed Monday through Friday.

Czech Museum of Fine Arts
(Ceske Muzeum Vytvarnych Umeni)

19-21 Husova, Prague 1, Stare Mesto, 11001, Czech
 Republic
(420-22) 222-0218
www.cmvu.cz

2003 EXHIBITIONS

Through February 2
Czech Cartoons

July–August
About Technology

PERMANENT COLLECTION

Painting and sculpture from the early period of Czech Modernism; works from the 1930's to the 60's.

Admission: 40 koruna; students and children, 20 koruna.
Hours: Tuesday through Sunday, 10 a.m.–9 p.m. Closed Monday.

Rudolfinum Gallery
(Galerie Rudolfinum)

12 Alsovo Nabrezi, Prague 1 11000, Czech Republic
(420-22) 705-9346
www.galerierudolfinum.cz

2003 EXHIBITIONS

Through February 9
Czechoslovak Socialist Realism

Through February
Falsification in 20th-Century Czech Art

March 15–June 9
Reality Check
Contemporary British photography and video art.

Architecture: 1884 neo-Renaissance building by Josef Zítek and Josef Schulz.

Admission: Varies. Approximately 100 koruna; seniors, students and the disabled, 50 koruna; children under 15, free.
Hours: Tuesday through Sunday, 10 a.m.–6 p.m. Closed Monday.

Mucha Museum

7 Panska, Prague 1 11000, Czech Republic
(420-22) 145-1333
www.mucha.cz

PERMANENT COLLECTION

Paintings, lithographs and personal effects of the Czech Art
Nouveau artist Alphonse Mucha (1860–1939), known for the
posters he created for the actress Sarah Bernhardt.
Architecture: 18th-century Kaunitz Palace.

Admission: 120 koruna; seniors and students, 60 koruna.
Hours: Daily, 10 a.m.–6 p.m.

Prague National Gallery
(Národní Galerie v Praze)

www.ngprague.cz

Kinsky Palace
(Palác Kinskych)

12 Staromestske Namesti, Prague 1, Stare Mesto 11000,
 Czech Republic
(420-22) 481-0758

2003 EXHIBITIONS

Through January 6
Surface Born to Be Decorated
Approximately 250 examples of Japanese lacquerwork from
the 16th century to the 19th. (Travels)

February–April
Great Epoch of German Drawing
Drawings by artists from German-speaking countries in the
15th and 16th centuries. Includes works by Hans Baldung,
Jörg Breu and Hans Holbein.

PERMANENT COLLECTION

Prints and drawings. **Architecture:** 1765 late Baroque-Classical-style building by Anselmo Lurago.

Sternberg Palace
(Sternbersky Palác)

15 Hradcanske Namesti, Prague 1, Hradcany 11000
 Czech Republic
(420-22) 051-4634; (420-23) 335-7332

2003 EXHIBITIONS
Spring–Fall
Ferucci: The Head of Christ

PERMANENT COLLECTION

Fourteenth- and 15th-century Italian art; 15th- and 16th-century Dutch art; Cretan-Venetian art; Russian icons; German paintings from the 15th, 16th and 17th centuries. Works by Dürer, Van Dyck, El Greco, Rembrandt and Rubens. **Architecture:** 1707 Baroque palace by Giovanni Battista Alliprandi and Domenico Martinelli.

St. Agnes Convent
(Kláster Sv. Anezky Ceské)

17 U Milosrdnych, Prague 1, Stare Mesto, 11000, Czech
 Republic
(420-22) 481-0628

2003 EXHIBITIONS
Through May
Tesin Madonna

Summer–Fall
Madonna the Savior

PERMANENT COLLECTION

Medieval art from Bohemia and Central Europe. **Highlights:** 14th-century altars. **Architecture:** 13th-century structure in the Cisterian-Burgundian Gothic style.

St. George Convent
(Kláster Sv. Jiri)

33 Jirske Namesti, Prague
1, The Prague Castle,
11000, Czech Republic
(420-25) 732-0536

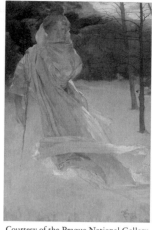

Courtesy of the Prague National Gallery.
V. Hsynais, *Winter,* 1901.

2003 EXHIBITIONS
Through May
*Restored Paintings From the
Sycina Church*

Summer–Fall
Bartholomeus Spranger: Epitaph
of Goldsmith Nicholas Müller

PERMANENT COLLECTION

Czech Baroque art. **Architecture:** 10th-century Romanesque
church building.

Veletrzni Palace
(Veletrzní Palác)

47 Dukelskych Hrdinu, Prague 7, Holosovice, 17000,
Czech Republic
(420-22) 430-1024

2003 EXHIBITIONS

September–January 2004
Vojtech Preissig
Works by the Czech graphic artist and designer.

PERMANENT COLLECTION

Nineteenth- and 20th-century art, including works by Czech
artists and French Impressionists. Works by Braque, Bonnard,
Cézanne, Chagall, Corot, Coubert, Delacroix, Gauguin and
Picasso. **Architecture:** 1925–29 Functionalist building by
Oldrich Tyl and Josef Fuchs; renovated and opened in 1995.

Zbraslav Chateau
(Zámek Zbraslav)

15600 Prague 5, Zbraslav, Czech Republic
(420-25) 792-1638

2003 EXHIBITIONS
Through March 1
Isnik Ceramics
Turkish works from the 15th century to the 17th.

March 22–June 22
Contemporary Japanese Design
Lacquerworks by eight artists.

June 28–September 28
Suiseki: The Japanese Art of Arranging Stones

PERMANENT COLLECTION

Asian art, including bronzes, funerary sculpture, ceramics, paintings, lacquerware and metalwork; Japanese art; Chinese holdings, including works from the Han dynasty (207 B.C.-A.D. 220). **Highlights:** Chinese tomb figures; Tibetan thangkas; Koran manuscript. **Architecture:** Cistercian monastery, founded in 1292 by Wenceslas II; rebuilt in the 18th century by Giovanni Santini Aichl and Frantisek Maxmilian Kanka.

FOR ALL MUSEUMS
Hours: Daily, 10 a.m.–6 p.m.

Admission: 80 to 120 koruna; students and seniors, 40 to 100 koruna; children under 6, free.

Denmark

Louisiana Museum of Modern Art

13 Gammel Strandvej, Humlebaek, DK-3050, Denmark
(454) 919-0719; (454) 919-0791 (recording)
www.louisiana.dk

2003 EXHIBITIONS

Through January 12
Arne Jacobsen
A retrospective featuring the designer's architecture, furniture, garden layouts, textiles, photographs and watercolors.

Through January 19
Wolfgang Tillmans: View From Above
Images, including some enormous prints, that the photographer shot while looking down at his subject.

Spring
Wassily Kandinsky and Gabriele Munter, 1906–14
Paintings by Kandinsky and the student who became his partner. Includes works from the Blue Rider period.

Summer
Arnold Newman
Photographic portraits.

Summer
The Architect's Studio: Renzo Piano

Winter
Roy Lichtenstein

PERMANENT COLLECTION

Works by Francis Bacon, Baselitz, Giacometti, Johns, Kiefer, Klein, Picasso, Warhol and others. Sculpture garden featuring works by Calder, Henry Moore and others. **Architecture:** 1958 building designed by Jergen Bo and Vilhe Im Wohlert; several expansions.

Admission: Adults, 60 kroner; children, 20 kroner; under 4, free. Fee for special exhibitions. **Hours:** Daily, 10 a.m.–5 p.m.;

Wednesday, until 10 p.m. Closed New Year's Day, Christmas Eve and Christmas Day.

Egypt

The Museum of Mohammed Mahmoud Khalil and His Wife

1 Kafour Street, Orman Post Office, Giza, Egypt
(20-2) 336-2376; (20-2) 336-2379; (20-2) 336-2358
www.mkhalilmuseum.gov.eg

PERMANENT COLLECTION

Nineteenth- and early-20th-century European art, including works by Constable, Gauguin, van Gogh, Rodin and Rubens; Egyptian art; vases; Chinese miniatures. **Architecture:** 1915 Art Nouveau and neo-Classical style palace inaugurated as a museum in 1962 and remodeled in the early 1990's.

Admission: 25 Egyptian pounds; students, 12 pounds.
Hours: Tuesday through Sunday, 10 a.m.–6 p.m. Closed Monday.

England

Ikon Gallery

1 Oozells Square, Brindleyplace, Birmingham B1 2HS, England
(44-121) 248-0708
www.ikon-gallery.co.uk/ikon

Hayley Newman,
Crying Glasses, 1998.

Courtesy of the Ikon Gallery.

2003 EXHIBITIONS

Through January
On Kawara
Focuses on the artist's preoccupation with the nature of human consciousness.

Architecture: Victorian school building refurbished and extended in the 1980's by Levitt Bernstein Associates.

Admission: Free.
Hours: Tuesday through Sunday, 11 a.m.–6 p.m. Closed Monday except bank holidays.

Fitzwilliam Museum

Trumpington Street, Cambridge CB2 1RB, England
(44-122) 333-2900
www.fitzmuseum.cam.ac.uk

The museum's courtyard development project, begun in February 2002, will last about 18 months. Only the Founder's Building remains open, with highlights from the permanent collection. No temporary exhibitions until 2004.

PERMANENT COLLECTION

Antiquities from Ancient Egypt, Greece, Cyprus and Rome; sculpture, furniture, clocks and rugs; paintings, including works by Titian, Veronese, Rubens, Van Dyck, Canaletto, Constable, Monet, Renoir, Cézanne and Picasso; miniatures; drawings and prints.

Admission: Free.
Hours: Tuesday through Saturday, 10 a.m.–5 p.m.; Sunday, 2:15–5 p.m. Closed Monday except some bank holidays. Closed Good Friday and from December 24 through January 1.

Kettle's Yard

Castle Street, Cambridge CB3 0AQ, England
(44-122) 335-2124
www.kettlesyard.co.uk

PERMANENT COLLECTION

Early 20th-century art, including paintings by David Jones, Joan Miró, Ben Nicholson and Alfred Wallis, along with sculpture by Constantin Brancusi, Henri Gaudier-Brzeska, Barbara Hepworth and Henry Moore.

Admission: Free.
Hours: House: Tuesday through Sunday, 2–4 p.m. from September to Good Friday, and 1:30–4:30 p.m. from Easter Saturday through August. Exhibition gallery: Tuesday through Sunday, 11:30 a.m.–5 p.m. Closed Monday.

Tate Liverpool

Albert Dock, Liverpool L3 4BB, England
(44-151) 702-7400
www.tate.org.uk/liverpool

2003 EXHIBITIONS

Through January 19
Pin-up: Glamour and Celebrity Since the Sixties
Charting the face of fame from Pop Art to the present, featuring works by Andy Warhol, Linda McCartney, David Hockney and Peter Blake.

Through March 23

Shopping: Art and Consumer Culture

Explores shopping as a phenomenon of 20th-century culture and tracks art's dialogue with commercial display, distribution and presentation techniques.

PERMANENT COLLECTION

Part of the Tate family of galleries, including Tate Britain and Tate Modern in London and Tate St. Ives. **Architecture:** Historic Albert Dock warehouse converted for gallery use by James Stirling and Michael Wilford.

Admission: Free. Fee for special exhibitions.
Hours: Tuesday through Sunday, 10 a.m.–5:50 p.m. Closed Monday (except public holidays), New Year's Day, December 24–26 and December 31.

Walker Art Gallery

William Brown Street, Liverpool L3 8EL, England
(44-151) 478-4199
www.thewalker.org.uk

PERMANENT COLLECTION

Holdings span the 12th to 21st centuries; Dutch, pre-Raphaelite and Victorian British art; works by Cézanne, Constable, Degas, Hockney, Rembrandt and Turner. **Highlights:** Gibson, *The Tinted Venus;* Martini, *Christ Discovered in the Temple;* Rossetti, *Dante's Dream;* Hockney, *Peter Getting Out of Nick's Pool.* **Architecture:** Opened in 1877 and expanded in the 1930's; recently refurbished to create new special exhibition galleries.

Admission: Free.
Hours: Monday through Saturday, 10 a.m.–5 p.m.; Sunday, noon–5 p.m.

Barbican Gallery

Silk Street, London EC2Y 8DS, England
(44-207) 638-8891
www.barbican.org.uk

The gallery may be closed in 2003 for renovation.

Architecture: Barbican, designed by Chamberlin, Powell and
Bon and opened in 1982, includes two art galleries — the
Barbican Gallery and The Curve — as well as a concert hall,
theaters, a library and exhibition halls.

Admission: Varies.
Hours: Monday through Saturday, 10 a.m.–6 p.m.;
Wednesday, until 8 p.m.; Sunday and bank holidays, noon–6
p.m. Closed Christmas Eve and Christmas Day.

National Maritime Museum, Queen's House and Royal Observatory Greenwich

Greenwich, London, SE10 9NF, England
(44-208) 858-4422; (44-208) 312-6565
www.nmm.ac.uk

PERMANENT COLLECTION

British and 17th-century Dutch maritime art; cartography,
manuscripts; ship models and plans; scientific and navigational
instruments. British portraits. Maritime reference library,
including books dating to the 15th century. **Highlights:**
Admiral Horatio Nelson's bloodstained uniform from the
Battle of Trafalgar and John Harrison's famous chronometer.
Architecture: 17th-century Queen's House by Inigo Jones,
with museum redevelopment completed in 1999; Flamsteed
House (1675–76), the original part of the Royal Observatory,
designed by Christopher Wren.

Admission: Free.

Hours: Daily, 10 a.m.–5 p.m.; June through September, until 6 p.m.

British Museum

Great Russell Street, London, WC1B 3DG, England
(44-207) 323-8299
www.thebritishmuseum.ac.uk

2003 EXHIBITIONS

Through January 9
Discovering Ancient Afghanistan: The Masson Collection
Archeological finds from the 3rd century B.C. to the 16th century A.D. collected by Charles Masson (1800–1853), the first explorer and recorder of ancient sites near Kabul and Jalalabad.

Through January 26
Antony Gormley's Field for the British Isles
A "terracotta army" by an artist known for his communities of diminutive clay figures.

Through March 23
Albrecht Dürer and His Legacy: The Graphic Work of a Renaissance Artist
Explores the artist's development as a graphic artist, featuring more than 200 drawings, woodcuts, engravings and printed books.

Through April 21
Piranesi Prints and Drawings
Series of prints celebrating the grandeur of Rome's classical monuments.

Through April 21
The Satires of Richard Newton, 1777–1798
Grotesque, humorous caricatures of greedy aristocrats and pompous politicians.

Through April 21
Hans Sloane's Collection in Print and Drawings
Prints and drawings concerned with plants and natural history collected by Sir Hans Sloane, whose collections formed the basis of the British Museum, the Natural History Museum and the British Library.

Through April 21
Drawings by Antony Gormley
About 50 drawings, some related to the artist's sculptures.

February 5–April 13
Arts of Kazari: Japan on Display, 15th to 19th Centuries
Explores the concept and practice of kazari, used to arrange decorative objects, through the display of painting, ceramics, lacquer and textiles from the 15th to 19th century. (Travels)

April 10–September 7
Art and Memory
Some 100 objects investigating memory across different cultures and time periods, including portraiture, currency, funerary and commemorative sculpture and memorabilia.

May 23–November 23
London, 1753
Prints, drawings, watercolors and artifacts reflecting London in 1753, the year the British Museum was founded.

June 26–November 16
Medicine Man: Sir Henry Wellcome and His Collections
Range of objects amassed by a pharmacist and collector (1853–1936) who viewed history and culture through medical eyes.

June 19–January 2004
Cityscapes

September–January 2004
Arts of Japan

November 7–February 29, 2004
Treasure: Finding Our Past

PERMANENT COLLECTION

More than seven million objects, including antiquities from Egypt, Western Asia, Greece and Rome, prehistory, early and medieval Europe, Renaissance; Modern and Oriental Collections; prints and drawings; coins and medals.

Highlights: Parthenon sculptures; the Rosetta Stone; Sutton Hoo treasures; Portland vase. **Architecture:** Neo-Classical mid-19th-century buildings by Robert and Sidney Smirke. Great Court (opened in 2000), glass-covered square at the heart of the museum, designed by Lord Foster.

Admission: Free. Fee for some exhibitions.
Hours: Daily, 10 a.m.–5:30 p.m.; Thursday and Friday, until 8:30 p.m.

Courtauld Institute of Art

Somerset House, Strand, London WC2R 0RN, England
(44-020) 7848-2526
www.courtauld.ac.uk

PERMANENT COLLECTION

One of the most important collections in Britain, featuring Impressionist and Post-Impressionist paintings, including works by Cézanne, Degas, Manet, Monet, Pissarro, Renoir, Seurat and Toulouse-Lautrec; 14th- to 20th-century works, including paintings by Rubens and Tiepolo; early Flemish and Italian paintings; 34,000 Old Master drawings and prints.
Highlights: Master of Flémalle, *Entombment;* Cranach, *Adam and Eve;* Rubens, *Moonlight Landscape and Deposition;* Tiepolo oil sketches. **Architecture:** 1780 neo-Classical Somerset House by Sir William Chambers.

Admission: Adults, £5; concessions, £4. Free on Monday, 10 a.m.–2 p.m., except bank holidays.
Hours: Daily, 10 a.m.–6 p.m.

The Dulwich Picture Gallery

Gallery Road, London SE21 7AD, England
(44-0208) 693-5254
www.dulwichpicturegallery.org.uk

2003 EXHIBITIONS

Through March 2
Arthur Rackham
Illustrations for classics of English and European literature,
including fairy tales by Hans Christian Andersen and Grimm,
A Midsummer Night's Dream and *Peter Pan.*

April 1–June 22
Abstraction on the Beach: John Piper in the 1930's
Works by a pioneer of modern art in Britain created early in
his career.

Mid-July–mid-October
Shakespeare in Art

Mid-November–mid-January 2004
William Heath Robinson

PERMANENT COLLECTION

England's oldest public art gallery, designed in 1811. Old
Master paintings from the 17th and 18th centuries; works by
Canaletto, Van Dyck, Gainsborough, Murillo, Poussin,
Rembrandt, Rubens, Tiepolo and Watteau. **Architecture:**
Neo-Classical building by John Soane; 2000 wing by Rick
Mather Architects.

Admission: Adults, £4; seniors, £3; students, disabled,
unemployed and children, free. Fee for some exhibitions.
Hours: Tuesday through Friday, 10 a.m.–5 p.m.; Saturday and
Sunday, 11 a.m.–5 p.m. Closed Monday (except bank
holidays), New Year's Day, Good Friday and December 24–26.

Estorick Collection of Modern Italian Art

39a Canonbury Square, London N1 2AN, England
(44-020) 7704-9522
www.estorickcollection.com

2003 EXHIBITIONS

January 22–April 13
Giorgio de Chirico and the Myth of Ariadne
A series of eight Ariadne paintings in which the artist depicted a reclining statue of the princess of Greek mythology in an empty, sun-drenched piazza.

PERMANENT COLLECTION

Opened in 1998, the collection is known for its Futurist works as well as figurative art from 1890 to the 1950's. Includes works by Giacomo Balla, Umberto Boccioni, Carlo Carrà, Gino Severini, Luigi Russolo, Ardengo Soffici, Giorgio De Chirico and Amedeo Modigliani.

Admission: Adults, £3.50; concessions, £2.50.
Hours: Wednesday through Saturday, 11 a.m.–6 p.m.; Sunday, noon–5 p.m.

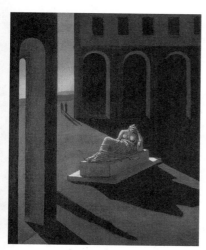

Giorgio de Chirico,
Melancholy, 1912.

Courtesy of the Estorick Collection of
Modern Italian Art.

Hayward Gallery

Belvedere Road, London SE1 8XZ, England
(44-207) 960-4242
www.haywardgallery.org.uk

2003 EXHIBITIONS

July 10–September 21
Time Stands Still: Eadweard Muybridge and the Instantaneous Photography Movement
Explores the photographic depiction of movement and the birth of the moving picture, focusing on the work of Muybridge and his contemporaries in Europe and America. (Travels)

October–January 2004
The National Art Collections Fund Centenary Exhibition
Works spanning 5,000 years, from classical antiquity to the present, including sculpture, paintings, drawings, ceramics, costumes, textiles, archaeological treasures and ethnographic material.

PERMANENT COLLECTION

The gallery manages the Arts Council Collection on behalf of the Arts Council of England. The collection is not normally displayed at the Hayward but travels. **Architecture:** Opened in 1968, the Hayward is considered a classic example of 1960's "brutalist" architecture; neon tower on the roof designed by Philip Vaughan and Roger Dainton.

Admission: Varies.
Hours: Daily, 10 a.m.–6 p.m.; Tuesday and Wednesday, until 8 p.m.

The Imperial War Museum

Lambeth Road, London, SE1 6HZ, England
(44-207) 416-5000
www.iwm.org.uk

See separate listing for Imperial War Museum North in Manchester.

2003 EXHIBITIONS

June 19–September 7
Hughie O'Donohue
Works by a contemporary artist based on his father's letters and photos from his service in Italy and France in World War II.

Opening late September
Women in Uniform

October 23–January 4, 2004
Eric Ravilious
Retrospective marking the centenary of this artist.

PERMANENT COLLECTION

The largest collection of 20th-century British art after the Tate galleries; photographic archive with more than six million images; national collection of airplanes, tanks, memorabilia and other items relating to 20th-century military conflicts.
Branches: HMS Belfast, Morgan's Lane, Tooley Street, London, SE1 6JH, (44-0207) 940-6328; Cabinet War Rooms, Clive Steps, King Charles Street, London, SW1A 2AQ, (44-207) 930-6961; Imperial War Museum — Duxford, Duxford, Cambridgeshire, CB2 4QR, (44-122) 383-5000.

Admission: Free for main museum; fees for branches.
Hours: Daily, 10 a.m.–6 p.m. Closed December 24–26.

Institute of Contemporary Arts

The Mall, London SW1Y 5AH, England
(44-207) 930-3647
www.ica.org.uk

Admission: Monday through Friday, £1.50; Saturday and
Sunday, £2.50.
Hours: Tuesday through Saturday, noon–1 a.m.; Sunday, until
10:30 p.m.; Monday, until 11 p.m.; galleries close at 7:30 p.m.

Museum of London

150 London Wall, London EC2Y 5HN, England
(44-207) 600-3699; (44-207) 600-0807 (recording)
www.museumoflondon.org.uk

PERMANENT COLLECTION

More than one million objects that chart the history of London
from prehistoric times to the present. Includes displays of
recent archaeological discoveries in the city; extensive costume
and textile collection; nearly 300,000 historical photographs.

Admission: Free.
Hours: Monday through Saturday, 10 a.m.–5:50 p.m., Sunday,
noon–5:50 p.m. Closed New Year's Day and December 24–26.

The National Gallery

Trafalgar Square, London WC2N 5DN, England
(44-0207) 747-2885
www.nationalgallery.org.uk

2003 EXHIBITIONS

Through January 12
Madame de Pompadour:
Portraits of Louis XV's official mistress, one of the most

powerful women of 18th-century France, as well as sculpture, porcelain, furniture, gems and prints.

Through January 19
An Indian Encounter: Portraits for Queen Victoria
Portraits of the queen's Indian subjects that she commissioned from the Austrian artist Rudolph Swoboda.

Through February 16
Art in the Making: Underdrawings in Renaissance Paintings
A look at the preliminary drawings under the paint layers of a group of important Renaissance paintings from Italy, Germany and the Netherlands.

January 31–April 27
Holbein: Portraits of Sir Henry and Lady Guildford
Reunites after 400 years two portraits of an English courtier couple painted by Hans Holbein the Younger in 1527.

February 19–May 18
Titian
First major exhibition in Britain devoted to the 16th-century artist, featuring some of his most famous paintings, like *Flora* and *Danae.*

March 19–June 22
Ron Mueck: Making Sculpture at the National Gallery
New sculptures of the human figure by an Australian-born artist working in London and serving as the fifth National Gallery Associate Artist.

May 14–August 3
Pissarro in London
Exhibition of paintings made on Pissarro's four visits to London between 1870 and 1897, to mark the centenary of the artist's death.

June 25–September 14
A Private Passion: 19th-Century Paintings and Drawings From the Grenville L. Winthrop Collection, Harvard University
Works by French, British and American artists, including Ingres, David, Gèricault, Delacroix, Renoir, Beardsley, Whistler, Sargent and Homer.

July 10–September 28
Paradise
Explores ways that artists have reinterpreted the world to create images of paradise, featuring paintings by Poussin, Watteau and Constable.

PERMANENT COLLECTION

Western European painting from 1260 to 1900. Founded in 1824. Works by Botticelli, Leonardo, Raphael, Michelangelo, Holbein, Titian, El Greco, Rubens, Rembrandt, Vermeer, Gainsborough, Constable, Turner, Monet, Renoir, Cézanne, van Gogh and Seurat. **Architecture:** 1838 neo-Classical building by William Wilkins; 1975 northern expansion by PSA; 1991 Sainsbury Wing.

Admission: Free. Fee for special exhibitions.
Hours: Daily, 10 a.m.–6 p.m.; Wednesday, until 9 p.m.
Closed New Year's Day, Good Friday and December 24–26.

National Portrait Gallery

St. Martin's Place, London WC2H 0HE, England
(44-0207) 306-0055
www.npg.org.uk

2003 EXHIBITIONS

Through February 16
Mad, Bad and Dangerous: The Cult of Lord Byron
Explores how Byron's literary fame and social notoriety was fueled by visual representations of the poet.

February 6–May 18
Julia Margaret Cameron
Portraits and fancy-dress tableaux by Cameron (1815–1879), one of the most important figures in the history of photography. (Travels)

June 5–September 14
BP Portrait Award
Annual art prize aimed at encouraging young artists to focus on portraiture.

July–September
Tessa Traeger: Gardeners
Photographs of leading gardeners, garden writers and horticulturists.

PERMANENT COLLECTION

More than 10,000 portraits of famous Britons, including paintings, drawings, sculptures, miniatures, caricatures, silhouettes, photographs and electronic media; photography and document archive. **Highlights:** G. L. Brockelhurst, *The Duchess of Windsor*; Terence Donovan, *Diana, Princess of Wales*. **Architecture:** 1896 building designed by Ewan Christian; 1933 Duveen wing by Richard Allison and J.G. West; 1980's alterations by Roderick Gradidge and Christopher Boulter; a 2000 wing, designed by the Dixon-Jones Partnership, that includes the new Tudor Gallery.

Admission: Free. Fee for special exhibitions.
Hours: Daily, 10 a.m.–6 p.m.; Thursday and Friday, until 9 p.m.

Royal Academy of Arts

Burlington House, Piccadilly, London, W1J 0BD, England
(44-207) 300-8000; (44-207) 300-5760 (recording)
www.royalacademy.org.uk

2003 EXHIBITIONS

Through April 11

Aztecs

The most comprehensive survey of Aztec culture ever mounted, bringing together many works never before shown outside Mexico.

March 15–June 8

Hamzanama

Series of Islamic manuscript illustrations from 1557 to 1572 charting the travels of Hamza, an uncle of the Prophet Muhammad.

June 3–August 11

Summer Exhibition 2003

Annual exhibition of paintings, drawings, sculptures and models by British artists and architects.

June 28–September 21

18th-Century Portraiture

Portrait-oriented view of the sweeping political and social changes between 1760 and 1830, featuring works by Reynolds, Gainsborough, Goya, Ingres and David.

November 29–February 22, 2004
Illuminating the Renaissance
Traces the development of illuminators working in Flanders between 1467 and 1561.

PERMANENT COLLECTION

Founded in 1768, the Royal Academy is the oldest fine arts institution in Britain. Examples of British art from the 18th century to the present, including paintings, sculpture, plaster casts, artists' memorabilia, prints and drawings. A small selection of paintings and sculpture can be viewed as part of the Burlington House tour; others can be viewed by making an appointment with the curator.

Admission: Varies. Tickets: www.wayahead.com.
Hours: Daily, 10 a.m.–6 p.m.; Friday, until 10 p.m.

The Saatchi Gallery

98a Boundary Road, London NW8 ORH, England
(44-207) 624-8299

The gallery plans to move into new premises sometime in 2003.

PERMANENT COLLECTION

More than 2,000 contemporary paintings, sculptures and installations, focusing on young British artists. **Architecture:** Former paint factory converted into almost 30,000 square feet of gallery space by Max Gordon.

Admission: Adults, £5; seniors and students, £3.
Hours: Thursday through Sunday, noon–6 p.m.

The Serpentine Gallery

Kensington Gardens, London, W2 3XA, England
(44-207) 402-6075; (44-207) 298-1515 (recording)
www.serpentinegallery.org

Architecture: 1934 tea pavilion opened as a gallery in 1970;
renovations completed in 1998.

Admission: Free.
Hours: Daily, 10 a.m.–6 p.m.

Tate Britain

Millbank, London SW1P 4RG, England
(44-207) 887-8000; (44-207) 887-8008 (recording)
www.tate.org.uk

2003 EXHIBITIONS

February 6–May 11
*Constable to Delacroix: British Art and the French Romantics,
1820–1840*
Analyzes the influence of British artists on 19th-century
French painting, featuring works by Constable, Delacroix,
Turner and Gericault.

February 27–May 26
Tate Triennial
A look at contemporary developments in British art.

June 26–September 28
Bridget Riley
Major retrospective of the work on the internationally
renowned British painter.

October 15–January 9, 2004
Turner and Venice
Explores Turner's trip to Venice and the body of work he
created in response to the city.

October 15–January 23, 2004
Turner Prize 2003
Works by the four artists shortlisted for the prize.

PERMANENT COLLECTION

Part of the Tate family of galleries, including the Tate Modern
in London, Tate Liverpool and Tate St. Ives. The Tate Britain
houses the national collection of British art from the 16th
century to the present, including works by Blake, Constable,
Hogarth and Spencer.

Admission: Free. Fee for special exhibitions.
Hours: Daily, 10 a.m.–5:50 p.m. Closed December 24–26.

Tate Modern

Bankside, London SE1 9TG, England
(44-207) 887-8000; (44-207) 887-8008 (recording)
www.tate.org.uk

2003 EXHIBITIONS

February 13–May 5
Max Beckmann
Exhibition covering the entire career of Beckmann
(1884–1950), one of Germany's leading 20th-century painters.

June 5–September 7
Photography
First major exhibition at the Tate entirely dedicated to
photography.

September 10–March 21, 2004
The Unilever Series
Annual commission for the Turbine Hall at the Tate Modern.

PERMANENT COLLECTION

Twentieth-century art, including works by Picasso, Matisse,
Dalí, Duchamp, Moore, Bacon, Gado, Giacometti and Warhol.
Architecture: Power plant by Giles Gilbert Scott converted to
gallery space by the Swiss architects Herzog and de Meuron.

Admission: Free.

Hours: Sunday through Thursday, 10 a.m.–6 p.m.; Friday and Saturday, until 10 p.m.

Victoria and Albert Museum

Cromwell Road, South Kensington, London SW7 2RL, England
(44-207) 942-2000
www.vam.ac.uk

2003 EXHIBITIONS

March 27–July 20
Art Deco, 1910–1939
Major exhibition tracing the development of Art Deco from its emergence in Europe before World War I to its worldwide popularity in the late 1930's. Includes more than 350 works in painting, sculpture, architecture, furniture, textiles, glass, metal, jewelry, graphic art, fashion, photography and film. (Travels)

April 17–June 29
Guy Bourdin
Overview of the work of a major innovator in fashion photography, whose creative peak was in the 1970's.

October 9–January 18, 2004
The Glory of Gothic
A look at the art, architecture and culture of the period, including tapestries, sculptures, paintings, jewelry, stained glass, gold and silver plate, arms and armor, woodwork, illuminated manuscripts and early printed books.

PERMANENT COLLECTION

Decorative arts dating from antiquity. to the present. Some four million items. Newly opened British Galleries, 1500–1900, with 3,000 examples of British design and art; Raphael Gallery, with seven prized cartoons by Raphael; John Constable paintings; national collection of watercolors; Devonshire Hunting Tapestries; Dress Collection showing fashion from 1500 to the present; Asian collection; medieval

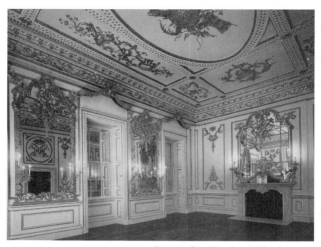

Courtesy of the Victoria and Albert Museum.
Norfolk House Music Room, 1756.

treasures; Renaissance sculpture; Victorian plasters; Jewelry Gallery; 20th-Century Gallery; New Contemporary Space; National Art Library. **Architecture:** 1891 building by Captain Francis Fawke; 1899-1909 south front by Aston Webb.

Admission: Free.
Hours: Daily, 10 a.m.–5:45 p.m.; Wednesday and the last Friday of the month, until 10 p.m. Closed December 24–26.

Wallace Collection

Hertford House, Manchester Square, London W1U 3BN, England
(44-207) 563-9500
www.wallace-collection.org.uk

2003 EXHIBITIONS
Through February 5
The Art of Love: Madame Pompadour and the Wallace Collection

January 23–April 27
Bonington and His Contemporaries: Watercolors in the Wallace Collection
Exhibition of the 25 watercolors by the English artist Richard Parkes Bonington (1802–1828) in the Wallace Collection, along with 30 by his contemporaries and admirers in France and England.

May 8–August 10
Kate Whiteford

August 21–October 26
From Palace to Parlor: 19th-Century British Glass

November 13–February 2004
French Bronzes in the Wallace Collection

PERMANENT COLLECTION

Fine and decorative arts, including Old Masters, 18th-century French pictures, porcelain, sculpture, furniture, arms and armor. **Architecture:** Late-18th-century town house; new floor refurbished by Rick Mather.

Admission: Free.
Hours: Monday through Saturday, 10 a.m.–5 p.m.; Sunday, noon–5 p.m.

Whitechapel Art Gallery

80-82 Whitechapel High Street, London E1 7QX, England
(44-0207) 522-7888; (44-0207) 522-7878 (recording)
www.whitechapel.org

2003 EXHIBITIONS

Through March 9
Mies van der Rohe — Mies in Berlin
A look at the early career, from 1905 to 1938, of the leading exponent of the refined glass-and-steel architecture that characterized the International Style of the mid-20th century.

April 8–June 1
Cristina Iglesias: New Corners of the World
Works by a young artist from Madrid who fuses techniques from architecture, theater, printmaking and photography in her installations.

Admission: Free. Fee for some exhibitions.
Hours: Tuesday through Sunday, 11 a.m.–5 p.m.; Wednesday, until 8 p.m. Closed Monday.

Imperial War Museum North

Trafford Wharf Road, Trafford Park, Manchester M17
 1TZ, England
(44-161) 836-4000
www.iwm.org.uk

2003 EXHIBITIONS

Through March 30
In the Mood
A look at entertainment during wartime, on radio, screen and stage.

May 2–September 14
Family History
Sculptures and installations that explore notions of family history.

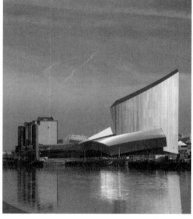

Len Grant

The Imperial War Museum North.

PERMANENT COLLECTION

Opened in 2002, museum features objects from the collection of the Imperial War Museum in London, reflecting how people's lives are shaped by war. **Highlights**: Dynamic 360-degree audiovisual presentation. **Architecture:** Building designed by Daniel Libeskind and created from the pieces of a shattered globe.

Admission: Free.
Hours: Daily, 10 a.m.–6 p.m. Closed December 24–26.

The Lowry

Pier 8, Salford Quays, Manchester M50 3AZ, England
(44-0161) 876-2000
www.thelowry.com

2003 EXHIBITIONS

Through January 5
At Home With Lowry
Includes works by Lowry from the museum's collection.

Through January 12
Bill Longshaw: 1962
Local artist's interactive evocation of an imaginary street from 1962, with shops, houses, flats, washing lines and a pub.

Through January 5
Jaghit Chuhan: New Work
Richly colored oils and drawings based on traditional and modern sources and blending Western and South Asian artistic influences.

Through January 5
Bhupen Khakhar
Retrospective of the career of an Indian artist who based his work on daily urban life.

January 18–July 5
Lowry's Travels

January 19–April
Scottish Art From the Royal Bank of Scotland

January 25–April 6
A Sympathetic Eye: Grace Robertson Photography

PERMANENT COLLECTION

Opened in 2000 as a visual and performing arts center, the Lowry has more than 300 paintings and drawings by the 20th-

century British artist L. S. Lowry, the largest collection of his work in the world, shown in changing thematic exhibitions. **Architecture:** Designed by Michael Wilford and Partners.

Admission: Free.
Hours: Sunday through Wednesday, 11 a.m.–5 p.m.; Thursday–Friday, 11 a.m.–7:30 p.m.; Saturday, 10 am.– 7:30 p.m.

Manchester Art Gallery

Mosley Street, Manchester M2 3JL
(44-0161) 235-8888
www.manchestergalleries.org

2003 EXHIBITIONS

Through February 1
Dalziel and Scullion — Home

Through February 1
Jeff Wall

September 6–October 12
Jim Partridge

September 6–October 12
Ben Cook

October 24–January 2004
JMW Turner: The Late Seascapes

PERMANENT COLLECTION

Collection of 19th-century pre-Raphaelite paintings, including works by Ford Madox Brown, Rossetti, Holman Hunt and Millais; 18th-century paintings by Joshua Reynolds, Gainsborough and George Stubbs; 20th-century works by Francis Bacon, Bridget Riley and Lucian Freud; Gallery of Craft and Design, with more than 1,000 decorative art objects; CIS Manchester Gallery, celebrating Manchester's past and present culture.

Admission: Free.

Hours: Tuesday through Sunday, 10 a.m.–5 p.m. Closed Monday except bank holidays, New Year's Day, Good Friday, December 24–26, December 31.

The Ashmolean Museum

Beaumont Strett, Oxford OX1 2PH, England
(44-01865) 278-000
www.ashmol.ox.ac.uk

PERMANENT COLLECTION

Europe's oldest museum, founded in 1683, housing Oxford University's collection of objects from ancient Egypt to 20th-century art.

Admission: Free.
Hours: Tuesday through Saturday, 10 a.m.–5 p.m.; Sunday, 2–5 p.m.

Modern Art Oxford

30 Pembroke Street, Oxford OX1 1BP, England
(44-0186) 572-2733; (44-0186) 581-3830 (recording)
www.moma.org.uk

2003 EXHIBITIONS

Through January 19
Tracey Emin: This Is Another Place
New works by a British artist, including a major installation inspired by her personal history.

February 1–March 30
David Goldblatt: 51 Years
Some 200 photographs by a South African photographer offering a portrait of South Africa from 1948 to the present.

April 12–June 8
Jake & Dinos Chapman
Large-scale sculptures by brothers perhaps best known for their sexualized mannequins and their sculptural work *Holocaust.*

September 13–November 9
Jim Lambie and Candice Breitz
Works by two New York–based artists who share an interest in pop music.

Admission: Free.
Hours: Tuesday through Saturday, 11 a.m.–5:30 p.m.; Thursday, until 8 p.m.; Sunday, noon–5:30 p.m. Closed Monday.

Tate St. Ives

Porthmeor Beach, St. Ives, Cornwall TR26 1TG, England
(44-0173) 679-6226
www.tate.org.uk

2003 EXHIBITIONS

Through January 26
Real Life
Video works demonstrating the frailty of human nature and life experience.

February 8–May 11
Painting Not Painting
Highlights works by a St. Ives artist, Terry Frost, in the context of a group of younger artists.

February 8–January 25, 2004
Pier Arts Centre Collection
Works from the collection of the Pier Arts Centre in Orkney while it is under renovation, including several by St. Ives artists.

May 24–October 12
Barbara Hepworth Centenary Exhibition
Works by one of the foremost British artists of the 20th century, particularly wood and stone carvings.

PERMANENT COLLECTION

Part of the Tate family of galleries, including the Tate Britain and Tate Modern in London and the Tate Liverpool.

Admission: Adults, £4.25; students, £2.50; under 18 and over 60; free.
Hours: Daily, 10 a.m.–5:30 p.m. November through February, Tuesday through Sunday, 10 a.m.–4:30 p.m.; closed Monday. Closed New Year's Day and December 24–26.

The New Art Gallery Walsall

Gallery Square, Walsall WS2 8LG, West Midlands,
 England
(44-01922) 654-400
www.artatwalsall.org.uk

2003 EXHIBITIONS

Through January 26
Jonathan Callan
Works by an emerging British artist.

Through January 26
Walsall Society of Artists
Annual exhibition of works by Walsall artists.

May 14–November 24
From Tate to Walsall: The Visitation *by Jacob Epstein*
Major sculpture of a pregnant woman.

PERMANENT COLLECTION

European art in the Garman Ryan Collection, which was donated to the people of Walsall by Kathleen Garman, widow of the sculptor Jacob Epstein. **Highlights:** The Discovery Gallery, which includes an artist's studio and activity room with interactive elements for children. **Architecture:** 1999 Caruso St. John building in the town's shopping district.

Admission: Free.
Hours: Tuesday through Saturday, 10 a.m.–5 p.m.; Sunday, noon–5 p.m. Closed Monday except bank holidays.

France

Centre National d'Art Contemporain

155 Cours Berriat, Grenoble 38028, France
(33-4) 76-21-95-84
www.magasin-cnac.org

Architecture: A 1900 industrial building with the word "Magasin" on the facade. Because of that, and in honor of the Magasin exhibition of Russian Dadaism held in Moscow in 1916, the museum is often referred to as "The Magasin."

Admission: Adults, 3.5 euros; reduced admission, 2 euros; under 10, free.
Hours: Tuesday through Sunday, noon–7 p.m. Closed Monday.

Musée de Grenoble

5 Place de Lavalette, Grenoble 38000, France
(33-4) 76-63-44-44
www.ville-grenoble.fr/musee-de-grenoble

2003 EXHIBITIONS

Through January 5
Florence Lazar
Photographs and videos by a young French artist.

February–April
The New Objectivity
Graphic art representative of this 20th-century artistic movement.

PERMANENT COLLECTION

Italian art; 17th-century French paintings; 19th-century Romantic and Realist paintings; modern and contemporary art. **Highlights:** Works by Rubens and Zurbarán; outdoor

sculpture garden. **Architecture:** On the Isère River overlooking the Alps.

Admission: Adults, 4 euros; students, 2 euros.
Hours: Thursday through Monday, 11 a.m.–7 p.m. (10 a.m.–6 p.m. in summer); Wednesday, until 10 p.m. (9 p.m. in summer). Closed Tuesday.

Musée des Beaux Arts de Lyon

Palais St. Pierre, 20 Place Terreaux, Lyon 69001, France
(33-4) 72-10-17-40
www.mairie-lyon.fr

2003 EXHIBITIONS

Through January 10
Alfred Sisley, The Poet of Impressionism

February 20–April 28
Sacred Symbols, 4,000 Years of Arts in the Americas
Graphic art representative of this 20th-century artistic movement.

February–April
The Winthrop Collection

PERMANENT COLLECTION

Works from antiquity to the present. **Highlights:** French and Flemish painting from the 14th to the 18th centuries.
Architecture: 17th-century convent converted into a museum in 1803.

Admission: Adults, 3.80 euros for permanent collection, 5.50 euros for temporary exhibitions; under 18, free.
Hours: Wednesday through Monday, 10 a.m.–6 p.m.; Friday, 10 a.m.–noon, 2:15–6:30 pm. Closed Tuesday.

Musée d'Art Moderne et d'Art Contemporain

Promenade des Arts, Nice 06300, France
(33-4) 93-62-61-62
www.mamac-nice.org

2003 EXHIBITIONS

Through February 16
César, Iron Instinct

Through May 25
Barry Flanagan

February 28–June 1
Bloum

June 14–October
Pier Paolo Calzolari

June 14–September 7
Arte Povera: Photographs of Paolo Mussat Sartor

Mid-September–Mid-October
September of Photography

October 31–December 7
Margaret Michel/Bernar Venet

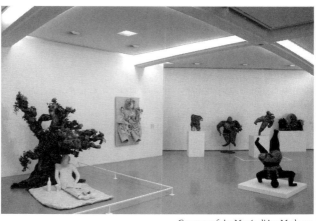

Courtesy of the Musée d'Art Moderne.
Sculptures.

PERMANENT COLLECTION

French and American works since 1960. Collection of assemblage, New Realism and Pop art. **Architecture:** Four polyhedrons by Yves Bayard and Henri Vidal, built in 1990.

Admission: Adults, 3.80 euros; reduced admission, 2.30 euros.

Hours: Tuesday–Sunday, 10 a.m.–6 p.m. Closed Monday and holidays.

Musée des Art Asiatiques

405 Promenade des Anglais, Nice 06200, France
(33-4) 92-29-37-00
www.arts-asiatiques.com

PERMANENT COLLECTION

Japanese, Chinese, Korean and Cambodian art. **Highlights:** The paths of Buddhism; furniture collection. **Architecture:** Modern marble building by the Japanese architect Kenzo Tange.

Admission: Adults, 5.35 euros; reduced rate, 3.80 euros; under 7, free.

Hours: Wednesday through Monday, 10 p.m.–5 p.m.; May through September, until 6 p.m. Closed Tuesday and holidays.

Musée des Beaux Arts, Nice

33 Avenue des Baumettes, Nice 06000, France
(33-4) 92-15-28-28
www.musee-beaux-arts-nice.org

2003 EXHIBITIONS

March 7–June 1
Jules Chéret: Pastels

June 20–late October
Around van Dongen's Tango

PERMANENT COLLECTION

Painting and sculpture from the 15th through the early 20th centuries, including 17th-century Dutch paintings, 18th-century French paintings, sculptures by Jean-Baptiste Carpeaux and August Rodin, Impressionist and Post-Impressionist works, paintings by Kees Van Dongen and Raoul Dufy.
Architecture: Late 19th-century mansion built in the 17th-century Mannerist style for a Ukrainian princess; opened as a museum in 1928.

Admission: Adults, 3.80 euros; reduced admission, 2.30 euros; 17 and under and disabled, free. Free on first and third Sunday of the month.

Hours: Tuesday through Sunday, 10 a.m.–6 p.m. Closed Monday and holidays.

Musée Matisse

164 Avenue des Arènes-de-Cimiez, Nice 06000, France
(33-4) 93-81-08-08
www.musee-matisse-nice.org

PERMANENT COLLECTION

Works donated by Matisse and his family. Oil paintings from all periods; paper cutouts; Vence Chapel Chasubles.
Highlights: *Portrait of Mme. Matisse,* 1905; *Odalisque au Coffret Rouge,* 1926; *Fauteuil Rocaille,* 1946; *Nature Morte aux Grenades,* 1947. **Architecture:** 17th-century Italian villa on the Cimiez Hill near the hotel where Matisse lived and died.

Admission: Adults, 3.80 euros; reduced admission, 2.30 euros; 17 and under and the disabled, free.
Hours: Wednesday through Monday, 10 a.m.–6 p.m. Closed on Tuesday. Open until 5 p.m. from October to March.

Musée National Message Biblique Marc Chagall

36 Avenue du Docteur Ménard, Nice 06000, France
(33-4) 93-53-87-20
www.ac-nice.fr/chagall/chagall.htm

2003 EXHIBITIONS

Summer
Introduction to Jewish Theater

PERMANENT COLLECTION

More than 700 works by Marc Chagall. **Highlights:** 17 large
biblically themed paintings, executed between 1954 and 1967;
39 gouaches and 105 engravings designed as illustrations for a
bible.

Admission: Adults, 5.50 euros; reduced admission and
Sundays, 4 euros; under 18, free.
Hours: Wednesday through Monday, 10 a.m.–5 p.m.; July
through September, until 6 p.m. Closed Tuesday, New Year's
Day, May 1 and Christmas Day.

Centre National d'Art et de Culture Georges Pompidou

Rue Rambuteau and Rue St. Merri, Paris 75001, France
(33-1) 44-78-12-33
www.centrepompidou.fr

2003 EXHIBITIONS

Through January 6
Max Beckmann

Through January 6
Sonic Process: New Geography of Sound

Through March 10
Roland Barthes

March 5–July 1
Nicolas de Stael

September 24–January 4, 2004
Jean Cocteau

PERMANENT COLLECTION

Major collection of 20th-century art, including Impressionism, Cubism, abstract art, Surrealism, Pop Art. Artists include Brancusi, Braque, Chagall, Dalí, Dubuffet, Léger, Kandinsky, Matisse, Mondrian, Picasso, Pollock, Warhol. **Highlights:** Niki de Saint-Phalle courtyard fountain sculptures; Braque, *Woman With Guitar*; Matisse, *The Sadness of the King*; Picasso, *Harlequin*. **Architecture:** 1977 building by Renzo Piano and Richard Rogers recently reopened after extensive renovation.

Admission: 10 euros for combination tickets including the permanent collection and temporary exhibitions; reduced admission, 8 euros; 17 and under, free for the permanent collection; 12 and under, free for temporary exhibitions and permanent collection. Free on first Sunday of the month.
Hours: Wednesday through Monday, 11 a.m.–9 p.m. Closed Tuesday.

Galerie Nationale du Jeu de Paume

Jardin des Tuleries (entry from Place de la Concorde),
 Paris 75001, France
(33-1) 47-03-12-50
www.paris.org/Musees/JeudePaume

2003 EXHIBITIONS

February 11–June 9
Rene Magritte Retrospective

Admission: Adults, 6 euros; reduced admission, 4.50 euros; under 13, free.

Hours: Tuesday, noon–9:30 p.m.; Wednesday through Friday, noon–7 p.m.; Saturday and Sunday, 10 a.m.–7 p.m. Closed Monday.

Galeries Nationales du Grand Palais

3 Avenue du General Eisenhower, Paris 75008, France
(33-1) 44-13-17-17
www.rmn.fr

2003 EXHIBITIONS

Through January 6
Matisse-Picasso

March 10–June 25
Marc Chagall

September 25–January 5, 2004
Vuillard

October 2–January 19, 2004
Gauguin in Tahiti

Architecture: Built for the 1900 World's Fair based on a design by Deglane, Louvet & Thomas.

Admission: Varies from 8–10 euros, according to exhibition; reduced admission, 5–8 euros.

Hours: Thursday through Monday, 10 a.m.–8 p.m.; Wednesday, until 10 p.m. Closed Tuesday. Entrance by reservation only until 1 p.m.

Louvre

34-36 Quai du Louvre, 75058 Paris Cedex 01, France
(33-1) 40-20-50-50; (33-1) 40-20-51-51 (recording, in
 five languages)
www.louvre.fr

2003 EXHIBITIONS

January 17–April 14
Memory of the Visible: Copper Plates and Engravings From the Louvre's Chalcography
Includes collections of copper plates from before the French Revolution that were united in 1797 when the Louvre's Chalcography was founded.

January 17–Fall 2003
The Metamorphosis of the Louvre: Photographs of the Museum
Images by Jean-Christophe Ballot documenting the transformation of the museum from 1992 to 1994.

March 7–June 30
Ushabtis: Pharaonic Workers for Eternity
Exhibition of ushabtis, inscribed statuettes that were placed in Egyptian tombs and entrusted to labor in the afterworld instead of the deceased.

March 28–June 23
Michelangelo: The Louvre's Drawings
Some 40 works owned by the museum, on display together for the first time since 1975.

May 9–July 14
Leonardo da Vinci: Drawings and Manuscripts
Eighty-eight drawings by da Vinci, as well as 12 manuscripts on architecture and scientific inquiry.

May 23–August 18
Savoir-Faire: The Variant in 16th-Century Italian Drawing
Explores the presence of variants — instinctive reflexes that lead the artist to develop a line of thought — in 77 drawings by Italian artists.

September 17–January 5, 2004
Creative Spirit From Pigalle to Casanova
European terra cotta from 1740 to 1830.

September 17–January 5, 2004
Tanagra: Myth and Archeology

PERMANENT COLLECTION

Major collection of Western art from the Middle Ages to 1848; Oriental antiquities and arts of Islam; Egyptian antiquities; Greek, Etruscan and Roman antiquities; paintings, sculptures, objets d'art, prints and drawings. **Highlights:** da

Vinci, *Mona Lisa; Venus de Milo; Winged Victory of Samothrace;* Géricault, *Raft of the Medusa;* David, *Coronation of Napoleon.*
Architecture: An 800-year-old former palace of the French kings, which has undergone almost continuous expansion; 1989 glass pyramid by I. M. Pei.

Admission: Combined ticket for permanent collection and temporary exhibitions: Adults, 7.50 euros until 3 p.m.; 5 euros after 3 p.m. and on Sunday; free for age 17 and under. Free on the first Sunday of each month. Combined and multiple-day packages available. Advance ticket purchase is recommended (by Internet or by calling 0 862 684 694 or 0 892 697 073 within France).
Hours: Wednesday through Monday, 9 a.m.–6 p.m.; Monday and Wednesday, until 9:45 p.m. Closed Tuesday and major holidays.

Musée d'Art Moderne de la Ville de Paris

11 Avenue du President Wilson, Paris 75116, France
(33-1) 53-67-40-00
www.mairie-paris.fr

PERMANENT COLLECTION

Work from all modern periods, from Fauvism and Cubism to the present. **Highlights:** Several large Robert Delaunay paintings; Matisse, *La Danse*; Raoul Dufy, *La Fée Éléctricité,* a 6,500-square-foot painting that occupies a room of its own.
Architecture: Palais du Tokyo built by the architects Dondel, Aubert, Viard and Dastugue for the 1937 international exposition.

Admission: Free for permanent collection. Admission for temporary exhibitions varies for adults but is free for age 13 and under.
Hours: Tuesday through Friday, 10 a.m.–5:40 p.m.; Saturday and Sunday, until 7 p.m. Closed Monday.

Musée de l'Orangerie

Place de la Concorde, Paris 75001, France
(33-1) 40-20-67-71

Closed for renovation until at least the end of 2003.

PERMANENT COLLECTION

Impressionists and modern art. Includes Monet's *Waterlilies* and works by Cézanne, Renoir, Matisse, Picasso, Rousseau and Modigliani. **Architecture:** 18th-century mansion.

Musée d'Orsay

62 Rue de Lille, Paris 75007, France
(33-1) 40-49-48-14
www.musee-orsay.fr

2003 EXHIBITIONS

June 16–September 28
Jongkind

Fall
The Origins of Abstraction

PERMANENT COLLECTION

Significant painting, sculptural and decorative work from 1848 to 1914; noted Impressionist collection. Works by Degas, Manet, Monet, Cézanne, van Gogh, Gauguin, Toulouse-Lautrec and Rodin. **Architecture:** Converted late–19th-century railway station.

Admission: Adults, 7 euros, 5 euros on Sunday; reduced admission, 5 euros; under 18, free. For certain exhibitions, adults, 8.50 euros, reduced admission, 6.50 euros. Free the first Sunday of each month.
Hours: Tuesday through Saturday, 10 a.m.–6 p.m.; Thursday, until 9:45 p.m.; Sunday, 9 a.m.–6 p.m. Closed Monday.

Musée du Petit Palais

Avenue Winston Churchill, Paris 75008, France
(33-1) 42-65-12-73

Closed for renovation until the end of 2003.

PERMANENT COLLECTION

Nineteenth-century art and works from the medieval period
through the 17th century from the collection of Dutuit and
Edward Tuck. Works by Gros, Géricault and Delacroix.
Architecture: Built for the Universal Exhibition of 1900.

Musée Guimet

6 Place d'Iena, 75116 Paris, France
(33-1) 56-52-53-00
www.museeguimet.fr

2003 EXHIBITIONS

Through February 28
Secret Visions of the Fifth Dalai Lama
Ritual and liturgical objects from the 17th century.

Late October–November
Confucius
Some 150 works of art related to the Chinese philosopher.

PERMANENT COLLECTION

One of the world's leading museums of Asian art.
Comprehensive collection of art from Afghanistan, Pakistan,
the Himalayas, Indian subcontinent, Southeast Asia, Central
Asia, China, Korea and Japan. Collection of Khmer sculpture.
Admission: Adults, 5.5 euros; students, 4 euros. Reduced
admission on Sunday for everyone. Free on first Sunday of the
month. Includes admission to the Buddhist Pantheon next
door at 16 Avenue d'Iéna.
Hours: Wednesday–Monday, 10 a.m.–6 p.m. Closed Tuesday.

Musée Jacquemart André

158 Boulevard Haussmann, Paris 75008, France
(33-1) 45-62-11-59
www.musee-jacquemart-andre.com

PERMANENT COLLECTION

Italian Renaissance and 15th- to 17th-century French paintings collected by Nelie and André Jacquemart, the former residents of the 19th-century mansion that now houses the museum. Decorative art, furniture, textile art and sculpture.

Admission: Adults, 8 euros; reduced admission, 6 euros; under 7, free.
Hours: Daily, 10 a.m.–6 p.m.

Musée Marmottan Monet

2 Rue Louis-Boilly, Paris 75016, France
(33-1) 44-96-50-33
www.marmottan.com

PERMANENT COLLECTION

Hundreds of Impressionist and Post-Impressionist works, including paintings by Monet, Caillebotte, Carrière, Guillaumin, Manet, Morisot, Pissarro and Renoir; medieval illuminations; works by German, Flemish and Italian primitive painters, including Renaissance tapestries. **Architecture:** 19th-century mansion donated to the state by Paul Marmottan.

Admission: 6.50 euros; students, 4 euros; under 8, free.
Hours: Tuesday through Sunday, 10 a.m.–6 p.m. Closed Monday, May 1 and Christmas Day.

Musée Picasso

5 Rue de Thorigny, Paris 75003, France
(33-1) 42-71-25-21

PERMANENT COLLECTION

Works by Picasso from every period, beginning in his adolescence; works by contemporaries, including Corot, Cézanne, Giacometti and Braque. Picasso's private collection, including primitive art. **Architecture:** Housed in Picasso's private mansion in the Marais area, built by Jean Boullier de Bourges at the end of the 17th century.

Admission: Adults, 5.50 euros; students, 4 euros; under 18, free. 4 euros for all on Sunday and free for all the first Sunday of each month.
Hours: Wednesday through Monday, 9:30 a.m.–5:30 p.m. (until 6 p.m. April–September); Thursday, until 8 p.m. Closed Tuesday.

Musée Rodin

77 Rue de Varenne, Paris 75007, France
(33-1) 44-18-61-10
www.musee-rodin.fr

PERMANENT COLLECTION

Large collection of work by Auguste Rodin.
Highlights: Large sculpture garden; *The Thinker*; *Door to Hell*; *The Kiss*; a room dedicated to the work of Camille Claudel, Rodin's companion and student. **Architecture:** 18th-century mansion.

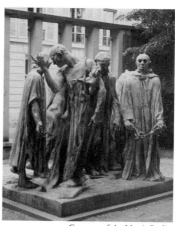

Courtesy of the Musée Rodin.
Auguste Rodin, *The Burghers of Calais.*

Admission: Adults, 5 euros; reduced admission, 3 euros; 17 and under, free. Entrance to the park, 1 euro.
Hours: Tuesday through Sunday, 9:30 a.m.–5:45 p.m. (until 4:45 p.m. October–March). Slightly shorter hours during the winter. Closed Monday.

 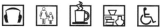

Union Centrale des Arts Décoratifs

107 Rue de Rivoli, Paris 75001, France
(33-1) 44-55-57-50
www.ucad.fr

Musée des Arts Décoratifs
(Decorative Arts Museum)

The museum will be closed until 2004 for renovation.

PERMANENT COLLECTION

Medieval and Renaissance art, including altarpieces, tapestries and sculptures. **Architecture:** In the Marsan wing of the Louvre Palace.

Musée de la Publicité
(Museum of Advertising)

PERMANENT COLLECTION

Posters, objects, television and film commercials and print advertisements from around the world. **Architecture:** Designed by Jean Nouvel to resemble a city.

Musée de la Mode et du Textile
(Fashion and Textile Museum)

2003 EXHIBITIONS

Through March 16

Jacqueline Kennedy, The White House Years
Sixty-six suits, dresses and accessories worn between 1959 and
1963, plus archive documents, films and photographs of the
era.

Through March 16

The Sixties: Instruction Manual
Developments in Parisian fashion in the 1960's.

PERMANENT COLLECTION

Textiles and clothing from the 18th century to the present;
about 40 "wardrobes" donated by prominent people, including
the Duchess of Windsor and Fina Gomez.

Musée Nissim de Camondo

63 Rue de Monceau, Paris 75008, France
(33-1) 53-89-06-50

PERMANENT COLLECTION

Collection of 18th-century furniture displayed in a villa
inspired by Petit Trianon in Versailles. Collection of Count
Moise de Camondo.

Admission: For Musée Nissim de Camondo: Adults, 4.60
euros; students, 3.10 euros; under 18, free. For other three
museums: Adults, admission varies according to exhibition;
under 18, free.

Hours: For Musée Nissim de Camondo: Wednesday–Sunday,
10 a.m.–5 p.m. Closed Monday and Tuesday. For other three
museums: Tuesday through Friday, 11 a.m.–6 p.m.;
Wednesday, until 9 p.m.; Saturday and Sunday, 10 a.m.–6 p.m.
Closed Monday.

Fondation Maeght

623 Che Gartettes, Saint-Paul 06570, France
(33-4) 93-32-81-63
www.fondation-maeght.com

PERMANENT COLLECTION

Modern art, including works by Kandinsky, Chagall, Braque and Giacometti. **Highlights:** *The Labyrinth of Dreams,* a series of monumental sculptures that Joan Miró made for the foundation's gardens. **Architecture:** 1960's José Luis Sert building, built in collaboration with many of the artists whose works are displayed there, including Giacometti, Miró and Braque.

Admission: Adults, 8 euros; students, 6.50 euros; under 10, free. Admission during temporary exhibitions: adults, 9 euros; students, 7.50 euros.
Hours: 10 a.m.–7 p.m., July–September; 10 a.m.–12:30 p.m. and 2:30-6 p.m., October–June.

Germany

Bauhaus-Archiv Museum für Gestaltung

(Bauhaus Archive and Museum of Design)

14 Klingelhöferstrasse, Berlin 10785, Germany
(49-30) 254-0020
www.bauhaus.de

2003 EXHIBITIONS

Through March
Bauhaus Furniture

March–Summer
Kandem Light!
Lamps.

Summer
Marianne Brandt
Photo collages.

PERMANENT
COLLECTION

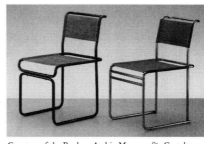

Courtesy of the Bauhau-Archiv Museum für Gestaltung.
Chairs, 1925-26.

Materials related to
the activities and
ideas of the Bauhaus, the influential art school that flourished
between 1919 and 1933. Includes architectural models,
furniture, metalware, ceramics, weavings, murals, paintings,
drawings, sculpture and photography. **Highlights:** Klee, *Neues
in Oktober*; Kandinsky, *Meinem Lieben Galston*; Schlemmer,
Abstrakter; Brandt, *Tea and Coffee Set*; architectural models by
Bayer, Feininger, Itten, Moholy-Nagy. **Architecture:** 1979
structure built from plans by Walter Gropius, founder and
director of the Bauhaus.

Admission: Adults, 4 euros; reduced admission, 2 euros.
Hours: Wednesday through Monday, 10 a.m.–5 p.m. Closed
Tuesday except holidays.

Deutsche Guggenheim Berlin

13-15 Unter den Linden, Berlin 10117, Germany
(49-30) 202-0930
www.deutsche-guggenheim-berlin.de

2003 EXHIBITIONS

Through January 5
Gerhard Richter: Eight Gray

January 18–April 27
Kasimir Malevich: Suprematism

Architecture: Gallery designed by Richard Gluckman on the
ground floor of a 1910 sandstone Deutsche Bank building.

Admission: Adults, 2.56 euros; students, 1.53 euros. Monday
free. Additional fees for special exhibitions.
Hours: Daily, 11 a.m.–8 p.m.; Thursday, until 10 p.m.

Jüdisches Museum Berlin
(*Jewish Museum Berlin*)

9-14 Lindenstrasse, Berlin 10969, Germany
(49-30-30) 878-5681
www.jmberlin.de

2003 EXHIBITIONS

October–January 2004
The Power of Numbers

PERMANENT COLLECTION

Historical archives. Herbert Sonnenfeld's photos on Jewish life
in Berlin, 1933–38; paintings by Max Liebermann, Ludwig
Meidner, Lesser Ury, Hermann Struck, Jakob Steinhardt, Felix
Nussbaum and Arthur Segal; the Loewenhardt-Hirsch
Palestine Collection; Zvi Shofer's Judaica Collection.
Architecture: 1998 zinc-clad building by Daniel Libeskind.

Jewish Museum Berlin.

Admission: 5 euros; seniors and students, 2.50 euros; children under 6, free; families (two adults), 10 euros.
Hours: Daily, 10 a.m.–8 p.m.; Monday, until 10 p.m. Closed Rosh Hashanah, Yom Kippur and December 24.

Kunst- und Ausstellungshalle der Bundesrepublik Deutschland

(Art and Exhibition Hall of the Federal Republic of Germany)

4 Friedrich Ebert Allee, Bonn 53113, Germany
(49-228) 917-1200
www.bundeskunsthalle.de

2003 EXHIBITIONS

Through January 12
Venezia: Treasures From Venetian Palaces
More than 350 works, including fabrics, theater decorations and paintings by Bosch, Fortuny y Carbo, Giorgione, Tiepolo, Tintoretto, Titian and Veronese, in a survey of collecting in Venice from the 13th century to the 19th.

Through April 6
Glances Into the 18th Century
Works from the Petit Palais in Paris, including 16 tapestries, plus the complete first edition of Diderot and d'Alembert's encyclopedia with their elaborate copper engravings.

May 9–August 24
Archaeology in Germany: Peoples Through Space and Time

Architecture: 1990's cube-shaped building, with roof garden, by Gustav Peichl.

Admission: Adults, 6.50 euros; reduced admission, 3.50 euros; families, 10.50 euros. Discounts for two-day admission and for groups.

Hours: Tuesday and Wednesday, 10 a.m.–9 p.m.; Thursday through Sunday and holidays, 10 a.m.–7 p.m. Closed Monday, Christmas Eve and New Year's Eve.

Kunstmuseum Bonn

2 Friedrich Ebert-Allee, Bonn 53113, Germany
(49-228) 77-6260
www.bonn.de/kunstmuseum

2003 EXHIBITIONS

Through February 16
Ernst Wilhelm Nay
Some 130 works by the German artist (1902–68).

Through February 23
The Bridge: Masterpieces From the Brücke Museum, Berlin
More than 175 oil paintings, watercolors, pastels, drawings, woodcuts and lithographs, featuring works by Ernst Ludwig Kirchner, Erich Heckel, Karl Schmidt-Rottluff, Fritz Bleyl, Max Pechstein, Emil Nolde, Cuno Amiet and Otto Mueller.

March 13–May 11
Transfer North Rhine Westphalia–Israel

March 20–May 25
Gerhard Wittner
Works on paper.

September 11–November 16
Dieter Mammel
Drawings.

October 2–November 30
Olav Christopher Jenssen
Contemporary works by the Norwegian abstract painter.

December 4–February 2004
Fluxus and Friends
Works from the collection of Walter and Maria Schnepel.

PERMANENT COLLECTION

Twentieth-century works by German and international artists, with an emphasis on the 1950's through the 90's; works by the Rhineland Expressionists, Auguste Macke, Max Ernst and Joseph Beuys; photography; video art. **Architecture:** 1992 building by Axel Schultes.

Admission: 5 euros; reduced admission, 2.50 euros; children under 6, free. Discounts for two-day visit and for families.
Hours: Tuesday through Sunday, 10 a.m.–6 p.m.; Wednesday, until 9 p.m. Closed Monday, Christmas Eve, Christmas Day and New Year's Eve.

Museum Ludwig

1 Bischofsgartenstrasse, Cologne 50667, Germany
(49-221-2) 212-6165; (49-221-2) 212-2382
www.museenkoeln.de

2003 EXHIBITIONS

Through January 19
Per Kirkeby
Works by the Danish Expressionist.

Through January 19
Fischli/Weiss
Images by the collaborators Peter Fischli and David Weiss.

Through March 2
Hans-Peter Feldmann

February 7–May 11
Peter Herrmann/Fritz Schwegler

February 7–May 11
Bruce Nauman

March 14–June 9
William Eggleston
Photographs from the 1960's and 70's, including examples from *The Los Alamos Project.*

March 28–June 22
From Donkey's Tail to Jack Diamonds

July 11–November 9
Richard Hamilton

Opening October 18
Dieter Rot

PERMANENT COLLECTION

German Expressionist, Russian avant-garde and Surrealist art; works by Picasso; Pop Art; contemporary art; prints; photography. **Highlights:** 80 works by Robert Rauschenberg; video art. **Architecture:** Complex designed by Busman and Haberer; piazza by Dani Karavan.

Admission: Adults, 6.40 euros; reduced, 3.20 euros. Permanent collection plus current exhibition: 8.50 euros; reduced, 6 euros.
Hours: Tuesday, 10 a.m.–8 p.m.; Wednesday through Friday, 10 a.m.–6 p.m.; Saturday and Sunday, 11 a.m.–6 p.m. Closed Monday.

Museum für Moderne Kunst

10 Domstrasse, Frankfurt 60311, Germany
(49-69) 212-30447
www.mmk-frankfurt.de

2003 EXHIBITIONS

Through March
The Museum, the Collection, the Director and His Loves

PERMANENT COLLECTION

Contemporary art, including the 60's Collection (Jasper Johns, Roy Lichtenstein, Andy Warhol, Claes Oldenburg, Robert Rauschenberg, George Segal) and works by young German artists. **Architecture:** Triangular 1991 building by Hans Hollein.

Admission: 5 euros; children and students, 2.50 euros; children under 6, free. Wednesday, free.

Hours: Tuesday through Sunday, 10 a.m.- 5 p.m.; Wednesday, until 8 p.m. Closed Monday and major holidays.

Hamburger Kunsthalle

Glockengiesserwall, Hamburg 20095, Germany
(49-40) 42854-2612
www.hamburger-kunsthalle.de

2003 EXHIBITIONS

Through February 23
Artists, Explorers, Travelers
Paintings, watercolors, drawings, prints and travelogues. A look at the interaction of art and the natural sciences, as illustrated by landscape paintings created around 1800 by Carl Gustav Carus, John Constable, Johan Christian Dahl, Caspar David Friedrich, Moritz Rugendas and others.

Courtesy of the Hamburger Kunsthalle.
Samuel Birmann, Zasenberg. *Blick gegen Schreckhoerner,* 1829.

Through March 16
Alfred Lichtwark
Marks the 150th anniversary of the birth of the gallery's first director.

February 14–May 11
Gregor Schneider

March 7–June 15
Vilhelm Hammershøi
Works by the Danish painter (1864–1916).

May 9–August 17
German Drawings From the 19th Century
From Caspar David Friedrich to Adolf von Menzel.

September 12–November 16
Wald Collection

September 19–January 11, 2004
Lyonel Feininger
Early works by the Classical Modernist (1871–1956).

December 12–March 2004
Paul Klee: 1933

PERMANENT COLLECTION

Gothic to contemporary paintings; 19th- and 20th-century sculpture, drawings and graphics. **Highlights:** Meister Bertram, *The Creation of the Animals*; Rembrandt, *Simeon and Anna Recognize Jesus as the Lord*; Beckmann, *Ulysses and Calypso*; Friedrich, *The Sea of Ice, Runge Morning*; Hockney, *Doll Boy*. **Architecture:** 1869 building by Hude and Schirrmacher; 1919 annex; 1997 extension with limestone facade and red granite exterior base by Oswald Mathias Ungers.

Admission: Adults, 7.50 euros; students and children under 16, 5 euros. Discount for families.
Hours: Tuesday through Sunday, 10 a.m.–6 p.m.; Thursday, until 9 p.m. Closed Monday.

Alte Pinakothek

27 Barer Strasse, Munich 80333, Germany
(49-0) 892-380-5216

PERMANENT COLLECTION

Art from the Middle Ages to the end of the Rococo period. Italian art by Giotto, Botticelli, da Vinci, Paphael, Titian and Tintoretto; Dutch Baroque art by Rembrandt and Hals; early German painting by Holbein the Elder, Dürer, Lochner and Altdorfer. **Highlights:** One of the world's largest collections of works by Rubens; Dürer's self-portrait from 1500 and *Four Apostles*. **Architecture:** Designed by Leo von Klenze and completed in 1836; 1957 reconstruction by Hans Döllgast; extensive interior renovation in 1998.

Admission: 5 euros; reduced admission, 3.50 euros. Sunday, free. Additional fees for special exhibitions.
Hours: Tuesday through Sunday, 10 a.m.–5 p.m.; Tuesday and Thursday, until 10 p.m. Closed Monday, Christmas Eve, Christmas Day and New Year's Eve.

Neue Pinakothek

29 Barer Strasse, Munich 80799, Germany
(49-0) 89-23805-195
www.neue-pinakothek.org

PERMANENT COLLECTION

European paintings and sculpture from the late 18th century to the beginning of the 20th; German art of the 19th century; French Impressionist works; portrait and landscape paintings from England, France and Spain. **Architecture:** 1991 building by Alexander von Branca.

Admission: 5 euros; reduced, 3.50 euros.
Hours: Friday through Monday, 10 a.m.–5 p.m.; Wednesday and Thursday, 10 a.m.–10 p.m. Closed Tuesday.

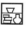

Pinakothek der Moderne

40 Barer Strasse, Munich 80333, Germany
www.museum-der-moderne.de

PERMANENT COLLECTION

Some 400,000 drawings and prints, from Leonardo to contemporary artists; works by Beckmann, Kandinsky, Klee, Magritte, Picasso, Bacon, Baselitz, Beuys, Judd, Polke, Twombly and Warhol; photography; 50,000 items of 20th- and 21st-century applied arts; some 350,000 architectural drawings, plus approximately 100,000 photographs and 500 models. **Architecture:** 2002 building by Stephan Braunfels.

Hours: Tuesday through Sunday, 10 a.m.–5 p.m.; Thursday and Friday, until 8 p.m. Closed Monday.

Staatsgalerie Stuttgart

30-32 Konrad Adenauer Strasse, Stuttgart 70174, Germany
(49-711) 212-4050
www.staatsgalerie.de

2003 EXHIBITIONS

Through January 23
Württemberg
Paintings from 1750 to 1900.

Through February 9
Edouard Manet and the Impressionists

March 22–June 15
Photo Art
Works from the gallery's collection.

March 22–January 11, 2004
World Art Series
Works by Dürer, Rembrandt, Piranesi, Goya, Toulouse-Lautrec, Picasso, Newman and others.

July 19–November 16
Serenity in the Shadow: Gaspare Traversi
Age of Enlightenment works by the Italian painter.

PERMANENT COLLECTION

Early German, Dutch and Italian painting; 19th-century French painting; Swabian classicism; European modern art, including Fauvist, Expressionist and Constructivist works; American Abstract Expressionism; Pop Art and Minimalism; drawings; watercolors; collages; prints; illustrated books; posters; photographs. **Architecture:** Old building by G.G. von Barth, 1843; 1880's extensions by Albert von Boks; new building by James Stirling, 1984.

Admission: Adults, 4.50 euros; students, 2.50 euros; children under 14, free.

Hours: Tuesday through Sunday, 10 a.m.–6 p.m.; Thursday, until 9 p.m. First Saturday of the month, 10 a.m.–midnight. Closed Monday.

Hong Kong

Art Museum, The Chinese University of Hong Kong

Shatin, New Territories, Hong Kong
(852) 2609-7416
www.cuhk.edu.hk/ics/amm

2003 EXHIBITIONS

Through February
Inkplay in Microcosm: Chinese Inside-Painted Snuff Bottles
Some 150 snuff bottles from the late 19th century to early 20th.

February–May
Shiwan Pottery From the Eryi Caotang Collection
Some 100 items of Shiwan pottery from the Guangdong province from the 15th to early 20th century.

July–September
Changsha Wares of the Tang Dynasty
Works produced by Chinese potters in the ninth century.

October–December
Objects for Scholars
Artistic objects with which traditional Chinese scholars surrounded themselves.

PERMANENT COLLECTION

More than 7,000 items, including Chinese paintings, calligraphy, rubbings, sculpture, ceramics, jades, bronzes, seals and other decorative arts.

Admission: Free.

Hours: Monday through Saturday, 10 a.m.–4:45 p.m.; Sunday, 12:30–5:30 p.m. Closed public holidays.

The University Museum and Art Gallery

University of Hong Kong, Pokfulam, Hong Kong
(852) 2241-5500
www.hku.hk/hkumag

2003 EXHIBITIONS

March 12–June
Ancient Taoist Art
Sculptural works in stone, wood and bronze as well as porcelain and paintings, some dating back as far as the Tang dynasty.

March 29–June 22
China Trade Paintings
Paintings exploring East-West cultural relations and China trade of the 18th and 19th centuries in southern China.

October–December
Chinese Painting and Calligraphy From the Collection of Dr. S.Y. Yip
Eighty examples from a collector best known for his connoisseurship in ancient Chinese furniture.

PERMANENT COLLECTION

Chinese antiquities, including ceramics, bronzes and paintings; contemporary Chinese paintings. **Highlights:** Nestorian bronze crosses of the Yuan dynasty; underglaze blue water pot of the Tang dynasty.

Admission: Free.
Hours: Monday through Saturday, 9:30 a.m.–6 p.m.; Sunday, 1:30–5:30 p.m. Closed holidays.

India

Asutosh Museum of Indian Art

Centenary Building, University of Calcutta, College
 Street, Calcutta 700012, India
(91-33) 241-0071; (91-33) 241-4984

PERMANENT COLLECTION

More than 25,000 objects of Indian art and antiquity, with an
emphasis on Eastern India and Bengal, including sculpture,
paintings, folk art, textiles and terra cotta. **Highlights:**
Ancient Indian and Ceylonese mural paintings; banner paint-
ings from Tibet and Nepal; Mughal, Rajasthani, Pahari and
local paintings; pats (scroll paintings); pata (painted manu-
script covers); kantha (embroidered textiles).

Admission: Free.
Hours: Monday through Friday, 11 a.m.–4:45 p.m. Closed
Saturday, Sunday and national and state holidays.

Baroda (Vadodara) Museum and Picture Gallery

Sayaji Baug (Park), Baroda, Gujarat 390005, India
(91-26) 579-3801

PERMANENT COLLECTION

Art, archaeology, natural history, geology and ethnology;
11th-century Shiva Natraj; ninth-century ivory; miniatures
from Razm Nama; a Persian version of the Hindu epic
Mahabharata commissioned by Emperor Akbar; European art
from early Greek times to the 20th century. The Picture
Gallery features European art from the 15th, 18th and 19th
centuries; works by Veronese, Giordano and Zurbarán;

Flemish and Dutch school paintings; Turner and Constable; Mughal miniatures; palm-leaf manuscripts of Buddhist and Jain origin. **Architecture:** Two buildings connected by a covered bridge, modeled on the Victoria and Albert and Science Museums of London; designed by Maj. R.N. Mant and R.F. Chisholm in 1897.

Admission: Adults, 10 rupees; under 4, free.
Hours: Daily, 10:30 a.m.–5:30 p.m. Closed national holidays.

National Gallery of Modern Art

Jaipur House, near India Gate, New Delhi 110003, India
(91-11) 338-8853
www.ngma-india.com

PERMANENT COLLECTION

More than 14,000 works of Indian and Western modern art, including Indian works from the Company School (1857) and from the Bengal School of the early 20th century (Jamini Roy, Rabindranath Tagore, Nandalal Bose).

Admission: 150 rupees.
Hours: Tuesday through Sunday, 10 a.m.–5 p.m. Closed Monday and national holidays.

National Museum

Janpath, New Delhi 110001, India
(91-11) 301-9272
www.nationalmuseumindia.org

PERMANENT COLLECTION

Works that span 5,000 years; pre-history gallery; Indus Valley civilization; Maurya, Satvahana and Shunga art; late medieval art; Indian bronzes; Central Asian art; Chamba Rangmahal; Indian miniature paintings; manuscripts; pre-Columbian and Western art; Indian coins and copper plates; wood carvings; musical instruments; arms and armor; Buddhist art, including Buddha's relics from Kapilavastu and life scenes from the fifth century B.C.; decorative arts; paintings from South India, Tanjore and Mysore; Indian textiles and jewelry.

Admission: 150 rupees; camera fee, 300 rupees.
Hours: Tuesday through Sunday, 10 a.m.–5 p.m. Closed Monday and national holidays.

Sanskriti Museum of Everyday Art and Indian Terracotta

Sanskriti Kendra, Anandgram, Qutab-Mehrauli-Gugaon
 Road, New Delhi 110047, India
(91-11) 650-1796
www.sanskritifoundation.org

PERMANENT COLLECTION

Museum of Everyday Art: Collection of about 2,500 objects from everyday life in traditional India, including folk and tribal sacred images, ritual accessories, lamps, incense burners, writing materials and kitchen implements. Museum of Indian Terracotta: About 1,500 objects of terracotta, including earthenware pots and ritual figures.

Admission: Free.
Hours: Tuesday through Sunday, 10 a.m.–5 p.m. Closed Monday and national holidays.

Ireland

Hugh Lane Municipal Gallery of Modern Art

Charlemont House, Parnell Square North, Dublin 1,
 Ireland
(353-1) 874-1903
www.hughlane.ie

PERMANENT COLLECTION

Twentieth-century Irish art, including works by Jack B. Yeats
and contemporary artists such as Willie Doherty, Dorothy
Cross, Sean Scully and Kathy Prendergast; paintings by Degas,
Manet, Monet and other Impressionists; modern art by Albers,
Christo, Beuys, Agnes Martin, Francis Bacon and others.
Architecture: Georgian building.

Admission: Free. Francis Bacon Studio: 7 euros, seniors and
students, 3.50 euros; children, free.
Hours: Tuesday to Thursday, 9.30 a.m.–6 p.m.; Friday and
Saturday, 9.30 a.m.–5 p.m.; Sunday, 11 a.m.–5 p.m.

Irish Museum of Modern Art

Royal Hospital, Military Road, Kilmainham, Dublin 8,
 Ireland
(353-1) 612-9900
www.modernart.ie

2003 EXHIBITIONS

Through January 12
Karen Kilimnik
More than 30 works by the American, including paintings,
drawings, sculptures and photographs created since 1997.

Through January
Louise Bourgeois
New soft sculptures and related drawings.

Through January
"The Táin" by Louis le Brocquy
Twenty tapestries that grew out of le Brocquy's illustrations for poet Thomas Kinsella's translation of the "Táin Bó Cuailnge."

Through February
Willie Doherty
Photographs by the Irish artist,

Courtesy of the Irish Museum of Modern Art.
Louis le Brocquy, *The Morrigan in Bird Shape,* 1969.

ranging from early black and whites to large color images, plus recent video works.

Through February
The Unblinking Eye
Recent additions to the museum's collection, including works by Hannah Starkey, Beat Klein and Hendrikje Kühne.

PERMANENT COLLECTION

Some 4,000 works of 20th-century Irish and international art; Sean Scully paintings; sculpture; photography by Marina Abramovic; video works; an installation by Ilya Kabakov.
Architecture: The former Royal Hospital Kilmainham, built in the 17th century as a home for retired soldiers.

Admission: Free.
Hours: Tuesday through Saturday, 10 a.m.–5:30 p.m.; Sunday and holidays, noon–5:30 p.m. Closed Monday, Good Friday and December 24–26.

National Gallery of Ireland

Merrion Square (West), Dublin 2, Ireland
(353-1) 661-5133
www.nationalgallery.ie

2003 EXHIBITIONS

February 20–May 18
Paul Henry
More than 100 paintings by the landscape artist (1876–1958), plus works on paper.

September–December
Love Letters
Scenes involving letters—their writing, dictation, delivery and reception—painted in the 17th century by Dutch artists, including Hoogh, Metsu, Steen, Ter Borch and Vermeer.

PERMANENT COLLECTION

Some 13,000 works of art, more than 2,500 of which are oil paintings. Irish art from the 17th century to the 20th, including works by Barry, le Brocquy, Henry, Jervas, O'Connor, Orpen and Yeats; European art, including works by Canova, Caravaggio, Gainsborough, Goya, Mantegna, Poussin, Rembrandt and Vermeer. **Highlights:** Yeats Museum; National Portrait Collection. **Architecture:** 1864 Dargan Wing by Francis Fowke; 1903 Milltown Wing by Thomas N. Deane; 1968 Beit Wing, refurbished in 1996; just-completed wing by Benson and Forsyth.

Admission: Free. Fees for some exhibitions.
Hours: Monday through Saturday, 9:30 a.m.–5:30 p.m.; Thursday, until 8:30 p.m.; Sunday, noon–5:30 p.m. Closed Good Friday and December 24–26.

Israel

Israel Museum

Givat Ram (Ruppin Road, across from Knesset),
 Jerusalem 91710, Israel
(972-2) 670-8811
www.imj.org.il

2003 EXHIBITIONS

Through January 11

Chagall in Israel

Some 80 paintings and works on paper by one of the most famous Jewish artists, including depictions of village scenes, self-portraits and paintings of lovers and flowers.

Through February

Handled With Care: Glass in the Israel Museum

Some 150 examples of ancient glass displayed with glass works from the museum's departments of Judaica, fine arts and design.

Through February

Jacques Lipchitz

Sculpture, sculptural sketches and drawings by one of the first artists to apply the principles of Cubism to sculpture.

Through March

Who's Afraid of Contemporary Art?

Exhibition designed to make contemporary art more accessible to the general public.

Through April

Weegee's Story

Photographs by Weegee (1899–1968), known for his bold, gritty and voyeuristic images of New York life.

Through April

Raffi Lavie: Works From 1956–2001

Works by one of the most dominant figures in Israeli art over the past 30 years.

Through May

Plant, Vegetable, Mineral

Paintings and works on paper by Old Masters portraying plants, animals and household objects.

Through June

Focus on the Collection: Jacob Epstein

Some 70 works tracing the artistic development of a pioneering American-born British sculptor (1880–1959).

Through July

North African Lights: Hanukkah Lamps From the Schulmann Collection

Display of 120 Hanukkah lamps from North Africa.

Through March 2004
Food: An Exhibition of the Ruth Young Wing
Explores food in different societies and cultures through works
of art and interactive and edible installations.

February 20–June 28
Mordecai Ardon: Landscapes of Infinity
Landscapes of Israel by an artist who immigrated to Palestine
in 1933.

PERMANENT COLLECTION

Israel's largest museum, containing archaeological and fine arts
collections of the Holy Land from antiquity to the present day.
Highlights: The Dead Sea Scrolls; noted collection of Judaica
and the ethnology of the Jewish people around the world; fine
art holdings from European Old Masters through international
contemporary art.

Admission: Adults, NIS 37 (New Israeli shekels); seniors, stu-
dents and the handicapped, NIS 18; children, free.
Hours: Monday, Wednesday and Saturday, 10 a.m.–4 p.m.;
Tuesday, 4–9 p.m.; Thursday, 10 a.m.–9 p.m.; Friday, 10 a.m.–2
p.m. Closed Sunday and Yom Kippur Eve and Yom Kippur.

Italy

Galleria dell'Accademia

58-60 Via Ricasoli, Florence 50122, Italy
(39-055) 238-8609
www.sbas.firenze.it/accademia

PERMANENT COLLECTION

Michelangelo sculptures; paintings, mostly dating between the
13th and 15th centuries. **Highlights:** Michelangelo, *David, St.
Matthew, Pietà di Palestrina* and *The Four Slaves*, created for the
tomb of Pope Julius II. **Architecture:** 16th-century building,
restored in the 18th and 19th centuries.

Admission: 6.50 euros. Advance ticket purchase recommended, at reduced rate; contact the Florence Museum reservation office at (39-05) 529-4883.
Hours: Tuesday through Sunday, 8:15 a.m.–7 p.m. Closed Monday, New Year's Day, May 1 and Christmas Day.

Galleria degli Uffizi

5 Via della Ninna, Florence 50122, Italy
(39-055) 238-8651
www.sbas.firenze.it/uffizi

PERMANENT COLLECTION

Italian Renaissance art from the 14th to 17th century.
Highlights: Botticelli room; paintings by Caravaggio, Giotto, Cimabue, Leonardo da Vinci, Michelangelo and Titian.
Architecture: Designed by Giorgio Vasari for the Medici family in 1560.

Admission: 6.50 euros. Advance ticket purchase recommended; contact the Florence Museum reservation office at (39-05) 529-4883.
Hours: Tuesday through Sunday, 8:30 a.m.–7 p.m. Closed Monday, New Year's Day, May 1 and Christmas Day.

Museo Nazionale del Bargello

4 Via del Proconsolo, Florence 50122, Italy
(39-055) 238-8606
www.sbas.firenze.it/bargello

PERMANENT COLLECTION

Major collection of Renaissance sculpture. Works by Donatello, Della Robbia, Verrocchio and Michelangelo; base of Benvenuto Cellini's *Perseus;* decorative arts. **Architecture:** 14th-century Gothic Podestà Palace.

Admission: 4 euros. Advance ticket purchase recommended; contact the Florence Museum reservation office at (39-05) 529-4883.

Hours: Daily, 8:15 a.m.–1:50 p.m. Closed New Year's Day, May 1 and Christmas Day. Closed the first, third and fifth Sunday and second and fourth Monday of each month.

Museo Poldi Pezzoli

12 Via Manzoni, Milan 20121, Italy
(39-0) 279-6334
www.museopoldipezzoli.it

2003 EXHIBITIONS

Through February 28
Renaissance Works From the Paris Jacquemart-André Musée

PERMANENT COLLECTION

Paintings, sculpture, works of gold, arms and armor, fabric, clocks and bronzes. **Highlights:** Paintings by Giovanni Bellini, Botticelli, Piero della Francesca, Pollaiolo, Mantegna, Canaletto and Raphael. **Architecture:** 17th-century mansion of a 19th-century art collector.

Admission: 6 euros; slightly higher for some exhibitions.
Hours: Tuesday through Sunday, 10 a.m.–6 p.m. Closed Monday, New Year's Day, Easter Sunday and Easter Monday, April 25, May 1, August 15, November 1 and December 8, 25 and 26.

Pinacoteca di Brera
(Brera Picture Gallery)

28 Via Brera, Milan 20121, Italy
(39) 02-8942-1146
www.brera.beniculturali.it

PERMANENT COLLECTION

Mostly paintings from churches and cloisters closed during the
Napoleonic period and from donations; Lombard and Venetian
school works from the 14th to 20th century. **Highlights:**
Caravaggio, *Supper at Emaus*; Tintoretto, *Finding of the Body of St.
Mark*; Mantegna, *Dead Christ*; Luini, *Madonna of the Rose Hedge*;
Giovanni Bellini, Pietà; Raphael, *The Betrothal of the Virgin*; Piero
della Francesca, Montefeltro altarpiece. **Architecture:** Begun in
the 12th century as a cloister; additional construction in the early
17th century by Francesco Maria Richini; 18th-century alterations
by Giuseppe Piermarini. Opened as a museum in 1809.

Admission: 5 euros.
Hours: Tuesday through Sunday, 8:30 a.m.–7:30 p.m. Slightly
shorter hours during the winter. Closed Monday, New Year's
Day, May 1 and Christmas Day.

Veneranda Biblioteca Ambrosiana, Pinacoteca Ambrosiana

(Ambrosiana Library and Picture Gallery)

2 Piazza Pio XI, Milan 20123, Italy
(39-0) 280-6921
www.ambrosiana.it

PERMANENT COLLECTION

Founded in 1609 with a bequest by Cardinal Federico
Borromeo. **Highlights:** Sketches for Raphael's *School of Athens*;
works by Flemish, Lombard and Venetian masters, including
Caravaggio, Leonardo da Vinci, Luini and Titian.
Architecture: Part of a palace built for Cardinal Borromeo,
begun in 1603 and finished in 1630. Restored in 1997.

Admission: 7.50 euros.
Hours: Tuesday through Sunday, 10 a.m.–5:30 p.m. Closed
Monday, New Year's Day, Easter Sunday, May 1 and Christmas

Day. The library is closed from December 24 to January 6, from April 13 to 27, from May 1 to 3, June 2, from July 13 to August 31 and on December 8.

Museo Archeologico Nazionale Napoli
(Naples Archaeological Museum)

19 Piazza Museo, Naples 80135, Italy
(39-08) 144-0166
www.marketplace.it/museo.nazionale

PERMANENT COLLECTION

Classical antiquities from the 18th-century excavations of Pompeii, Herculaneum and Stabiae. **Highlights:** Roman wall frescoes from the Vesuvius region; statue of the Farnese *Hercules*; sculptural group of the Farnese bull; mosaic of Alexander from the House of the Faun in Pompeii; frescoes and sculpture from the Villa of the Papyri in Herculaneum and the Temple of Isis in Pompeii. **Architecture:** Built at the end of the 16th century; reconstructed at the beginning of the 17th century, when it became the University of Naples, and expanded at the end of the 18th century to become the Royal Bourbon Museum.

Admission: Adults, 6.50 euros; European Union citizens over 65 or under 18, free.
Hours: Wednesday through Monday, 9 a.m.–7:30 p.m. Hours may be shorter during the winter. Closed Tuesday, New Year's Day, May 1 and Christmas Day.

Museo di Capodimonte

1 Via Miano, Naples 80137, Italy
(39-081) 749-9111
capodimonte.selfin.net/capodim/home.htm

PERMANENT COLLECTION

Works from the Borgia, Bourbon and Farnese collections; contemporary art. **Highlights:** Works by Bruegel the Elder, the Carraci, Caravaggio, Mantegna, Martini, Masaccio, Parmigianino, and Titian; 18th-century porcelain; decorative art from the 16th to 18th century. **Architecture:** Former royal estate, begun in 1738 by Antonio Medrano and completed a century later.

Admission: 7.5 euros.
Hours: Tuesday through Sunday, 8:30 a.m.–8 p.m.; holidays, 9 a.m.–8 p.m. Closed Monday, New Year's Day, May 1 and Christmas Day.

Galleria Nazionale dell'Umbria

Palazzo dei Priori, 1 Corso Vannucci, Perugia 06100, Italy
(39-075) 574-1257
www.gallerianazionaledellumbria.it

PERMANENT COLLECTION

Central Italian art, with emphasis given to artists working in Umbria. **Highlights:** Sculptures from a fountain by Arnolfo di Cambio; paintings by Duccio di Buoninsegna, Gentile da Fabriano and Piero della Francesca; works by Perugino. **Architecture:** 13th-century palace, recently restored and expanded.

Admission: 6.5 euros.

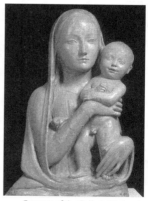

Courtesy of the Galleria Nazionale Dell'Umbria.
Agostino di Duccio, *Madonna col Bambino,* c. 1460.

Hours: Daily, 8:30 a.m.–7:30 p.m. Closed the first Monday of the month, New Year's Day and Christmas Day.

Galleria Borghese

5 Piazza Scipione Borghese, Rome 00197, Italy
(39-06) 854-8577
www.galleriaborghese.it

PERMANENT COLLECTION

Italian art, especially Roman, Venetian, Tuscan and Emilian works. **Highlights:** Caravaggio paintings; Bernini sculptures; Raphael, *Deposition*; Tiziano, *Sacred and Profane Love;* Canova, *Pauline Bonaparte.* **Architecture:** Designed by Jan van Santen in the early 17th century for Cardinal Scipione Borghese; recently restored.

Admission: 8.03 euros plus mandatory 1 euro reservation fee; call (39) 063-2810 for reservations.
Hours: Tuesday through Sunday, 9 a.m.–7 p.m. Closed Monday, New Year's Day, May 1 and Christmas Day.

Galleria Nazionale d'Arte Antica, Palazzo Barberini

13 Via Barberini, Rome 00184, Italy
(39-06) 481-4591
www.galleriaborghese.it

PERMANENT COLLECTION

Art dating from the 13th century to the 18th. **Highlights:** Fresco in the Grand Salon by Pietro da Cortona; Raphael, *Fornarina*; Caravaggio, *Judith and Holofernes*; Hans Holbein the Younger, *Portrait of Henry VIII.* **Architecture:** 17th-century

palace built for Pope Urban VIII by Carlo Maderno, Gian
Lorenzo Bernini and Francesco Borromini.

Admission: 5 euros; reservations can be made by calling (39)
063-2810 (for a 1 euro fee), but are not required.
Hours: Tuesday through Thursday and Sunday, 9 a.m.–8 p.m.;
Friday and Saturday, 9 a.m.–10 p.m. Closed Monday, New
Year's Day, May 1 and Christmas Day.

Galleria Nazionale d'Arte Moderna

131 Viale delle Belle Arti, Rome 00196, Italy
(39-063) 229-8225
www.gnam.arti.beniculturali.it

PERMANENT COLLECTION

Paintings and sculpture, mostly Italian, from 1780 to the
present; works by Balla, Boccioni and other Futurists;
paintings by Burri, Fontana and Morandi. **Highlights:**
Canova, *Hercules and Lychas*; Giulio Aristide Sartorio, *Gorgon
and the Heroes*. **Architecture:** Built in 1911; since expanded.

Admission: 6.50 euros; European Union citizens over 65 or
under 18, free.
Hours: Tuesday through Sunday, 8:30 a.m.–7:30 p.m. Closed
Monday, New Year's Day and May 1.

Museo Mario Praz

Palazzo Primoli, 1 Via Zanardelli
(39-06) 686-1089
www.gnam.arti.beniculturali.it/prazco.htm

PERMANENT COLLECTION

Aristocratic 19th-century residence, containing antique
furniture, paintings, sculptures, carpets and porcelains from
the end of the 18th century.
Hours: Tuesday through Sunday, 9 a.m.–7 p.m.

Museo Boncompagni Ludovisi

18 Via Boncompagni
(39-064) 282-4074
www.gnam.arti.beniculturali.it/boncco.htm

PERMANENT COLLECTION

Aristocratic residence from the early 20th century.
Hours: Visits only upon request.

Manzù Collection

1 Via Sant'Antonio, Ardea
(39-06) 913-5022
www.gnam.arti.beniculturali.it/manzco.htm

PERMANENT COLLECTION

Houses 461 works from 1950 to 1970, including sculptures,
jewelry, medals and drawings, donated by the sculptor Manzuí
donated in 1979.
Hours: Monday, 2–7 p.m.; Tuesday through Sunday, 9 a.m.–
7 p.m.

Museo Hendrik C. Andersen

24 Via Pasquale Stanislao Mancini
(39-06) 321-9089
www.gnam.arti.beniculturali.it/andeco.htm.

PERMANENT COLLECTION

Works by the painter and sculptor Hendrik Christian
Andersen, who lived in Rome from 1896 to 1940.
Hours: Tuesday through Sunday, 9 a.m.–8 p.m.

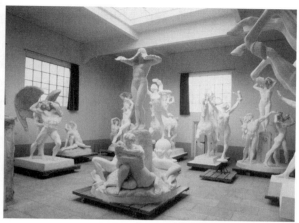

Courtesy of the Museo Hendrik C. Andersen.
Hendrik C. Andersen, *The Night*, 1904-11.

Musei Capitolini

Piazza del Campidoglio, Rome 00186
(39-063) 996-7800
www.comune.roma.it/cultura/italiano/
musei_spazi_espositivi/musei/musei_capitolini

PERMANENT COLLECTION

Divided into two buildings: One houses a collection of ancient
sculpture; the other, frescoes and a picture gallery. Ancient
Roman busts of emperors and philosophers; paintings by
Caravaggio, Guercino, Pietro da Cortona, Reni and Rubens.
Highlights: Equestrian statue of Marcus Aurelius; the
Capitoline Venus. **Architecture:** The Palazzo dei Conservatori
was built in the 15th century, the Palazzo Nuovo in the 17th.
The square between the two palaces was designed by
Michelangelo. The museums were recently expanded to
include new exhibition spaces as well as a gallery overlooking
the Roman Forum.

Admission: 6.20 euros.
Hours: Tuesday through Sunday, 9:30 a.m.–7 p.m. Closed
Monday, New Year's Day and Christmas Day.

Museo Nazionale Romano, Palazzo Altemps

8 Piazza di Sant'Apollinare, Rome 00186, Italy
(39-06) 683-3759
www.archeorm.arti.beniculturali.it/sar2000/altemps/
 pal_altemps.htm

PERMANENT COLLECTION

Antique statuary, including the 15 statues remaining from the
original Altemps collection; works from the Boncompagni-
Ludovisi, Mattei, Del Drago and Brancaccio collections.
Highlights: *Ludovisi Throne* and *Ares Ludovisi*. **Architecture:**
Built from the 15th to the 18th century by the architects
Antonio da Sangallo, Baldassare Peruzzi, Martino Longhi the
Elder and others.

Admission: 5 euros.
Hours: Tuesday through Sunday, 9 a.m.–7 p.m. Closed
Monday, New Year's Day, May 1 and Christmas Day.

Museo Nazionale Romano, Palazzo Massimo alle Terme

1 Largo di Villa Peretti, Rome 00185, Italy
(39-064) 890-3500
www.archeorm.arti.beniculturali.it/sar2000/
 museo_romano/pal_massimo.htm

PERMANENT COLLECTION

Ancient Roman art, including mosaics, frescoes, sculpture and
bronzes. Some Greek originals. Underground vault with a coin
collection spanning the origins of currency to the present.
Highlights: Series of frescoes from the Roman Villa of the
Farnesina and the triclinium of Livia's Villa on the Via
Flaminia. **Architecture:** 19th-century structure.

Admission: 6 euros.

Hours: Tuesday through Sunday, 9 a.m.–7:45 p.m. Closed
Monday, New Year's Day, May 1 and Christmas Day.

Museo Egizio
(Egyptian Museum)

6 Via Accademia delle Scienze, Turin 10123, Italy
(39-011) 561-7776
www.museoegizio.it

2003 EXHIBITIONS
February 22–May 18
Deir el-Medina: The Artists of the Pharoahs

PERMANENT COLLECTION

Founded in 1824. Statues, mummies, sarcophagi, papyri rolls
and tomb jewels. **Highlights:** Complete set of funerary objects
from the tomb of the architect Kha and his wife, Merit (1430
B.C.); statue of Ramses II (1299-1233 B.C.); Rock Temple of
Thutmose III (circa 1430 B.C.) from Ellessya. **Architecture:**
17th-century Palazzo dell'Accademia delle Scienze, designed
by Guarino Guarini.

Admission: 6.50 euros; ages 18–25, 3 euros; under 18 and
over 65, free.
Hours: Tuesday through Sunday, 8:30 a.m.–7:30 p.m. Closed
Monday, New Year's Day, May 1 and Christmas Day.

Gallerie dell'Accademia
(Academy of Fine Arts)

1050 Dorsoduro, Campo di Carità, Venice 30100, Italy
(39-041) 522-2247
www.artive.arti.beniculturali.it

PERMANENT COLLECTION

Venetian paintings; works by Bellini, Giorgione, Tiziano, Veronese, Lotto, Mantegna, Tiepolo, Tintoretto and Canaletto. **Highlights:** Giorgione, *Tempest*; Titian, *Pietà*; Carpaccio, *Legend of Saint Ursula*. **Architecture:** 15th-century school and church, and 16th-century monastery designed by Andrea Palladio.

Admission: 6.50 euros; European Union citizens over 60 or under 18, free.
Hours: Tuesday through Sunday, 8:15 a.m.–7 p.m.; Monday, until 2 p.m. Closed on New Year's Day, May 1 and Christmas Day.

Museo Nazionale di Palazzo Venezia

Via del Plebiscito, Venice 30118, Italy
(39-06) 679-8865

2003 EXHIBITIONS
Through February 15
Giacomo Manzu

Spring-Summer
Barocco, the Jesuit vision in the Paintings of the 17th Century

PERMANENT COLLECTION

Decorative arts, including Romanesque and 14th-century ivory, majolica, church silver and terra cotta; sculpture; paintings. **Architecture:** Palace built in the mid-15th century for Cardinal Pietro Barbo, who became Pope Paul II; attributed to Francesco del Borgo.

Admission: 4 euros. Reservations recommended for exhibitions.
Hours: Tuesday through Sunday, 8:30 a.m.–7:30 p.m. Slightly later hours for exhibitions. Closed Monday, New Year's Day, May 1 and Christmas Day.

Palazzo Grassi

3231 San Samuele, Venice 30134, Italy
(39-041) 523-1680
www.palazzograssi.it

2003 EXHIBITIONS
Through May 25
The Pharaons

Architecture: Built 1740–1760 by Giorgio Massari for the Grassi family.

Admission: 8.50 euros.
Hours: Daily, 10 a.m.–7 p.m.

Peggy Guggenheim Collection

701 Dorsoduro, Venice 30123, Italy
(39-041) 240-5411
www.guggenheim-venice.it

PERMANENT COLLECTION

European and American art, including Cubism, Futurism, metaphysical painting, European abstraction, Surrealism and American Abstract Expressionism. Works by Brancusi, Braque, Calder, Duchamp, Ernst, Kandinsky, Mondrian and Picasso.
Highlights: Magritte, *Empire of Light*. **Architecture:** Mid-18th-century mansion on the Grand Canal.

Admission: Adults, 8 euros; students, 5 euros; under 12 and members, free.
Hours: Wednesday through Monday, 10 a.m.–6 p.m. Slightly longer hours during the summer. Closed Tuesday and Christmas Day.

Monumenti Musei e Gallerie Pontificie
(Vatican Museums)

Vatican City, 00120
(39-066) 988-4466
www.vatican.va/museums

PERMANENT COLLECTION

Egyptian, Etruscan, Greek, Roman and Renaissance art;
contemporary religious art. Picture Gallery: Paintings by
Leonardo, Raphael, Caravaggio, Poussin, Van Dyck. Pio-
Clementino Museum: Greek and Roman sculptures. Pio-
Christian Museum: Christian sarcophagi from the third
century to the fifth. **Highlights:** Sistine Chapel; Raphael's
Rooms; the *Laocoon*; *Apollo Belvedere*; map gallery.

Architecture: The museums occupy the palaces built by the
popes from the 13th century onward. The long courtyards and
galleries that connect the Belvedere Pavilion to other buildings
were designed by Bramante in 1503. Most of the successive
additions were made in the 18th century.

Admission: 10 euros.

Hours: Monday through Friday, 8:45 a.m.–4:45 p.m.;
Saturday, 8:45 a.m.–1:45 p.m. Slightly shorter hours during
the winter. Closed Sunday and Vatican holidays. Open the last
Sunday of each month, unless it is a holiday.

Japan

Kyoto National Museum

527 Chayamachi, Higashiyama-ku, Kyoto 605-0931,
 Japan
(81-75) 541-1151
www.kyohaku.go.jp

2003 Exhibitions

April 15–May 25
Koyasan Exhibition
Exhibition focusing on a Buddhist monastic complex of the Shingon sect on Mt. Koya that contains more than 110 temples and monasteries.

Fall
Exhibition of Gold Ornaments

Permanent Collection

Approximately 5,500 works, including 170 designated by the Japanese government as national treasures or "important cultural properties." Archaeological items, ceramics, sculpture, paintings, calligraphy, textiles, lacquerware and metalwork.
Architecture: 1895 Main Exhibition Hall, red-brick Main Gate and adjoining ticket gate and fences are remains of the former Imperial Museum of Kyoto; 1965 New Exhibition Hall by Keiichi Morita.

Admission: Adults, 420 yen; students, 70–130 yen. Discounts for groups of 20 or more. Additional fees for special exhibitions.
Hours: Tuesday through Sunday, 9:30 a.m.–5 p.m.; Friday until 8 p.m. Closed Monday and December 26 through January 3. December through March, Friday until 5 p.m.

The National Museum of Western Art

7-7 Ueno-koen, Taito-ku, Tokyo 110–0007, Japan
(81-33) 828-5131
www.nmwa.go.jp

2003 Exhibitions

Spring
Tapestry Exhibition

PERMANENT COLLECTION

Art from the late medieval period through the early 20th century, including sculpture by Rodin and paintings by Courbet, Delacroix, Monet and Renoir. **Architecture:** 1958 main building by Le Corbusier; wings added in 1979, 1997.

Admission: Adults, 420 yen; students, 130 yen; children, 70 yen. Free on the second and fourth Saturday of each month. Discounts for groups of 20 or more. Additional fees for special exhibitions.

Hours: Tuesday through Sunday, 9:30 a.m.–5 p.m.; Friday, until 8 p.m. Closed Monday and December 28 through January 4.

The National Museum of Modern Art, Tokyo

3-1 Kitanomaru Koen, Chiyoda-ku, Tokyo 102-8322, Japan
(81-33) 214-2561
www.momat.go.jp

2003 EXHIBITIONS

Through January 8
Matsuda Gonroku: Design in Lacquer Work

January 18–March 9
Wolfgang Laib

January 18–March 9
Hermann Muthesius and the German Werkbund: Modern Design in Germany, 1900–1927

March 25–May 11
Shigeru Aoki and Romanticism in Modern Japanese Art

March 28–May 11
Eyes Toward the Doll

PERMANENT COLLECTION

More than 8,600 20th-century works, including paintings, prints, watercolors, drawings, sculpture and photographs.
Architecture: 1910 red-brick Crafts Gallery, originally built as the headquarters of the imperial guards. Rescued from ruin after World War II. An example of Meiji-era, Western-style architecture.

Admission: Adults, 420 yen; students, 130 yen; children, 70 yen. Free on the second and fourth Saturday of each month, free; November 3, free.
Hours: Tuesday through Sunday, 10 a.m.–5 p.m. Closed Monday and December 28 through January 4.

Tokyo National Museum

13-9 Ueno Park, Taito-ku, Tokyo 110-8712, Japan
(81-33) 822-1111
www.tnm.go.jp

2003 EXHIBITIONS

January 15–February 23
Great Exhibition of Nichiren
Art related to Nichiren, founder of Nichiren Buddhism.

Spring
Treasures of the Nishi Hongwanji
Display of art from the main temple of the Jodo Shinshu school of Buddhism, Nishi Hongwanji, including painted scrolls and calligraphy.

June 3–July 13
The 750th Anniversary of Kenchoji: Kamakura and the Art of Zen Buddhism
Exhibition on the art of Zen Buddhism, particularly in the Kamakura region, including treasures from Zen temples and examples of ink painting.

PERMANENT COLLECTION

More than 89,000 Asian works and archeological objects.
Highlights: Some 90 items registered by the Japanese government as national treasures and 575 items registered as "important cultural properties."

Admission: Adults, 420 yen; students, 130 yen; children, 70 yen; seniors, free; January 10 and September 15, free. Discounts for groups of 20 or more.
Hours: Tuesday through Sunday, 9:30 a.m.–5 p.m.; during the summer, until 8 p.m. Closed Monday and during the New Year's holidays.

Mexico

Museo de Arte Carrillo Gil

Avenida Revolución 1608, Colonia San Angel, Mexico
 City 01000, Mexico
(52555) 550-6260; (52555) 550-3983
www.macg.inba.gob.mx

2003 EXHIBITIONS

January–April
Orozco in Mexico
Works by the Mexican muralist.

PERMANENT COLLECTION

Created from the collection of Dr. Alvar Carrillo Gil, including works by José Clemente Orozco, Wolfgang Paalen, Diego Rivera and David Alfaro Siqueiros; Japanese stamps from the 17th century to the 20th.

Admission: Adults, 15 pesos; teachers and students, 9 pesos; seniors, free. Free on Sunday.

Hours: Tuesday through Sunday, 10 a.m.–6 p.m. Closed Monday.

Museo de Arte Contemporáneo Internacional Rufino Tamayo

Paseo de la Reforma y Gandhi, Bosque de Chapultepec, Mexico City 11580, Mexico

(52555) 286-6529; (52555) 286-3572

www.museotamayo.org

2003 EXHIBITIONS

March 13–June 22
Douglas Gordon

July 10–October 12
Iñigo Manglano Ovalle

July 31–October 26
Kevin Appel

PERMANENT COLLECTION

More than 300 works of international contemporary art; works by Mexican artists, including Francisco Toledo, Lilia Carrillo, José Luis Cuevas and Rufino Tamayo. **Highlights:** Works by Picasso, Rothko, de Kooning, Miró, Dubuffet, Noguchi, Chadwick, Soulages and Francis Bacon. **Architecture:** 1981 building by Teodoro González de León and Abraham Zabludovsky.

Admission: Adults, 20 pesos; students, children and seniors, free. Sunday, free.

Hours: Tuesday through Sunday, 10 a.m.–6 p.m. Closed Monday.

 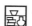

Museo de Arte Moderno

Paseo de la Reforma y Gandhi, Bosque de Chapultepec,
Mexico City 11560, Mexico
(52555) 553-6233; (52555) 211-8729
www.arts-history.mx/museos/mam

PERMANENT COLLECTION

Works by 20th-century Mexican artists, including David
Alfaro Siqueiros, José Clemente Orozco and Diego Rivera.
Highlights: Frida Kahlo, *The Two Fridas*.

Admission: 15 pesos; seniors, teachers, students and children
under 10, free. Free on Sunday.
Hours: Tuesday through Sunday, 10 a.m.–6 p.m. Closed
Monday.

Museo Dolores Olmedo

Avenida México 5843, Colonia la Noria, Xochimilco,
Mexico City 16030, Mexico
(52555) 555-1016; (52555) 555-0891
www.arts-history.mx/museos/mdo

2003 EXHIBITIONS

April–June
Pablo Picasso
Sixty works, including paintings and sculpture.

PERMANENT COLLECTION

Olmedo collection of modern art; colonial objects and
furniture; collection of Mexican folk art, with ceramics, glass,
papier-mâché, masks and lacquers. **Highlights:** Some 135
works by Diego Rivera; 25 paintings by Frida Kahlo; 43 prints
by Angelina Beloff; more than 600 pre-Columbian pieces.
Architecture: 17th-century Hacienda la Noria.

Admission: 25 pesos; students and teachers, 15 pesos; seniors and children under 6 with an adult, free. Free on Tuesday.
Hours: Tuesday through Sunday, 10 a.m.–6 p.m. Closed Monday.

Museo Franz Mayer

Avenida Hidalgo 45, Colonia Guerrero, Mexico City
063000, Mexico
(52555) 518-2265; (52555) 518-2266;
(52555) 518-2271
www.arts-history.mx/museos/franz

2003 Exhibitions

June–July
World Press Photos

Permanent Collection

Some 10,000 examples of Mexican furniture and household accessories, mostly from the 16th through the 19th centuries; Talavera pottery; gold and silver religious pieces; sculpture; tapestries; rare watches and clocks; Old Master paintings from Europe and Mexico; a library with books dating from 1484, including approximately 800 editions of *Don Quixote* in 15 languages. **Architecture:** A restored 16th-century building in the city's historic center.

Admission: 20 pesos; students and teachers, 10 pesos; seniors and children under 12, free. Free on Tuesday.
Hours: Tuesday through Sunday, 10 a.m.–5 p.m. Closed Monday.

Museo de Arte Contemporáneo de Monterrey

Gran Plaza at Zuazua and Jardon, Monterrey 64000,
 Mexico
(52818) 342-4820; (52818) 342-4830
www.mtyol.com/marco

PERMANENT COLLECTION

Art from Mexico and Latin America. **Architecture:** Designed
by Ricardo Legorreta in the style of a Moorish palace.

Admission: 30 pesos; students and seniors, 18 pesos; children
under 5, free. Free on Wednesday.
Hours: Tuesday through Sunday, 11 a.m.–7 p.m.; Sunday and
Wednesday, until 9 p.m. Closed Monday.

Museo de Arte Contemporáneo de Oaxaca

Macedonio Alcala, Centro, Oaxaca 68000, Mexico
(52951) 514-2228; (52951) 514-7110
www.arts-history.mx/museos/maco

2003 EXHIBITIONS

February 14–April 14
Mona Hatoum

May 2–June 16
Polvo/Proch
Twenty sculptures and other works by Xawery Wolski.

PERMANENT COLLECTION

Highlights: Works by artists from Oaxaca, including Rufino
Tamayo, Francisco Gutiérrez, Rodolfo Morales and Francisco
Toledo. **Architecture:** Casa de Cortés, a building dating from
the end of the 17th century.

Admission: Adults, 10 pesos; students, 5 pesos; seniors free. Free on Sunday.
Hours: Wednesday through Monday, 10:30 a.m.–8 p.m. Closed Tuesday.

The Netherlands

Rijksmuseum

42 Stadhouderskade, Amsterdam 1071 ZD, the
 Netherlands
(31-20) 674-7047
www.rijksmuseum.nl

2003 EXHIBITIONS

Through January 5
The Hare and the Moon: Arita Porcelain in Japan, 1620–1820
Selection of Japanese porcelain with typical Japanese motifs made for the deomstic market.

Through January 5
Document the Netherlands: Celebrations!
Photographs depicting the changing nature of celebrations in the Netherlands.

Through February 2
From Watteau to Ingres
Eighteenth-century French drawings from the museum's collection, including works by Boucher, Watteau, Fragonard and Ingres.

Through February 9
The Dutch Encounter With Asia, 1600–1950
Explores the Dutch presence on Asian soil, from the merchants of the 1600's who tried to develop trading contacts to the decolonization of Indonesia.

PERMANENT COLLECTION

Major collection of 15th- to 19th-century Dutch paintings, including works by Rembrandt, Vermeer, Hals and Jan Steen; sculpture and applied arts; large collections of silver, delftware, prints and drawings; presentation on Dutch history.
Highlights: 20 works by Rembrandt, including *The Night Watch, The Jewish Bride* and *The Draper's Guild*; Hals, *The Merry Drinker*; Vermeer, *Young Woman Reading a Letter* and *The Kitchen Maid*. **Architecture:** 1885 Renaissance Revival building by P. J. H. Cuypers.

Admission: Adults, 8.50 euros; 18 and under, free; additional fees for some exhibitions.
Hours: Daily, 10 a.m.–5 p.m. Closed New Year's Day.

Stedelijk Museum

13 Paulus Potterstraat, Amsterdam 1071, the
 Netherlands
(31-20) 573-2911
www.stedelijk.nl

PERMANENT COLLECTION

Modern and contemporary paintings, sculptures, drawings, prints, photographs, graphic design and applied arts, with an emphasis on postwar artists, including Appel, de Kooning, Newman, Judd, Stella, Lichtenstein, Warhol and Nauman; extensive collection of Malevich paintings; works by Beckmann, Chagall, Cézanne, Kirchner, Matisse, Mondrian, Monet and Picasso. **Architecture:** 1895 neo-Renaissance building by A. W. Weissman; 1954 modern glass wing by J. Sargentini and F. A. Eschauzier.

Admission: Adults, 5 euros; children 7–16 and seniors over 65, 2.50 euros; children under 7, free.
Hours: Daily, 11 a.m.–5 p.m. Closed New Year's Day.

Van Gogh Museum

Paulus Potterstraat 7, Amsterdam, the Netherlands
(31-20) 570-5252

www.vangoghmuseum.nl

The museum will mark the 150th anniversary of Van Gogh's birth in 2003.

2003 EXHIBITIONS

Through January 19
American Beauty
Painting and sculpture from 1770 to 1920 from the Detroit Institute of Arts.

Through January 19
Fire & Ice
Works from the photographic collection of Frederic Church.

February 14–June 15
Vincent's Choice: The Musée Imaginaire of Van Gogh
One of two exhibitions celebrating the 150 years since the birth of Van Gogh, featuring works by artists Van Gogh admired, from Old Masters to Millet, Delacroix and Toulouse-Lautrec.

June 27–December 10
Gogh Modern
Second exhibition marking the 150th anniversary, focusing on Van Gogh and his role in modern art.

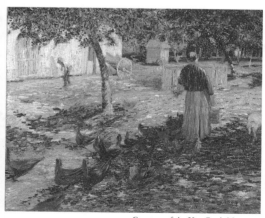

Charles Angrand, *Feeding the Chickens,* 1884.

Courtesy of the Van Gogh Museum.

November 7–February 8, 2004
Ernst Ludwig Kirchner
Works by the Expressionist artist.

November 7–February 8, 2004
La Scala
Set designs and costumes related to the Milan opera house.

November 7–February 8, 2004
Die Brücke
Drawings and prints from the Hamburger Kunsthalle.

PERMANENT COLLECTION

World's largest collection of works by van Gogh, with more than 200 paintings, 500 drawings and 700 letters. Also works by artists van Gogh admired, including Seurat and Gauguin.
Architecture: Original building designed by the Dutch architect Gerrit Rietveld (1888–1964) and partners, renovated by Martien van Goor, Greiner van Goor Architects (Amsterdam); new wing designed by the architect Kisho Kurokawa of Tokyo.

Admission: Adults, 7 euros; youths 13–17, 2.50 euros; under 13, free.
Hours: Daily, 10 a.m.–6 p.m. Closed New Year's Day.

Mauritshuis

8 Korte Vijverberg, the Hague 2513, the Netherlands
(31-70) 302-3456
www.mauritshuis.nl

2003 EXHIBITIONS

Fall
Hans Holbein the Younger
Paintings, drawingts and miniatures by the German painter (1497/8–1543) known for his portraits of wealthy merchants and leading courtiers.

PERMANENT COLLECTION

Since 1822, the museum has housed the Royal Cabinet paintings. Masterpieces from the Dutch Golden Age, including paintings by Vermeer, Rembrandt, Jan Steen and Frans Hals, as well as a panorama of Dutch and Flemish art from the 15th to 17th century. **Highlights:** Vermeer, *View of Delft;* Rogier van der Weyden, *The Lamentation of Christ;* Frans Hals, *A Laughing Boy.* **Architecture:** Dutch classical-style mansion designed by Jacob van Campen and built around 1640.

Admission: Adults, 7 euros; seniors, 3.50 euros; 18 and under, free.
Hours: Tuesday through Saturday, 10 a.m.–5 p.m.; Sundays and holidays, 11 a.m.–5 p.m. Closed Monday.

Kröller-Müller Museum

6 Houtkampweg, Otterlo 6730, the Netherlands
(31-31) 859-1241
www.kmm.nl

The museum is collaborating with the Van Gogh Museum to celebrate the 150th anniversary of Van Gogh's birth.

2003 EXHIBITIONS

February 14–October 12
Vincent and Helene: The Significance of Van Gogh in the Kröller-Müller Collection
A look at what compelled the museum's founder, Helene Kröller-Müller to acquire so many works by Van Gogh.

PERMANENT COLLECTION

Opened in 1938 to house the collection of Helene Kröller-Müller, which she bequeathed to the state in 1935. Features art from the 19th and 20th centuries, including works by van Gogh, Seurat, Picasso, Léger and Mondrian, and one of Europe's largest sculpture parks, including works by Rodin, Moore, Serra and Oldenburg. **Architecture:** Designed by Henry van de Velde with new 1977 wing by Wim Quist and located in Huge Veluwe National Park.

Vincent Van Gogh, *Chestnut Tree in Blossom*, 1890.

Courtesy of the Kröller-Müller Museum.

Admission: Adults, 10 euros; ages 6–12, 5 euros; under 6, free. Discount for groups of 20 or more.
Hours: Tuesday through Sunday and bank holidays, 10 a.m.– 5 p.m. Closed Monday, New Year's Day.

 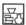

Kunsthal Rotterdam

Westzeedijk 341, 3015 Rotterdam, The Netherlands
(31-010) 44-00-300
www.kunsthal.nl

2003 EXHIBITIONS

Through January 5
Wonderland: From Pietje Bell to Harry Potter
Large-scale exhibition of children's books, organized in cooperation with the Dutch National Library.

Through April 27
Kees van Dongen: Parading on Paper — Etchings, Lithos and Pochoirs
Retrospective of graphic works by the artist, including the colorful prints known as pochoirs.

442

January 18–May 25
Impressionism: The Miracle of Color, Masterpieces From the Fondation Corboud
About 110 works from the Barbizon School to post-Impressionism, created from 1860 to around 1900.

Spring
A Lasting Attraction: Dutch Artists in Italy, 1800–1940
A look at how Dutch artists, especially historical and landscape artists, were drawn to Italy, often to round out their artistic education.

May 10–August 31
Martin Parr
An overview of photographs produced from 1970 to 2000 by an influential and innovative British photographer.

May 31–September 6
Isamu Noguchi
Retrospective of the diverse work of the Japanese-American artist and designer.

September 19–November 30
The Burning Brush: Smoking in Art
Some 120 works from the 17th century to the present that reflect the popularity of smoking as a motif in visual art.

September–November
Fiep Westendorp
Retrospective of the career of a children's book illustrator.

September 20–January 11, 2004
Blackfoot Indians
A look at the history and culture of the Blackfoot Indians of North America.

Architecture: Designed by Rem Koolhaas, a Rotterdam native.

Admission: Adults, 7.50 euros; reduced rates for teens, seniors and groups; under 12, free.
Hours: Tuesday through Saturday, 10 a.m.–5 p.m.; Sunday and holidays, 11 a.m.–5 p.m. Closed Monday, New Year's Day, April 30 and Christmas Day.

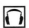 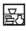 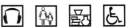

Museum Boijmans Van Beuningen

18-20 Museumpark, Rotterdam, the Netherlands
(31-10) 441-9400
www.boijmans.rotterdam.nl

PERMANENT COLLECTION

Art ranging from the Middle Ages to the present day: 15th- to 17th-century Dutch art, including works by van Eyck, Rubens and Rembrandt; Surrealist art by Magritte, Dalí and others; contemporary German and American art; contemporary sculpture, including works by Bruce Nauman and Frank Stella.
Architecture: 1935 Expressionist building with sculpture garden.

Admission: Adults, 6 euros; reduced admission, 3 euros; under 4, free.
Hours: Tuesday through Saturday, 10 a.m.–5 p.m.; Sunday and holidays, 11 a.m.–5 p.m. Closed Monday, New Year's Day, April 30 and Christmas Day.

Norway

The Astrup Fearnley Museum of Modern Art

4 Dronningensgate, 0107 Oslo, Norway
(472) 293-6060
www.af-moma.no

2003 EXHIBITIONS

January 16–March 2
Janet Cardiff

February 1–April 20
Robert Gober

March 13–May 4
Torbjoern Roedland

May 3–August 31
Mystery and Discovery
Works from the museum's collection.

September 13–November 16
Jeff Koons

PERMANENT COLLECTION

Works by Francis Bacon, R.B. Kitaj and others from the
London School; Norwegian art, including works by Bjorn
Carlsen and Knut Rose. **Highlights:** Anselm Kiefer, *The High
Priestess/Zweistromland*; Damien Hirst, *Mother and Child
Divided*; sculpture court.

Admission: Adults, 50 kroner; children, students, artists and
senior citizens, 25 kroner. Free on Tuesday.
Hours: Tuesday through Friday, 11 a.m.–5 p.m.; Thursday,
until 7 p.m.; Saturday and Sunday, noon–5 p.m. Closed
Monday.

The Munch Museum

Tøyengaten 53, 0608 Oslo, Norway
(472) 324-1400
www.munch.museum.no

PERMANENT COLLECTION

Some 1,000 paintings, 18,000 prints and 4,500 drawings by
Edvard Munch.

Admission: Adults, 60 kroner; children, seniors and students,
30 kroner. Discount for groups of 10 or more. Free admission
with Oslo Card.
Hours: Tuesday through Friday, 10 a.m.–4 p.m.; Saturday and
Sunday, 11 a.m.–5 p.m. Closed Monday. June 1 through
September 15: Daily, 10 a.m.–6 p.m.

National Gallery

13 Universitetsgaten, Oslo 0164, Norway
(472) 220-0404
www.museumsnett.no/nasjonalgalleriet

PERMANENT COLLECTION

Some 43,000 prints and drawings from Norway and the rest of th
world; 4,500 paintings; 900 original sculptures and 950 plaster
casts. Nineteenth- and 20th-century Norwegian art, featuring
romantic landscape painting, Realism, neo-Romanticism,
Impressionism, Post-Impressionism and Expressionism; works
from other Scandinavian countries; Old Masters and Roman
sculptures; French art since Delacroix; graphic arts; Russian icons.
Highlights: More than 55 paintings by Edvard Munch, including
Frieze of Life, *Moonlight*, *The Scream* and *The Dance of Life*.
Architecture: 1881 neo-Renaissance building by Adolf Schirmer

Admission: Free.
Hours: Monday and Wednesday through Friday, 10 a.m.–6
p.m.; Thursday, until 8 p.m.; Saturday and Sunday, 11 a.m.–4
p.m. Closed Tuesday.

Philippines

The Metropolitan Museum of Manila

Bangko Sentral ng Pilipinas Complex, Roxas Boulevard,
 Manila 1004, Philippines
(632) 521-1517; (623) 523-7856

PERMANENT COLLECTION

Gold belts, rings, earrings and necklaces dating from the 10th
to the 14th centuries; Philippine pottery from 200 B.C. to
900 A.D.

Admission: Adults, 50 pesos; children and students, 30 pesos.
Hours: Monday through Saturday, 10 a.m.–6 p.m. Closed
Sunday and holidays.

Portugal

Evora Museum

Largo Conde de Vila Flor, Evora 7000, Portugal
(351-26) 670-2604

The museum is closed for renovation through 2004.

PERMANENT COLLECTION

Stone sculpture from the Middle Ages and the Renaissance;
portraits from the Portuguese School; religious and domestic
silver from the 14th century to the 19th. **Highlights:** 16th-
century cenotaphs of Dom Alvaro da Costa and Bishop Afonso
of Portugal; the Flemish polyptych *The Life of Virgin Mary*.
Architecture: 17th-century former archbishop's residence.

Calouste Gulbenkian Museum

45a Avenida de Berna, Lisbon 1067-001, Portugal
(351-21) 782-3000
www.gulbenkian.pt

2003 EXHIBITIONS

June 18–September 7
Goa and the Great Mughal

PERMANENT COLLECTION

Painting, sculpture and decorative arts; Oriental and Islamic art; Greek coins; Egyptian art. **Highlights:** René Lalique collection.

Admission: Adults, 3 euros; museum directors and curators, school groups, teachers, students and seniors, free. Free on Sunday and holidays.
Hours: Tuesday through Sunday, 10 a.m.–6 p.m. Closed Monday and New Year's Day, Easter Sunday, May 1 and Christmas Day.

National Museum of Ancient Art

Rua das Janelas Verdes, Lisbon 1249-017, Portugal
(351-21) 391-2800
www.ipmuseus.pt

PERMANENT COLLECTION

Portuguese and European paintings, sculpture and decorative arts from the 12th through the 19th centuries; African and Asian decorative arts that reflect relations with Portugal.

Admission: Adults, 3 euros; seniors and children,1.5 euros; under 14, free. Free on Sunday until 2 p.m.
Hours: Tuesday, 2–6 p.m.; Wednesday through Sunday, 10 a.m.–1 p.m. and 2–6 p.m. Closed Monday, New Year's Day, Easter Sunday, May 1 and Christmas Day.

Russia

Pushkin Museum of Fine Arts

12 Volkhonka Street, Moscow 121019, Russia
(7-095) 203-7412
www.museum.ru/gmii

2003 EXHIBITIONS

Through February 3
Images of Venice
Italian paintings.

February 17–April 13
Kingdom of Flora and Ceres

April 27–August 3
300th Anniversary of St. Petersburg

October 6–November 16
The Theme of the Staircase in Fine Arts and Architecture

December 1–mid-February 2004
Russia-Germany, 19th Century

PERMANENT COLLECTION

Ancient Greek and Roman sculpture, including the marble sarcophagus *Drunken Hercules* and a torso of Aphrodite; French Barbizon and modern painting. **Highlights:** Botticelli, *The Annunciation*; San di Pietro, *Beheading of John the Baptist*; six Rembrandts, including *Portrait of an Old Woman*; five Poussins; Picassos from the Blue period; Cézanne, *Pierrot and Harlequin*; van Gogh, *Landscape at Auvers After the Rain* and *Red Vineyards*; Monet, *Rouen Cathedral at Sunset*; Renoir, *Bathing on the Seine* and *Nude on a Couch*; 10 Gauguins. **Architecture:** Neo-Classical Roman Klein building (1898–1912) with a large colonnade and glass roof.

Admission: Adults, 160 rubles; children and students, 60 rubles.
Hours: Tuesday through Sunday, 10 a.m.–6 p.m. Closed Monday.

Tretyakov Gallery

12 Lavrushinsky Pereulok, Moscow, Russia
(7-095) 951-1362; (7-095) 953-5223 (tours)
www.tretyakov.ru

2003 EXHIBITIONS

January 28–March 2
Aleksandr Drevin
Abstract works, figurative works and landscapes by the 20th-century artist.

February 13–March 16
Vladimir-Suzdal Preserve: Art of the 18th to 20th Centuries
Includes 18th-century paintings from former estates and mansions as well as works by members of the Vladimir art school, formed in the 1960's.

April 24–May 11
A.D. Shmarinov
Illustrations by Aleksei Dementyevich Shmarinov for works by Pushkin, Shakespeare, Gogol, Hemingway and others.

May 22–September 8
Exhibition of Works From the Museum of Ramat Gan
Works from the only gallery of Russian art in Israel.

September 9–28
V.V. Favorskaya and I.I. Chekmazov
Works by Vera Vasilyevna Favorskaya (1896–1977) and Ivan Ivanovich Chekmazov (1901–1961), a married couple.

October 9–November 2
Konstantin Melnikov
Photos of the buildings, architectural projects, paintings and graphic works by the architect, who was one of the founders of constructivism.

November 18–December 15
Nikolai Sapunov
Works by a graphic artist and painter who was one of the founders of the "Blue Rose" society and a representative of Russian symbolism.

December–January 2004
Pavel Kuznetsov and Pyotr Utkin
Compares the work of two Russian symbolist artists.

PERMANENT COLLECTION

More than 100,000 works of Russian art, including ancient
works; icons; classical 18th- and 19th-century works. Original
collection donated by Tretyakov brothers in 1895 from their
private home next door. **Architecture:** 1900 building in early
Art Nouveau style; facade by Viktor Vasnetsov.

Krymsky Val Branch

10 Krymsky Val, Moscow, Russia
(7-095) 238-1378; (7-095) 238-2054 (tours)

2003 EXHIBITIONS

Through February 2
Dionisius
Exhibition marking the 500th anniversary of the creation of
the frescoes in the Church of Nativity of the Mother of God in
the Pherapont monastery by the Russian icon painter
Dionisius.

February–March
Yuri Zlotnikov
Works by a painter and graphic artist who was part of the
Russian underground of the 1960's to 1980's.

March 4–23
Evgeny Dybsky
Paintings based on the interrelation of space, plane and object.

April–August
Living Tradition
Explores a century of works by the "Moscow School."

April–September
Painters of the Russian Society of the Friends of Books
Works by Russian graphic artists of the 1920's.

April–May
Exhibition of New Additions of Modern Graphics
Works added to the gallery's collection of modern graphics.

August 24–November 16
Cubism: East-West
Works by Russian and European Cubist artists.

August–September 2003
Boris Turetsky
Works by a painter who has worked in a variety of modern art styles, including abstraction, Pop Art and conceptualism.

October
Konstantin Rozhdestvensky
Paintings and graphic art by the avant-garde painter and designer.

November
Twentieth Century in Children's Drawing and *Creative Studio of the 20th Century*
Interactive exhibition for children to help them understand modern art, along with display of children's art.

December
Aleksandr Tyshler
Works by the 20th-century Russian painter.

PERMANENT COLLECTION

Twentieth-century Russian art. Russian Avant-Garde of the 1910's and 1920's, including works by Petrov-Vodkin, Malevich, Kandinsky, Chagall; Social Realism, the official style of the totalitarian state of the 1930's to 1950's; nonconformist art of the 1960's and 1970's, known as the Second Russian Avant-Garde. .

Admission for both buildings: Adults, 210 rubles; children and students, 120 rubles.
Hours: Tuesday through Sunday, 10 a.m.–7:30 p.m.; last admission at 6:30. Closed Monday.

The State Hermitage Museum

34 Dvortsovaya Naberezhnaya, St. Petersburg 190000, Russia
(7-812) 110-9079; (7-812) 219-4751 (tours)
www.hermitage.ru

PERMANENT COLLECTION

More than three million works of art, including antiquities from Egypt, Babylon, Byzantium, Greece, Rome and Asia; prehistoric Russian artifacts; more than one million medals and coins; Old Masters of Western Art; French Impressionists and Post-Impressionists up to the 20th century. **Highlights:** The Jordan staircase; Scythian gold; Michelangelo's *Crouching Boy* sculpture; works by Leonardo and Raphael; eight Titians; works by El Greco, Velázquez, Zurbaran and Goya; works by Rubens andRembrandt; Matisse, *Dance*; Cézanne, *Banks of the Marne*; Picassos from the Blue, Pink and Cubist periods. **Architecture:** Five buildings in the historical center of St. Petersburg: Winter Palace, the former residence of Russian emperors, built for the daughter of Peter I by Bartolomeo Rastrelli; the Small, the Great and the New Hermitages, and the Hermitage Theater.

Admission: Adults, 300 rubles; students and under 17, free.
Hours: Tuesday through Saturday, 10:30 a.m.–6 p.m.; Sunday, 10:30 a.m.–5 p.m. Closed Monday.

The State Russian Museum

4 Inzhenernaya Street, St. Petersburg 191011, Russia
(7-812) 219-1608; (7-812) 314-8368
www.rusmuseum.ru

2003 EXHIBITIONS

February
National Roots and the Russian Avant-Garde

April
Saint Petersburg
Works depicting the city and its citizens.

May
Russian Paris

September
The World of Art

November
Three Centuries of Russian Art

December
Orthodox Petersburg

PERMANENT COLLECTION

Russian art from the 10th to the 20th centuries, including Russian icon, avant-garde and contemporary art. Works by Dionisy, Kandinsky, Malevich and Rublev. **Architecture:** Empire-style Mikhailovsky Palace (1819–25) designed by Carlo Rossi; Benois Wing (1914–20) by L.N. Benois and O. Ovsyannikov; classicist Marble Palace (1768–1785) by Antonio Rinaldi and Engineer's Castle (1799–1801) by V. Brenna; Baroque-style Stroganoff Palace rebuilt in the 1750's by Francesco Bartolomeo Rastrelli.

Admission: Adults, 240 rubles; students and children, 120 rubles.
Hours: Wednesday through Sunday, 10 a.m.–6 p.m.; Monday, until 5 p.m. Closed Tuesday.

Scotland

Dundee Contemporary Arts

152 Nethergate, Dundee DD1 4DY, Scotland
(44-13) 82-432-000
www.dca.org.uk

Architecture: 1999 building by Richard Murphy Architects that houses galleries, cinemas and facilities for artists, as well as educational resources, including the University of Dundee visual research center.

Admission: Free to galleries.
Hours: Tuesday through Sunday, 10:30 a.m.–5:30 p.m.; Thursday and Friday, until 8 p.m. Closed Monday except for Dundee public holidays.

National Galleries of Scotland

(44-131) 624-6200
www.nationalgalleries.org

National Gallery of Scotland

The Mound, Edinburgh EH2 2EL, Scotland

2003 EXHIBITIONS

Through January 31
The Vaughan Bequest of Turner Watercolors

Through March
The Print in Italy, 1550–1620

April 4–June 22
Gainsborough's Beautiful Mrs. Graham

August 2–October 26
Monet: The Seine and the Sea
Some 80 paintings Claude Monet created while living in rural Vétheuil and on the Normandy coast from 1878 to 1883. Also includes landscapes by Camille Corot, Gustave Courbet and Charles-François Daubigny, whom Monet admired.

Courtesy of the National Galleries of Scotland.
Monet, *Cliffs at Pourville,* 1882.

December 12–February 29, 2004
Degas and the Italians

PERMANENT COLLECTION

Masterpieces from the Renaissance to Post-Impressionism, including works by Constable, van Gogh, El Greco, Monet, Rembrandt, Turner, Velázquez and Vermeer; Scottish paintings by Raeburn, Ramsay, Wilkie and others; Italian and Netherlandish drawings. **Architecture:** 1895 neo-Classical building by William Playfair.

Scottish National Portrait Gallery

1 Queen Street, Edinburgh EH2 1JD, Scotland

2003 EXHIBITIONS

Through January 19
On Top of the World: Scottish Mountaineers at Home and Abroad
Paintings, sculpture and photographs, plus early instruments and documents.

Through February 9
Calum Colvin: Fragments of Ancient Poetry
An installation featuring approximately 30 new, large-scale photographic works. Inspired by James Macpherson's disputed translations of ancient epic poetry, *The Poems of Ossian and Related Works* (1765).

January 31–May 18
Robert Louis Stevenson

March 14–May 25
Mad, Bad and Dangerous: Lord Byron

March–June
Portrait Miniatures From the Daphne Foskett Collection

June 20–September 14
Francis Grant

October 10–January 5, 2004
Fay Goodwin

PERMANENT COLLECTION

Subjects include Mary, Queen of Scots; Robert Burns; Sir Walter Scott; Jimmy Shand; and Sean Connery. Photography, sculpture, miniatures, coins and medallions. **Architecture:** 1880's red sandstone neo-Gothic building designed by Robert Rowand Anderson.

Scottish National Gallery of Modern Art

Belford Road, Edinburgh EH4 3DR, Scotland

2003 EXHIBITIONS

Through January 31
International Contemporary Art From a Private Collection
Works by Anselm Kiefer, Gerhard Richter, Ed Ruscha, Jeff Wall, Andy Warhol, Rachel Whiteread, Bill Viola and others.

Through February 23
More Than Reality: Duane Hanson
Thirty of the American's lifelike sculptures, dating from the 1960's until shortly before the artist's death in 1996.

June 21–September 21
Winifred Nicholson

August 14–November 23
The Boyle Family

Opening in October
Ben Nicholson
Paintings from the gallery's collection.

PERMANENT COLLECTION

Twentieth-century paintings, sculpture and graphic art, including works by Bacon, Bonnard, Baselitz, Kirchner, Léger, Lichtenstein, Matisse, Moore and Picasso. Works by Scottish artists, including the Colorists. **Architecture:** 1820's neo-Classical former school building designed by William Burn.

Dean Gallery

Belford Road, Edinburgh EH4 3DS, Scotland

2003 EXHIBITIONS

Through January 12
A Maverick Eye: The Photography of John Deakin
More than 100 works by the photographer (1912–72), selected
by Robin Muir, former photo editor of British Vogue.

Through February 13
Jazz by Henri Matisse

April 16–June 15
Ashley Havinden Centenary Exhibition

July–September
The Bruce Bernard Collection
Nearly 100 photographs, from 1850 to the 1900's, once
selected by Bernard for a collector, including works by
Eadweard Muybridge and William Henry Fox Talbot.

PERMANENT COLLECTION

Dada and Surrealist works; prints, drawings, plaster maquettes
and moulds by Eduardo Paolozzi, as well as the contents of his
studio. **Architecture:** 1830's hospital building converted to a
gallery in the 1990's by Terry Farrell and Partners.

FOR ALL FOUR MUSEUMS:

Admission: Free. Fees for some exhibitions.
Hours: Monday through Saturday, 10 a.m.–5 p.m.; Sunday,
11 a.m.–5 p.m.

Hunterian Art Gallery

University of Glasgow, 22 Hillhead Street, Glasgow G12
8QQ, Scotland
(44-41) 330-5431
www.hunterian.gla.ac.uk

2003 EXHIBITIONS

Through January 11
Season's Greetings: Artist's Cards
Holiday cards created by artists for their friends. Includes examples by Milton Avery, Leonard Baskin and Red Grooms.

Through April
Intimate Friends: Scottish Colorists at the University of Glasgow
Works from the gallery's collection.

January 17–Spring
Prints by the Colorists
Monotypes, etchings, copperplates and drypoints.

June 21–October 4
Whistler at the Hunterian
Paintings, furniture, silver, ceramics, artist's materials and personal effects. The exhibition is part of a Glasgow-wide celebration marking the centenary of James McNeill Whistler's death.

June 21–October 4
Anna Matilda Whistler: A Life
The famous painting of Whistler's mother returns to Scotland for the first time in more than 50 years, plus archival material that sheds light on her life.

June 21–October 4
Beauty and the Butterfly: Whistler's Depictions of Women
Pastel drawings and other works on paper.

June 21–October 4
1890's Women
Works by Aubrey Vincent Beardsley, Carlos Schwabe, Jan Theodoor Toorop and others.

June 21–October 4
Copper into Gold: Whistler and 19th-Century Printmaking
Whistler's etchings and lithographs, alongside works by Seymour Haden, Édouard Manet and other contemporaries.

June 21–October 4
Whistler and Scotland
Explores the artist's many Scottish links, with other artists and with dealers and collectors. Includes works by J.D. Fergusson, James Guthrie, George Henry, S.J. Peploe and E.A. Walton.

PERMANENT COLLECTION

Paintings by Rembrandt, Koninck, Stubbs and Chardin; 18th-century portraits by Ramsay and Reynolds; 19th- and 20th-century Scottish paintings; 19th-century French art, including works by Pissarro and Rodin; prints; some 70 paintings by James McNeill Whistler; works by the Scottish architect and designer Charles Rennie Mackintosh, including some 80 pieces of furniture and more than 700 drawings, watercolors and designs, as well as the Mackintosh House, a reconstruction of interiors from his Glasgow home.

Admission: Free.
Hours: Monday through Saturday, 9:30 a.m.–5 p.m. Closed Sunday and public holidays.

South Africa

South African National Gallery

Government Avenue, Cape Town 8000, South Africa
(27-21) 465-1628
www.museums.org.za/sang

PERMANENT COLLECTION

Southern African and international art.

Admission: Adults, 5 rand; seniors, students and children, free. Free on Sunday.
Hours: Tuesday through Sunday, 10 a.m.–5 p.m. Closed Monday and May 1.

Johannesburg Art Gallery

Klein Street, Joubert Park, Johannesburg 2044, South
 Africa
(27-11) 725-3130
www.johannesburgart.org

PERMANENT COLLECTION

Nineteenth- to early-20th-century French and British art;
17th-century Dutch art; 19th- and 20th-century traditional art
from the subcontinent; Modern art, including South African;
print collection from Dürer and Rembrandt to the present day;
small collection of lace, ceramics, furniture, textiles; sculpture,
including large-scale works on the gallery grounds and in the
park. **Architecture:** 1913–1915 Classical building designed
by Sir Edwin Lutyens; construction and 1940 wings supervised
by Robert Howden; 1980's expansion by Meyer Pienaar and
Partners.

Admission: Free.
Hours: Tuesday through Sunday, 10 a.m.–5 p.m. Closed
Monday, Good Friday and Christmas Day.

Spain

Fundació Antoni Tàpies

255 Aragó, Barcelona 08007, Spain
(34-93) 487-0315

PERMANENT COLLECTION

Examples from every period of Tàpies's career.

Admission: 4.20 euros; seniors and students, 2.10 euros;
under 16, free.

Hours: Tuesday through Sunday, 10 a.m.–8 p.m. Closed Monday.

Fundació Joan Miró

Parc de Montjuïc, Barcelona 08038, Spain
(34-93) 443-9470

PERMANENT COLLECTION

Nearly 300 paintings, 150 sculptures and 7,000 drawings and prints by Miró, from every period of his career. **Architecture:** Building by Josep Lluís Sert in the Parc de Montjuïc.

Admission: 7.20 euros; students and seniors, 3.90 euros; under 14, free. Discounts for groups.
Hours: Tuesday through Saturday, 10 a.m.–7 p.m.; Thursday, until 9:30 p.m.; Sunday and public holidays, 10 a.m.–2:30 p.m. Slightly longer hours during the summer. Closed Monday.

Museu d'Art Contemporaneo de Barcelona

1 Plaça dels Àngels, Barcelona 08001, Spain
(34-93) 412-0810
www.macba.es

PERMANENT COLLECTION

More than 1,600 works by Spanish and international artists, including Dubuffet, Kiefer, Klee, Long, Manzoni, Merz, Rauschenberg and Tàpies. **Architecture:** 1995 Richard Meier building.

Admission: 6 euros; students, 4 euros; under 16, free; Wednesday, 3 euros.

Hours: Monday and Wednesday through Friday, 11 a.m.–7:30 p.m; Saturday, 10 a.m.–8 p.m.; Sunday, 10 a.m.–3 p.m. Slightly longer hours during the summer. Closed Tuesday.

Museo Picasso

15-23 Carrer de Montcada, Barcelona 08003, Spain
(34-93) 319-6310

PERMANENT COLLECTION

More than 3,500 works from Picasso's formative years, including paintings, drawings, engravings, ceramics and graphics. **Architecture:** Three 13th-century palaces.

Admission: 4.80 euros; seniors, students and the unemployed, 2.40 euros; under 16, free. Additional fees for special exhibitions.
Hours: Tuesday through Saturday, and holidays, 10 a.m.–8 p.m.; Sunday, 10 a.m.–3 p.m. Closed Monday, New Year's Day, Good Friday, May 1, June 24, Christmas Day and December 26.

Guggenheim Bilbao

2 Abandoibarra, Bilbao 48001, Spain
(34-94) 435-9080
www.guggenheim-bilbao.es

PERMANENT COLLECTION

Modern and contemporary art, including works by Klein, de Kooning, Motherwell, Rauschenberg, Rosenquist, Still, Tàpies and Warhol. **Highlights:** Mark Rothko, *Untitled (1952),* the oldest work in the collection; works by Francesco Clemente, Jenny Holzer, Sol LeWitt and Richard Serra, designed for specific exhibition areas in the museum. **Architecture:** 1997 titanium-and-limestone building by Frank O. Gehry.

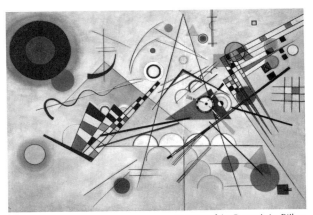

Courtesy of the Guggenheim Bilbao.

Kandinsky, *Composition 8,* 1923.

Admission: 7 euros; students and seniors, 3.50 euros; under 12 accompanied by an adult, free. Discounts for groups of more than 20. Advance tickets recommended.

Hours: Tuesday through Sunday, 10 a.m.–8 p.m. Closed Monday, New Year's Day and Christmas Day. July and August, daily, 9 a.m.–9 p.m.

Teatre-Museu Dalí

5 Plaça Gala i Salvador Dalí, Figueres 17600, Spain
(34-97) 267-7500
www.dali-estate.org

PERMANENT COLLECTION

A broad range of works by Salvador Dalí, from his earliest works and his Surrealist period up to the last years of his life; jewelry the artist designed between 1932 and 1970, illustrating the evolution of his style.

Admission: 9 euros; students, 6.50 euros; under 9, free.
Hours: Tuesday through Sunday, 10:30 a.m.–5:45 p.m. Closed Monday, New Year's Day and Christmas Day. July through September, daily, 9 a.m–7:45 p.m.

Museo del Prado

Paseo del Prado, Madrid 28014, Spain
(34-91) 330-2800; (34-91) 330-2900
museoprado.mcu.es

PERMANENT COLLECTION

Master paintings from the Italian Renaissance; Northern
European and Spanish court painters, collected by the royal
family since the 15th century; works by Velázquez, Murillo,
Rubens, van Dyck, Raphael, Botticelli, Titian and Dürer;
sculpture, from Greco-Roman pieces to 18th-century works;
drawings, etchings, coins and medals; decorative arts.
Highlights: Fra Angelico, *The Annunciation*; Titian, *Danae*;
Bosch, *The Garden of Delights*; Bruegel, *The Triumph of Death*; El
Greco, *The Nobleman With His Hand on His Chest*; Velázquez,
The Surrender of Breda; Goya, *Nude Maja, Clothed Maja, Third of
May*. **Architecture:** 1819 neo-Classical building by Juan de
Villanueva.

Admission: Adults, 3 euros; students, 1.50 euros; seniors and
under 18, free; Free all day on Sunday and on Saturday, 2:30
p.m.–7 p.m., free.
Hours: Tuesday through Saturday, 9 a.m.–7 p.m.; Sunday and
holidays, 9 a.m.–2 p.m. Closed Monday, New Year's Day, Good
Friday, May 1 and Christmas Day.

Museo Reina Sofía

Santa Isabel 52, Madrid 28012, Spain
(34-91) 467-5062; (34-91) 467-5161
museoreinasofia.mcu.es

PERMANENT COLLECTION

More than 10,000 works of European modern and
contemporary art; works by the Spanish artists Gris, Dalí,
Picasso, Miró and González, as well as artists influenced by the
Modernist movement; sculpture, including works by Gargallo,
Alfaro and Serrano; more than 4,500 drawings and engravings.

Highlights: Picasso, *La Naguese*, *Guernica*; Kapoor, *1,000 Names*. **Architecture:** Former hospital building designed by Sabatini in 1788; 1980 restoration by Antonio Fernández Alba; 1988 renovation and expansion by José Luis Iñíguez de Onzoño and Antonio Vázquez de Castro.

Admission: Adults, 3 euros; students, 1.50 euros; seniors and under 18, free. Free on Saturday and Sunday.
Hours: Monday and Wednesday through Saturday, 10 a.m.–9 p.m.; Sunday, 10 a.m.–2:30 p.m. Closed Tuesday.

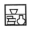

Museo Thyssen-Bornemisza

8 Paseo del Prado, Madrid 28014, Spain
(34-91) 420-3944
www.museothyssen.org

2003 Exhibitions
February 11–May 25
Musical Analogies: Kandinsky and His Contemporaries

Permanent Collection

Some 800 paintings, including works by Italian Primitives; Renaissance and Baroque art; 17th-century Dutch landscapes; 19th-century American School; Impressionism; German Expressionism; avant-garde; Surrealism; Pop Art.
Architecture: Villahermosa Palace, renovated from 1989 to 1992 by Rafael Moneo.

Admission: 4.80 euros; seniors and students, 3 euros; under 12 accompanied by an adult, free.
Hours: Tuesday through Sunday, 10 a.m.–7 p.m. Open daily until midnight during the summer. Closed Monday, New Year's Day, May 1 and Christmas Day.

Instituto Valenciano de Arte Moderno

118 Guillem de Castro, Valencia 46003, Spain
(34-96) 386-3000
www.ivam.es

2003 EXHIBITIONS

January 16–May 4
Gori Collection

March 14–May 18
Gonzalo Fonseca-Caio Fonseca

May 29–September 7
Henry Moore

July 17–October 12
View and Vision

September 18–November 30
Charles Simmonds

October 23–January 11, 2004
Henri Matisse

December 11–March 1, 2004
Francis Bacon

PERMANENT COLLECTION

Sculpture by Julio González; avant-garde works, focusing on the development of abstraction, typographical montage and photomontage; European Informalism; Pop Art; New Figuration. **Architecture:** 1989 Centre Julio González and the historic Centre del Carme.

Admission: Centre Julio González, 2.10 euros; students, 1 euro; seniors and children, free. Free on Sunday. Centre del Carme, free.
Hours: Tuesday through Sunday, 10 a.m.–8 p.m. Closed Monday.

Sweden

Modern Museum

Klarabergsviadukten 61, Box 16382,
 Stockholm 10327, Sweden
(46-85) 195-5200; (46-85) 195-5282 (recording)
www.modernamuseet.se

The museum is scheduled to return to its Skeppsholmen,
Stockholm, home late in 2003.

2003 EXHIBITIONS

Through June 16
20th-Century Abstract Art

June 1–September 29
Bodies
Video works on the themes of movement, bodies and identity,
by Alexander Calder, Sam Taylor-Wood, Katarzyna Kozyra and
Jaan Toomik.

August 24–September 22
Love
Paintings and drawings by children in Mozambique and
Sweden.

PERMANENT COLLECTION

Swedish and foreign art, including works by Matisse and
Munch; German Expressionists; Dadaism; Cubism; Surrealism;
Picasso; works produced between 1945 and 1970 by Kelly,
Klein, Newman and others; Pop Art, with works by
Rosenquist, Warhol and contemporaries; Minimalism and
conceptual art, including works by Flavin, Judd and Kawara.

Admission: Free.
Hours: Tuesday through Thursday, 10 a.m.–8 p.m.; Friday
through Sunday, 10 a.m.–6 p.m. Closed Monday, New Year's
Day, Christmas Eve, Christmas Day and New Year's Eve.

National Museum

Södra Blasieholmshamnen, Stockholm, Sweden
(44-85) 195-4300
www.nationalmuseum.se

2003 EXHIBITIONS

Through January 6
Nicodemus Tessin the Younger: Royal Architect and Visionary
A look at one of Stockholm's city planners.

Through January 19
Impressionism and the North
Some 70 paintings by Cézanne, Gauguin, van Gogh, Monet
and other Impressionists, together with works by Nordic
artists who were influenced by them.

Through February 9
Master Drawings From 17th-Century Bologna

Through February 16
Art Needs Room
Paintings, sculpture, drawings, prints, applied arts and design
from the museum's collection.

February 27–May 18
Spanish Paintings
Paintings from the museum's collection, by Goya, El Greco,
Meléndez and Zurbarán.

March 21–August 10
From Tail to Trunk: Animals in Art
Works, which are bound to appeal to children, from the past
five centuries.

Clocks from
five centuries.

Courtesy of the National Museum.

Continuing
Design, 1900–2000

PERMANENT COLLECTION

Some 16,000 works of painting and sculpture, from the Middle Ages to the 20th century; 500,000 prints and drawings, from the 15th century to the turn of the 20th century; Swedish 18th- and 19th-century painting; 17th-century Dutch art; 18th-century French art; about 30,000 decorative-arts objects from six centuries, including china, glass, Swedish silver and furniture; tapestries from the 15th to the 17th centuries; 20th-century design and applied arts.

Architecture: In the Florentine and Venetian Renaissance style.

Admission: 75 kronor; students and groups, 60 kronor; under 16, free. Wednesday, 60 kronor.

Hours: Tuesday through Sunday, 11 a.m.–5 p.m.; Tuesday, until 8 p.m.; Thursday from September through May, until 8 p.m. Closed Monday.

Switzerland

Kunstmuseum Basel

16 St. Alban-Graben, Basel 4010, Switzerland
(41-61) 206-6262
www.kunstmuseumbasel.ch

2003 EXHIBITIONS

Through January 19
The Netherlands as an Example: Shown in the Light
Nineteenth-century paintings by various artists.

Through February 9
Werner von Mutzenbacher

PERMANENT COLLECTION

Paintings and drawings from the Swiss Upper Rhine area and the Netherlands from the 15th and 16th centuries; 19th- and 20th-century art; works by Holbein, Picasso, Braque and Gris; German Expressionism; Abstract Expressionism; Pop Art.

Admission: Adults, 10 francs; students and groups, 8 francs; 15 and under, free. Includes admission to the Museum of Contemporary Art.

Hours: Tuesday through Sunday, 10 a.m–5 p.m. Closed Monday, February 22–24, May 1, Christmas Eve, Christmas Day and December 31.

Museum für Gegenwartskunst (Museum of Contemporary Art)

60 St. Alban-Rheinweg, Basel 4010, Switzerland
www.mgkbasel.ch
(41-61) 272-81-83

2003 EXHIBITIONS

Through January 26
Bruce Nauman
Sculpture, video, film and prints.

PERMANENT COLLECTION

Art made since 1960; minimal art; conceptual art; "Die Neuen Wilden"; works by Joseph Beuys and Frank Stella.

Architecture: Built in 1980 by Katharina and Wilfried Steib, the extension of a late 19th-century factory building with creek running beneath it.

Admission: Adults, 10 francs; students and groups, 8 francs; 15 and under, free. Includes admission to the Kunstmuseum.

Hours: Tuesday through Sunday, 11 a.m.–5 p.m. Closed Monday.

Kunstmuseum Bern

8-12 Hodlerstrasse, Bern 3000, Switzerland
(41-31) 311-0944; (41-31) 312-0955
www.kunstmuseumbern.ch

PERMANENT COLLECTION

More than 3,000 paintings and sculptures and 40,000 works
on paper. Italian Trecento; Swiss art from the 15th century,
including Manuel, Anker and Hodler; works by Delacroix,
Courbet, Dalí, Masson, Kirchner, Klee, Pollock and contempo-
rary artists.

Admission: Adults, 7 francs; students and groups, 5 francs.
Higher fees for special exhibitions.
Hours: Tuesday, 10 a.m.–9 p.m.; Wednesday through Sunday,
10 a.m.–5 p.m. Closed Monday, Good Friday, Easter Sunday,
Pentecost Sunday, Chistmas Eve and Christmas Day.

Museum Barbier-Mueller

10 Rue Calvin, 1204 Geneva, Switzerland
(41-22) 312-0270
www.barbier-mueller.ch

2003 EXHIBITIONS

March 15–October 1
The Fruits of My Passion
Works from Africa, Indonesia, Oceania and pre-Columbian
America.

PERMANENT COLLECTION

Founded in 1977 by Jean Paul and Monique Barbier-Mueller.
Some 8,000 works of art, mainly sculptures, but also masks,
textiles and personal ornaments. Works from Africa, Indonesia,
Oceania, America and Asia as well as from ancient civiliza-
tions, including Greece, Italy and Japan.

Admission: Adults, 5 francs; students, groups and the handi-
capped, 3 francs; 11 and under, free.
Hours: Daily, 11 a.m.–5 p.m.

Fondation de l'Hermitage

2 Route du Signal, Lausanne 1000, Switzerland
(41-21) 320-5001
www.fondation-hermitage.ch

2003 EXHIBITIONS

Through February 23
The Collections of the Fondation de l'Hermitage
Selection of works from the permanent collection.

March 14–June 9
André Derain
More than 100 works from four periods of the artist's career:
Fauvism, early analytical Cubism, Neo-Classicism and
Primitivism.

June 27–October 12
Frantisek Kupka (1871–1957)
Works by a Czech painter and draftsman who moved from
Fauvism to Cubism to nonfigurative art.

PERMANENT COLLECTION

Nearly 800 paintings, sculptures, drawings and engravings,
including works by Bocion, Bosshard, Boudin, Degas, Fantin-
Latour, Magritte, Sisley, Vallotton and Vuillard. The collection
is not on permanent display. **Architecture:** Country villa
designed by Louis Wenger and built for Charles-Juste Bugnion
between 1842 and 1850; restoration in 1976.

Admission: Adults, 15 francs; children, free.
Hours: Tuesday through Sunday, 10 a.m.–6 p.m.; Thursday,
until 9 p.m. Closed Monday.

473

Museo dell'Arte Moderna

Riva Caccia 5, Lugano 6900, Switzerland
(41-91) 800-7214
www.mdam.ch

2003 EXHIBITIONS

March 16–June 29
Egon Schiele: Lugano, Switzerland
About 40 paintings and 20 works on paper done by the artist between 1907 and 1918.

Admission: Adults, 10 francs; students and groups, 7 francs; ages 14–18, 3 francs; under 14, free.
Hours: Tuesday through Sunday, 9 a.m.–7 p.m. Closed Monday.

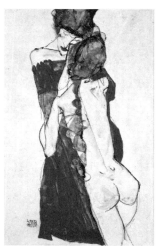

Courtesy of Museo dell'Arte Moderna.
Egon Schiele, *Mother and Daughter,* 1913.

Fondation Pierre Gianadda

29 Rue de Forum, Martigny 1920, Switzerland
(41-27) 722-3978
www.gianadda.ch

2003 EXHIBITIONS

Through January 26
Jean Lecoultre

January 31–June 9
From Picasso to Barcelo
Works by Spanish artists.

PERMANENT COLLECTION

Franck Collection, with paintings by Cézanne, van Gogh, James Ensor, Toulouse-Lautrec, Kees van Dongen and Picasso;

automobile museum, with about 50 antique cars from 1897 to 1939; sculpture park, with works by Rodin, Brancusi, Miró, Arp, Moore, Ernst and others.

Admission: Families, 30 francs; adults, 14 francs; seniors, 12 francs; students, 7 francs.

Hours: Daily, 10 a.m.–6 p.m. (Extended hours in the spring and summer.)

Kunstmuseum Winterthur

52 Museumstrasse, Winterthur 8402, Switzerland
(41-52) 267-5162
www.kmw.ch

2003 EXHIBITIONS

March 1–May 25
Richard Artschwager
Paintings, objects and drawings.

June 6–August 24
Thomas Schutte

September 6–November 23
Medardo Rosso

September 6–November 23
Marisa Merz: Una Stanza

PERMANENT COLLECTION

Paintings and sculptures from the late 19th century to the present by van Gogh, Klee, Mondrian, Giacometti, Morandi, Richter, Agnes Martin, Kelly, Marden, Merz and Kounellis.
Architecture: 1915 Art Nouveau building by Rittmeyer/Furrer with extension built in 1995 by Annette Gigon and Mike Guyer, which is completely framed in glass.

Admission: Adults, 10 francs; seniors, students and groups, 7 francs. Fees vary with exhibitions.
Hours: Tuesday, 10 a.m.–8 p.m.; Wednesday through Sunday, 10 a.m.–5 p.m. Closed Monday, New Year's Day, Mardi Gras,

Good Friday, Easter Sunday, May 1, Pentecost Sunday, Albani Festival (last Sunday in June) and Christmas Day.

Kunsthaus Zürich

1 Heimplatz, Zürich 8024, Switzerland
(41-1) 253-8484
www.kunsthaus.ch

2003 EXHIBITIONS

March 20–July 13
Duane Hanson

October 23–February 1, 2004
Georgia O'Keeffe

PERMANENT COLLECTION

Medieval art; Baroque art; Venetian art; Swiss art; 19th- and 20th-century French painting; Modern Croatian art; Dada; Modern American art. **Highlights:** Rodin sculptures; works by Alberto Giacometti, Ferdinand Hodler, Matisse and Chagall.

Admission: Adults, 10 francs; students and groups, 6 francs. Additional fees for special exhibitions.
Hours: Tuesday through Thursday, 10 a.m.–9 p.m.; Friday through Sunday, 10 a.m.–5 p.m. Closed Monday.

Thailand

The National Gallery

Chao-Fa Road, Bangkok 10200, Thailand
(66-2) 282-2639; (66-2) 281-2224

PERMANENT COLLECTION

Works by Thai artists from various periods, including works of King Rama VI and King Rama IX; traditional Thai paintings; contemporary Thai art. **Architecture:** Built during the reign of King Rama V for the Royal Mint, which used the building from 1902–72.

Admission: Adults, 30 baht; children and students, free.
Hours: Wednesday through Sunday, 9 a.m.–4 p.m. Closed Monday, Tuesday and national holidays.

Wales

National Museum and Gallery of Wales

Cathays Park, Cardiff, CF1 3NP, Wales
(44-292) 039-7951
www.nmgw.ac.uk

PERMANENT COLLECTION

Medieval and Renaissance art; 17th-century French and Italian art; British art from the Pre-Raphaelites to the 20th century; 18th- and 19th-century Welsh landscapes and portraits; Gwendoline and Margaret Davies collection, which includes paintings by Old Masters, established British artists and French Impressionists; ceramics.

Admission: Adults, £4.50; students and the disabled, £2.65; seniors, unemployed, under 18, free.
Hours: Tuesday through Sunday, and bank holiday Mondays, 10 a.m.–5 p.m.

Index